A HISTORY OF
WESTERN SCULPTURE

CONSULTANT EDITOR
JOHN POPE-HENNESSY

Sculpture
Renaissance to Rococo

Other volumes in the series

Classical Sculpture
Author George M. A. Hanfmann

Medieval Sculpture
Author Roberto Salvini

Sculpture
19th & 20th Centuries
Author Fred Licht

A HISTORY OF
WESTERN SCULPTURE

CONSULTANT EDITOR
JOHN POPE-HENNESSY

Sculpture
Renaissance
to Rococo

Herbert Keutner

MICHAEL JOSEPH · LONDON

© GEORGE RAINBIRD LTD 1969

This book was designed and produced by
George Rainbird Ltd
Marble Arch House
44 Edgware Road, London, W.2

Text translated from the German:
Introduction by John Willett
Notes by Lily Cooper and Erika Millman

House editor: Jocelyn Selson
Designers: Ronald Clark and George Sharp

SBN 7181–0448–X
Printed by Jarrold & Sons Ltd, Norwich

MATRI
OCTOGENARIAE
CARISSIMAE

ILLUSTRATION CREDITS

The publishers are greatly indebted to Professor Keutner for the loan of many photographs which would otherwise have been unobtainable. They acknowledge with gratitude the helpfulness and generosity of museums, private collectors and photographers all over Europe and in the U.S.A. in supplying photographs for this volume. Copyright owners are shown in italics. Small roman numerals indicate introduction pictures, large roman numerals colour plates. All other illustrations have arabic numerals.

AMSTERDAM *A.N.E.F.O.* 146, 209–10; *Rijksmuseum* 135, 143, 200, 202, 255

AUGSBURG *Städtische Kunstsammlung* 116

BARCELONA *MAS* III, IV, ii, 93–110, 275–6, 278–80, 282–95

BERLIN *Staatliche Museen* 9, 113, 140, 239, 253, 325

BRUSSELS *A.C.L.* xviii, xxiii, 131–3, 136–9, 141–2, 203–6, 213, 215–20

COLOGNE *Rheinisches Bildarchiv* 191

DRESDEN *Deutsche Fotothek* 243–4, 256–7

DUBLIN *Board of Trinity College* 227 (The Green Studio photo)

EDINBURGH *National Gallery of Scotland* 129 (photo Annan)

FLORENCE *Alinari* [*Mansell*, London] iv, vii, viii, ix, x, xi, xii, xiv, xvii, xix, xx, 2–8, 11–13, 16–18, 20–2, 24–5, 28, 30, 33, 35–6, 39, 42, 45, 47–8, 51–5, 60, 64, 68–72, 85, 155–7, 163, 168–9, 172–3, 175–6, 178, 182–3, 192, 196–7, 199, 296, 304–8, 317, 330, 333; *Brogi di Laurati* [*Mansell*, London] 43; *Scala* I, II, VI, 46; *Soprintendenza alle Gallerie* 44, 49, 63

FRANKFURT-AM-MAIN *Dr Harald Busch* (photo) 122

FRIBOURG *Musée d'Art et d'Histoire* 118

THE HAGUE *Rijksbureau* 208, 212

HEIDELBERG *Kurpfälzisches Museum der Stadt* (photo Schulze) 254

KARLSRUHE *Staatliche Kunsthalle* 237

KEW GARDENS 65

KONSTANZ *Jeanine Le Brun* (photo) 236, 262

LEIPZIG *Museum der Bildenden Künste* 242

LENINGRAD *Hermitage* xv, 331, 336

LINCOLN *Usher Art Gallery* 231

LONDON *Courtauld Institute* 153 (*by permission of Lord Salisbury*), 301–2, 309–10; *F. L. Kenett* (photo) 274, 281; *A. F. Kersting* (photo) 149 (*by permission of Lord Salisbury*), 226, 230; *National Buildings Record* 148, 151, 222, 225 (*by permission of Lord Cholmondeley*), 229; *George Rainbird, Ltd.* 75 (John Freeman photo),

207, 214 (Keystone photo), 152, 162, 224, 228 (Picturepoint photo); *St James Piccadilly* 221; *Victoria and Albert Museum* Crown copyright xxi, 147, 232 (*by courtesy of the Tate Gallery*), 335; *Wallace Collection* (*by permission of the Trustees*) 88, 311

MADRID *Prado* xiii, 50

MARBURG *Bildarchiv Foto Marburg* 119

MUNICH *Bayerisches Nationalmuseum* 128, 233; *Hirmer Foto-Archiv* 265–7; Firma Preiss (photo) [*George Rainbird*, London] VIII; *B. Schwarz* (photo) x, xii, 258

MÜNSTER *Landesdenkmalamt Westfalen-Lippe* 121

NAPLES *Soprintendenza alle Gallerie* 158

NEW YORK *Frick Collection* 145; *Metropolitan Museum* 66, 160

OXFORD *Ashmolean Museum* 223

PARIS *Archives Photographiques* i, 76–8, 81, 86, 90, 92, 297–8, 319, 321, 323, 328–9, 334, 338; *Bulloz* 79, 325–6, 327 (by permission of the Musée Jacquemart-André), 332, 337; *Giraudon* xxiv, 83, 91, 170, 312, 314–16, 318; Studio Josse Lalance (photo) [*George Rainbird, Ltd.*, London] vi, 84, 87, 299, 300, 322; *Jean Roubier* (photo) 81

PRAGUE *Čestmir Šila* (photo) 117, 246–7

RAVENSBURG *Foto Hütter* 234–5

ROME *Anderson* [*Mansell*, London] iii, v, xvi, 1, 14, 15, 19, 23, 26–7, 29, 31–2, 40–1, 67, 73–4, 159, 161, 164–5, 167–8, 171, 177, 179, 180–1, 184–7, 190, 193–5, 198

ROTTERDAM Herbouw Grote Kerk (photo Kroeze) 211

SEVILLE *Foto-Laboratorio de arte*, University of Seville 277

SONTHOFEN IM ALLGÄU *Lala Aufsberg* (photo) 111, 112, 264

STADTHAGEN *Wilh. Gewecke* (photo) 124

STOCKHOLM *Nationalmuseum* 144, 201, 324

STUTTGART *Helga Schmidt-Glassner* (photo) 114, 115, 125, 130, 134, 259–61

TURIN *Soprintendenza ai monumenti* 188–9

VATICAN 174

VERSAILLES *Service de documentation photographique* V, 83, 89, 303, 313, 320

VIENNA *Bildarchiv der Österreichischen Nationalbibliothek* 238, 240–1, 248, 250–2, 271; *Kunsthistorisches Museum* 61; *Österreichische Galerie* 249, 272–3

WÜRZBURG *Leo Gundermann* (photo) 120, 126, 268–70

ACKNOWLEDGEMENTS

My sincere thanks for all his help in connection with the inception of this book are due to Mr John Pope-Hennessy; they are due in equal measure to the publisher's editor, Miss Jocelyn Selson, who has handled many difficult situations while the work was in progress with admirable patience and tact. I must also thank Mrs Lily Cooper, Mrs Erika Millman and Mr John Willett for the great care they have taken in the translation of my German text.

H. K.

CONTENTS

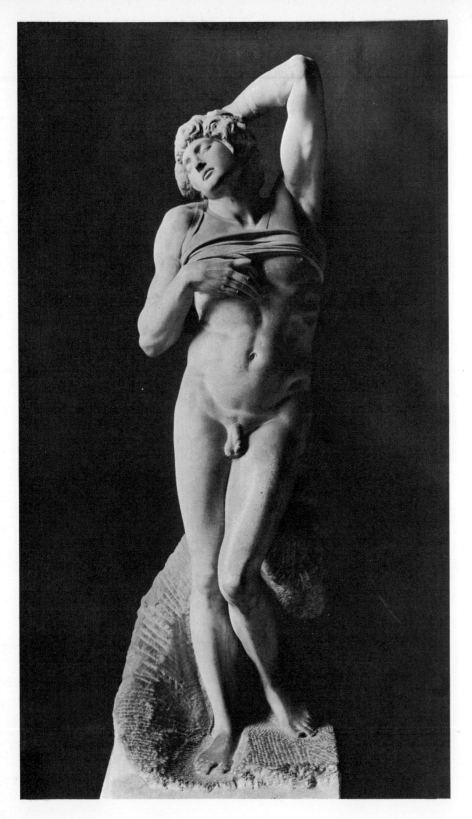

i MICHELANGELO
The dying slave c. 1513
marble 2·29 m.
Paris, Louvre

INTRODUCTION

A Western Age

The third great age of Western culture, stretching from the early fifteenth to the late eighteenth century, has no specific name and thus differs both from Classical Antiquity and the Middle Ages, which preceded it, and from the Modern Age that followed it. None the less it too is a unit.

Politically speaking, its unity becomes clear when one considers the special relationship between Church and State, the two great communities that controlled each individual's existence. Whereas the Christian Middle Ages had seen all temporal power either absorbed by the spiritual or subordinated to it, while in the modern secularized world the spiritual leaders take their orders from the temporal, during the age that now concerns us the two powers functioned as equal partners, each representing its own needs, fighting for its own claims and clearly distinguishing its own fields of operations from those of the other. Never before or since were Church and State in a position to try out their respective strengths so freely, or to develop their energies under conditions that oscillated so sharply between equilibrium and tension. This competitiveness in the political sphere unleashed similarly strong and complex influences on the world of the mind, not only on scholarship but on writing, music and the visual arts.

Within the Medieval *respublica christiana* the whole of cultural life was linked firmly to the next world: monks and priests unquestioningly directed all creative thought and action towards such tasks as promoted the representation, consolidation and illumination of the world of faith. This politically and religiously self-contained realm finally declined and disintegrated between 1380 and 1520, after the first controversies about the Church's task and doctrines had begun early in the fourteenth century. Division in matters of faith led in due course to the separation of the Protestant churches from Rome, while the shaking of the structure of authority resulted in the setting-up and consolidation of the first independent modern state systems. Once Church and State had settled down side by side, however, they concentrated all the more on their respective tasks. The Church strove to arouse a purer religious sense and deepen the understanding of metaphysics as the summit of all earthly existence; the State to work out a just and rational arrangement of human society, and realize it in ordinary life. It was in the course of these developments and transformations that the individual first became fully aware of his spiritual and at the same time material position in the world: that duality of his nature which the Middle Ages, with their unitary structure, had never brought out. It was not till the fifteenth century that he began applying his abilities and inclinations not just to concentrating on the next world but also to operating freely in this one, and taking an active part in every conceivable intellectual and artistic field.

The artists were still expected to provide popes, bishops and the monastic orders with churches and monasteries, monuments and statues of saints, murals and altarpieces and every conceivable liturgical apparatus. At the same time, princes, nobles and burghers were no less quick to demand palaces and villas, the decoration of squares and gardens for public ceremonies, or paintings, sculpture, furniture and *objets d'art* for the interiors of their private dwellings. Whereas, however, when working for the Church the artists could carry on from the themes and types which the Middle Ages had bequeathed them, for secular tasks they could seldom make use of precedents from their own immediate past. They found these by looking back to the world of Antiquity, reading of them in Classical works on the arts, or discovering them with their own eyes in the ruins of Classical buildings or in newly unearthed Classical coins and sculptures.

This combination of continued Medieval influence and Classical revival left its distinctive mark not only on the opening stages of the age in question but on every phase of it between the fifteenth and the eighteenth centuries, and not only on Christian works on the one hand and secular on the other but on every conceivable type of art. Thus, in tackling secular subjects, artists repeatedly exploited the Medieval heritage, while similarly, for religious purposes, they kept returning to the lessons and experience of Classical times. Just as on the political level this age is distinguished from both Middle Ages and modern times by the inter-related yet separate existence of Church and State, so in the artistic sphere it is set apart by continual swapping and fusing of Christian and Classical forms and ideas. Based equally on Classical Antiquity and the Middle Ages, ever activated and fertilized by the spirit of humanism and Christianity alike, our unnamed third age has more claim than any other to be called the truly Western Age.

Renaissance, Mannerism, Baroque, Rococo: four cultural periods

Renaissance (1400–1550), Mannerism (1520–1620), Baroque (1600–1750) and Rococo (1720–80) are the conventional concepts normally used to describe the successive artistic periods within this age. The terms were formulated between 1850 and 1920 by art historians who sought in this way to define spans of time when masters, sharing a more or less common artistic approach, obeyed similar or identical stylistic principles in their works. Over the past hundred years, the specific hallmarks of the styles in question have been observed, collected, and codified, an undertaking which has greatly sharpened our eye for the wealth of forms in art, and enriched our verbal and other resources for communicating what we have seen. By looking at everything in terms of the history of styles, the art-lover soon learned to identify a Renaissance palace, a Mannerist painting, a Baroque statue, or a piece of Rococo furniture. Increasingly detailed study however soon led to the conclusion that it was not enough to distinguish four main stylistic periods, so that each became sub-divided into middle, high and late. But this finer differentiation raised new problems, for, although the broad chronology and general hallmarks of the four main concepts still applied throughout the visual arts, the shorter time-spans and more subtle pointers involved in dividing styles into Early, High, and Late Renaissance no longer applied equally to painting, sculpture

and architecture; given the varying gradation of styles, the turning points now fell in different decades for each art. The sequence of styles was likewise in many ways awkward, as can be seen from the cases of Late Renaissance, Mannerism, and Early Baroque. Students of painting went out of their way to avoid speaking of Late Renaissance and Early Baroque whenever they saw half a chance to call a picture Mannerist. Those concerned with sculpture, on the other hand, preferred using the first two concepts, and had sound reasons for suppressing the term 'Mannerism'.

The relevance of these concepts however becomes questionable as soon as it is no longer simply a matter of a single personality, a limited period, or a specific province but concerns – as does the present study – four centuries of artistic activity over the whole of the Western world. How, for instance, can the accepted stylistic concepts help us to tell whether Albrecht Dürer (1471–1528) was a Renaissance painter, Giovanni Bologna (1529–1608) a Mannerist sculptor, Claude Perrault (1613–88) a Baroque architect, or Thomas Chippendale (1709–79) an artist of the Rococo; or, for that matter, what constitutes Spanish Renaissance painting, English Baroque architecture or Italian Rococo sculpture? The old terms for stylistic periods depended on establishing time limits and hallmarks, derived from artistic activity in the great European centres and the earliest areas of influence: thus Renaissance derived from Italy, Mannerism from Italy and France, Baroque from Italy, Germany and the Low Countries, and Rococo from France and Germany. Given our present wider and more intensive knowledge of detail, together with the number of newly discovered areas of Western art, the old terms no longer serve. Such are the new ways of regarding art that these concepts can no longer breathe freely in the stylistic straitjacket which an earlier generation of scholars designed for them.

Although the concepts Renaissance, Mannerism, Baroque and Rococo have thus lost something of their original meaning and can no longer be used in that sense, we shall continue to use them because they remain indispensable to art history, and even more to exchanges between art history and neighbouring branches of scholarship. These stylistic concepts may have originated with the art historians, but scholars in other fields have taken them over. Literary criticism, musicology and cultural history have seized on them, as have also philosophy and history proper, and made use of them not for qualitative description but simply for division into periods. What gave these sometimes rather unfortunately yet always vividly formulated concepts their universal appeal was not the stylistic characteristics associated with them by art historians but their inherent chronological limits. These the neighbouring branches of study could take over without any great reservations, for they derived from artistic developments in those important areas of the West on which the whole of our political and intellectual life has always centred.

Art history has no intention of abandoning stylistic research, at any rate where specific problems remain to be settled; but it has long ceased to treat the history of styles as its sole legitimate theory and method. The idea of 'art history as the history of styles' is now itself part of the history of our subject; talk of 'stylistic periods' now recalls an earlier state of our knowledge and previous areas of research. In future therefore we ought to conform with neighbouring branches of study and restrict the use of the terms Renaissance, Mannerism, Baroque and Rococo to chronological periods, treating these now not as stylistic periods but as broad periods of culture. At the same time, the internal evolution of art history itself, its

involvement and interconnection with theology and mythology, history and literary criticism, sociology and aesthetics, brings it close to the realm of general cultural history and suggests that we ought to maintain our old concepts only in the restricted sense in which these other disciplines know them.

Beyond this concept of styles, rooted in formal analysis and the history of development, an effort is now being made to define categories of a more thematic and systematic kind. One such concept that might be significant is that of the 'modus', a classification by type or function, which has been the subject of a fair amount of investigation to see whether and how far it can be applied. Common enough in classical rhetoric, musical and architectural theory, this concept, according to which a work's theme and purpose dictate the employment of particular formal and expressive conventions, was revived in Italy from the fifteenth century on, and played an important part in French seventeenth- and eighteenth-century criticism and writing on aesthetics. It ought with luck to provide us with fresh criteria for understanding the art of periods between Renaissance and Rococo, and judging the relevant works.

To write a history of the whole of Western sculpture between 1400 and 1780 – that is, to take works produced simultaneously in a number of European countries and deal with them in a chronological sequence which will reflect a logical formal or stylistic development – is no longer feasible, unless we are to regard the maintenance of a now questionable scheme of arrangement as more important than the identification of art's variety and originality.

The artists and their patrons

In the politically and religiously isolated West of the Middle Ages, with its hierarchically organized society, the arts had their set place among the *artes mechanicae*; artists were grouped in masons' lodges, and had a clearly defined range of tasks within which to labour for the Faith. Neither the name nor the particular talents of the master responsible were normally associated with the work of art or put on record, for the meaning and value of the work did not derive from its specifically artistic aspect, which would necessarily have implied a creative personality, but rather from such extra-artistic features as its suitability and effectiveness in the ecclesiastical or ceremonial context for which it had been commissioned: all the enduring honour was for the religious object or saint's image, not for the artist who had made it. In the Modern Age, with its politically and religiously divided world, the arts were disposed in an autonomous zone founded on aesthetics and independent of all national or ideological frontiers; artists tried to keep their work and plans as free as possible from external commitments to their patrons or to the world around them. The works which they produced were ranked not according to their religious or secular usefulness in the life of society but solely according to their aesthetic presence, their specifically artistic utterance. All the honour and admiration were reserved for the genius of the creative personality which this revealed, not for the finished work of art *qua* object.

By comparison with Medieval times and the Modern Age – with their virtually anonymous or markedly individualistic artistic life, their functional or functionless art, their creative subjection to or freedom from the patron's demands – artists in the age between Renaissance and Rococo had a much less clear and consistent

relationship with their surroundings and with themselves. From the fourteenth century on, there was an increasing tendency for men not only to sense the artistry with which a work was conceived and executed, over and above its function as altarpiece or holy figure, but also to speak of it, and to express admiration for the master responsible as well as for the work. Practising the arts was now seen as one of mankind's creative achievements, to be ranked with the free exercise of the human mind, the *artes liberales*; artists became respected in the same way as poets and scholars. They shifted from architectural or sculptural workshops into studios, gave up guilds and corporations in order to unite in formally constituted academies which represented their profession. Although their external commitment to their patrons (now secular as well as ecclesiastical) had been only slightly relaxed, they confronted these with far greater self-awareness and inner freedom. The two parties met as partners, both because of the high public esteem enjoyed by artists as specially gifted people, and even more because the patron himself had changed his outlook and way of life; he now bestowed his commissions not merely as the donor of a sacred work, like in the Middle Ages, but also as an art-lover to whom the decoration of an altar or chapel seemed a tribute to art as well as to the Church. Similarly in discussions about the commissioning of an equestrian statue, say, or a papal tomb, it was the artist's name and reputation that now mattered, not the mere provision of a worthy and lasting memorial – in other words, the reputation of the patron. Torn between their own projects and other people's, between artistic and extra-artistic thinking, between restrictive commission and free execution, the artists of the age that concerns us worked in conditions of tension such as invariably proved fruitful for their work. The leading artists of the Modern Age have very largely shed such restrictions and have liberated themselves from a variety of pressures due to outside patronage. But in so doing they have also cut themselves off from those sources from which earlier generations repeatedly drew fresh power of renewal and a variety of stimulating impulses.

The categories of sculpture

The drawbacks of the old stylistic concepts make it seem impossible, on reflection, to write a consequential period-by-period history of sculptural developments all over the West. It is equally inadvisable to try and convey the sculptural achievements of the age by means of the usual individual treatment: that is to say, by taking each country in turn and describing its works of sculpture in chronological order, for even within such narrow limitations of time and space each chapter would need to concentrate more on disparate artistic tendencies than on shared ones, and to establish contrasts rather than links. Where sculpture is concerned, the Italian sixteenth century, for instance, cannot by any means be regarded as the century of Michelangelo (i, II, 36, 38, 40–1, 45); only a handful of sculptors, working in Florence and elsewhere, such as Giovan Angelo Montorsoli (55), Vincenzo Danti (44) and Guglielmo della Porta (54), treated his problems and preoccupations as their own. Far more of them adhered to the opposite view of art so passionately affirmed by Michelangelo's adversary Baccio Bandinelli (ix, 46, 49): e.g. Stoldo and Battista Lorenzi (53, 58–9, 160), Giovanni Bandini (III, 62, 155), and Valerio Cioli (53, 68). Yet a third style was adopted by another Florentine of about the same age, Jacopo Sansovino (39, 42), followed by Niccolò Tribolo (56) and Bartolommeo

Ammanati (xvii, 57), and notably in the second half of the century by younger Venetian masters such as Alessandro Vittoria (52, 66) and Girolamo Campagna (74). Finally, from 1565 on, Giovanni Bologna (viii, xiv, 60–1, 63–4, 158) established an individual interpretation which proved widely influential. This multiplicity of styles is not confined to the sculpture of sixteenth-century Italy, for similar divisions appear simultaneously in Spain, with such disparate masters as Alonso Berruguete (102–3) and Juan de Juní (105–6) working alongside one another; or again in the seventeenth century with François du Quesnoy (165, 171) becoming influential in Italy as well as Gian Lorenzo Bernini (v, 159, 161, 164, 166–70) and both Pierre Puget (303–6) and Michel Anguier (300–2) at work in France; or for that matter in the German-speaking countries, where Georg Raphael Donner (249–52) and Balthasar Permoser (241–2, 244) were contemporaries in the early eighteenth century, as were Ignaz Günther (VIII, 265–7) and Franz Xaver Messerschmidt (272–3) a generation later.

During the age under study, sculptors seldom reflect any family likeness, but more often their own individual characteristics; similarly, throughout the West, their works normally speak with the creator's own voice rather than in the national language or local dialect of their places of origin or conservation. Caution and perseverance are the occupational virtues of sculptors, who are relatively slow to admit outside influences and much more sceptical than painters in their attitude to the changing fashions of the day. They like a certain isolation and detachment from the world around them, relying above all on themselves, their own talent and judgement. Hence a sculptor's works are apt to be very strongly stamped with his own personality, so that those with a wealth of movement and a heightened emotional activity lead us to deduce an awkward, urgent character with a penchant for daring invention, while restrained attitudes and tranquil beauty suggest an even, economical temperament with a distaste for portraying tense and excitable situations. For the same reason it often happens that the work of sculptors of different periods and countries who are linked by a common attitude seems much more akin than that of two contemporaries working in the same city. Instances of such masters working independently of one another but with this kind of basic artistic agreement can be seen in the statues of Venus by Giovanni Bologna, 1575–6 (64), and Christophe-Gabriel Allegrain, 1755–67 (329), or in the figures of St Bruno by Manuel Pereira, about 1660 (ii), and by Michelangelo Slodtz, 1744 (194); while on the other hand Michelangelo and Bandinelli, Puget and Anguier, Permoser and Donner provide examples of neighbours and contemporaries working along different lines. Such cases might seem to suggest that we ought to classify our sculptural heritage by different types of artistic personality and temperament – no light task, though it would doubtless illuminate the lack of unity and the characteristic variety of artistic efforts in the age we are studying.

A better way of studying sculpture of the periods between Renaissance and Rococo, however, would seem to be by categories: that is to say, by works and groups of works of similar designation but differing outward appearance, and characterized by common hallmarks which point to an identical function, forming the basis of their classification as categories. Sculptural categories of this sort include altars, pulpits, tombs, equestrian monuments, fountains and chimney-pieces (in so far as they were entrusted to and executed by sculptors), to which we would add figures of saints, gods and heroes for churches and secular buildings, squares and gardens – quasi-historical images, as it were – together with allegorical repre-

ii MANUEL PEREIRA
Oporto 1588 – Madrid 1667
St Bruno c. 1660
stone *c.* lifesize
Madrid, Academia de San Fernand

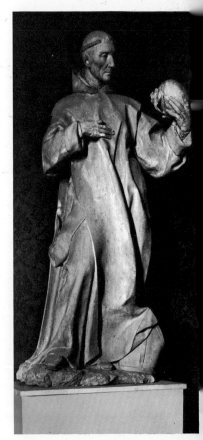

sentations and figures from everyday life, even though these cannot always be considered categories in the strict sense.

Treatment by categories seems doubly appropriate for the body of work before us, both because of the great variety of categories represented, which is unequalled in any other age, and on account of the general conditions which those categories imposed on sculptors for the excution of their works – something that was characteristic of the special position of the arts between Renaissance and Baroque. At the outset we suggested that the exceptional multiplication of sculptural commissions, due to the increased needs of Church, State and Middle Class, was one indication of the age's difference from the Medieval period and the Modern Age. This multiplication of commissions meant, more precisely, an increase and differentiation of sculptural categories on a scale that would have baffled the Middle Ages and would not interest the moderns at all. Certain Medieval religious categories were taken over and adapted by the artists, while others, previously only vaguely identifiable, they now worked out fully; the discovery and development of the secular categories, however, was entirely due to them. To the sculptors of the Modern Age the former hardly seemed an artistic task any longer; while they treated the latter selectively, often obliterating the old distinctions.

The significance of such categories for the age that concerns us, however, lies not only in their remarkable multiplicity but equally in that conditional freedom which is part of the very essence and idea of a category, at the same time reflecting the particular situation of the sculptor in that age, as he stands poised between restriction and freedom, between the Middle Ages and modern times. Restriction, that is, in that the category itself told him what his work's outward form and general subject-matter must be for any given function and position; freedom in that it made these conditions so exceedingly elastic as to allow his imagination the highest possible degree of mobility and play. Within such clearly delimited tasks as the pulpit, the portrait statue or the genre figure, the sculptor was allowed almost unlimited scope for asserting his own artistic individuality; and because there was and could be no ideal prescribed solution for the reconciling of function, form and subject-matter within a given category, he exploited that scope fully and as a result left us a great variety of more or less happy and interesting creations. For the detailed evaluation of these, we have relatively firm points of reference in the features of the different categories as they have become familiar to us through experience and general acquaintance with our culture.

Irrespective of where or when they originate, similar tasks lead to similar problems of execution, so that any concern with categories is likely as a rule to deal in supra-regional, supra-national and even supra-temporal relationships. Accordingly, in what follows we shall be discussing the different categories chronologically, freely ignoring national and provincial frontiers. We propose to start with purely plastic works such as single figures and groups, then move on to that larger field of plastic-architectonic categories, such as the portrait statue as honorific monument, the tomb and fountain, for which the sculptor also needed to design and build structures to serve as plinths, frameworks or kernels. Every newly formulated or newly evolved category originated in Italy and spread thence throughout the West. Without exception they can be traced back to the artists and patrons of that country, who during the fifteenth and sixteenth centuries gave fresh life to the art of the Middle Ages, complementing it with a secular-classical art and fusing Christian ideology and ethics with those of Classical Humanism.

Sculpture and its tasks from the Renaissance to the Rococo

SINGLE STATUES

Draped statues of Old and New Testament figures. Figures of saints or prophets or Old Testament heroes were typical commissions for the Medieval sculptor. Till about 1300 such figures were made primarily for the exteriors of churches and cathedrals, where they often formed part of the masonry. Even where they were free-standing on their pedestals they were always incorporated visually in the general decorative scheme of the architecture as a whole. Each individual figure was normally subordinated to a series, to the relationships within a larger iconographic plan. Usually they appeared as draped figures, which means to say that their combination and articulation depended on the drapery, whose own arrangement, however, derived not from the position of the body but from certain universally applied decorative principles. Individual figures were not distinguished by differences of stature or physiognomy but by means of inscriptions, attributes or a particular costume. Finally, their sanctity or worthiness would be expressed in a standard, generalized face of a worthy or saintly kind. Each of these hallmarks of the Medieval draped figure – its outward appearance, its characterization of the individual portrayed, and its means of demonstrating sanctity or worth – was realized in new ways by the artists of the periods that concern us.

The new age began wherever and whenever the appreciative rediscovery of Classical works of art coincided with a willingness to relearn and rethink the artistic principles of the time. This occurred first in Florence. In Ghiberti's statue of St John the Baptist (3) there is already a perceptible departure from Medieval conceptions of the draped figure, though it is not yet total. It is made very clear which leg carries the weight, and this gives the figure a slightly rocking rhythm; the rhythm of the drapery, however, follows other, independent rules, with the folds of the robe not deriving from the body's movement but following a sweep which seems to continue the curve of the surrounding niche, so that we admire the figure with its decorative arrangement of hair and beard for its ornamental, rather than for its organic beauty. Against that, Benedetto da Maiano, in his young, beardless Baptist (22), has suppressed all recollection of earlier methods. The body is no longer a support for a decoratively draped garment but wears the skin and robe in natural fashion; the skin lies as close across the buttocks as its weight permits, while the robe falls to the ground in the folds natural to the material. The figure is identified as St John the Baptist by the inscription and staff, but primarily by the camel-skin, worn not just partially and as a mark of identity but as the man's normal clothing. To round off the general impression of truth to nature, instead of standing this desert saint on a flat base Maiano set him on a piece of rock, to symbolize his natural dwelling-place. Subsequent sculptors sometimes plumped for the older, more fanatical St John, sometimes for the youthful, melancholic St John, and often came to include the Lamb of God as an emblem of his sanctity. The Baroque artists not only identified him as the Baptist but tried to bring him to life as a personality by showing him in his own environment. Pietro Bernini, for instance, portrayed him preaching, the zealot leaping up from his rocky seat (iii), while Cano showed him in more contemplative guise, meditating in isolation and in a mute dialogue with the Lamb (281).

Ghiberti was less deeply influenced by Classical sculpture than was Donatello,

iii PIETRO BERNINI
Sesto Fiorentino 1562 – Rome 16.
St John the Baptist 1615–16
marble over lifesize
Rome, S. Andrea della Valle
(*below*)

iv MICHELANGELO
David 1504
marble 4·10 m.
Florence, Accademia
(*above right*)

v GIOVAN LORENZO BERNINI
David 1623
marble 1·70 m.
Rome, Galleria Borghese

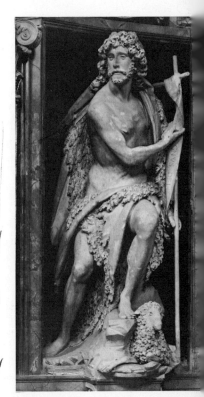

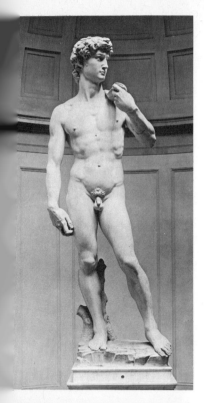

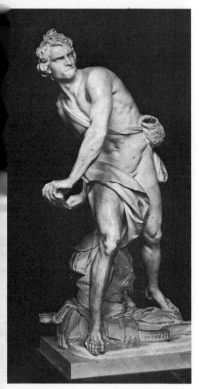

whom it taught to take the observation of nature and the human body seriously. Donatello's first David in marble (4) gives evidence of a much more radical break with traditional art: the body and its clothing here combine as two interlocked surfaces to make a single organic figure and one great coherent movement, with the biblical hero standing at full stretch in his loosely worn cloak and close-fitting leather jerkin. The features once again resume what is suggested by the attitude of the body: that here is an upright and fearless youth, apparently quite capable of the actions ascribed to him and attested by Goliath's head beside him and the sling in his right hand. So lifelike is the character given by Donatello to the features and shape of the head that David himself could have been the model: not that the sculptor could have given his heroic figure any authentic identity, but he did provide it with an idealized personality and with unmistakable features by portraying a youth of his own circle whose face struck him as particularly apt for David. If this figure shows how the examples of Classical Antiquity and of real life had already led Donatello to an intensive study of the play of limbs and muscles in a naked body, in a subsequent bronze he represented David completely naked, much as did Verrocchio some decades later, who almost ostentatiously disclosed the delicate, finely articulated body of his closely girt David (21). The physically and facially sensitive type of being selected by Verrocchio makes the observer think twice about David's heroism, so realistically does the artist portray both the artistically inclined boy and the future king. As for the well-known Davids by Michelangelo and Bernini (iv, v), Michelangelo again represented him completely naked, just as unprotected as when he faced his enemy trusting only in God and in his own strength; Bernini, at the outset of the seventeenth century, showed him in action, with his sling in his hands, pivoting energetically to gain momentum for the well-aimed fatal shot. Finally, in the transitional period between Baroque and Rococo, Marchiori, a sculptor later to be praised by Canova for his success in breaking free from the Baroque approach, none the less presented his David (195) in exceedingly theatrical guise, paying more attention to costume and attributes– in this case David has annexed Goliath's swordbelt and put it on – than to giving a credible account of an Old Testament hero. His figure gives the eye plenty to do, but scarcely touches the mind or the heart.

During these centuries the making of statues of saints and biblical characters may not have been a particularly sought-after task from the sculptor's point of view, but it was certainly one of the commonest; hardly a sculptor is known who did not produce figures of this sort. Almost invariably they were draped figures, whose evolution from Classical models began with Donatello, as the case of his David will already have shown. His realization that the structure of the body and the arrangement of the draperies stand in a natural relationship of cause and effect was expressed in the series of statues of prophets which followed the David, for instance in *The bearded prophet* (5). Here the body's motions are answered by the folds of the cloak which the prophet wears like a toga; these fall more smoothly over the weight-carrying leg than over the other, gather together on the left arm and become crumpled in the right sleeve of the relatively flimsy undergarment. While Donatello knew how to give his figure that air of natural coherence and life which distinguished the draped statues of Classical times, he expressed himself unclassically in its detailed execution, e.g. in the broad areas of material and the generous curves of the concave and convex folds, in the 'soft style' of his own day. At the same time, instead of following the Medieval tradition of portraying types,

he gave his bearded prophet the attitude and demeanour of a Classical philosopher, stamping his face with the individual features of an aged thinker and sage. With Andrea Sansovino (33) or Ordóñez (99), it became second nature to strive for conformity between the attitude of the body and the positioning of the draperies, for differentiation, separation and stratification of the various items of dress and for individual characterization of the face. Sansovino gave his Madonna classical features according to the early sixteenth-century idea of beauty; Ordóñez presented her in the image of a classic beauty of his own country.

Portrait statues of saints. The outward disposition of the figures, the character-ization of the subjects and the symbolizing or justification of their sanctity pre-occupied sculptors to a different extent in different countries and at different times. So far as arrangement went, the Baroque period saw a trend towards greater mobility in the attitude and positioning of the individual figure, as well as an increase in its volume by means of garments that separated from the body and fell at a distance, or rustled or billowed. Nicholas Stone (147) in his St Paul and Robert de Nole in his figure of St Amand (203) are among the earliest instances. More significant was the demand that the persons represented should be identifiable. If certain sculptors of the sixteenth century aimed to make their works not just broadly comparable with Classical models but so slavishly dependent on these as to be interchangeable with them, their sole object was to show that they had attained the same mastery as artists. It was a different matter in the seventeenth century when du Quesnoy produced a work of this type in his much admired St Susanna (171). He too chose to present his figure in unmistakably Classical guise, intending no doubt to convey all he could of the individuality of this Roman martyr (whose real appearance no one knew) by at least seeing to it that her clothing and general cast of face were historically correct; her piety and spirit of self-sacrifice he com-municated by giving her a gentle and expressive gaze. Further examples of the importance attached to attempting the most trustworthy possible portrait even of historical saints can be seen in Cano's or de Mena's (282) statues of St Francis, where the artist expressly guaranteed his account of clothing, attitude and features to be authentic by basing himself on documentary tradition. Similar assumptions can be made about de Mora's St Pantaleon in doctor's dress (283), or Pereira's and Slodtz's statues of St Bruno (ii and 194). Moreover, the seventeenth-century masters were virtually compelled to be accurate in reproducing the costume or clothing and the relevant physiognomy whenever statues of modern saints were called for: notably those of the Counter-Reformation, whose ecclesiastical appoint-ments and orders were still common knowledge and whose likenesses had been incontrovertibly established by paintings or death masks. Statues of this type in-clude St Ignatius by Martínez Montañés (277), St Philip Neri by Algardi (172), and St Teresa by de Mora (284). These are literally portraits of saints, whose sanctity is merely implied by means of general gestures and attitudes of rapture and devotion, or else conveyed anecdotally in an amiable portrayal of wonderful pious inspiration, as in the figure of St Teresa.

Sanctity in saints' statues. Finally there were other masters who concentrated all their talent on making their statues provide detailed evidence of their subjects' sanctity, by showing the miracles they experienced or the martyrdoms they suffered, not just by means of attributes but as a drama: for instance Gian Lorenzo

Bernini with his St Longinus (164), whose colossal statue shows that instant in the captain's life when God had opened his eyes; thus inspired, he spreads his arms wide in gratitude and awe, so that his huge military cloak slips off his shoulders and slides to the ground behind him. Du Quesnoy, instead of making his St Andrew (165) hold the instrument of his torture like a miniature attribute, set him leaning against a full-sized cross and embracing it with his right hand as the beloved object which enabled him to end his life as a martyr. Ferrata showed St Agnes (173) standing on a burning pyre whose flames flutter her garments upwards but leave her miraculously unharmed. Early in the eighteenth century Camillo Rusconi portrayed St John the Evangelist (182) with book and pen, as he pauses for a moment in writing the Apocalypse to listen for divine instructions; while Le Gros represented St Thomas (183) preaching, as a man summoned to a mission. In this entire group of works it is always by his own actions that the individual saint is identified, as he re-enacts some significant episode in his divinely inspired life.

Nude statues of Old and New Testament figures. The nude figure rarely concerned the Medieval sculptor, and when it did it was almost always a portrayal of our first forefathers, Adam and Eve, or (though this is hardly a statue in the strict sense) Christ on the Cross. In both cases the nakedness was symbolic: with Adam and Eve, it was a form of undressing to reveal mankind's sinfulness, our state *ante gratiam*, while in Christ's case it was the pure nudity of Paradise, with all sinfulness abolished.

Right from the beginning of the Renaissance the nude figure came to be one of sculpture's principal tasks, and its representation became more and more central to the sculptor's activities and ultimately to every form of academic art training. In the ecclesiastical sphere its Medieval associations continued to apply, leading to further demands for the traditional subjects as well as for their extension in certain new directions. But the main concern now was not with the nude's symbolic aspect but exclusively with its successful artistic handling, with the realistic reproduction of the human body, a task which gave the sculptor his special place in the general effort of the time to open up the macrocosm and the microcosm, investigate nature and its laws, and assimilate the art and thought of the Classical heritage. All the same, the introduction of the nude figure into the secular art of the age under study was neither instantaneous nor entirely divorced from the symbolic thinking of the Middle Ages.

In ecclesiastical art we still find figures of Adam and Eve, and, very commonly, Christ on the Cross. Thus Michelangelo gave him a young boy's delicate, yet compact figure (II), which seems to float rather than hang; Becerra represented a strong, firmly muscled man's body (104); while Carlo de Cesare and Petel created variants of a type of crucifix originating with Giovanni Bologna and to be found throughout the Western world (123, 233). But Christ is now also shown naked or scantily clothed in other episodes from the Passion: somewhat rarely as Christ Scourged or Christ at Rest (113), but frequently as Christ Risen, for instance by Michelangelo in Sta Maria sopra Minerva in Rome, or (a very different conception) by El Greco in a large statuette at Toledo (108); figures of Christ Risen often crown tombs, as did Pilon's figure (vi) before its removal, that by Adrian de Vries (124) still being in its original position. Another new departure in Christian art was the placing of nude statues of particular saints inside churches – for instance St Jerome expiating his sins, and more especially St Sebastian. Our two works by Vittoria and de Siloe (66, 100) differ in detailed execution, but they show the prevalence of a single

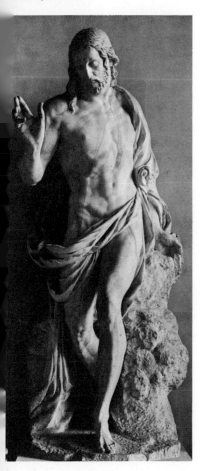

GERMAIN PILON
Christ Risen c. 1572
marble *c.* 1·70 m.
Paris, Louvre

basic convention for figures of this saint, in pose and movement alike, right into the eighteenth century (238). Admittedly the patrons who commissioned such figures were still chiefly interested in their religious or symbolic content; however, the communicative impact of this content was now judged to some extent according to the beauty and truth of the portrayal, for whose sake a certain amount of licence in the execution was accepted without question. It was thus simply conforming with truth and respecting tradition to show St Bartholomew stripped of his skin like an anatomical specimen, as he must have appeared before his decapitation. D'Agrate made a monumental figure of him along these lines for Milan Cathedral; Willem van den Broecke modelled a statuette of him holding his skin and draping it across a tree-stump (143).

Finally the Old Testament characters of Samson and the youthful David are also to be found as nude figures. Clothed or wearing armour they had had their allotted place in the great sculptural complexes of the cathedrals as forerunners and foils for Christ; now, however, as isolated figures they were no longer so much characters from the history of Christianity as exemplary heroes from the history of mankind, whose statues were commissioned not by the Church but by princes and civic authorities. With their origin in the Old Testament, but with a new content which was relevant to this life rather than to the next, they helped pave the way for the wholly pagan and secular nude, and its public acceptance in the course of our age. There is only one work where the naked Samson is still to be found in his biblical context: Ghiberti's statuette of him (vii) as one of the twenty Old Testament prophets and holy men who form part of *The Door of Paradise* to the Baptistry in Florence (8). All later representations of Samson, however monumental in character – often they are groups of Samson and the Philistine, like those by Perino da Vinci or Giovanni Bologna – originated, like most nude figures of David from Donatello's bronze onwards, as works of a secular nature, symbolizing courage in combating internal and external enemies, or the determination of princes and cities to be independent.

Classical gods and heroes in statue form. From such allusions to the heroes of Jewish history and legend it was only a short step to references to the gods and heroes of Roman history and mythology, and to their introduction into contemporary life and history as symbols of earthly situations and models of individual conduct. The first monumental nude figure with a purely secular content was the drunken Bacchus for Jacopo Galli's garden or courtyard in Rome (36), with which Michelangelo opened up the world of Classical gods and heroes as a vast new area of subject-matter for sculpture. Although we have no sure information as to the original purpose of Michelangelo's drunkenly swaying god of wine, the fact that Jacopo Sansovino's Bacchus (42) of a few years later was placed in the garden of the Villa Gualfonda in Florence suggests that it too may have started life as a garden statue, protecting the vineyards and the grapes. Later, de' Rossi's Bacchus found a similar place at the Villa Poggio Imperiale, the country seat of the Orsini (43).

The first statue since the Classical Era of Mercury, the patron of trade and of the arts and sciences, was a big bronze statuette by Rustici (37) which was intended to crown a fountain in the courtyard of the Medici palace; it was also the Medici who fifty years later commissioned Giovanni Bologna's well-known winged Mercury (63) as a gift for Maximilian II. Thereafter we repeatedly find Mercury in gardens (325), sometimes with Venus as counterpart, while no prince or art-loving burgher

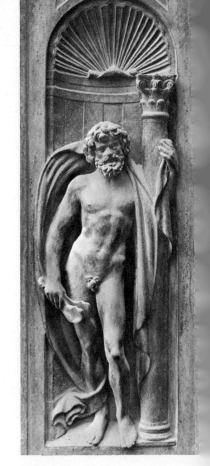

vii LORENZO GHIBERTI
Samson (detail of 8) between 144
and 1453
gilt bronze *c.* 0·30 m.
Florence, Baptistry

22

could feel that his collection was complete without a small Mercury in bronze (144), ivory, or porcelain. Apollo was relevant in many connections, and his image was much in demand; Michelangelo's statue for the papal commander Baccio Valori (38) and Sansovino's for the Venetian Republic (39) probably originated as symbols of just and good rule, while in Flötner's bronze (115), the Nuremberg Musketeers' Guild chose to honour him in preference to St Sebastian or St George as their mythical patron. Cellini portrayed him (47) with Hyacinth, personifying Nature's first beauty in springtime, almost as an everyday garden figure, while Francavilla (65) made him a *Sol* dispensing light and warmth in Antonio Bracci's garden where, with Venus as *Luna*, he led a group of twelve gods embodying all aspects of Nature's birth and decline in the year's cycle. Girardon again portrayed him at Versailles as driver of the sun's chariot, attended by nymphs (307). Representations of Saturn, Jupiter, Vulcan, Mars (302), Pluto or Aesculapius are rarer, while Neptune and his train are nearly always found in conjunction with a fountain or water feature – something that invariably makes a direct impact. Among the goddesses, the favourite subject in bronze or marble is repeatedly Venus as the goddess of beauty, bathing or rising from the sea (61, 64, 329), but likewise Venus the goddess of love, accompanied by Amor (231). Statues of Juno (62) or Minerva, Ceres or Diana were in much less demand.

Besides the gods, the heroes of Classical Antiquity were from the outset introduced into the contemporary environment: Orpheus (46), the guardian of all the arts, or Jason, Antiquity's 'Crusader', but particularly such shrewd, fearless benefactors of the human race as Meleager (III), Perseus (58), and, epitomizing the virtues of a ruler or military commander in peace and war, Hercules (220, 301). All these countless statues of gods and heroes, set in squares and gardens, in courtyards and interiors of public buildings, had been stripped of their old magical significance – in other words they were not intended as objects of religious devotion or to reintroduce the beliefs of Antiquity – and were accordingly treated as evidence of the humanistic principles of the day, or virtually as objects of secular devotion. Patrons saw the gods not as actual representatives of the powers at work in the life of man and nature but as their symbols; they saw heroes not as realistic portrayals of historic personages but as ideal patterns for their own behaviour in this world. As a result of this change in the original meaning and character of such statues, they often seem to us very like pure personifications of human impulses and human will, and are frequently very hard to distinguish from allegorical representations – in other words from freely invented personifications of abstract and cerebral ideas.

Allegorical statues. Sculptors in the Middle Ages were by no means unaccustomed to having to portray allegories in sculptural form, that is to say conveying verbal concepts in the form of human figures: something that had come down to them as part of the Classical tradition. Only a limited number of concepts or groups of concepts were so personified, those most commonly found being Ecclesia and Synagogue, the Virtues and Vices, and the Liberal Arts. Depending on their subjects, which derived from the body of theological dogma, they were placed as a rule within large-scale iconographic sculptural schemes on the cathedrals, but also as pairs or series of statues on pulpits or rood-screens. The sculptors never evolved a specific type of figure which would make it possible, by external evidence only, to distinguish an allegorical incarnation from the image of a saint; like the latter, the allegorical image was identified only by means of inscriptions or attributes.

During the periods which concern us, when allegory played an even more important role than ever before, it was above all the personifications of the three theological and four political virtues that were taken over from the Middle Ages; no longer set in the previous large-scale contexts, they continued to serve the faith on pulpits and rood-screens (xxi, 25, 136) and also on altars (VI, 23, 260) or in church interiors (179–81). Henceforward, however, they became more commonly used for the glorification of specific personalities and their achievements and characteristics, on tombs and monuments of all sorts. No other position did so much to promote the appearance of allegories between Renaissance and Rococo as the decorated tombs of spiritual and temporal rulers who were set on achieving fame. Accordingly after the middle of the fifteenth century the personified virtues in varying quantities and distributions became part of the regular sculptural equipment of such tombs (29, 35, 54, 77, 79, 94, 110, 149, 168, 185, 210); they were also included in certain public memorials, such as Calcagni's monument to Sixtus V (69). To the seven canonical virtues came to be added personifications of other ethical concepts, such as *Abstinentia* or *Castitas* (193, 196), or incorporations of such broad intellectual ideas and ideals as *Religio* (146, 184, 192, 246, 299), *Sapientia* (184, 309), *Pax* and *Libertas* (90, 146), *Vigilantia* and *Abundantia* (310, 295), *Tempus* (206, 246), and again and again *Fama* (91, 211, 212, 246). Finally, during these centuries we find allegories of the Liberal Arts, usually augmented and fused with the Fine Arts and other sciences, forming part of the tombs of their patrons and masters; thus Michelangelo's slaves (i) were intended for the tomb of Julius II, where they were to symbolize the arts, chained and deprived of liberty on account of the pope's death; Bontemps's reliefs on the *Monument for the heart of Francis I* (80) allude to the king as benefactor of the liberal and fine arts; while round Michelangelo's sarcophagus are the mourning figures of Architecture, Sculpture and Painting (53). On public monuments too it is not uncommon to find allegories of the arts and sciences bearing witness to the favours done them by the persons commemorated.

Unlike such personifications of abstract concepts, which normally served to glorify a personality or to transfigure an idea, and were accordingly nearly always erected as part of some larger project devoted to the personality or idea in question (a rood-screen, tomb or monument), those of concrete concepts derived from the cosmos or from the world of nature and humanity seldom found a place on tombs, Michelangelo's Night and Day in the Medici Chapel (40) and Peter Rijckx's allegory of seafaring (211) being among the exceptions. Within this second category of allegorical representations, where the visible, tangible aspects of our environment were translated into statues intended frequently as isolated, free-standing figures, the Classical figures of the gods often took over allegorical functions. None the less sculptors found that the personification of the elements (V) or the seasons (128, 337) or rivers (55–6, 126), cities (322), countries (127) and regions of the world gave them plenty of opportunities for new formulations and original creation.

To the sculptor the artistic problems posed by the monumental representation of Allegory were exactly the same as those involved in statues of saints or gods who could likewise only be identified by their attributes, irrespective whether it was a matter of architectural sculpture or free-standing statues, of drapery or of the nude. In the course of the sixteenth century, however, isolated attempts were made to render allegories unmistakably distinguishable in outward appearance from

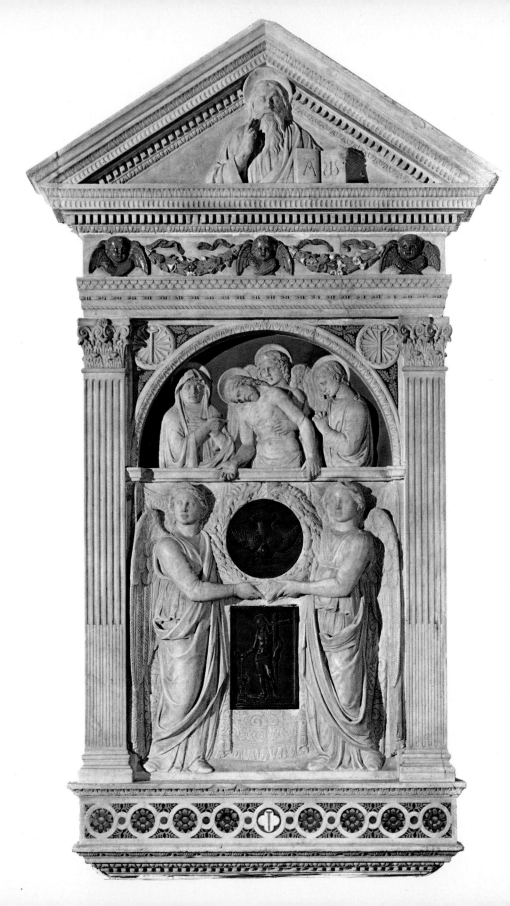

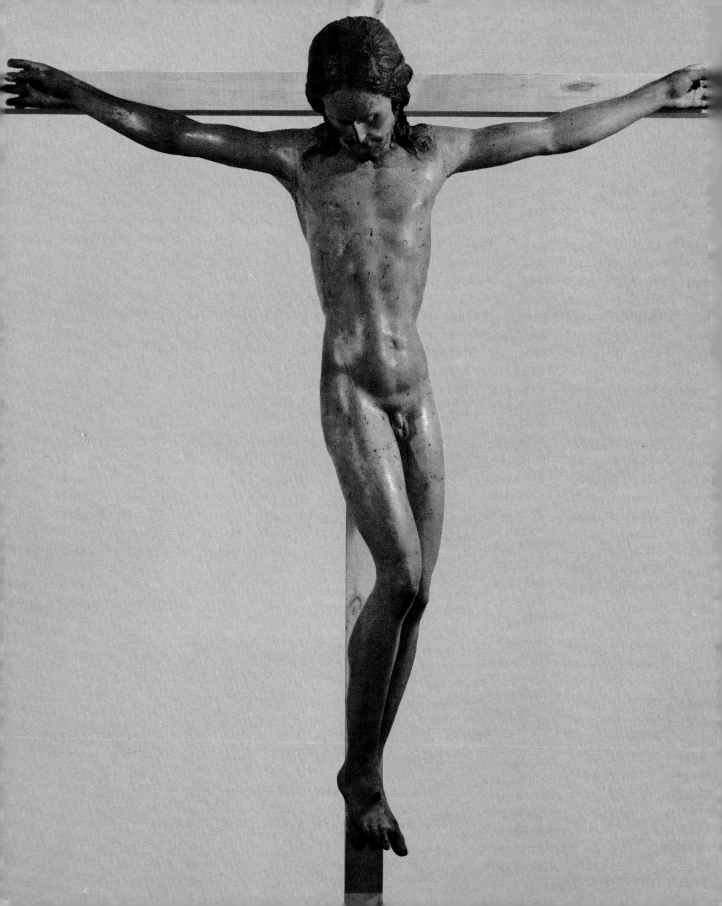

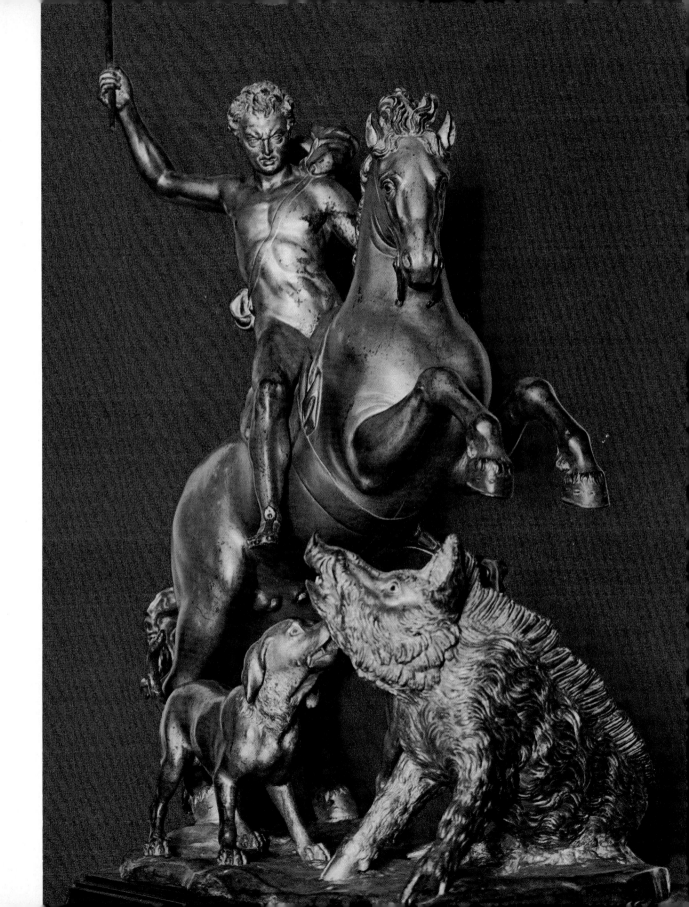

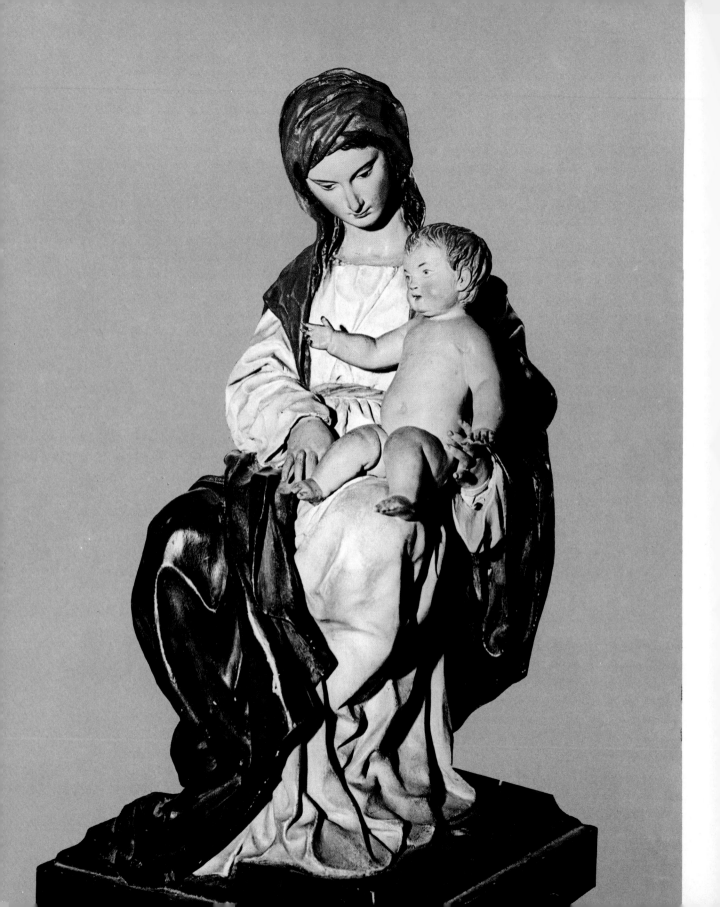

viii GIOVANNI BOLOGNA
 Florence triumphant over Pisa 1570–2
 marble 2·60 m.
 Florence, Museo Nazionale

IV Alonso Cano
 The 'Virgen de Belén' 1664
 Granada, Museo de la Catedral

'historical' statues. It was Michelangelo who first tried to break out of the conventional way of portraying them, by presenting them, as with some of the slaves or the figures of Night and Day (40), without attributes and conveying their specific meaning purely by expressive mime and bodily movement: Day as a woman waking up in the morning, Night as a man in the evening waiting for the dark. Trying to convey the content of a concept, however, simply by means of physical attitudes, by the figures' gestures and facial expressions, made too many demands on the imaginations of both artist and beholder for it to act as a valid precedent or have any influence worth mention. Much the same thing happened a few years later to Giovanni Bologna, who differed diametrically from Michelangelo as to the right way to represent allegory. Since he felt that attributes were indispensable as being the most important clue to recognition, he set out to give the human figure bearing them a characteristic appearance of its own which would distinguish it from the 'historical' statue. In view of Allegory's metaphysical origins, he felt that a figure would be more easily recognizable as embodying a concept if it were portrayed unequivocally as an attribute-bearer and nothing more, so as to make the most rigid, lifeless, unnatural and 'abstract' possible impression. Accordingly he made his Florence (viii) and his Architecture unemotional, apathetic, coolly sober creatures not unlike ornamental objects, so that they might contrast at a glance with any figures from history or real life and seem like representatives of another world, the world of concepts and ideas. Yet his approach too was only adopted by a narrow circle of pupils.

SCULPTURAL GROUPS

In structure and arrangement early Renaissance sculptural groups, such as Nanni di Banco's *Four crowned saints* (1) and Donatello's *Judith and Holofernes* (6) never disown their Medieval models, or their debt to the two forms of group composition commonest in Gothic art, which are: making the figures stand close together, in those cases where they approach one another harmoniously and as people of one mind, and setting them one above the other wherever they are to be distinguished as opponents. Sculptors of the periods under study maintained these two basic patterns beyond the early period well into the late eighteenth century, while at the same time contributing to the history and development of sculptural groups by varying these initial types and, in particular, enriching the second, with its piling of figures one above the other. In the process they also realized their own ideas about the portrayal of two opponents as a group. Moreover, in the late sixteenth century, they introduced the arranging of figures to form *tableaux vivants*.

Groups representing like-minded persons. From the Renaissance on, all variations on this type (the combining of like-minded persons to form groups of quiet communion or harmonious encounter) had been primarily designed to give as lifelike as possible an account of the subject in question, by means of the free and natural appearance and thoughtful attitude of the figures, and, at the same time, by explanatory allusions to the event's setting. Examples can be seen in sculptures of *The Annunciation* (7, 266), of the Virgin and Child with St Anne or the Baptism of Christ, of *Christ and the Woman of Samaria* (118, 219) and the *Pietà* (41, 236, 267), likewise in such pairs of figures as the group with the Guardian Angel (VIII), or Sir Thomas and Lady Salusbury (229). Sculptors of such genre-like subjects as the mythical lovers Alpheus and Apollo (160, 161) or pure genre groups like *Harlequin*

25

and Columbine (255) or *The unhappy union* (294) managed to achieve a high degree of movement and momentary tension, but even they failed to reach any fundamentally different solution for this kind of composition.

Groups representing opponents. Patrons and sculptors of the age under study also kept close to the traditional scheme for rendering two opponents, with the successful partner towering above the unsuccessful – a saint standing monumentally over the heretic who crouches unconscious beneath him, a Virtue triumphing over the Vice that is made to cringe at its feet. Donatello (6) adhered less closely to this type of personification of the triumphant and upright hero than did the sculptors who followed him: Bandinelli in his group of *Hercules and Cacus* (ix), Cellini in his Perseus triumphing over Medusa, Pompeo Leoni with Faith over Heresy (110), Hans Reichle with the Archangel Michael triumphing over the Devil (130), and on into the eighteenth century with F. M. Brokoff's group on the Charles Bridge in Prague showing the two representatives of the Faith elevated above paganism and fanaticism (247). During these centuries the vanquished no longer appear disproportionately small, as in the Middle Ages, but are generally the same size as their conquerors. Their significance, however, was exactly the same as before: as in earlier sculpture they simply functioned as attributes testifying to the hero's superiority, and at the same time served as plinths to raise him in actual fact.

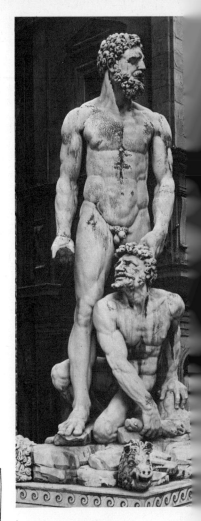

ix BACCIO BANDINELLI
Hercules and Cacus 1534
marble *c.* 5·50 m.
Florence, Piazza della Signoria

Apart from this sort of monumental and representative elevation of ethical or religious heroes above their disarmed and lifeless opponents – presenting the victor after the completion of his action – the sculptors under study tried from the first to work out another solution to the problem: to find some method of representing opponents still locked in dispute. It was Donatello (6) who gave the first impulse in this direction, by portraying Judith erect and triumphant, with her sword not delivering a mighty blow but raised ceremonially, while at the same time showing the actual beheading process. Michelangelo, too, in *The Victory group* (45) followed the same pattern, though sooner than set the partners in motionless poses side by side he made the victor apply all his strength to overthrowing the old man: the first instance of a group in which two opponents are so closely related by pressure and counter-pressure that not only their attitude but also their very existence only makes sense in terms of the relationship between them. A few years later the groups of *Hercules and Cacus* (x) and *Samson and the Philistine* show him finally breaking away from purely representational forms of portrayal. Although these too are both works which leave no room for doubt as to who will win, the hero no longer presents himself for the world's admiration but is wholly concentrated on overthrowing his opponent. In the ensuing period a large number of similar monumental, and also smaller scale groups of combatants with allegorical or historical subjects (44, 129) continually refer back to these examples set by Michelangelo.

The positioning of perpetrator and victim in such groups was inverted by Giovanni Bologna in the first monumental rendering of a rape, his marble group of the *Rape of a Sabine* in the Loggia dei Lanzi, whose composition was worked out in a bronze model (158); here the partners are no longer wrestling to gain the upper position and pin one another down, but struggling to rise in one and the same direction and with more or less equivalent movements, thus forming a team of pursuer and fugitive: the victim trying to defend herself, thrusting upwards without hope of escape or rescue, while the abductor raises her up so that she no longer has any ground under her feet. Bernini followed Bologna in the composi-

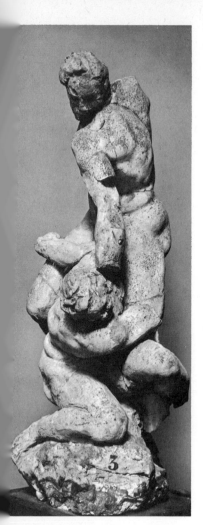

MICHELANGELO
Hercules and Cacus c. 1525
clay 0·41 m.
Florence, Casa Buonarroti

tion of *The rape of Proserpina* (159); Girardon, who had a bronze model of Bologna's marble group of *The rape of a Sabine* in his own collection, varied its composition yet again in his monumental three-figure group of *The rape of Proserpina* at Versailles (308). Finally Matielli's relief-like group of *Apollo and Daphne* (248), which is no rape but a pursuit, follows a pattern which, while certainly reminding us of Bernini's original version of this theme (161), once again recalls Bologna's *Rape*.

Just as the discovery of the Laocoön early in the sixteenth century had a particularly lasting impact on the artistic world, so did the excavation of the Classical Niobe group (154) towards its end. Where the Laocoön had been admired mainly for such specific details as the modelling of its well-muscled body and the movement of the limbs relative to one another in an organism in motion, what impressed people now was the grandeur of conception which led the Classical masters to combine fourteen figures in an extended scene so as to make a *tableau vivant*, presumably in much the same arrangement as that adopted for their re-erection in the open air in the garden of the Villa Medici. A number of sculptors were influenced by particular figures of the Niobe group: Bandini in the figure of Christ in his *Pietà* (155), Mochi in the Annunciation (156, 157), Puget in his Perseus group (304). But the importance of its example lay in the group itself and the general theatrical disposition of the figures, which in the Medici garden appeared to be alive and in motion.

The group as 'tableau vivant'. In ecclesiastical sculpture the grouping together of single figures to make *tableaux vivants* had long been one of the artist's tasks: see, for example, Mazzoni's and Juní's Lamentations (31, 105), or Berruguete's impressive staging of *The Transfiguration of Christ* (103), while in the eighteenth century, E. Q. Asam and Francisco Salzillo gave a highly theatrical or realistic presentation to such groups as *The Assumption* (258) or *The Agony in the Garden* (290). One instance where the *tableau vivant* overlaps with the grouping of figures as for a garden can be seen in the *Mount Calvary* in the Church of St Paul in Antwerp (215). All these last examples, with their particularly free arrangement, reflect the indirect influence of the Niobe group, and it was also the immediate model for all those secular *tableaux vivants* of the seventeenth and eighteenth centuries which, like Girardon's *Apollo and the nymphs* (307), Vanvitelli's *Diana and the nymphs* (199) or Tietz's *Parnassus* (268), were presented as though alive and in action on open ground or in surroundings cleverly arranged to look like natural vegetation.

The tasks of the sculptor in the secular world

THE BUST

It was not until the Renaissance that portrait busts, statues, and equestrian monuments (i.e. the chief forms of monumental portraiture) developed as independent sculptural categories. Although in the Middle Ages there were no portrait statues or equestrian monuments in our sense, portrait figures and horsemen were none the less produced for various purposes, and in the same way countless portrait heads or heads-and-shoulders appeared before the new age developed the bust proper.

Often they are astonishingly lively self-portraits of the artist and are to be found as an integral part of architecture or as church furnishing, executed in a variety of forms in accordance with the requirements of their allotted position. At the same time, a definite type of bust had been evolved which was intended as a free-standing reliquary, consisting of a figure cut off at breast height, a kind of saint's bust calling not for a portrait but for an individual face with a generalized expression of sanctity. It was from this form of reliquary bust that the history of the secular portrait bust developed.

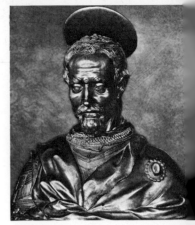

xi DONATELLO
Reliquary bust of S. Rossore c. 1424
gilt bronze 0·56 m.
Pisa, Museo di San Matteo

The reliquary bust. In Donatello's reliquary bust of S. Rossore (xi) of around 1424, the martyr, contrary to all previous custom, is characterized in such a lifelike way that we may take it to be a realistic portrait of the individual who acted as the artist's model. Around 1440 Donatello produced his second bust of a young humanist (in the Museo Nazionale in Florence), still in the form of a reliquary bust though no longer as an object of devotion; this is the first true secular portrait. His pupils and successors maintained the same pattern – individual portraits in the form of reliquary busts – well into the sixteenth century, trying at times to enrich it but without changing its essence (17, 18, 19). The only significant alteration was made by Verrocchio who in his portrait of the *Lady with a bunch of primroses* developed the bust into a half-length figure, a form thereafter employed for the representation of saints as well as of secular personages. Conrad Meit was the first Netherlandish Renaissance sculptor to adopt it (134); Van der Schardt used it for his portrait of the Nuremberg patrician Imhoff (140), while in Spain de Mena was still applying it in the late seventeenth century (286).

The revival of the Classical portrait bust. A fully independent form of bust, however, only developed in the sixteenth century, and it began as a revival of the Classical portrait bust. The earliest copies of Roman originals, such as we know to have been made by Jacopo Buonacolsi called Antico, suggested the possibility of making the same type serve for contemporary portraits, and Michelangelo's bust of the tyrannicide *Brutus* (xii) (1539–40) seems to have helped to clinch it. Immediately following him Bandinelli and Cellini made the first portraits since Classical times of a contemporary figure, Duke Cosimo (49, 51), in the old form of a bust. Henceforward the bust, with its underpart fully worked out and set on a base which raised the portrait off the supporting surface, was again an autonomous artistic 'figure', with none of the reliquary's chopped-off air. From 1545 onwards the new form spread rapidly. Although subsequent decades saw the torso lengthened as far as the hips, chiefly in upper Italy (50, 52) but occasionally in Tuscany and also in the Netherlands (145) and Spain, the shorter version none the less became established as the norm (88, 89, 200, 297). Bernini tried to loosen it up in his *Bust of Louis XIV* (170) by swathing the customary circular outline with a swirling cloak, but his example was not followed.

xii MICHELANGELO
Brutus 1539–40
marble 0·74 m.
Florence, Museo Nazionale

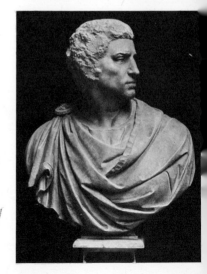

The 'informal bust'. None the less, during Bernini's lifetime, there were the beginnings of a new transformation which was of interest for the history and development of the bust. Whereas previously sculptors and patrons had thought it important to stress the sitter's rank and dignity by means of a suitable pose, or state or official robes, or prestigious or even pompous presentation, from the mid-seventeeth century onwards there was a tendency, originating in the English

Enlightenment, for busts not to record social position so much as individual personality, conveying the sitter's particular mode of life and thought through his physiognomy, and treating pretentiousness of outward presentation as increasingly unimportant. Hence the evolution of the category of *buste en négligé*, where the patron had himself portrayed quite unceremoniously in his housecoat or informally in his everyday or working clothes, with a natural, open countenance and an eloquent expression: something that was also a form of protest against exaggerated court ceremony and a proclamation of the freedom and independence of the individual.

Admittedly there was still a demand for busts of the old sort (191, 332), but during the course of the eighteenth century the *buste en négligé*, as first intimated in works by Pierce, Coysevox and Desjardins (223, 313, 314) became the preferred form of portraiture in France as well as in England (224, 227), though at times with a certain consciousness in the arrangement of the négligé, the carelessly draped robe (324, 331).

Bust of saints and allegorical figures. Once the sixteenth century had adopted the Classical form of bust for portraying contemporaries this began also to be used for busts of the saints, and of Mary and Jesus, though the saints of the Counter-Reformation were normally rendered by authentic likenesses, as in Egell's Rococo bust of *St Charles Borromeo* (253). Following Bernini's allegorical busts of the *Anima Beata* and *Anima Damnata*, busts now frequently began to be used to embody concepts, an exceptionally large number of allegorical themes being expressed in this way. Permoser's *The damned soul* (242) is one among many eighteenth-century versions of the idea first personified in bust form by Bernini.

THE PORTRAIT STATUE

Secular portrait statues, set on a plinth or pedestal in the open air or inside a public building, only appear with the sixteenth century. Whereas the bust was a form which could be directly derived from excavated Classical remains, there was nothing but written tradition from which to develop the portrait statue, which can thus be seen as a genuinely new departure by the sculptors of the Renaissance. Simple statues of patrons or figures on tombs, such as are in a sense forerunners of the portrait statue proper, are known as early as the eleventh century. They continued to be produced during the age which concerns us, though now not only for memorials of all sorts (114, 192, 210) but also as secular monuments, as for instance in the statue of Charles V over the chimney-piece in the Palais de Justice at Bruges (133), a portrait figure that not only served as a symbol of justice for the courtroom but at the same time was a conscious expression of the citizens' respect for the emperor, who had brought such benefits to the town. Later examples of purely honorific monuments include Colt's statue of James I in the drawing-room of Hatfield House (153) and Guillain's figures of the French royal family from the monument formerly on the Pont-au-Change in Paris (296).

Allegorical portraits and the monument in disguise. The earliest example of a portrait statue known to art history was that erected in honour of Andrea Doria by the city of Genoa between 1528 and 1540; it has survived only in fragmentary form. The citizens originally intended their monument to be put up inside the town hall, but this

failed to satisfy the admiral, who wished to see himself commemorated in the open air. Such an arrogant bid for maximum public glorification aroused the opposition of the citizens; none the less it was agreed that Bandinelli should make a statue which would be publicly displayed, but that it would not be a straight portrait, since it would show Doria as Neptune, disguised as a Classical god of the sea. When Bandinelli had nearly completed this project it was frustrated by the admiral's obstinacy. The plan as finally executed was entrusted to Giovan Angelo Montorsoli: Doria was allowed his portrait statue, but it was set on a plinth dominating the beaten Turks – symbols of heathendom – in such a way that Doria's figure seemed to symbolize virtuous Christianity, leaving the whole open to be interpreted as the anonymous embodiment of an allegory. From the chequered story of the Doria monument it emerges that there are three possible forms of portrait statue, which from now on become extremely common: the pure portrait statue (which Bandinelli never started), the unfinished portrait-in-disguise, and finally the allegorical portrait carried out by Montorsoli, of which we have the fragments.

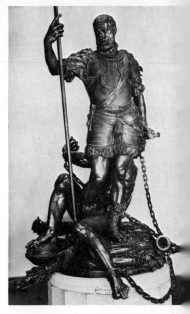

Portrait statues where the protagonist personifies a virtue and has a tendency to anonymity did not continue beyond the early seventeenth century; after Leone Leoni's memorial to Charles V (xiii) and Ferrante Gonzaga and Jacques Jonghelinck's to the Duke of Alba, the last works of this kind were excuted in Pisa and Leghorn by Giovanni Bologna and his pupil Pietro Tacca. The second form, however – the monument in disguise – was popular in all periods, even though from the seventeenth century onwards it was felt that to portray a contemporary figure in historical or mythological guise – as with Grinling Gibbons's James II as Caesar or the statues of Louis XV and Marie Leczinska as Jupiter and Juno (318, 319) – no longer represented any restriction of the subject's individuality but rather made something heroic of it.

The pure portrait statue. The first one with the sole function of publicly commemorating an individual was that offered in 1571 by the city of Messina to Don John of Austria, the victor of Lepanto, and executed by Andrea Calamech. It was followed by the statue of Grand Duke Ferdinand I of Tuscany (70) which Bologna designed and Francavilla carved. By contrast with Calamech's monument, where the figure of Don John was set on a disproportionately large base, the relation of figure to plinth was in this case so carefully thought out in terms of size and volume that subsequent sculptors – such as Cordier, Coysevox, Schlüter, Strudel (240) and Moll (271) – all used its measurements as a basis for their own calculations.

The portrait statue as apotheosis. This final type was also evolved in the sixteenth century, as a way of laying the utmost emphasis on individual glorification and personifying the sitter's claim to a place among the immortals. The earliest monument of this kind was made by Simone Moschino for Alessandro Farnese in 1596 and erected in the courtyard of the Palazzo Farnese in Rome, before being moved to the palace of Caserta in the late eighteenth century. Martin Desjardins, ninety years after Moschino, drew directly on him for the composition and iconography of his *Apotheosis of Louis XIV* in Paris (destroyed in 1792). Permoser and Donner however, while providing a similar number of figures in their apotheosized statues of Prince Eugen (241) and the Emperor Charles VI (249), were freer and more personal in the composition of their works.

THE EQUESTRIAN MONUMENT

Mounted saints and equestrian memorials. The history of the modern equestrian monument dates from about 1450, when Donatello's statue of the Condottiere Gattamelata on horseback was set on top of a high plinth in front of the Church of S. Antonio in Padua (14). In making this an equestrian statue Donatello was following a long-established tradition, for Medieval sculptors had often portrayed the same kind of mounted saints (Constantin, Martin, George), holy knights or horse-riding holy men, as were so often demanded and produced in the age that concerns us (76, 167, 259). Alongside these there were a number of equestrian memorials as symbols of sovereignty and the law, as for instance the free-standing equestrian figure of Otto I in Magdeburg or that of Oldrado da Tresseno on the façade of the Palazzo del Ragione in Milan. Finally, funerary art from the early fourteenth century onwards developed several different sorts of mounted memorial: formally constructed equestrian tombs in the body of a church or memorials set into a wall, with the mounted figure of the dead man on top.

Donatello's Gattamelata (14), too, had been conceived as a free-standing memorial in the church's old cemetery; it was not, however, intended as that military commander's actual tomb, which had been put inside the church, but as an empty and honorific cenotaph, somewhere halfway between a tomb and a monument, both in form and in function. It still appears to be a tomb because Donatello made the base like a tomb with a sarcophagus on it; at the same time it gives the impression of being a monument because from the outset he designed this substructure (in which the transition to a new monumental form is specially worth remark) so as to serve as a plinth for the mounted figure. Whereas earlier the tall, many-layered tombs of the Scaligers in Verona bore the figure of a horseman as a decorative crown and culminating point of the architecture, in the Gattamelata statue Donatello so balanced the measurements of rider and base as to make them form an indissoluble unity, a single figure: without the plinth the horseman would appear less lofty and magisterial and without the horseman the plinth would be nothing but a pointless architectural exercise.

The secular equestrian monument. The first entirely secular one was Verrocchio's and Leopardi's statue of Bartolomeo Colleoni in Venice (13) a few decades later. In the general structure of this work the artists closely followed the Gattamelata pattern, though their novel and imposing base surrounded by pillars finally did away with any suggestion of the tomb or of consecration, making this first modern monumental plinth seem like one leg of a triumphal arch.

During the next hundred years – i.e. up to Giovanni Bologna's completion of the third equestrian monument to Cosimo I (xiv) in Florence (1587–99) – no event was more important for the evolution of this type of monument than Michelangelo's re-erection of the Classical mounted figure of Marcus Aurelius on the Capitol in 1538–9. Contrary to the precedents set by Donatello and Verrocchio, and contrary also to Classical tradition, according to which equestrian statues were set on high pillars or (as was probably Marcus Aurelius's case) on triumphal arches, Michelangelo put him on a low plinth, so that the statue counted for more in the general effect than did the architecture of the base. This new form, with the horseman brought nearer to the observer's eye-level, was henceforward accepted as the rule, though sculptors would sometimes modify the proportions in favour of the mounted figure or of the plinth, according to their tastes. Thus Giovanni

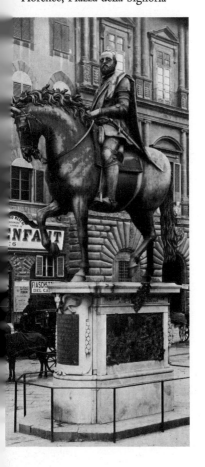

GIOVANNI BOLOGNA
The Cosimo I equestrian monument
1587–99
bronze *c.* 4·50 m.
Florence, Piazza della Signoria

Bologna, while making the plinth of his Cosimo I proportionately narrower, reduced it even further – probably the original plinth for Philip III's equestrian monument (162) took a similar form – while Francesco Mochi in his equestrian statue of Alessandro Farnese (163) stuck closely to Michelangelo's example.

Once Verrocchio had made the first secular plinth, thus establishing the distinction between equestrian monument and equestrian tomb sculpture, and once Michelangelo had laid down new proportions for the relation of figure to base, Bologna and Mochi went on to evolve two basic ways of portraying the horseman himself, which were repeatedly adopted in the ensuing years. In the monuments for which they were responsible in Florence, Paris and Madrid, Bologna and his studio showed him seated with dignity and ease, more enthroned than riding, with his commander's baton resting on his thigh and his feet set firmly in the stirrups, on a docile and obedient horse which appeared to be marking time. Such monuments symbolized authority, and they remained the model not only for the majority of French equestrian statues of Louis XIV (311) and Louis XV but also for English statues of William III (228). Mochi at Piacenza on the other hand showed horse and rider in action, with the horse thrusting impetuously forward and spurred on to a thundering trot by his rider, whose cloak spreads and billows in the wind. Whereas Bologna's princes seem to be reviewing a parade of troops marching by, Mochi's on the contrary appear to be riding past a formation at the halt. Mochi's two equestrian groups, with their strong and temperamental movement, provided the inspiration for Andreas Schlüter's equestrian monument to the Great Elector (239).

Equestrians on rearing horses. There is one last form of equestrian monument for which preliminary ideas and models can be traced as far back as Leonardo. This was exemplified between 1634 and 1640 in Pietro Tacca's massively large figure of Philip IV on a rearing horse, a type of monument well calculated to suggest grandeur and courage and the sitter's dynamic force. Bernini and (if the identification is right) Puget (305) portrayed Louis XIV in such a manner, and their example served Coysevox for his Fame on a galloping Pegasus (315). As the Baroque period drew to a close, Étienne-Maurice Falconet provided it with a last grand triumphal memorial in his Leningrad statue of Peter the Great on a rearing horse (xv).

SCULPTURE OF FAÇADES, DOORS AND GATEWAYS

It was an age when sculptors received many commissions for the decoration of public or private buildings: for façades, doors and gateways, staircases, walls and built-in features of their interiors. Sculptural schemes of this sort followed widely varying programmes, depending on the patron's wishes or on the artists' own ideas; often their theme was decided by the use to which the space or building in question was to be put. Thus we find façades filled and enlivened by persons or episodes providing more or less clear pointers to the building's function or to the princely rank, artistic, scholarly or mercantile profession of those commissioning it and living there (complete or partial examples can be seen in plates 39, 71–2, 243–4, 257 and 296). The St Michael above the entrance to the armoury in Augsburg (130) was an allusion to its function as a weapon store; similarly Verhulst's *The butter-buyer* (209) in the Butter Hall in Leyden was designed as a trade emblem; the entrance to the House of the Guild of St Luke in Antwerp carried portraits of Van Eyck and Dürer (141–2) as representatives of contemporary painting.

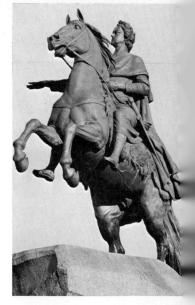

XV ÉTIENNE-MAURICE FALCONET
The Peter the Great equestrian monument 1766–78
bronze over lifesize
Leningrad, Senate's Place

DECORATED INTERIORS, MURAL AND CHIMNEY-PIECE SCULPTURE

Examples of artistically significant interior mural decorations are the stucco figures and reliefs by Primaticcio at Fontainebleau (84) and Artus Quellinus's frieze of caryatids (208) in the old courtroom in Amsterdam, while Bandini's *Juno* (62) and Matielli's *Apollo and Daphne* (248) belong in decorated interiors which have come down to us intact. Though Goujon's Musicians' Gallery in the Louvre (83) is a single precious survivor from a monumental scheme, a large number of chimney-pieces are still to be found in their original positions in castles, palaces and country houses, showing sometimes by their sculptural ornamentation that the room in question was used specifically for banquets and ceremonies (225), though more commonly advantage was taken of the fact that they were put in the grandest room in the house to make this a position of honour in which to commemorate a sovereign (133, 153) or to erect a monument to oneself and one's own family (92, 120). It was exceptional for a chimney-piece sculpture to portray the element of Fire by means of allegories or scenes from history and mythology, as in Tiziano Aspetti's relief showing Venus in Vulcan's smithy (xvi).

xvi TIZIANO ASPETTI
Padua 1565 – Pisa 1607
Chimney-piece c. 1585–90
marble
Venice, Palazzo Ducale

THE FOUNTAIN

Wall, niche and façade fountains. Such works within a strictly architectural context played a much less important part in the sculptor's activity than did the fountain. In the Middle Ages the construction of secular public fountains – with the notable exception of the city fountain at Perugia – was less the sculptor's business than that of the builder and the stonemason, who would make free-standing or wall fountains in the form of a round, rectangular or polygonal basin, normally with little decoration other than the emblems of the city or a few spouts in the form of heads. It was not until the age with which we are dealing that the fountain became a task for the sculptor and developed into a category of his art. The simple wall fountain of earlier times now evolved into more or less richly decorated fountains on façades or in niches, and these from the start were used to celebrate myth, world and element of water by means of their figures or reliefs, as for instance the niche fountains which Tribolo, Lorenzi, Grupello and Donner put in gardens, courtyards or even interiors (56, 58, 160, 213 and 250) or the great façade fountains which Goujon, Salvi and Bouchardon set at street corners or in street perspectives or against one side of a square (82, 198 and 322).

The monument fountain. One type of free-standing fountain, to be developed notably by Montorsoli, Ammanati (xvii) and Giovanni Bologna in their great city fountains in Messina, Florence and Bologna respectively, was the so-called monument fountain; a basin with a plinth set in its middle supporting a monument to some mythological, historical or (occasionally) contemporary figure – a form of fountain whose development is already foreshadowed in Peter Flötner's Apollo fountain in Nuremberg (115). Giovanni Bologna's Neptune fountain in Bologna inspired the arrangement of the monument fountains to Hercules and Augustus in Augsburg (125–6) by his two Flemish pupils Adrian de Vries and Hubert Gerhard, which are at once fountains and monuments in honour of the city's mythical patron and its actual historical founder. Generally the monument fountain is a type that was not very widely favoured, and in the seventeenth and eighteenth centuries one seldom comes across it.

The basin and the naturalistic fountains. A much more influential type was the basin fountain, where one or more circular basins are joined to a narrow central core bearing a statue on top. This form seems to have developed during the fifteenth century not so much from the free-standing Medieval city fountain as from fonts and holy water stoups or fountains in monasteries. Though the first fountains of this sort were covered all over with botanical or geometrical decorations, the total impression which they gave remained more like that of an inorganic architectural structure or some monumental object of applied art. Towards the end of the fifteenth century the core of the fountain began to be hidden under figures and reliefs, so as to disguise its function as a weight-bearing architectural element; in this way the shaft of the fountain at Gaillon (75), with its twin basins, evolved as the first purely sculptural creation. During the sixteenth century the inner circular basins, the edge of the outer main basin and its exterior were all given increasingly plastic form and decked out with sculpture: Montorsoli's Orion fountain in Messina, for instance (55), though its structure is virtually the same as that at Gaillon, no longer at any point suggests the use of ruler and compass; every part, down to the softly curved lips of inner basins and main basin, is the work of the

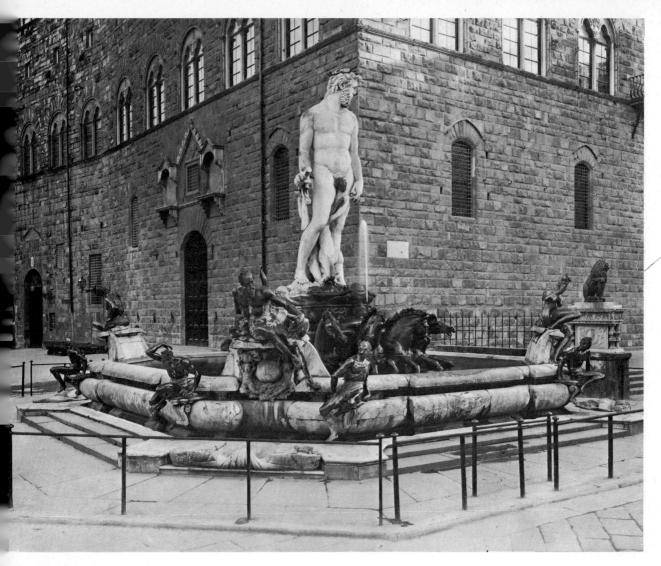

xvii BARTOLOMMEO AMMANNATI
The Neptune Fountain 1560–75
marble and bronze
Florence, Piazza della Signoria

sculptor's shaping hands. Yet even with the Orion fountain – Bologna's Venus fountain in the Boboli Gardens in Florence is another good instance (64) – the natural organic movement of outline and inner form cannot prevent the architectural core of the whole thing from determining the ultimate effect. Though this core is now there simply to support sculpture the combination does not yet seem a purely plastic ensemble like the naturalistic fountain, a type which Taddeo Landini further helped to evolve in his Tortoise fountain (67) near the end of the century by transforming the circular basins into four tightly rounded mussel-shells, and which was conclusively realized around 1635 when Bernini composed his Triton fountain (169) out of nothing but living organisms and natural forms. Another supreme example of the use of natural shapes to disguise the basin fountain's basically architectonic character, so that they seem to have coalesced into a fountain by accident, is to be found around 1750 in Guibal's Neptune fountain at Nancy (321).

35

Illusionistic water schemes and fountains. Alongside the naturalistic fountain, whose evolution from the basin fountain can be followed step by step – one architectural element after another being replaced by natural forms and its functions taken over – we find from the mid-sixteenth century onwards works best described as illusionistic. Whereas the naturalistic fountain always originated, even in its most highly developed form, as a self-contained artistic 'figure' contrasting with its surroundings, it is typical of the illusionistic scheme that nature and sculpture should be indistinguishably mixed, so that we see the figures in a real or confected natural setting amid which they seem to move and act, giving us the illusion of looking at a slice of nature with people in it. An early scheme of this sort seems to have been the occasion for Cellini's *Narcissus* (48), which at some date after 1571 was installed beside a watercourse in the garden of the Villa Pratolino; Giovanni Bologna designed his group of three boys fishing from a rock as a small illusionistic fountain for the garden of the Casino Mediceo in Florence, subsequently creating the group of the mountain giant Apennine pressing water out of a monster's mouth (60), which still survives in its original state at Pratolino. *The Vine-grower's Fountain* (68) installed at ground level in the Boboli Gardens by Valerio and Simone Cioli in 1605 can be seen as a wholly natural *tableau vivant*. Early in the eighteenth century Neptune and his court (59) were removed from Stoldo Lorenzi's old basin fountain and transferred to a 'natural' setting amid rocks on an island in the upper pond of the Boboli Gardens. Then in 1765 we find architectonic structures again developing among the natural forms in the Veitshöchheim Parnassus with Pegasus, Apollo and the Muses (268), indicating a widespread return to the architectural fountain in this period of Classical revival. The Actaeon and Diana groups (199) at Caserta date from slightly later, and provide a last characteristic example of the wholly illusionistic scheme.

The tasks of the sculptor in the ecclesiastical world

THE DECORATION OF THE CHOIR

Wall tabernacles and pyxes. When a church was to be built the most important area was always the choir. The choir's layout and decoration were dictated by its nature as a sanctuary – the place where the altar stood and the Host was kept – and a presbytery, that is the place where priests officiated. In the Middle Ages the Host was kept in a tabernacle let into the wall on the north side of the choir, then from the fourteenth century on sometimes in separate pyxes, whose construction and use, however, became rare after the middle of the sixteenth century. Both in form and in decoration Luca della Robbia's tabernacle at Peretola (I) is a classic example of the early Renaissance wall tabernacle; a late instance of a pyx is that by Cornelis Floris at Zoutleeuw (xviii, 139).

The tabernacle altar. From the early fifteenth century onwards there was a tendency to do away with pyx and tabernacle as it became commoner to keep the sacrament on the high altar, a practice first recommended then confirmed, by an order of the Council of Trent. The Renaissance consequently saw the development of a new form of altar, the sacrament or tabernacle altar, of which there were at first two main types, carrying on the tradition of wall tabernacle and pyx

respectively; in the one the tabernacle was set in the retable, in the other the pyx was placed on the altar table. The earliest examples of tabernacle altars with their retables formed into aedicules or triumphal arches were in the city and province of Venice; in Tuscany they were installed by Desiderio da Settignano, among others, in Florence, and by Lorenzo Marrina in the church at Fontegiusta near Siena (xix). With the sixteenth century the tabernacle began as a rule to be placed in the predella, which allowed the sculptural decoration of the retable to be finer and more of a whole, as in Montorsoli's high altar in Sta Maria dei Servi at Bologna (xx) or subsequently in Pedro Roldan's high altar in Seville (detail shown in 287). The tabernacle remained in the area of the predella even in cases where the sculpture of the altar took up an entire wall of a chapel, as in Pozzo's altar at St Ignatius (VI), or in those where the predella no longer served as plinth to a retable but formed a base for free-standing groups of figures, like the works by Campagna, Anguier and Stammel (74, 300, 259).

With altars of the second type the tabernacle consisted of a free-standing pyx in the form of a little temple on the surface of the table, as in the examples by Vecchietta in Siena (23), Benedetto da Maiano in the collegiate church at San Gimignano or Torrigiani in Rome (73); sometimes however such *tempietti* might be placed like a protagonist in the central niche of a carved retable, as with Andrea Ferrucci's in the cathedral at Fiesole, or backed by a retable as in Salamanca (275), or covered by a canopy as in S. Spirito in Florence. During the Baroque and

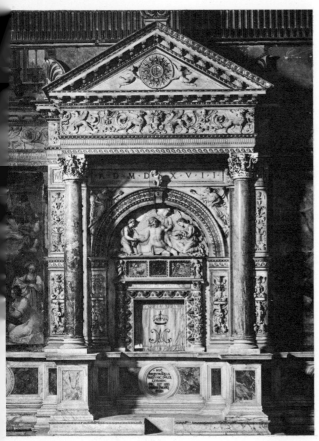

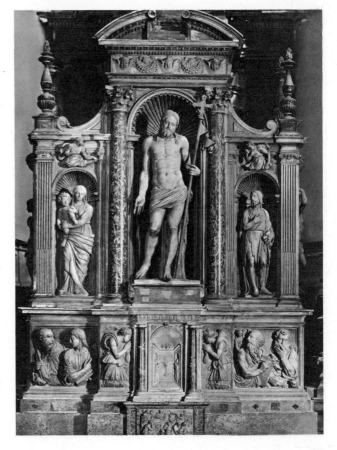

Rococo periods the tabernacle, usually a small cupboard decorated with carving (254), was set above the table as a centre and focus for the comprehensive decoration of the choir; some notion of this kind of setting, with its apotheosis of the Sacrament and its frequent tendency to turn the altar area into a sacred theatre, can be got from the details in 258, 260 and 263.

The relief altar. Alongside these tabernacle altars, which were primarily high altars, the chief innovation affecting lesser altars without tabernacles was the evolution of the single-piece or relief altar: an altar table dominated by a retable in the form of a large relief portraying a single scene from the Bible or from the lives of the saints. Following Donatello's altar of *The Annunciation* (7), Andrea and Giovanni della Robbia were the main contributors to this development. In France, where Michel Colombe's relief of St George (76) seems to have belonged to an early relief altar of this sort, in Germany, Spain (276) and the Low Countries it was only hesitantly followed. Undoubtedly the most important altars of this class are those created by the school and followers of Bernini in Rome and other centres of Italian Baroque art (174, 177–8, 188–9). Though in Bernini's and Raggi's St Teresa and *Noli me tangere* altars (166, 175) the figures are sculpted in the round, the effect aimed at is so much one of relief that they too can be counted as relief altars.

The choir stall. Beginning in the thirteenth century, furnishing of the choirs in cathedrals and monasteries came to include choir stalls, whose basic form, consisting of rows of seats with a high back to them, remained unchanged for centuries. Though in Italy the choir stalls were normally treated as so much furniture and made by cabinet-makers, in countries with a rich tradition of wood-carving they were regarded as a proper task for the fine arts. Thus not only in Spain but also in Flanders and Germany a number of masterpieces by famous sculptors of the age under study are to be found preserved in the form of relief and figure carvings on the backs of choir stalls: by Berruguete in Toledo Cathedral (102–3), by de Mena in Malaga (279) or in Germany by J. J. Christian in Ottobeuren (262).

ROOD-SCREENS, PULPITS AND OTHER INTERIOR ITEMS

As a result of the revision of the liturgy by the Council of Trent not only the wall tabernacle and the pyx but also the rood-screen – the structure separating the choir from the nave and the priest's area from that of the laity – lost in significance because the interiors of churches came to be treated as a single uninterrupted space where all the faithful might have a clear view of the high altar. In Italy they began demolishing the existing rood-screens as early as the sixteenth century, but elsewhere the process was slower, taking place, according to circumstance, in the seventeenth, eighteenth or nineteenth centuries. Generally, however, a stop was put to the erection of new rood-screens after 1565, with two exceptions: Spain, when the old *coros* which had served as rood-screens in that country were restored in the seventeenth century, or new ones erected, and Flanders, where splendid rood-screens rich with sculptural decoration arose from the end of the fifteenth century, forming one of the most active fields of ecclesiastical art for the local sculptors. J. du Broeuq and his workshop for instance sculpted no less than ten statues and twenty-six reliefs showing episodes from the history of salvation for the first purely Renaissance rood-screen (136, 138). Moreover in Flanders as a rule

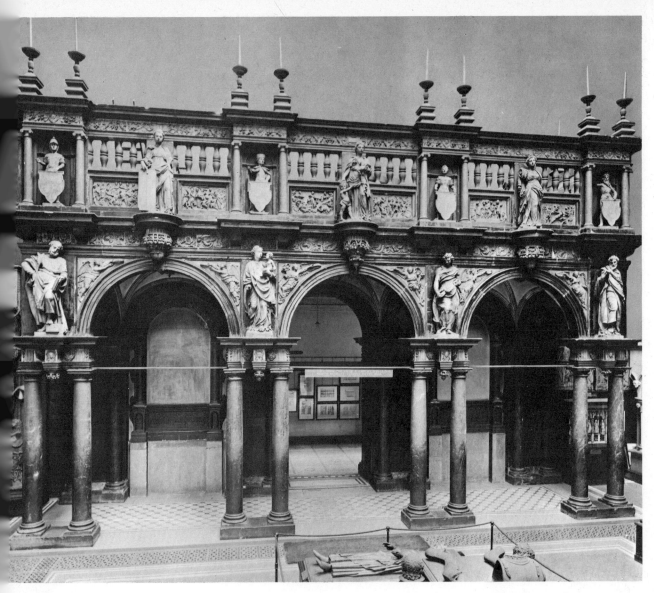

xi HENDRICK DE KEYSER
Rood-screen 1610–13
marble and alabaster
London, Victoria and Albert
Museum

there was no removal of rood-screens, which on the contrary went on being installed in old and new church buildings right up to the end of the seventeenth century (xxi, 147).

Not until Donatello's time did pulpits and their embellishment become a universally accepted task for the sculptor. Though isolated examples – some of them extremely famous – are known to us from earlier times, it was only with the fifteenth century that pulpits were created in such numbers that we can judge their development as a coherent whole; at the same time, it was not till then that the simple construction of pedestal and rostrum began to be surmounted by a sounding-board and reached by a permanent stairway, so that the structure came to consist of those four main elements which would in future go to make it up. The themes chosen for the sculptural decorations varied at different times: till the middle of the sixteenth century it was common for the base to display the evangelists or allegories of the

39

virtues, as in the pulpits by Buggiano, A. Rossellino, da Maiano (25) and de Salas (98), while the reliefs around the pulpit itself showed scenes from the life of the church's patron saint. With the greater weight given to the sermon after the Reformation and the Council of Trent, and the correspondingly more prominent place given to the pulpit in church interiors, the range of such themes was extended and stairs and sounding-board were included in the scheme of sculptural decoration. For example, in the pulpit in Trier, which dates from 1570–2, the base portrays not only the four evangelists but also the five senses, with acts of compassion (119) surrounding the pulpit proper and the Resurrection, the Ascension, the Last Judgement and the Sermon on the Mount all on the stairs; whereas nothing but scenes of teaching, preaching and conversion are to be found in those pulpit reliefs of around 1585–90 by Pilon's school which used to be in the Église des Grands-Augustins in Paris and are now in the Louvre. In the case of the pulpit at Wasserburg (1638), the sounding-board alone bears not only the Madonna on a crescent moon (xxii, 235) but, above and below it, the figures of St James, the church's patron, and the four doctors of the church, together with angels and a monogram of Christ. As more and more themes came to be represented sculpturally the pulpit's outward appearance was further transformed, so that one can no longer speak of its individual architectural beauty, such as can always be sensed in older designs. During the remainder of the seventeenth and eighteenth centuries it was normal to concentrate on one principal and one secondary theme, often enough The Fall and Redemption of Man, together with a scene from the life of the church's patron saint. At the same time the pulpit's structure and architectural elements became transformed into shapes from nature, rocks, trees and plants, and combined to form a coherent setting for the portrayal of such scenes (217–18), giving greater vividness and force to the limited range of ideas which the sculpture of these Flemish, German or Austrian 'nature pulpits' expressed. Finally, with the late eighteenth century, concepts of architectonic ornament once more prevailed (219).

Frequently, too, the sculptor was asked to design and decorate lesser objects of church furniture. Each of the various categories has its own more or less extensive history, but it will be enough here to pick out some individual works: among lecterns, Cano's famous work in the cathedral at Granada, crowned by the seated figure of the *Virgen de Belén* (IV); among confessionals, Verhaegen's monumental composition at Ninove (xxiii); among fonts, that by Gibbons, which is equally important as art and as iconography (221); among holy water stoups, A. Rossellino's beautiful design (24); finally, among sacristy fountains, Donner's two reliefs from the sacristy of St Stephen's Cathedral in Vienna (251–2).

THE TOMB

Free-standing tombs: the sarcophagus and the table tomb. The only ecclesiastical task where the number and significance of commissions given can be compared with the case of the altar is the sepulchral monument. Here, more than anywhere else, the Renaissance masters found themselves presented with an exceptionally rich tradition which determined not only the basic forms of monument but also their decoration: free-standing and wall tombs, together with their subdivisions into sarcophagus, canopy tomb and so on. The simplest form of free-standing tomb is the sarcophagus, a rectangular stone box with the dead man's effigy resting on the lid. If the forerunner of the Medieval sarcophagus can be said to be the prehistoric tumulus – an heredity that can still be detected in such monuments as Pollaiuolo's

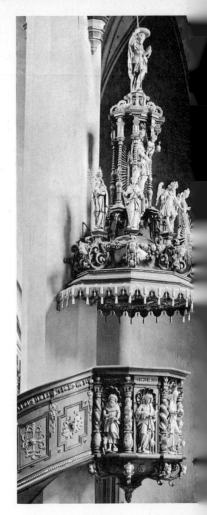

xxii MARTIN ZÜRN
Pulpit 1636–8
painted limewood
Wasserburg am Inn, St Jakob

V Etienne Le Hongre
The Element of Air 1683–4
Versailles, Palace Gardens

VI Andrea Pozzo
St Ignatius Altar 1695–9
Rome, Il Gesù
(*overleaf*)

VII Michelangelo Slodtz
*Tomb of Jean-Baptiste
Languet de Gergy* 1753–7
Paris, St Sulpice
(*overleaf*)

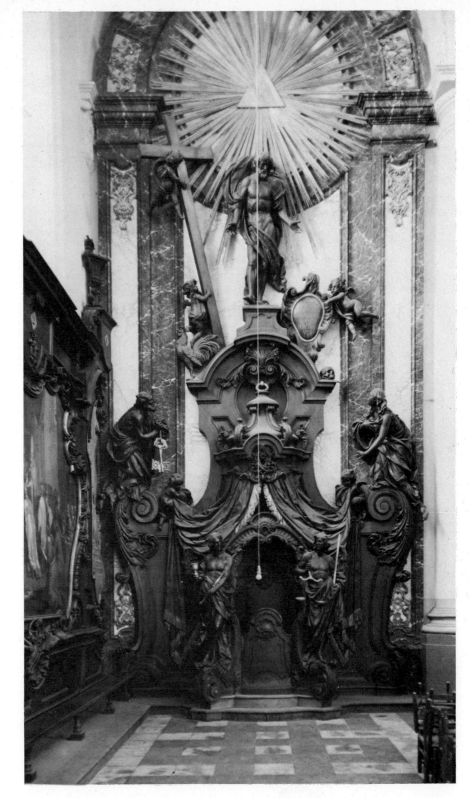

xxiii THEODOR VERHAEGHEN
Confessional 1736–9
oak
Ninove, Abbey

VIII Ignaz Günther
*The Guardian Angel with
Tobias* 1763
Munich, Bürgersaalkirche

to Pope Sixtus IV or Fancelli's for Don Juan (94) – in the Mediterranean countries memories of the Classical sarcophagus always helped decide the arrangement of its basic structure, particularly from the Renaissance on. Yet, despite the variety of Classical motives to be found on such Renaissance tombs, they can never be mistaken for sarcophagi of Classical times. And this, of course, applies equally to their decoration, whether it be angels or *amoretti* holding garlands, coats of arms or inscriptions round the sarcophagus (2, 148, 117), or saints, personifications of the virtues or scenes from Classical mythology placed in medallions or niches or at its corners (77–8, 94, 148). The risen figure on Ferdinand I's monument (117) shows how the old pattern was about to be changed, with the Baroque artists turning the sarcophagus into a focus and platform for such scenic representations as that of Christ's resurrection by Adrian de Vries (124), or that where the dying Cardinal Richelieu, supported by Faith and mourned by Dogma, commends his soul to God (xxiv).

In the course of the thirteenth century, we first encounter the table tomb, where the dead man's effigy rests not on a sarcophagus but on a slab carried on four supports, sometimes in the form of figures. The double tomb of Jan van Merode by C. Floris (137) represents a development of its earliest form. A variant which was evolved in the fourteenth and fifteenth centuries served as a devastating presentation of the idea of *Vanitas* and was taken up by Maximilian Colt around 1610 (149); it makes use of the two-tier arrangement to represent the dead man half-decayed or as a skeleton on the lower slab while the raised bier shows him alive and with open eyes, bearing all the outward marks of his worldly distinctions. A final adaptation of this type of tomb can be seen in the monumental sepulchral halls of the sixteenth-century French kings in Saint-Denis: for instance, Louis XII's monument (79), where the lower slab has been formed into a massive plinth, with the supports joining up to become arches of an open hall where the dead lie in a state of decay and on whose roof they are shown praying in their coronation robes.

The canopy tomb. The most ambitious form of free-standing tomb was the canopy tomb which was adapted through the West, following the erection of the first example of the type in memory of St Louis at Royaumont; here the dead man's effigy on the sarcophagus is covered by a canopy to emphasize his exceptional dignity and rank. The transition from Medieval times to Renaissance and Baroque is shown more clearly in the sculptural decoration of the canopy tomb than in any other type, thanks to the great reduction in the number of religious themes of all sorts in favour of purely secular subjects; thus monuments like those of Prince William or Admiral van Wassenaar (146, 210) seem intended less as a pious memorial than as a contribution to the dead man's fame and to his glorification in this world.

Wall and aedicular tombs. Examples like the monuments by Tino di Camaino and Nino Pisano in Florence, Siena and Pisa show in the course of the fourteenth century how the wall monument developed into a lofty, multi-storeyed structure composed of a great many elements, filled with numerous statues and reliefs, angels, saints and allegories of the virtues, scenic representations of episodes in the life of Christ or of the dead man. The Renaissance artists who revived this form abandoned such Gothic multiplicity in favour of classically inspired aedicules let into the wall or set on top of it; at the same time they showed themselves, like Bernardo Rossellino (15),

particularly restrained in their use of sculpture to decorate the new aedicular monuments, with the result that their works not only achieved a harmonic balance of architecture and sculpture but made the effigy on its raised ceremonial bed the focus and central point of the whole arrangement. Even in the second half of the fifteenth century, however, the beautifully austere articulation of the earlier works was disturbed by adding extra subsidiary figures and making these more animated, as in the Cardinal of Portugal's tomb (16). In the newly completed aedicular monuments by Bregno in Rome and G. A. Amadeo in Bergamo (26, 32), the dead man is once again escorted by individual saints. The sixteenth century saw the type which the Italians had evolved taken up throughout the West (116, 151); such Baroque sculptors as P. Rijckx and R. Verhulst (211–12) filled every corner of the aedicular framework with sculpture, in accordance with their idea of beauty.

iv FRANÇOIS GIRARDON
Tomb of Cardinal Richelieu 1675–94
marble
Paris, Église de la Sorbonne

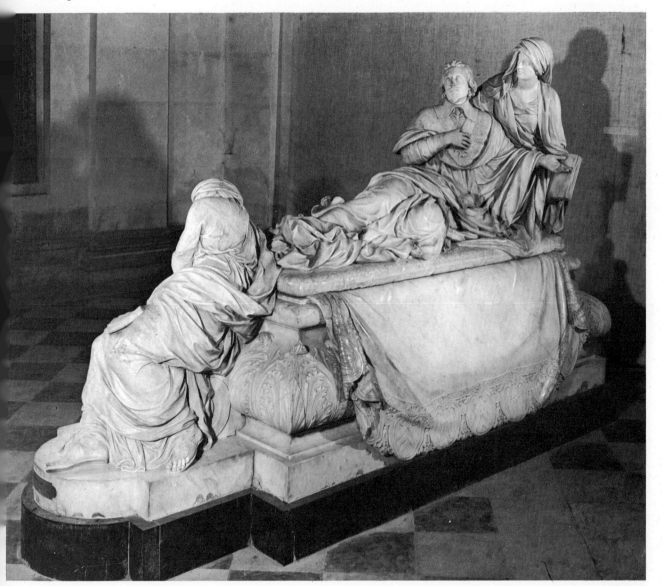

Tombs in the form of a triumphal arch. It seems to have been the broad, high monuments of the Romans and, even more, the Venetians, with their persisting Gothic influence, as in Rizzo's monument to Niccolò Tron (30), that led to the monument in the form of a triumphal arch (29), where the dead man lies in state under the central archway, while the lower side arches are arranged as niches in which are placed saints or personifications of the virtues. We owe the final form of this type of wall monument to Andrea Sansovino and his influence (35, 95) and to his pupil Jacopo Sansovino. A rather feeble seventeenth-century echo can be found in such a work as J. du Quesnoy's monument to Antonius Triest (205).

The pyramid-shaped tomb. The monument in pyramid form, as first realized by Michelangelo in the tombs of the Medici (40), was exceptional in the popularity which it enjoyed right into the late eighteenth century. Such sculptors, however, as della Porta, Bernini, Rusconi or Bracci (54, 168, 184, 192), not only followed this model in their general arrangement, with the dead man's effigy on top of the sarcophagus and two figures beside or before it at his feet, but from della Porta's time on made these figures into allegories to personify the dead man's virtues. These pretentious patrons were prepared to be commemorated simply by a portrait medallion, supported by Chronos or by a winged figure of Death (295, 185) and incorporated in a similar general arrangement, and even to dispense with any portrait of themselves and have a personified virtue erected above their sarcophagus (186–7). The pyramid pattern was modified and eventually dissolved thanks to late seventeenth-century designs where the persons represented develop a livelier relationship and stand in a dramatic relation to one another, as in the monuments to the Marquis de Vauban, Count Mitrowitz or Maurice of Saxony (312, 246, 326) or in late eighteenth-century English monuments (226, 229, 230) where the composition hardly suggests a pyramid any more.

The effigy in perpetual adoration. Monuments bearing the dead man's effigy in an attitude of perpetual adoration are always set in the walls of the choir on whose altar the Host, object of that adoration, is reserved. Such memorials, with the central figure directing his adoration towards the tabernacle, date from after the Council of Trent, when the Sacrament was removed to the altar. They probably owe their origins to those earlier memorial reliefs where the dead man is shown adoring a crucifix, as in that to Anton Kress or in the monumental Baroque erection to Theodor von Fürstenberg (111, 121). Among the earliest examples of a monument with figures in an attitude of perpetual adoration is one of the finest, P. Leoni's monument to Philip II in the Escorial; a contemporaneous tomb in triumphal arch form by the same sculptor showed Cardinal de Valdès likewise kneeling in prayer under the central archway (109–10). Around the middle of the seventeenth century, once Richelieu had expressed his wish to be shown on his tomb not in an attitude of prayer but *comme s'offrant à Dieu* (xxiv), we find the same attitude of commitment to God represented in effigies of the dead in the majority of monuments in Germany, Italy and the Low Countries (VII, 190, 193, 214).

NOTE: Where there is more than one illustration on a page the captions and pictures run from left to right, and top to bottom.

1. Nanni di Banco
The four saints, after 1412
Florence. Or San Michele

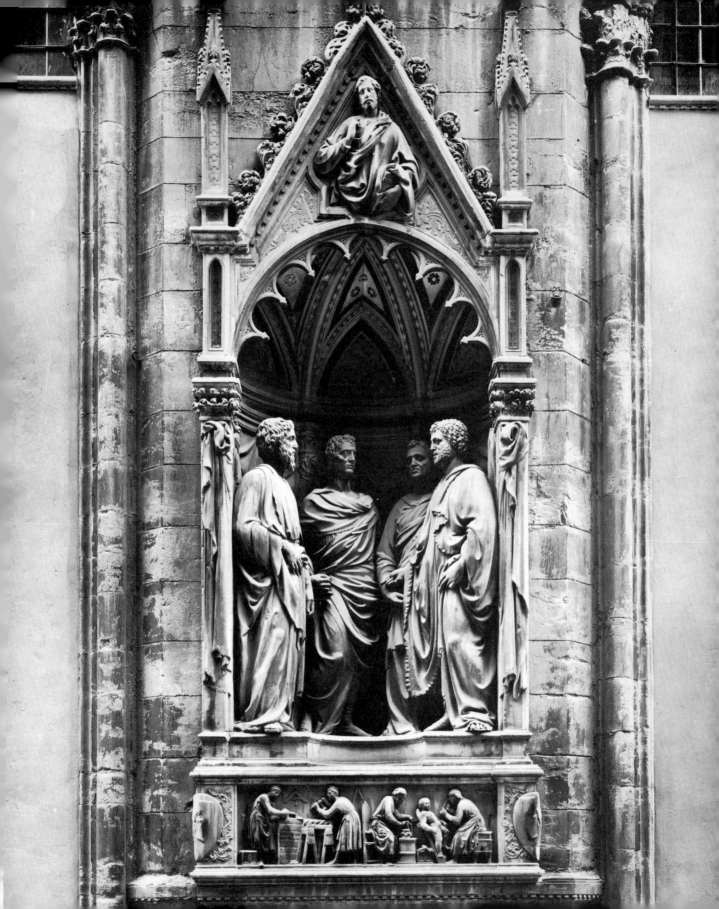

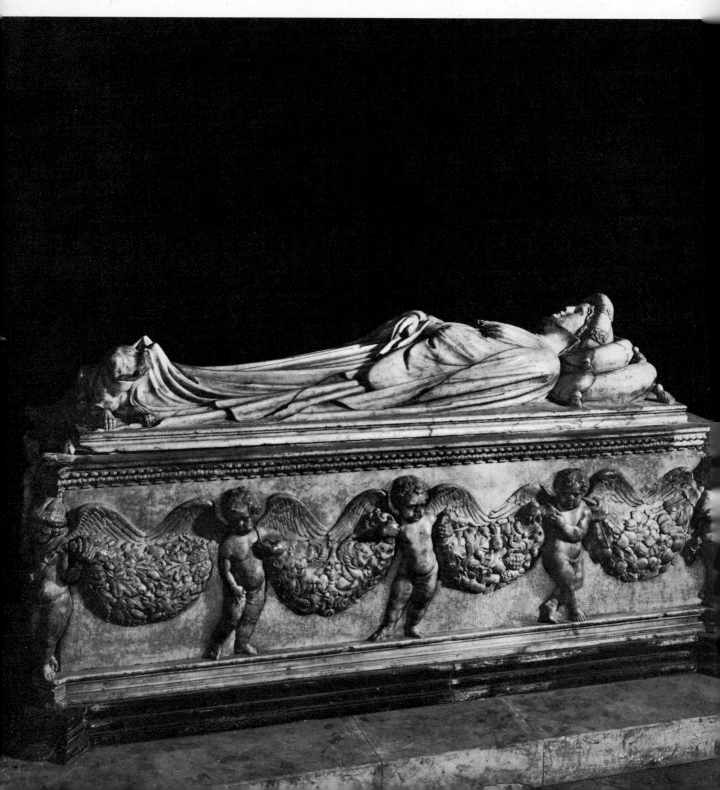

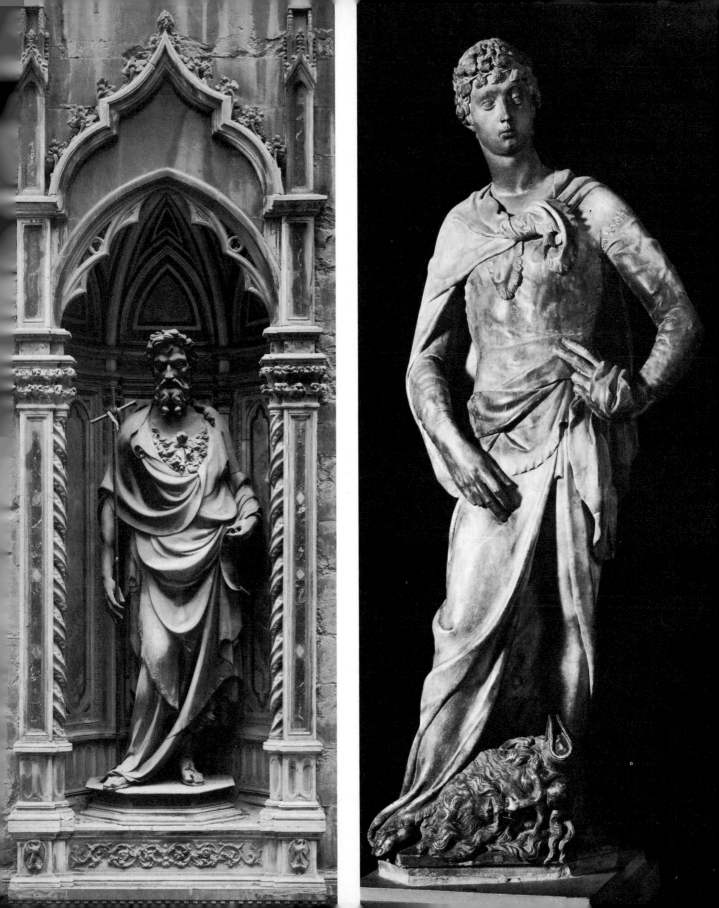

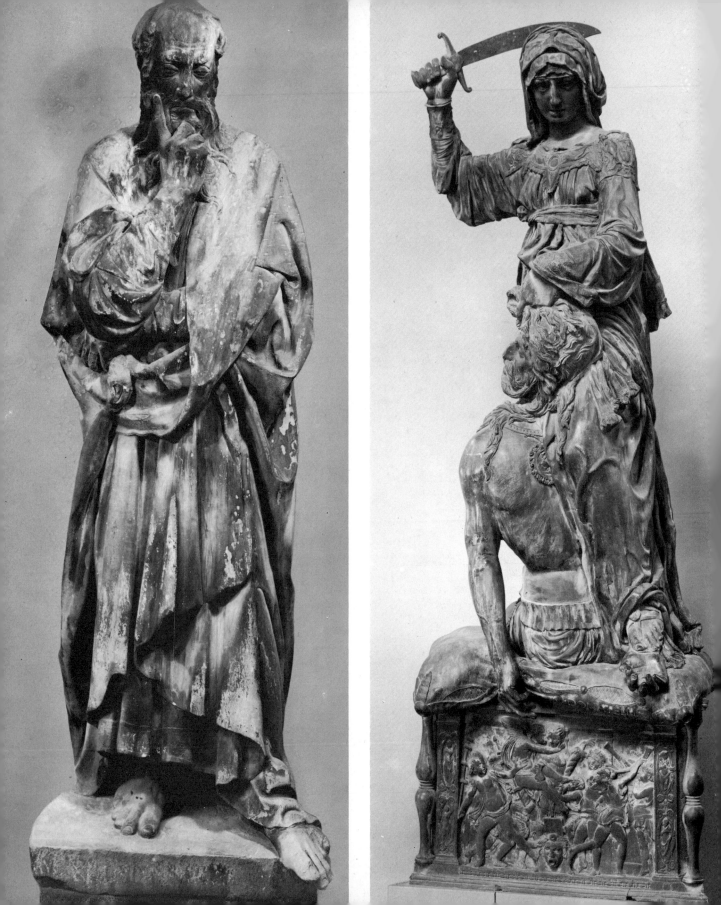

Donatello
The bearded prophet c. 1418–20
Florence, Museo dell'Opera del Duomo

Donatello
Judith and Holofernes c. 1455–60
Florence, Piazza della Signoria

7 Donatello
The Annunciation
between 1428 and 1435
Florence, Sta Croce

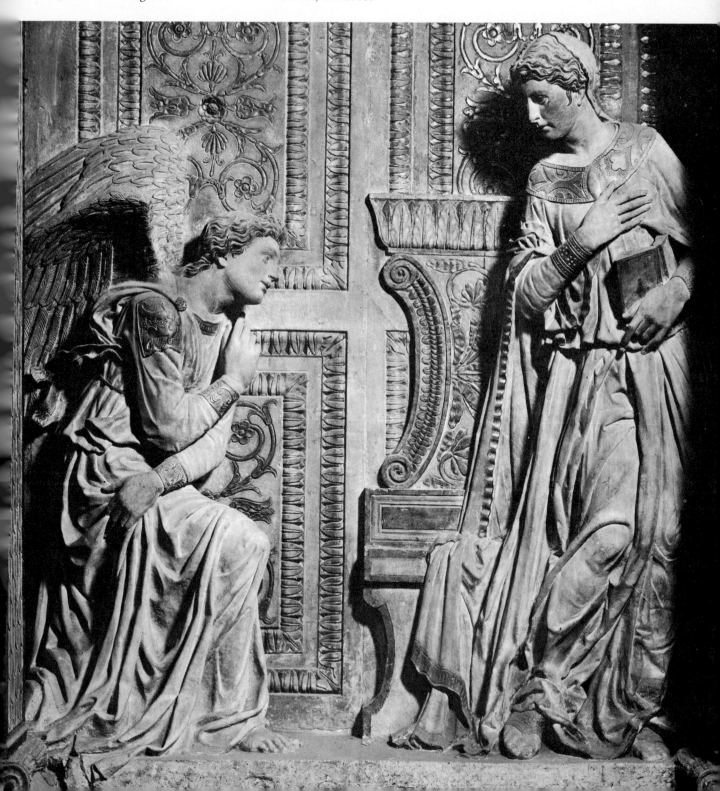

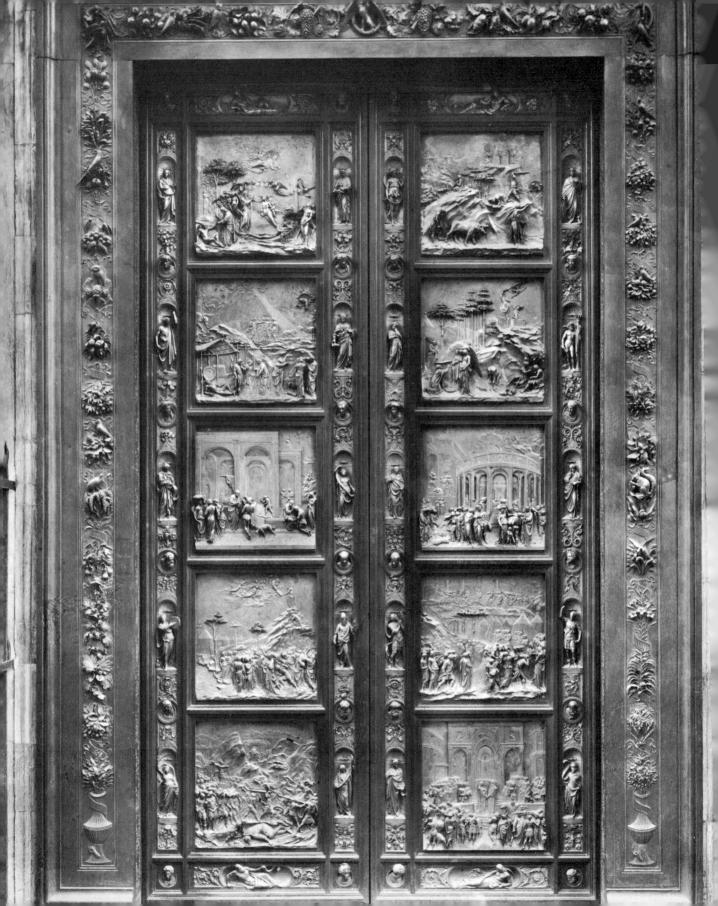

Lorenzo Ghiberti
The Door of Paradise 1425–52
Florence, Baptistry

Antonio Averlino called Filarete
Bronze doors 1433–45
Rome, St Peter's

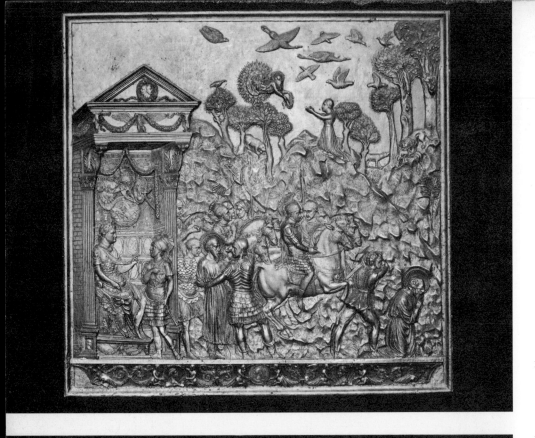

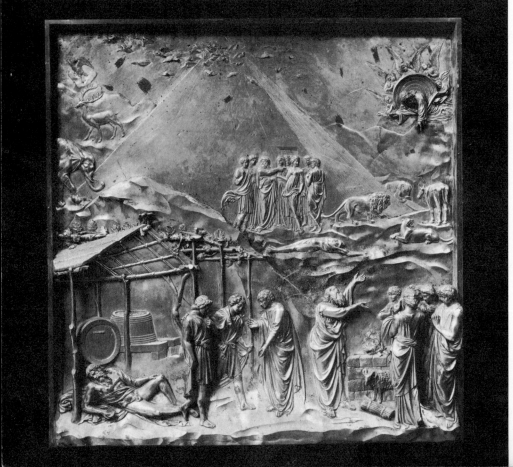

10 Antonio Averlino called Filaret
The Martyrdom of St Paul
(detail of 9)
Rome, St Peter's

11 Lorenzo Ghiberti
The story of Noah (detail of 8)
Florence, Baptistry

12 Luca della Robbia
*Children with a hand-organ and
stringed instruments*
(from the Cantoria) 1432–7
Florence, Museo dell'Opera
del Duomo

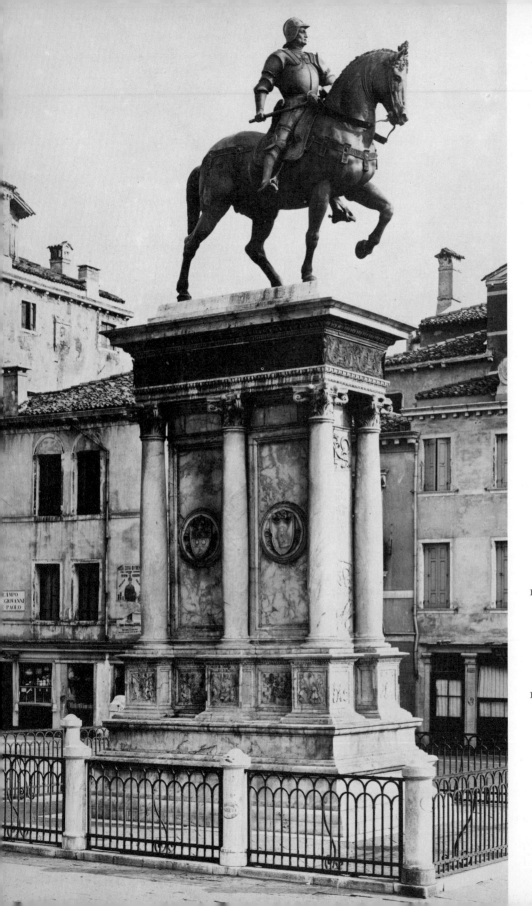

13 Andrea del Verrocchio and
Alessandro Leopardi
*The Bartolomeo Colleoni
equestrian monument* 1479–95
Venice, Campo di SS. Giovanni
e Paolo

14 Donatello
*The Gattamelata equestrian
monument* (detail)
before 1447–53
Padua, Piazza del Santo

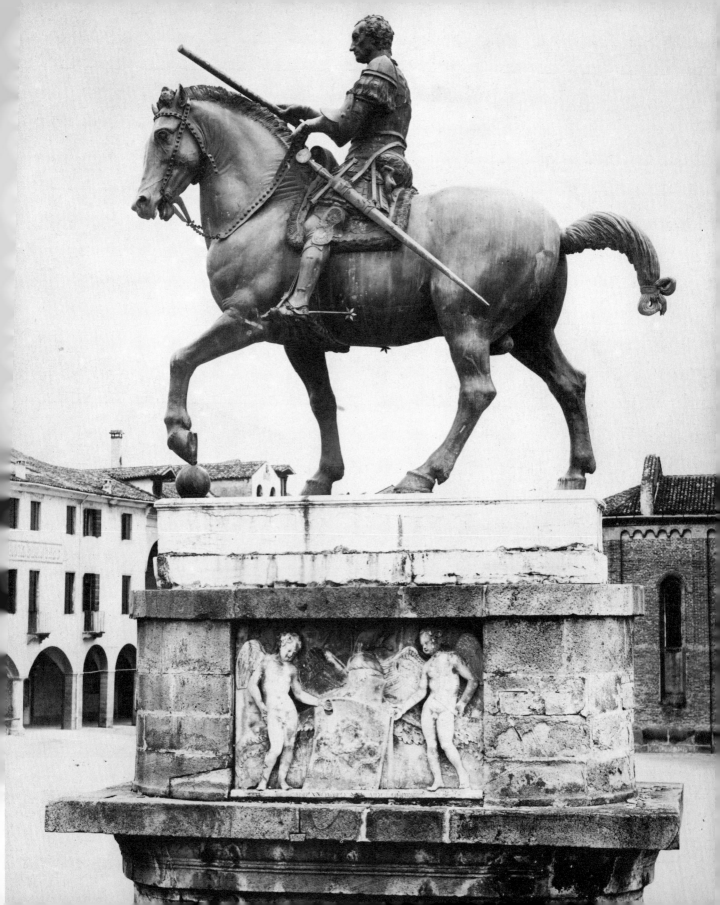

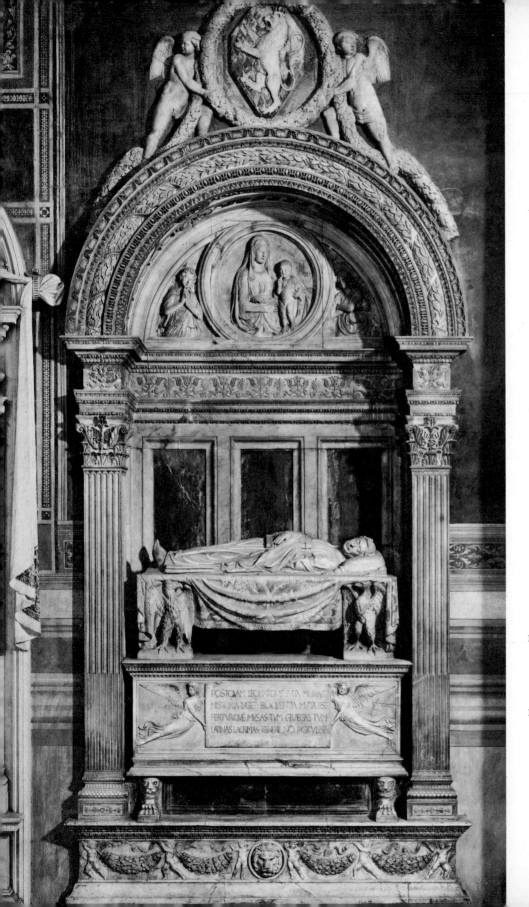

15 Bernardo Rossellino
 Tomb of Leonardo Bruni
 between 1444 and 1450
 Florence, Sta Croce

16 Antonio Rossellino
 Tomb of the Cardinal of Portugal
 1461–6
 Florence, S. Miniato al Monte

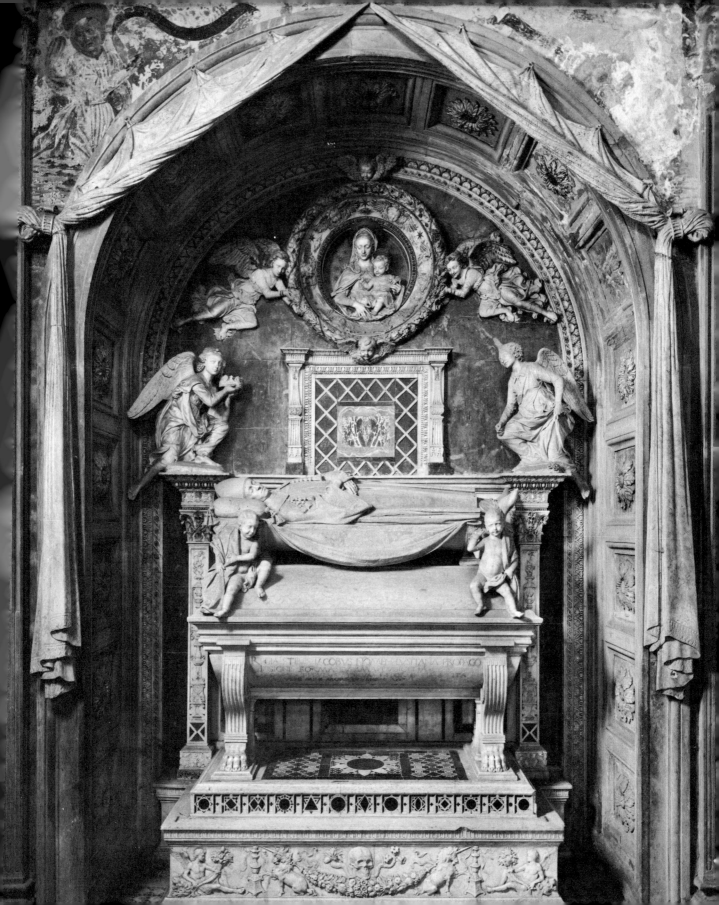

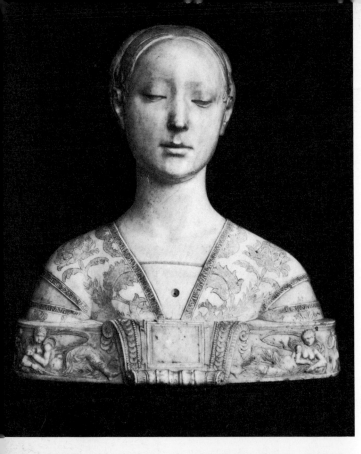

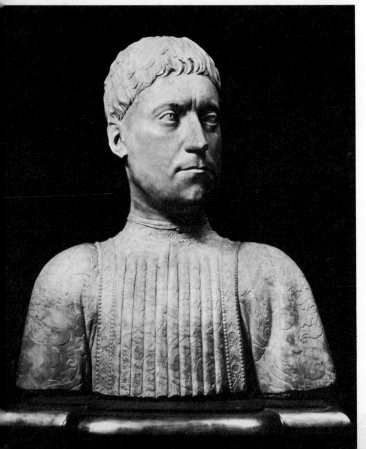

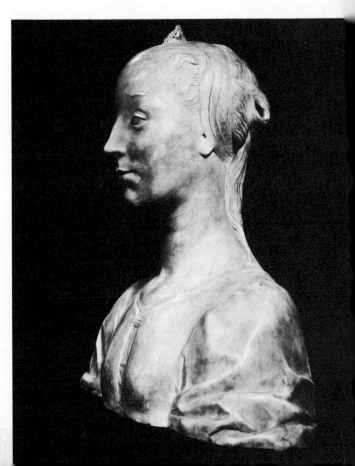

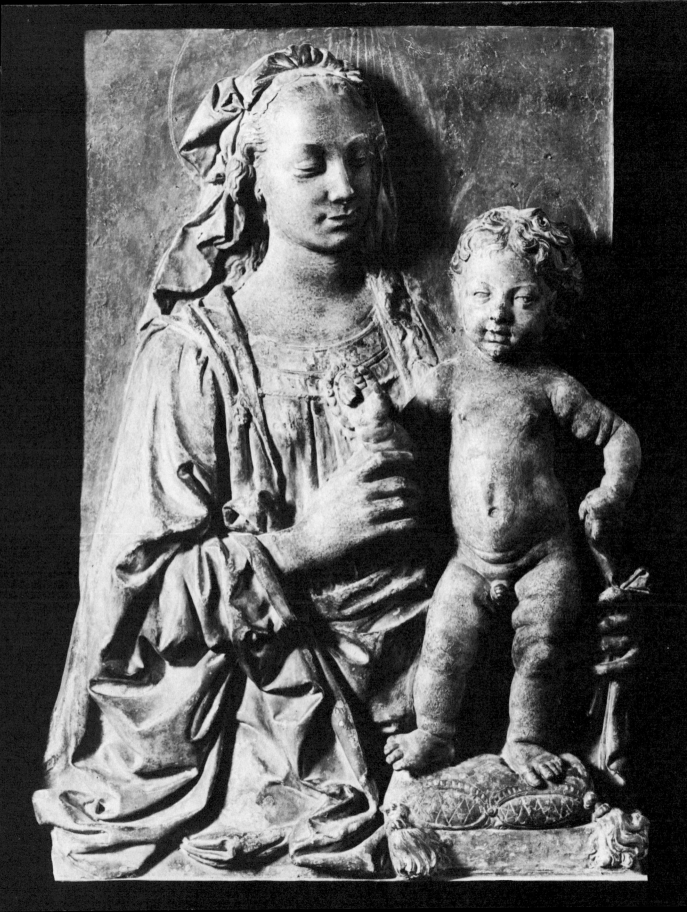

21 Andrea del Verrocchio
 David c. 1472–5
 Florence, Museo Nazionale

22 Benedetto da Maiano
 St John the Baptist c. 1480–1
 Florence, Palazzo Vecchio

23 Lorenzo di Pietro called Il Vecchio
 Ciborium 1472
 Siena, Duomo

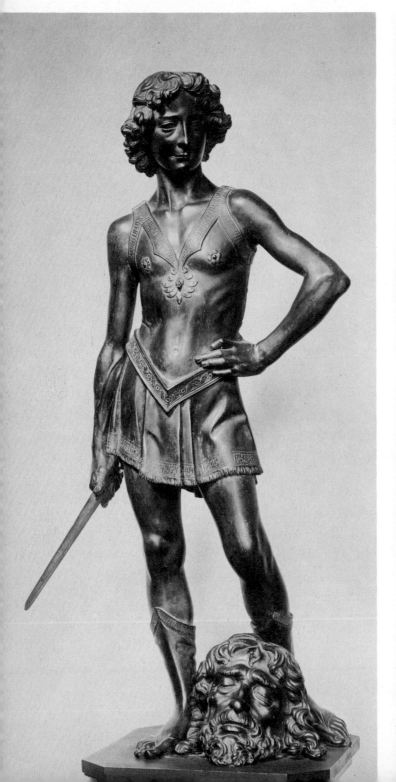

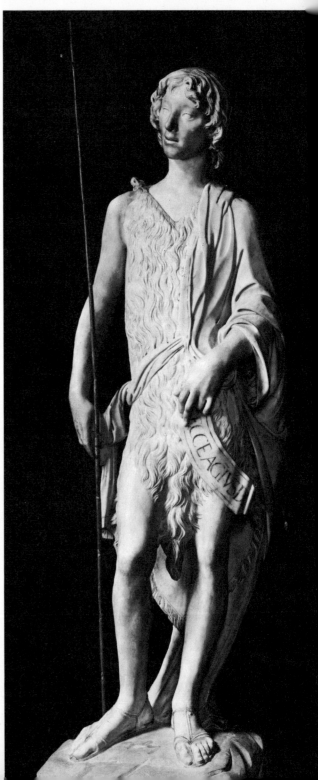

24 Antonio Rossellino
 Tomb of Francesco Nori
 before 1478
 Florence, Sta Croce

25 Benedetto da Maiano
 Pulpit between 1472 and 1475
 Florence, Sta Croce

26 Andrea Bregno
 Tomb of Lodovico Lebretto c. 1.
 Rome, Sta Maria in Aracoeli

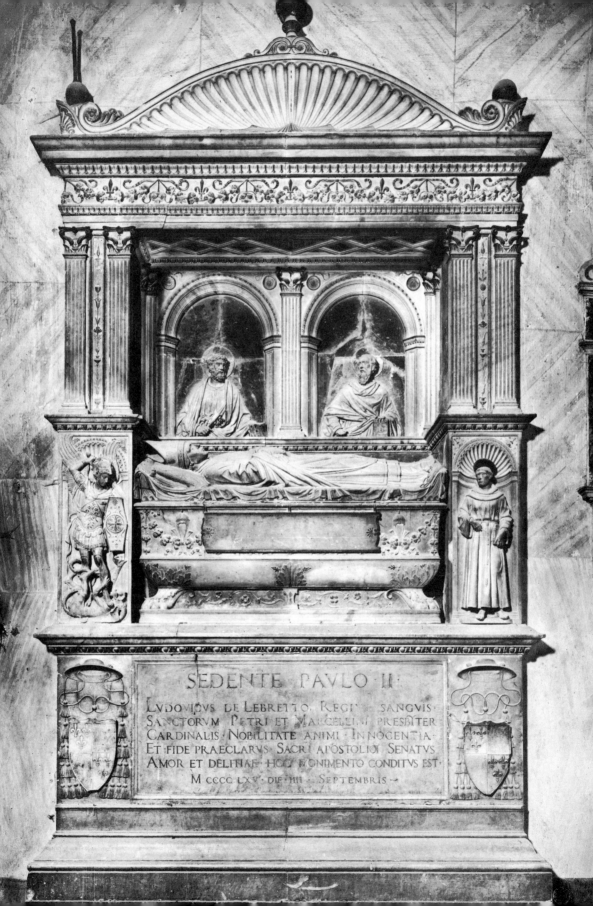

SEDENTE PAVLO II·
LVDOVICVS · DE · LEBRETTO · REGII · SANGVIS·
SANCTORVM · PETRI · ET · MARCELLINI · PRESBITER·
CARDINALIS · NOBILITATE · ANIMI · INNOCENTIA·
ET · FIDE · PRAECLARVS · SACRI · APOSTOLICI · SENATVS·
AMOR · ET · DELITIAE · HOC · MONIMENTO · CONDITVS · EST·
M · CCCC · LXV· · DIE · IIII · SEPTEMBRIS ·

27 Agostino Duccio
Façade 1457–62
Perugia, S. Bernardino

28 Agostino Duccio
Virginity (detail of 27)
Perugia, S. Bernardino

29 Pietro Lombardo
Tomb of Doge Niccolò Marc
after 1474
Venice, SS. Giovanni e Pa*

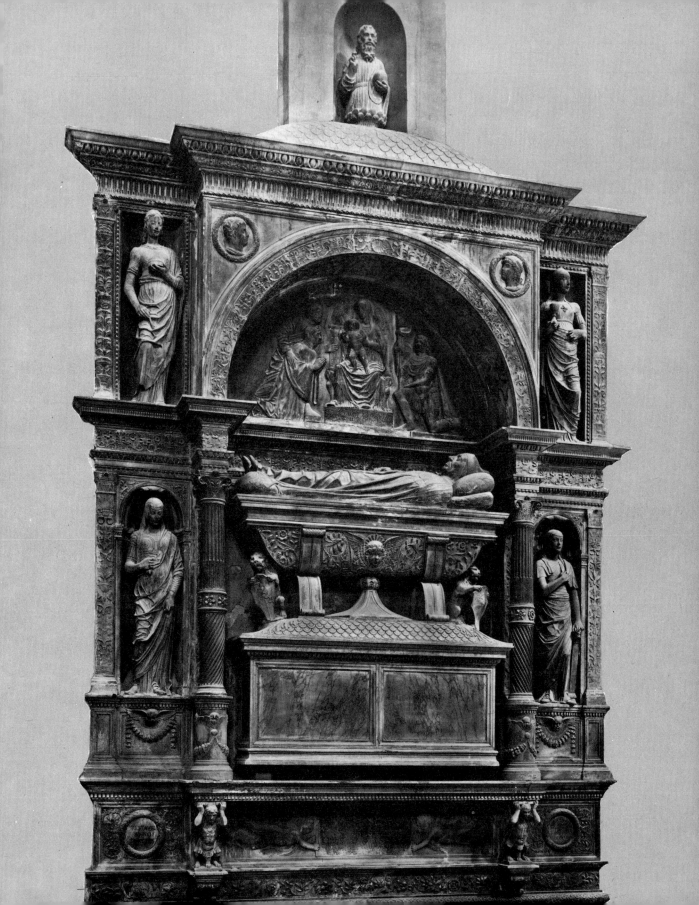

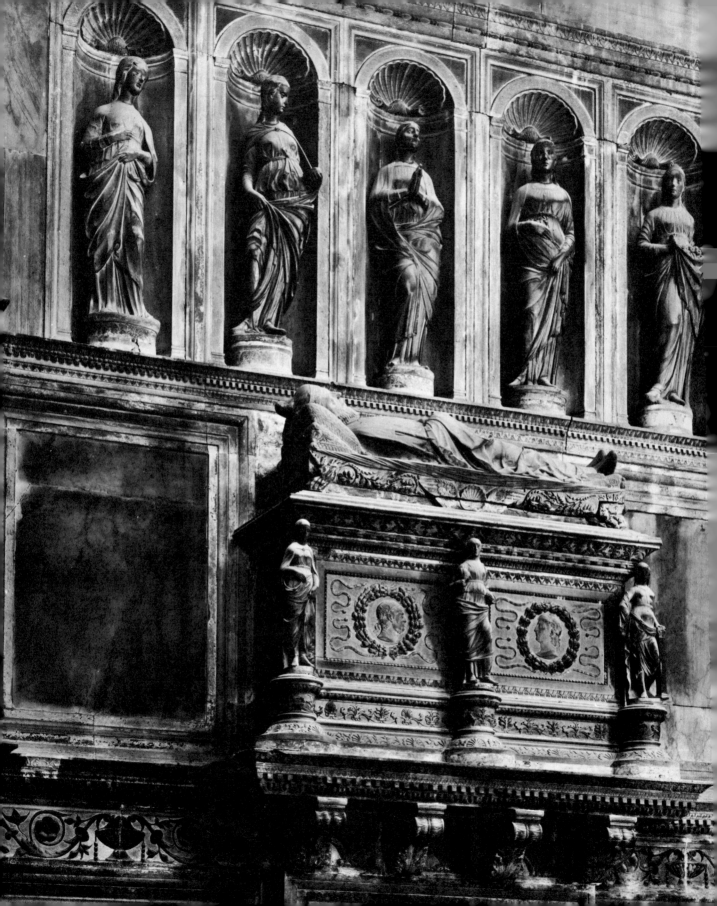

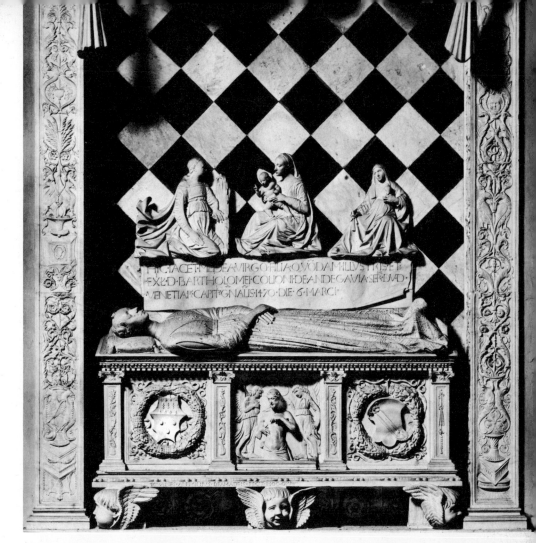

Antonio Rizzo
Tomb of Doge Niccolò Tron
after 1473–*c.* 1482
Venice, Sta Maria dei Frari

Giovanni Antonio Amadeo
Tomb of Medea Colleoni
between 1470 and 1476
Bergamo, Duomo, Cappella
Colleoni

Guido Mazzoni
The Lamentation of Christ
c. 1476–7
Modena, S. Giovanni della
Buona Morte

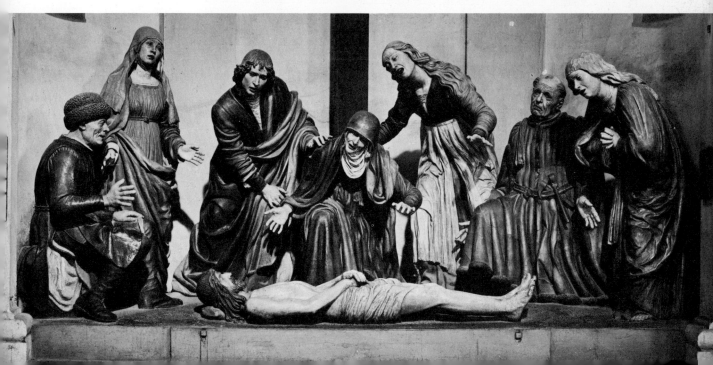

33 Andrea Sansovino
 Virgin and Child 1503–4
 Genoa, Duomo

34 Domenico Gaggini (Workshop)
 Virgin and Child
 between 1480 and 1500
 Berlin (West), Staatliche Museen

35 Andrea Sansovino
 Tomb of Ascanio Sforza 1505-
 Rome, Sta Maria del Popolo

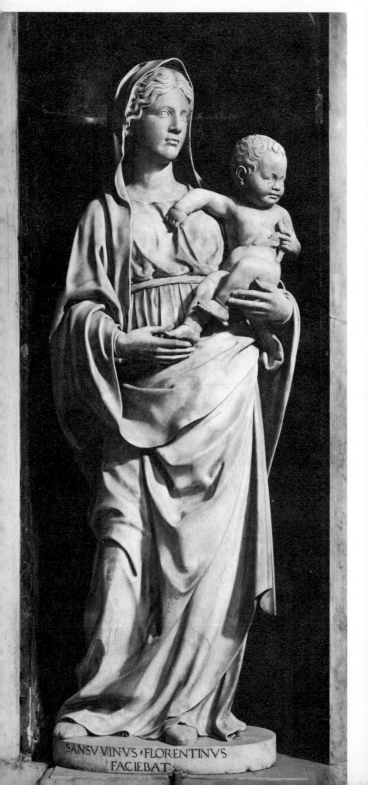

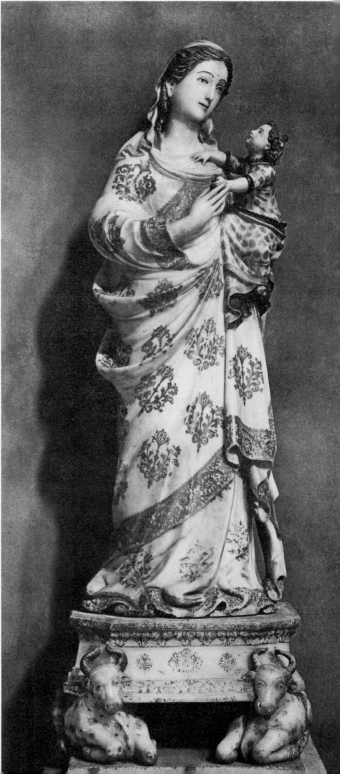

D O M
ASCANIO MARIAE VICECOMITI FRANCISCI SFORTIAE
INSVBR DVCIS F DIACONI CARD S R E VICEDANCELLARI
IN SECVNDIS REB MODERATO INADVERSIS SVMMO VIRO
VIX ANN LI MENSI II D XXV
IVLIVS II PONT MAX VIRTVTVM MEMOR HONESTISSIMAE
CONTENTIONVM OBLITVS SACELLO A FVNDAMENT ERECTO
POSVIT M D V

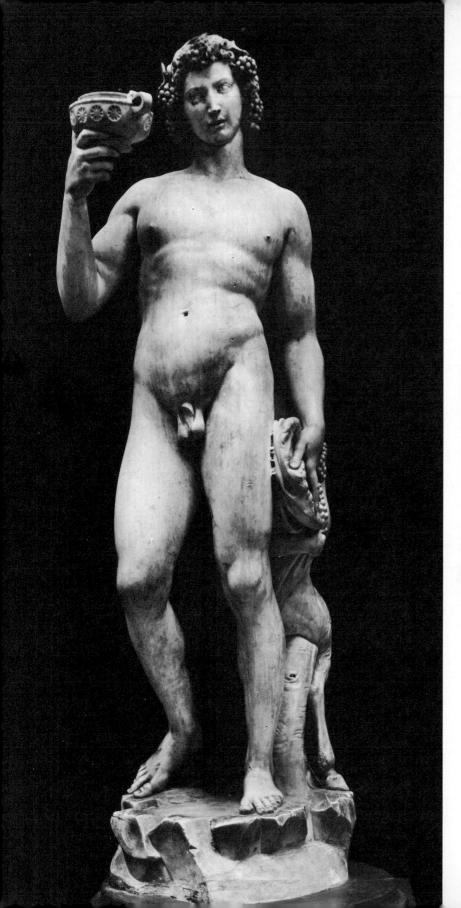

36 Michelangelo Buonarroti
Bacchus 1496–8
Florence, Museo Nazionale

37 Giovan Francesco Rustici
Mercury c. 1515
London, private collection

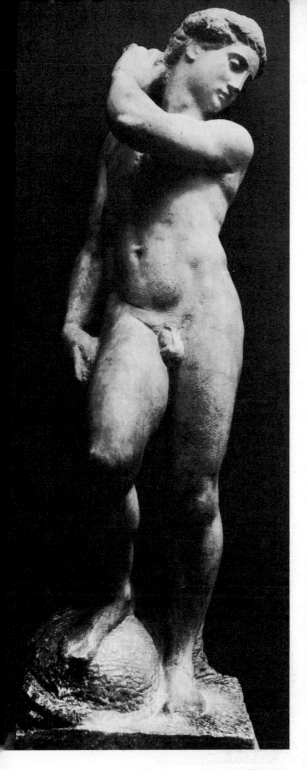

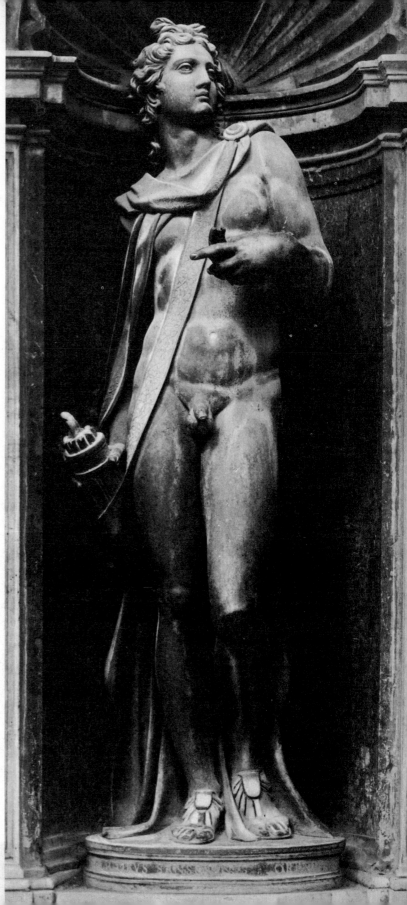

38 Michelangelo Buonarroti
Apollo (unfinished) 1530–2
Florence, Museo Nazionale

39 Jacopo Sansovino
Apollo 1540–5
Venice, Loggetta

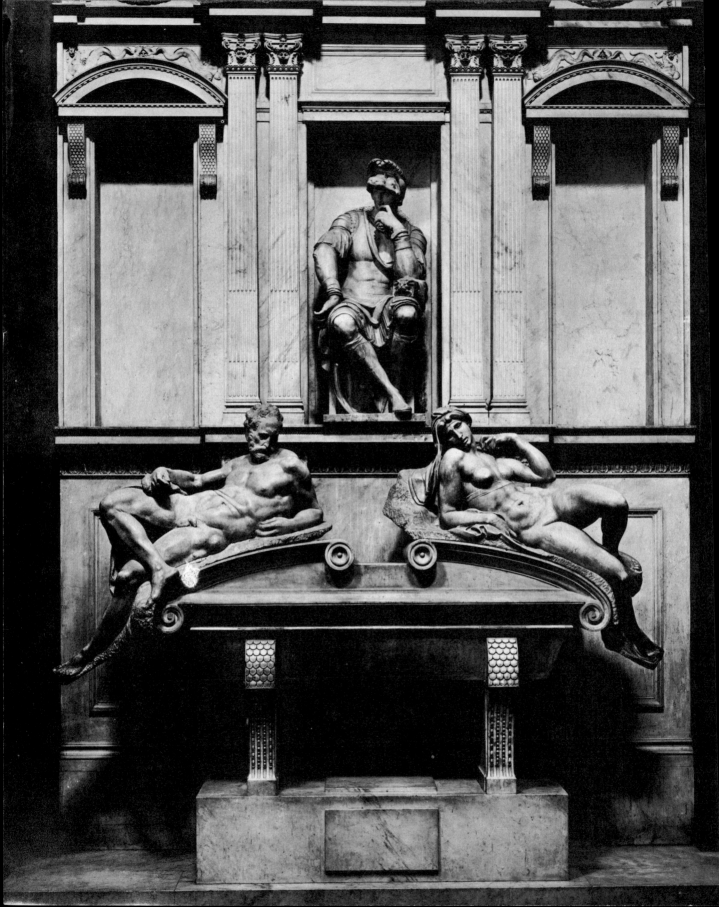

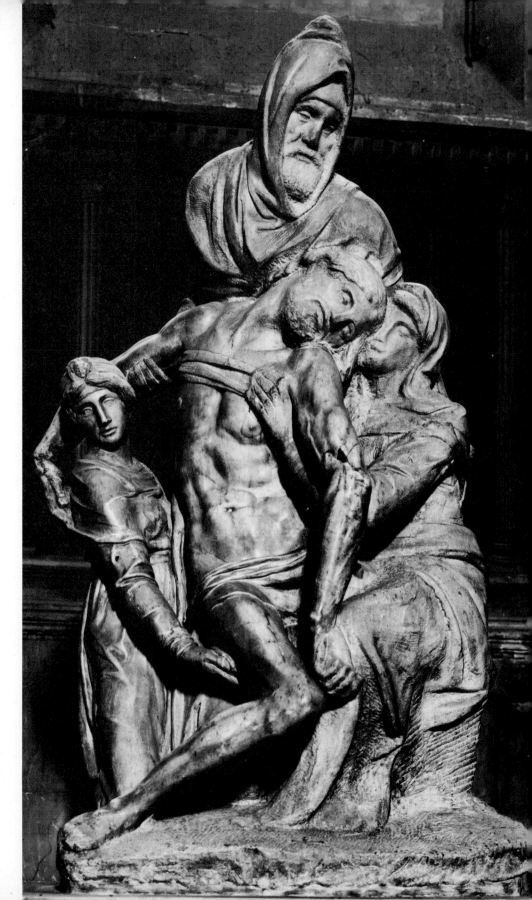

40 Michelangelo Buonarroti
Tomb of Lorenzo de' Medici
1526–31
Florence, S. Lorenzo
Medici Chapel

41 Michelangelo Buonarroti
Pietà (unfinished) before 1550–5
Florence, Duomo

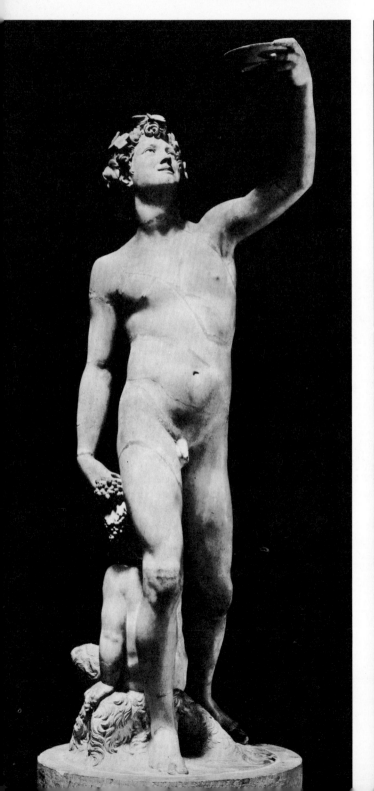

42 Jacopo Sansovino
Bacchus 1511–12
Florence, Museo Nazionale

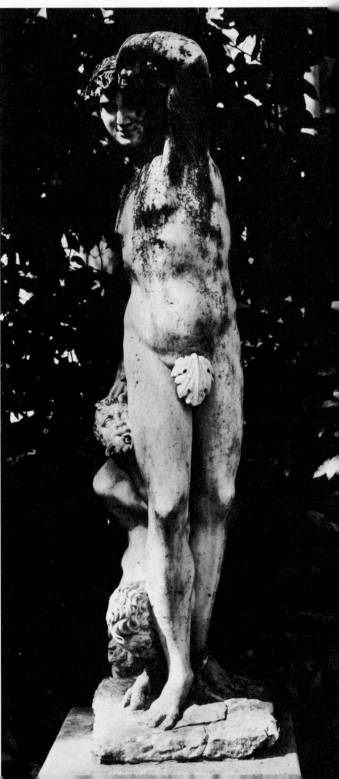

43 Vincenzo de' Rossi
Bacchus after 1565
Florence, Boboli Gardens

Vincenzo Danti
Honour triumphant over Falsehood
c. 1561
Florence, Museo Nazionale

45 Michelangelo Buonarroti
 The Victory group (unfinished)
 after 1519
 Florence, Palazzo Vecchio

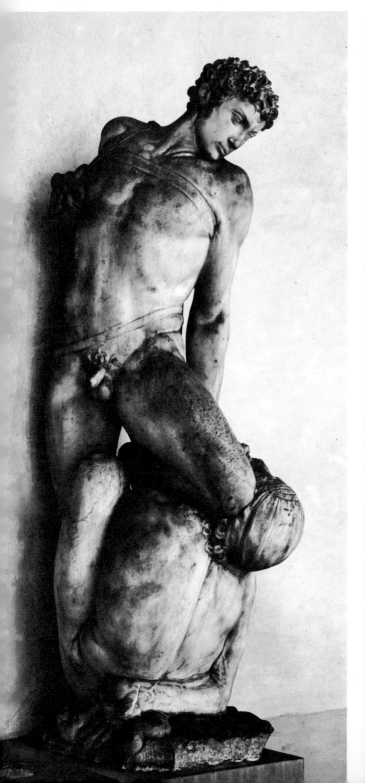

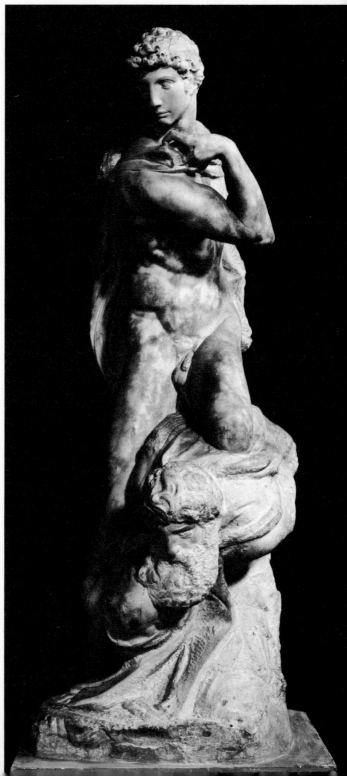

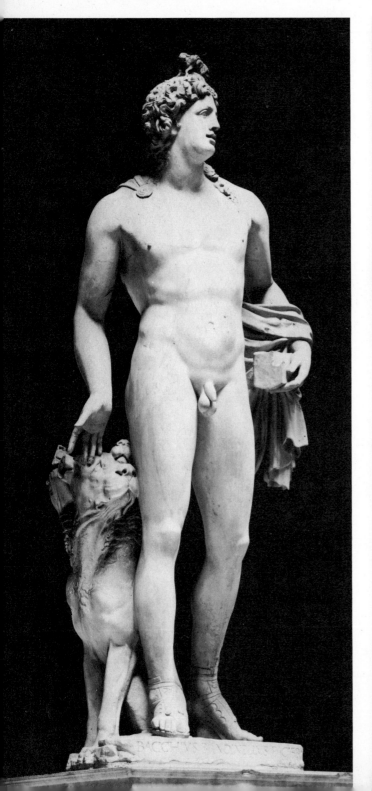

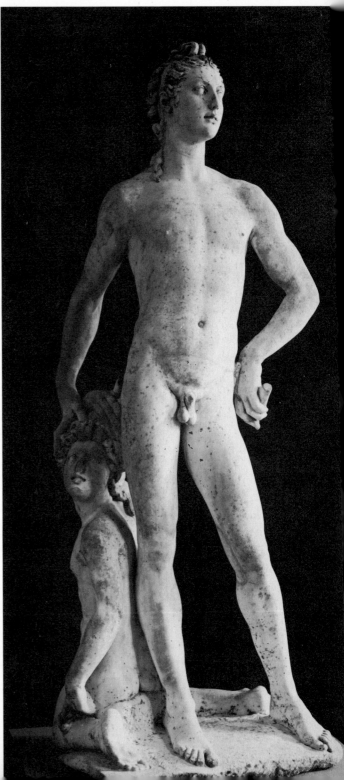

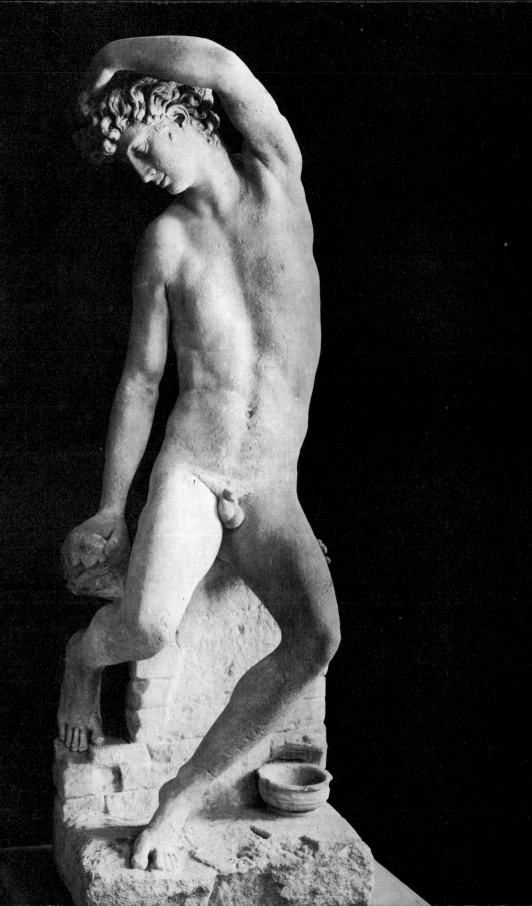

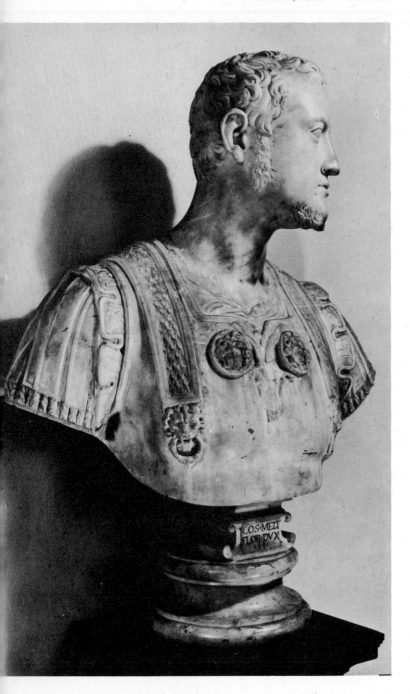

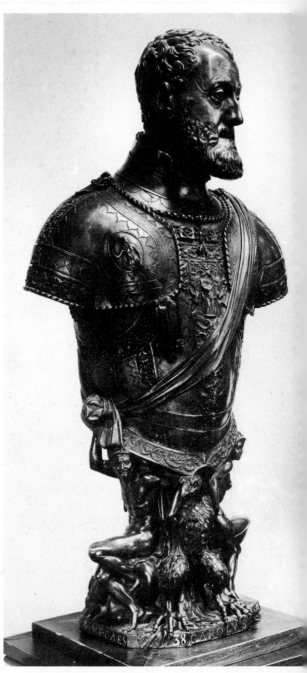

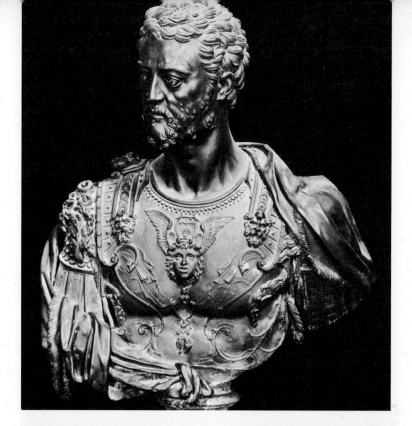

51 Benvenuto Cellini
 Bust of Cosimo I de' Medici
 1545–7
 Florence, Museo Nazionale

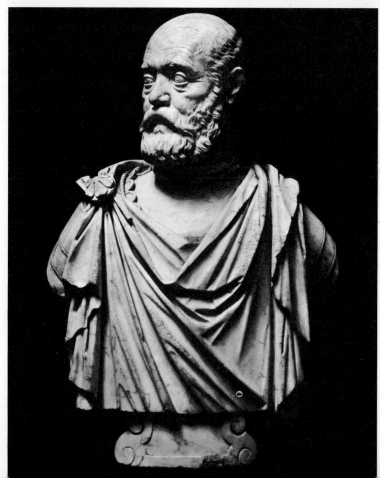

52 Alessandro Vittoria
 Bust of Francesco Duodo
 c. 1570–80
 Venice, Ca' d'Oro

53 (Giorgio Vasari)
 Tomb of Michelangelo Buonarroti
 1564–74
 Florence, Sta Croce

54 Guglielmo della Porta
 Tomb of Pope Paul III 1549–75
 Rome, St Peter's

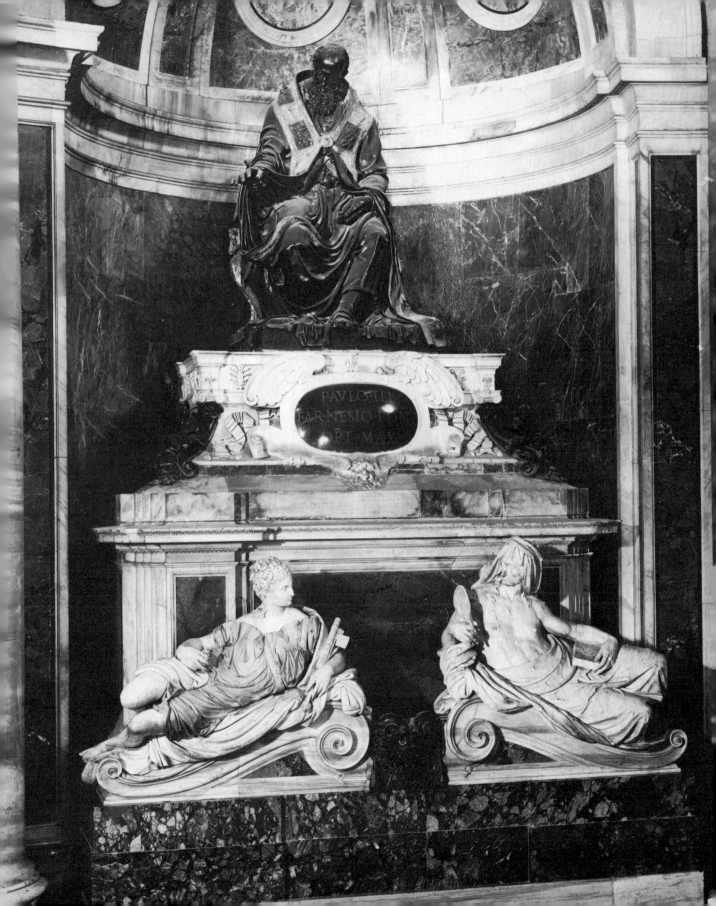

Giovan Angelo Montorsoli
The Orion Fountain 1547–53
Messina, Piazza del Duomo

Niccolò Tribolo
River God c. 1545
Castello near Florence, Villa Corsini

57 Bartolommeo Ammannati
A nymph of the Neptune Fountain
after 1564–75
Florence, Piazza della Signoria

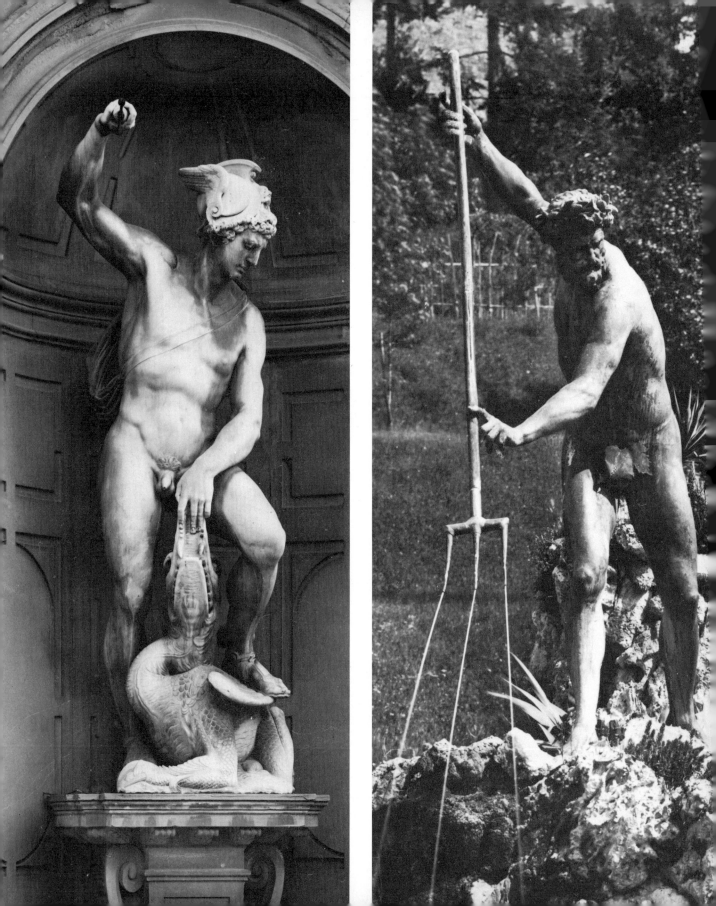

Battista Lorenzi
The Perseus Fountain c. 1576
Florence, Palazzo Nonfinito

Stoldo Lorenzi
Neptune c. 1569–72
Florence, Boboli Gardens

60 Giovanni Bologna
 The Apennine 1580–2
 Pratolino near Florence,
 Villa Demidoff

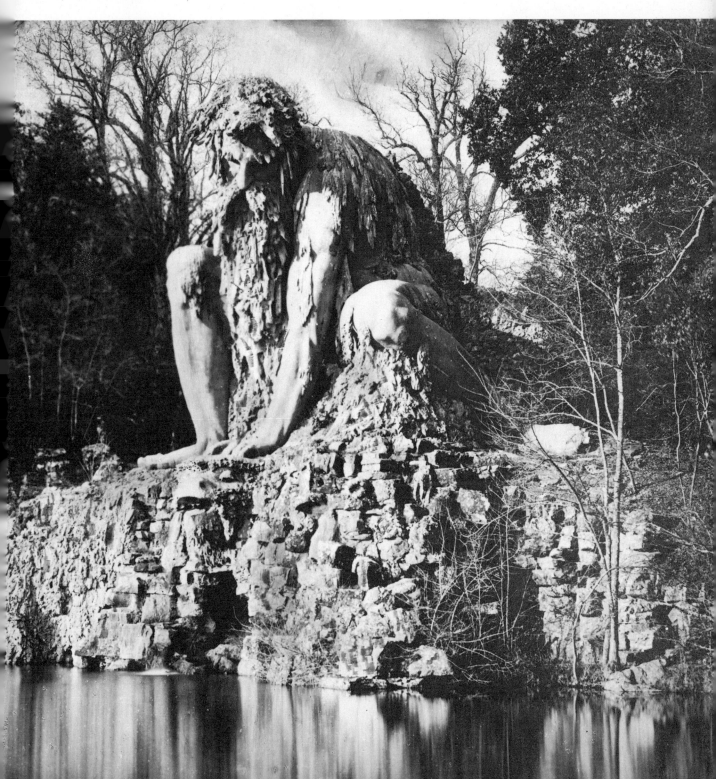

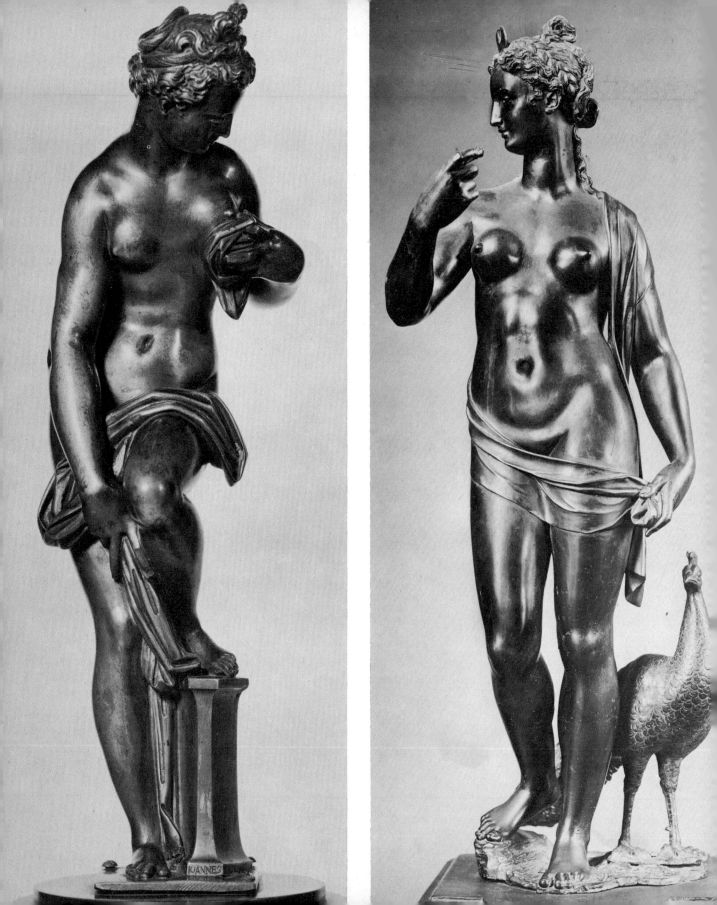

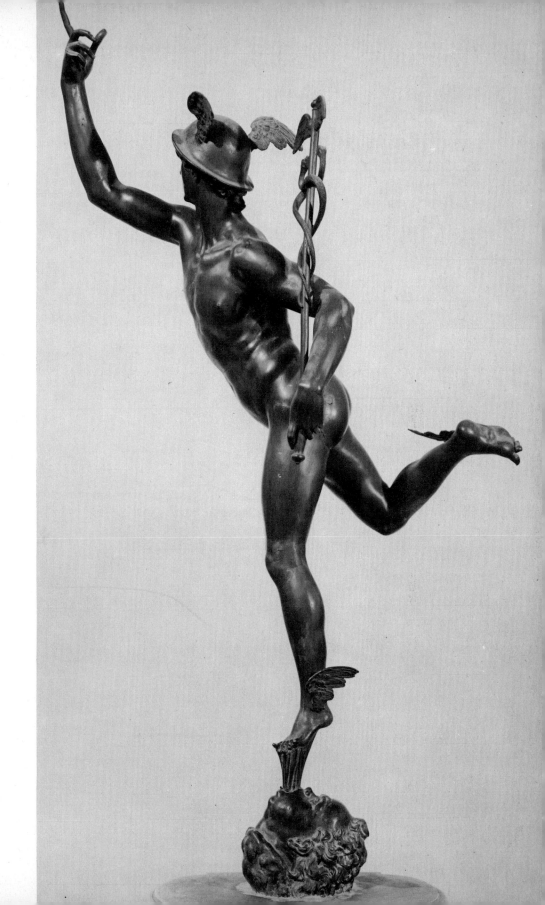

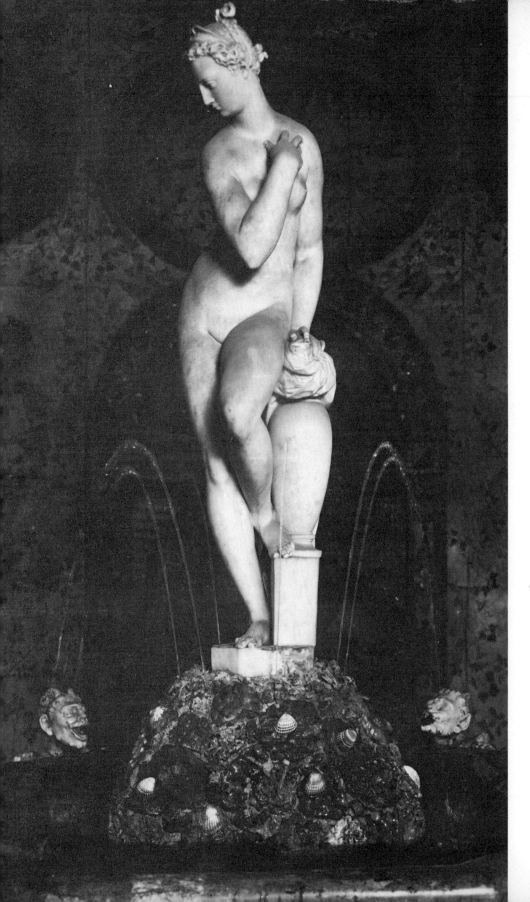

64 Giovanni Bologna
Venus of the Grotticella c. 1575–
Florence, Boboli Gardens

65 Pietro Francavilla
Apollo 1577
London, Kew Gardens

66 Alessandro Vittoria
St Sebastian 1566
New York, Metropolitan
Museum

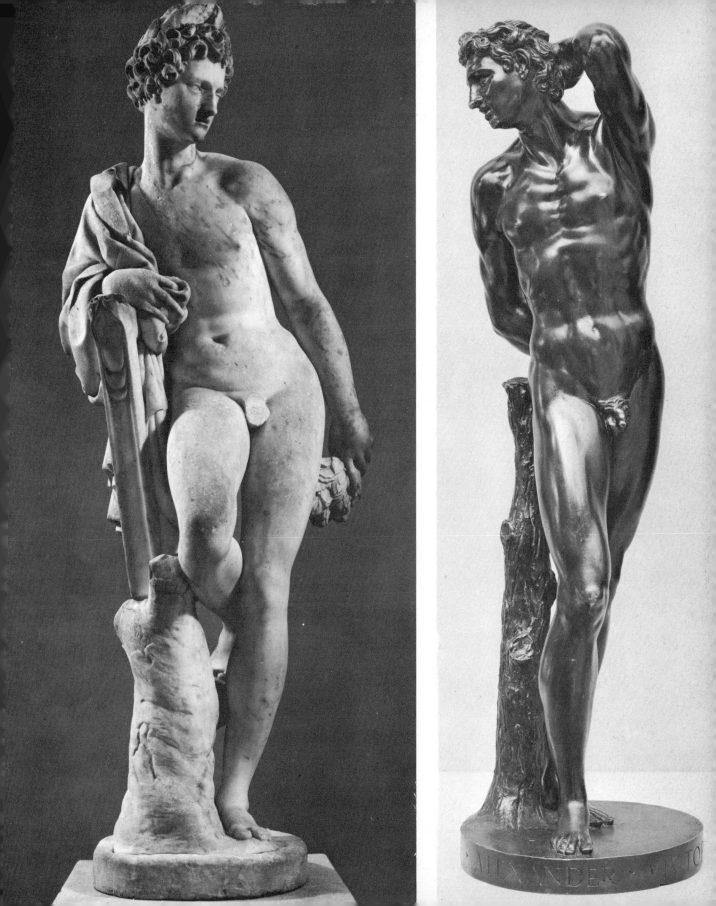

67 Taddeo Landini
The Tortoise Fountain 1581–5
Rome, Piazza Mattei

68 Valerio Cioli
The Vine-grower's Fountain
1598–1605
Florence, Boboli Gardens

69 Antonio Calcagni
Seated statue of Pope Sixtus V
1585–9
Loreto, Piazza della Madonna

70 Pietro Francavilla
Statue of Ferdinando I de' Medici
1594
Arezzo, Piazza del Duomo

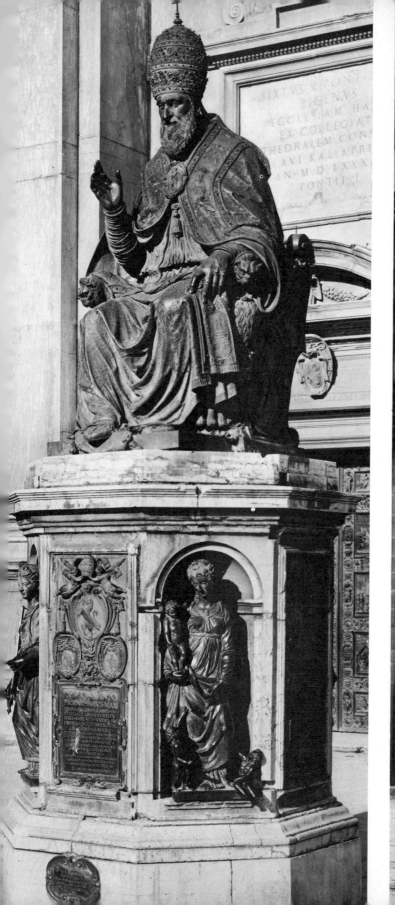

71 Leone Leoni
 Façade of Casa degli Omenoni
 c. 1565–70
 Milan, Via Omenoni

72 Giovanni Caccini
 Façade of Palazzo Altoviti
 c. 1604–5
 Florence, Borgo degli Albizzi

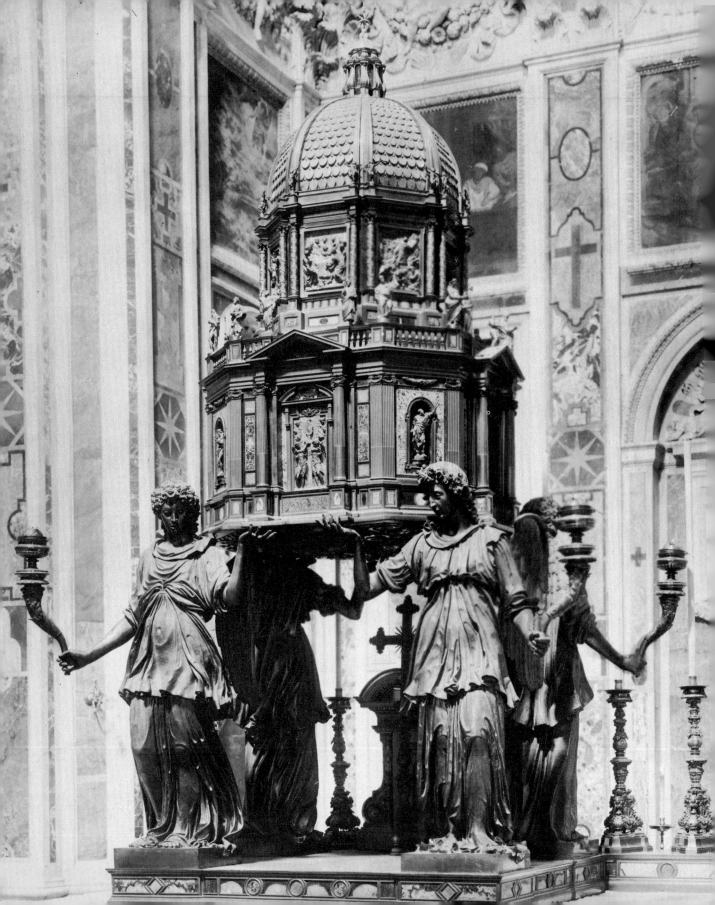

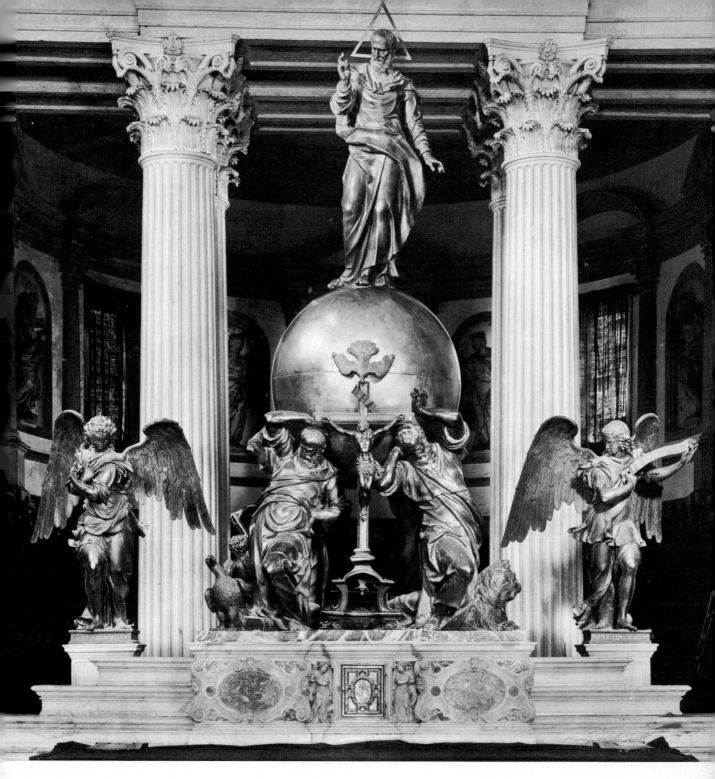

73 Sebastiano Torrigiani
Tabernacle Altar 1585–90
Rome, Sta Maria Maggiore

74 Girolamo Campagna
High Altar 1591–3
Venice, S. Giorgio Maggiore

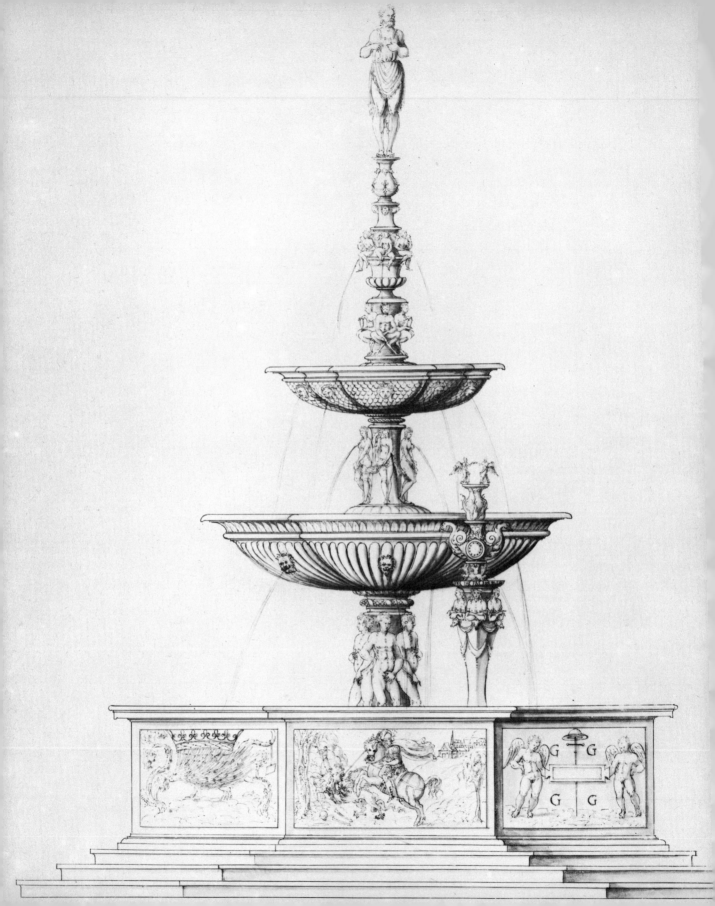

Agostino Solario
Fountain in the courtyard of the Gaillon Palace 1504–8
Drawing by J. Androuet du Cerceau c. 1575
London, British Museum

76 Michel Colombe
St George and the Dragon 1508–9
Paris, Louvre

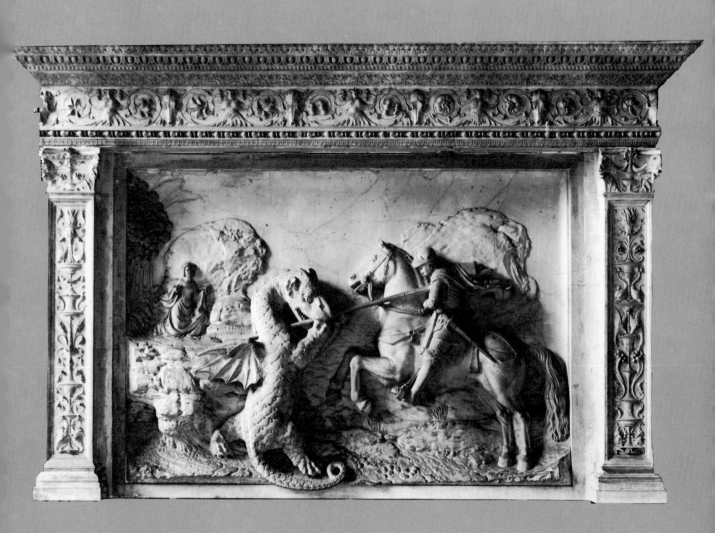

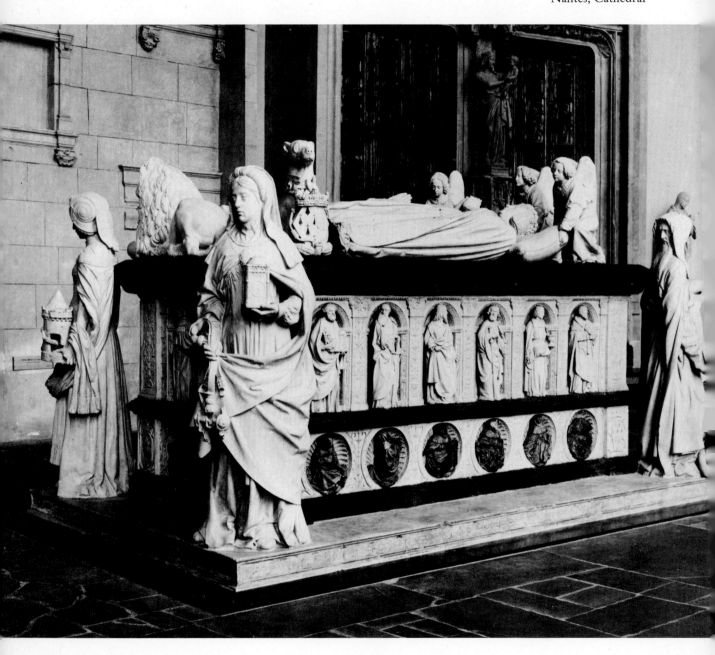

77 Michael Colombe
*Tomb of Francis II of Brittany
and Marguérite de Foix* 1499–
Nantes, Cathedral

Jérôme de Fiesole and Guillaume Regnault
Tomb of the children of Charles VIII 1499–1506
Tours, Cathedral

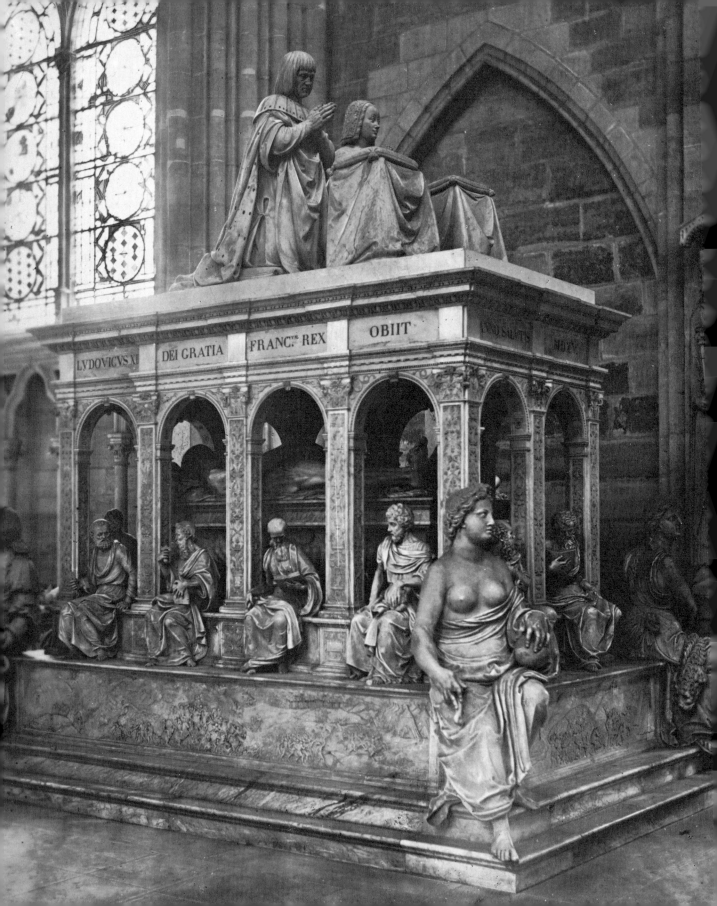

Jean Juste
Tomb of Louis XII and
Anne of Brittany c. 1515–31
St-Denis, Abbey Church

80 Pierre Bontemps
Monument for the heart of
Francis I 1550–6
St-Denis, Abbey Church

81 Ligier Richier
Tomb of René de Châlon
after 1544
Bar-le-Duc, St-Pierre

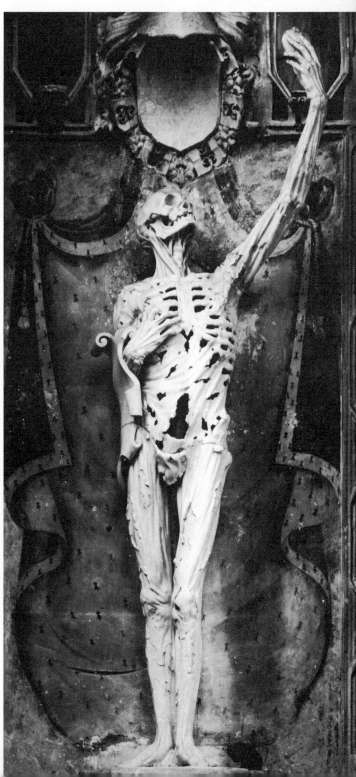

82 Jean Goujon
*A nymph from the Fontaine
des Innocents* 1547–9
Paris, Marché des Innocents

83 Jean Goujon
*Two caryatids from the Tribune
des Cariatides* 1550–1
Paris, Louvre

84 Francesco Primaticcio
*Wall decoration in the former
chamber of Anne d'Etampes*
1541–5
Fontainebleau, Escalier du Roi

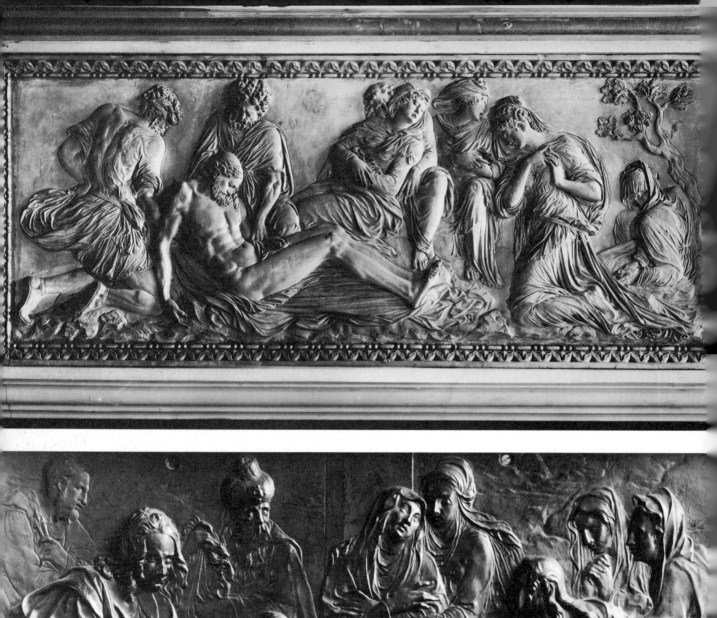
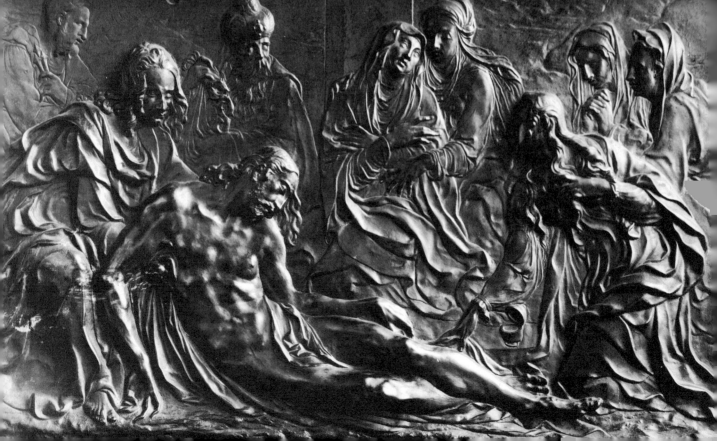

Jean Goujon
The Lamentation of Christ
1544–5
Paris, Louvre

Germain Pilon
The Lamentation of Christ
c. 1580–5
Paris, Louvre

Germain Pilon
The Three Graces from the
monument for the heart of
Henry II 1560–3
Paris, Louvre

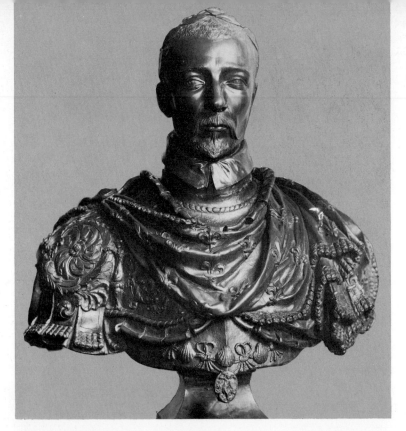

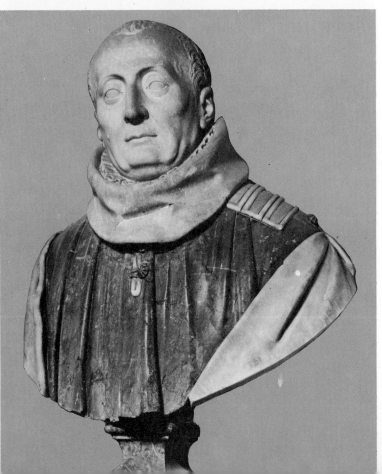

88 Germain Pilon
Bust of Charles IX c. 1572–3
London, Wallace Collection

89 Barthélemy Prieur
Bust of Christophe de Thou
1582–5
Paris, Louvre

Barthélemy Prieur
*The allegories of the Virtues from the monument
for the heart of Anne de Montmorency* 1573–8
Paris, Louvre

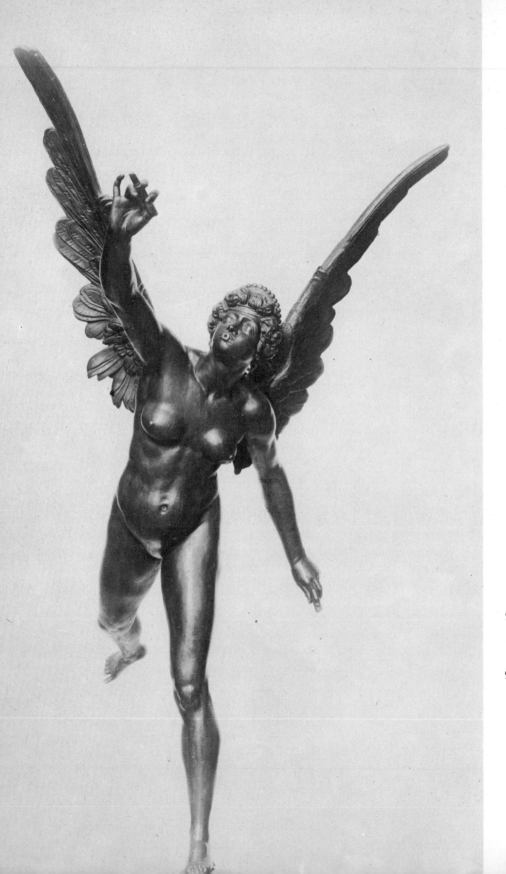

91 Pierre Biard
La Renommée 1597–9
Paris, Louvre

92 Matthieu Jacquet
*Equestrian relief of Henry IV
from the 'Belle Cheminée'*
1597–1600
Fontainebleau, Palace

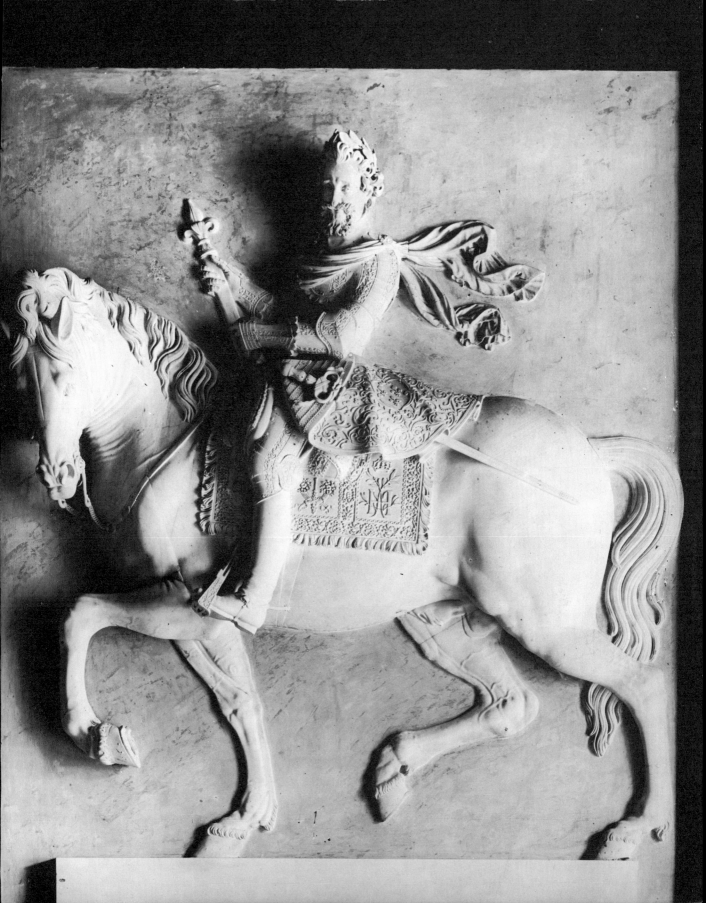

93 Damian Forment
Self-portrait
(detail from the High Altar)
between 1509 and 1515
Saragossa, Nuestra Señora
del Pilar

94 Domenico Fancelli
Tomb of Prince Don Juan
1511–13
Avila, Sto Tomás

95 Andrea Sansovino (his influen
Tomb of Cardinal Pedro Gonza
de Mendoza, after 1494–1504
Toledo, Cathedral

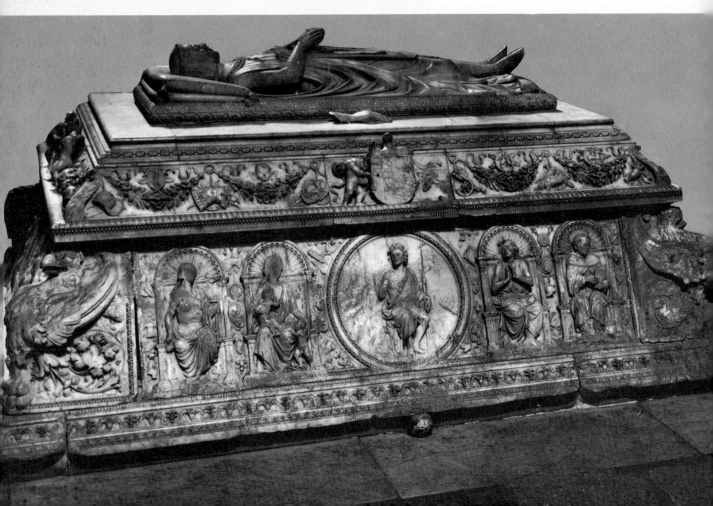

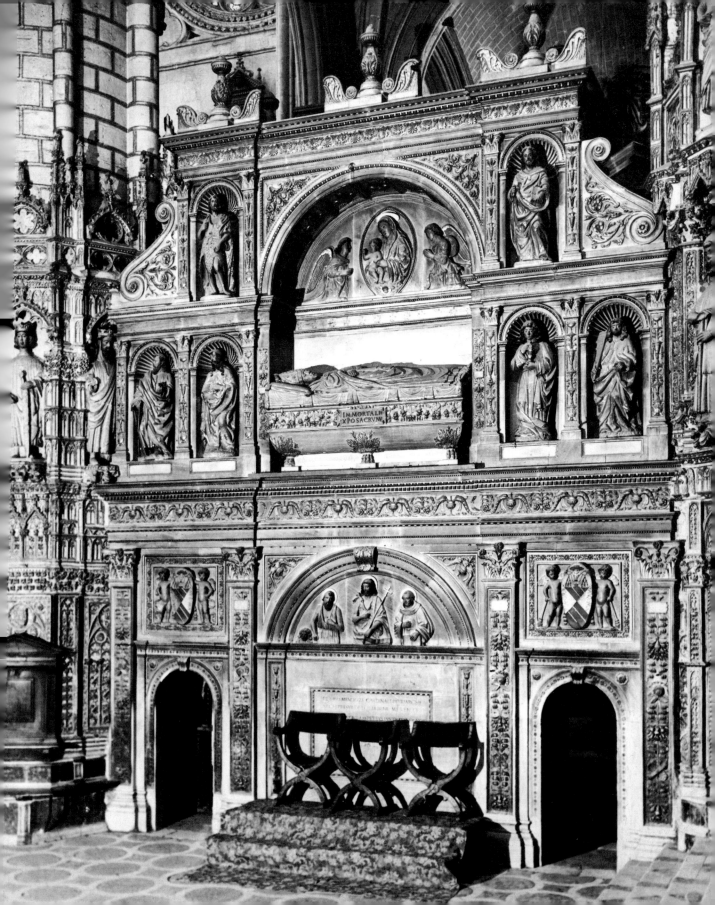

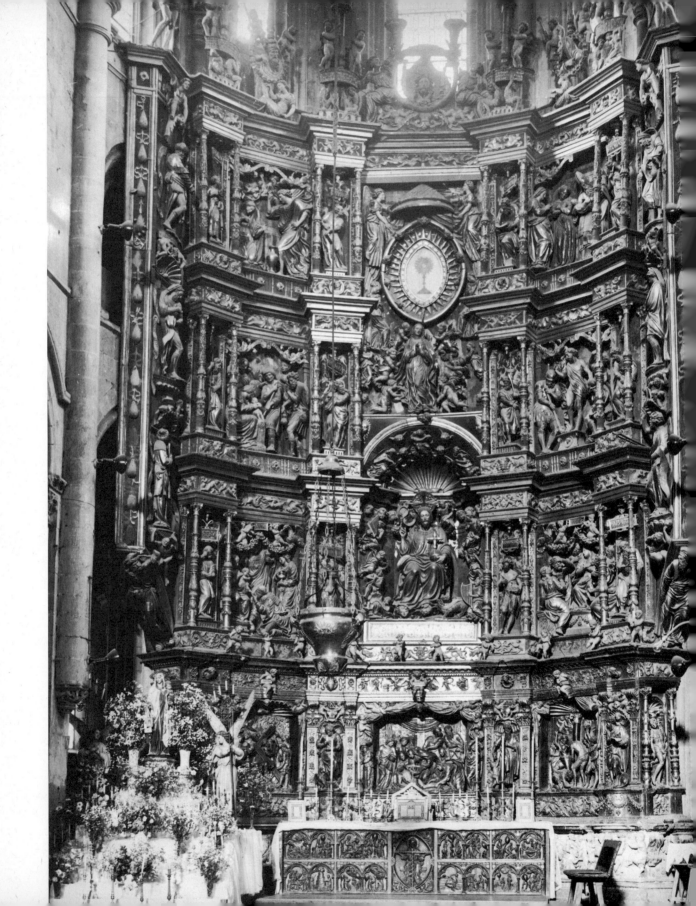

Damian Forment
High Altar 1537–42
Sto Domingo de la Clazada,
Cathedral

Felipe Vigarny and
Diego de Siloe
The Presentation in the Temple
1523–6
Burgos, Cathedral

Juan de Salas
Pulpit 1526–31
Palma de Mallorca, Cathedral

99 Bartolomé Ordóñez
Virgin and Child with St John
c. 1516–18
Zamora, Cathedral

100 Diego de Siloe
St Sebastian c. 1525–7
Barbadillo de Herreros,
Parish Church

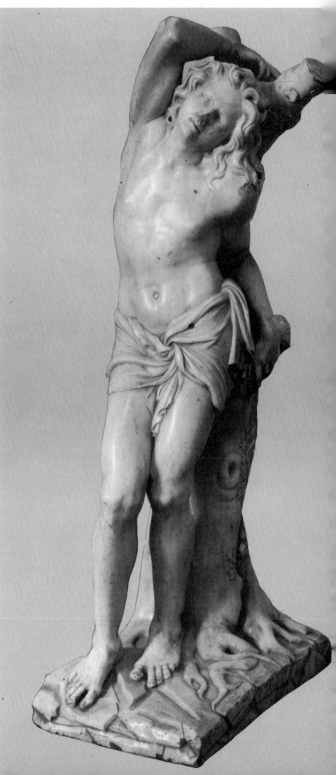

Bartolomé Ordóñez
St Eulalia before her judge 1518
Barcelona, Cathedral

102 Alonso Berruguete
St John the Baptist 1539–42
Toledo, Cathedral

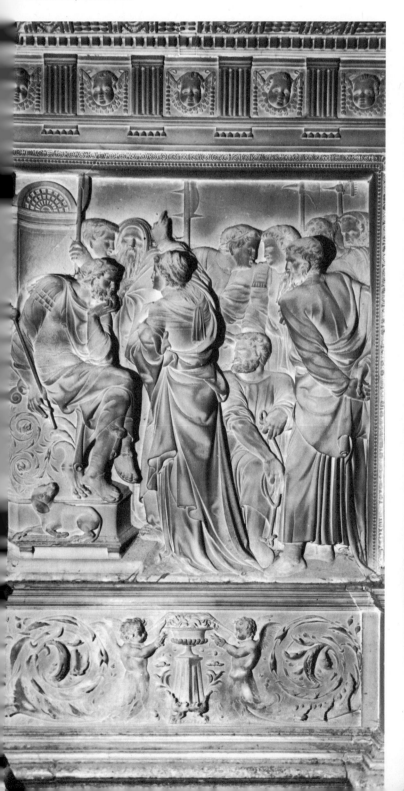

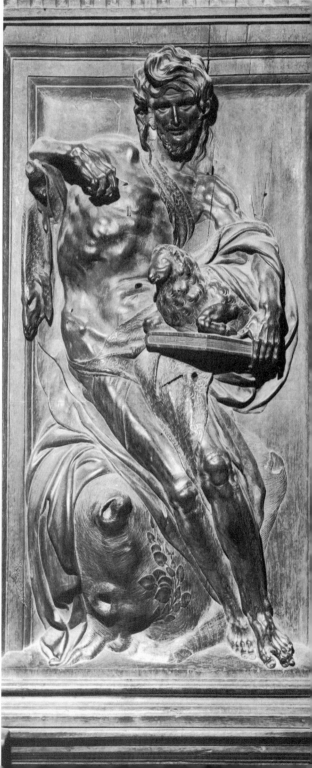

103 Alonso Berruguete
The Transfiguration of Christ
1543–8
Toledo, Cathedral

104 Gaspar Becerra
Crucifix c. 1560
Zamora, Cathedral

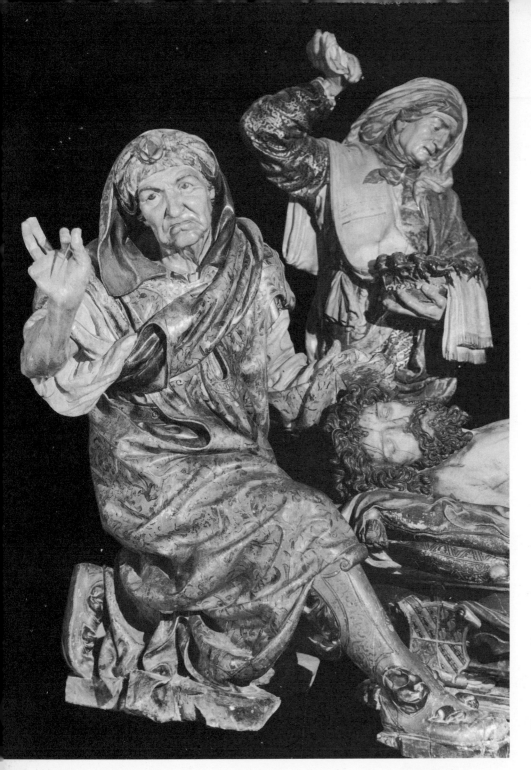

105 Juan de Juní
 The Burial of Christ (detail)
 1540–4
 Valladolid, Museo Nacional
 de Escultura

106 Juan de Juní
 High Altar 1550–4
 Burgo de Osma, Cathedral

107 Juan Bautista Vázquez
The Fall of Man 1563–4
Seville, Cathedral

108 Domenico Theotocopuli called El Gr
The Risen Christ 1595–8
Toledo, Hospital de S. Juan Bautista

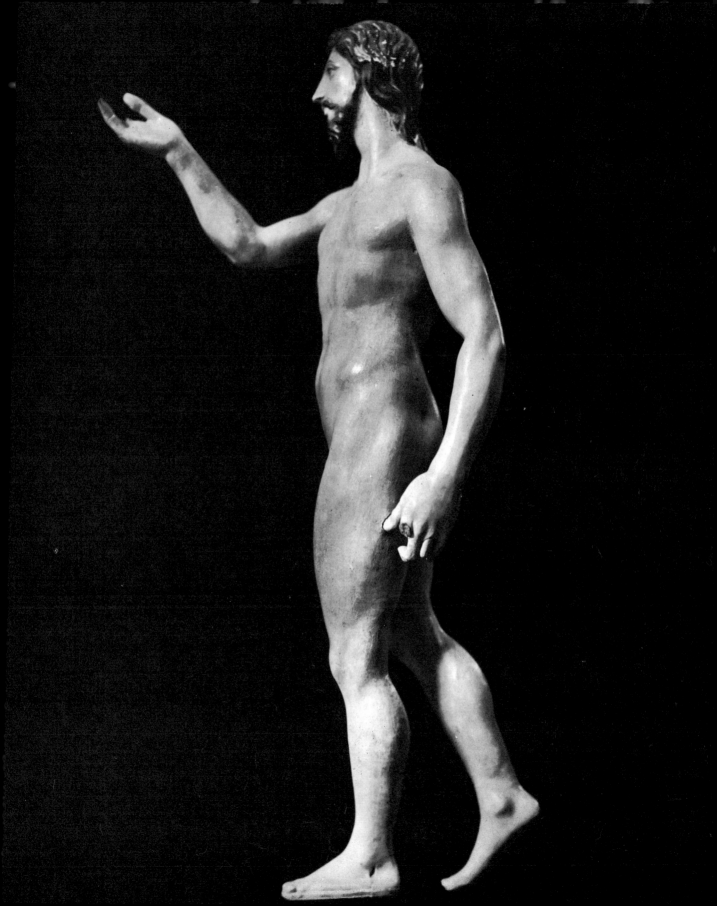

109 Pompeo Leoni
 Philip II and his family
 1579–1600
 El Escorial, S. Lorenzo

110 Pompeo Leoni
 Tomb of Don Fernando de Val
 1576–87
 Salas, Collegiate Church

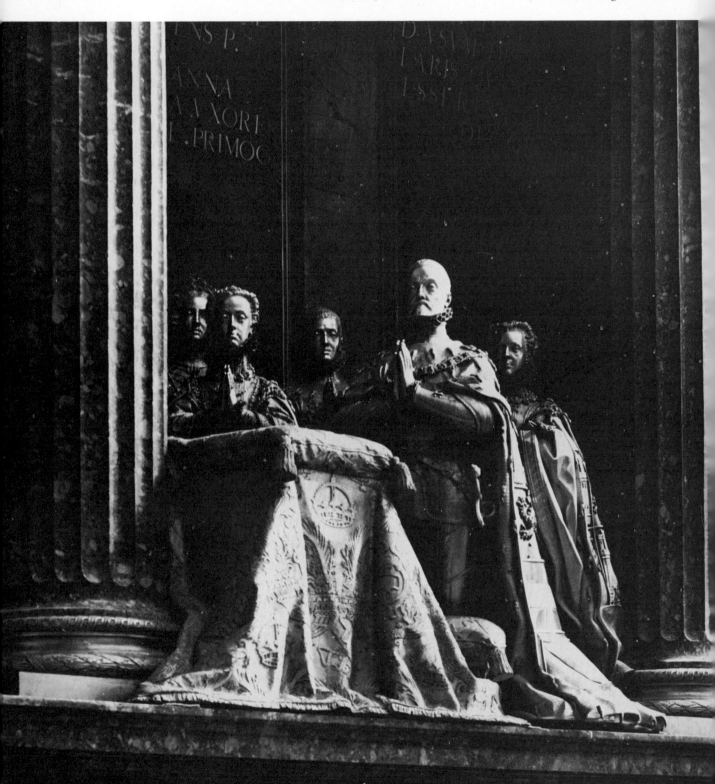

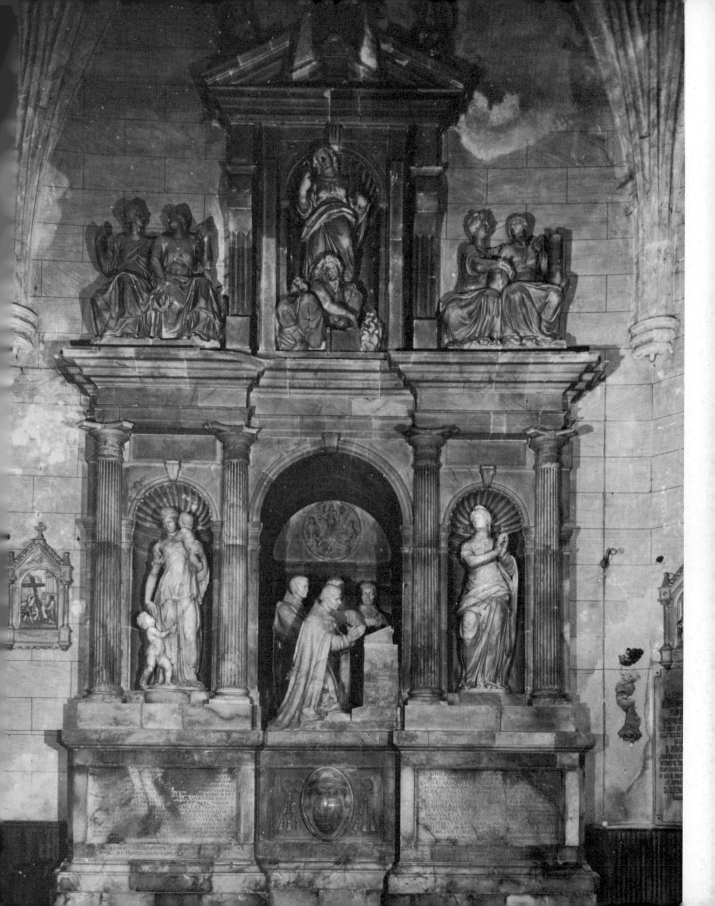

Anno domi M·D·xiii xn· die nativita
tis Marie obijt reverendus pr. dnus Au
ionnis brix iuris vtriusq: doctor clari
inis· ac huius ecclesie prepositus digniss
in... cu... aia requiescat in pace Amen·

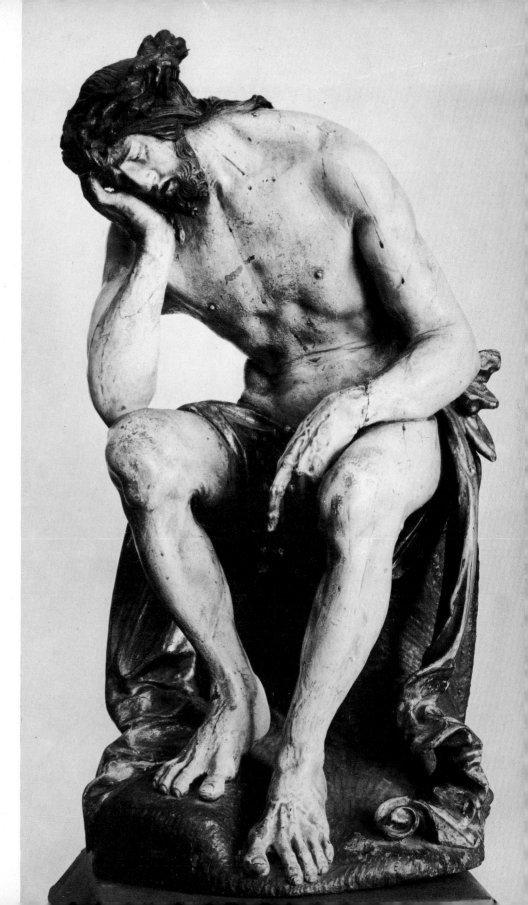

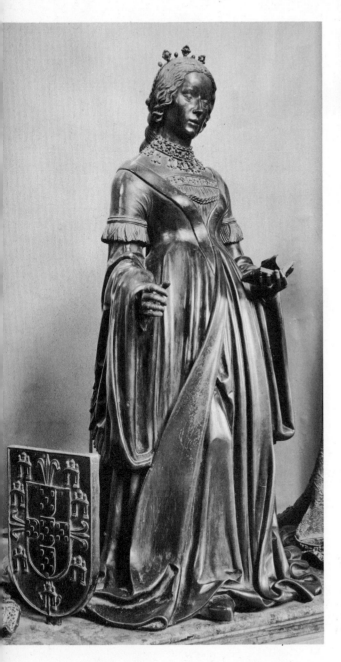

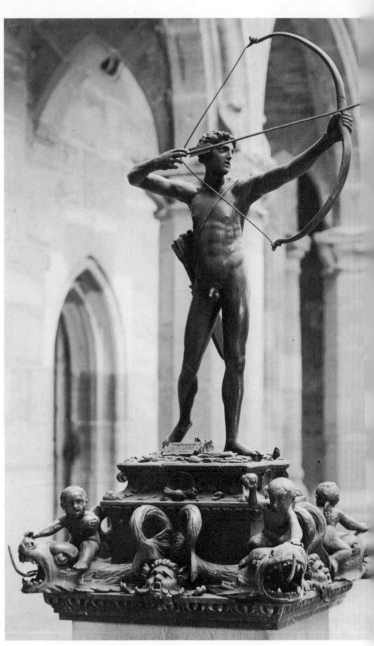

114 Gilg Sesselschreiber
Elizabeth of Austria 1516
Innsbruck, Hofkirche

115 Peter Flötner
Apollo Fountain 1532
Nuremberg, Pellerhaus

116 Sebastian Loscher
Tomb of Jacob Fugger
between 1511 and 1518
Augsburg, St Anna

Hans Gieng
Christ and the Woman of Samaria
1550–1
Fribourg (Switzerland),
Musée d'Art et d'Histoire

119 Hans Ruprecht Hoffmann
The Feeding of the Hungry
(detail from the pulpit) 1572
Trier, Cathedral

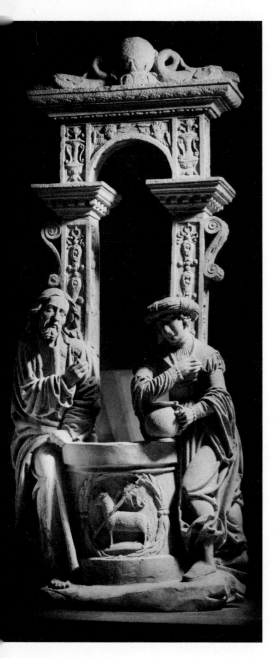

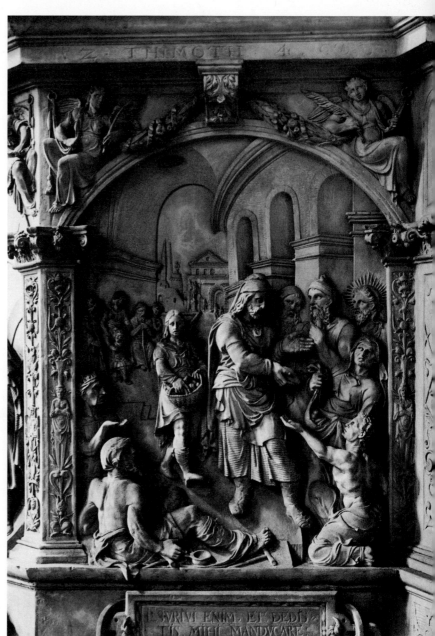

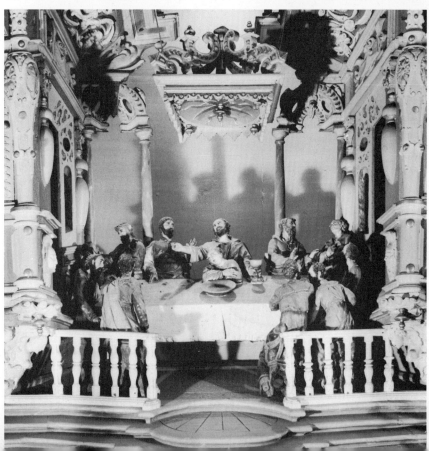

20 Michael Juncker
Fireplace 1601–2
Weikersheim (Württemberg),
Palace

21 Heinrich Gröninger
*Tomb of Theodor von
Fürstenberg* (detail) 1617–22
Paderborn, Cathedral

22 Ludwig Münstermann
The Last Supper (detail) 1620
Hohenkirchen (Oldenburg),
Parish Church

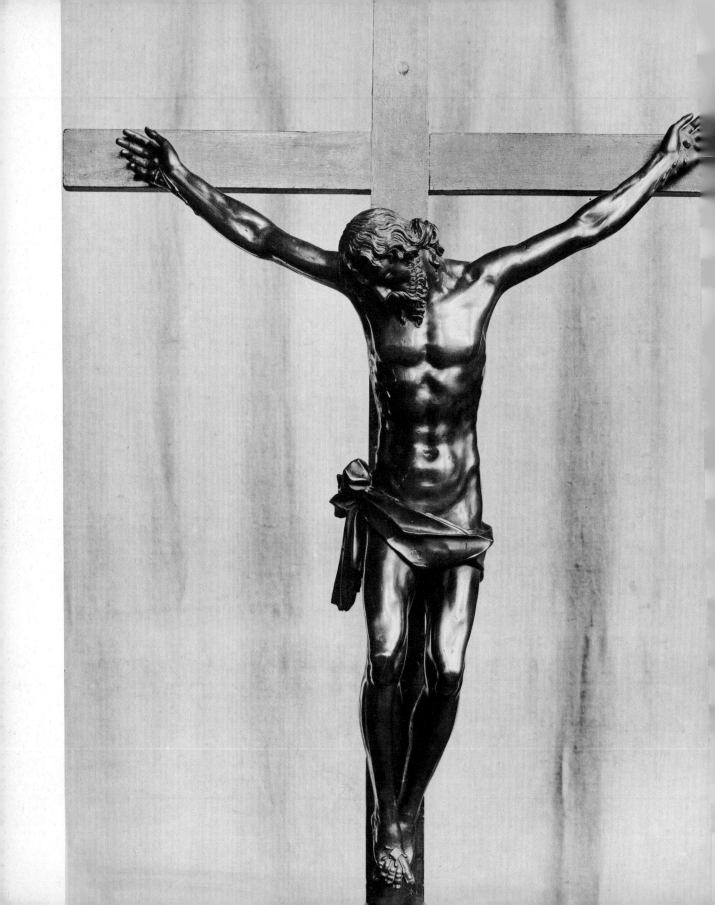

23 Carlo de Cesare
Crucifix
between 1590 and 1593
Dresden, Staatliche
Skulpturensammlung

24 Adrian de Vries
*Tomb of Duke Ernst von
Schaumburg-Lippe* 1618–20
Stadthagen, St Martin

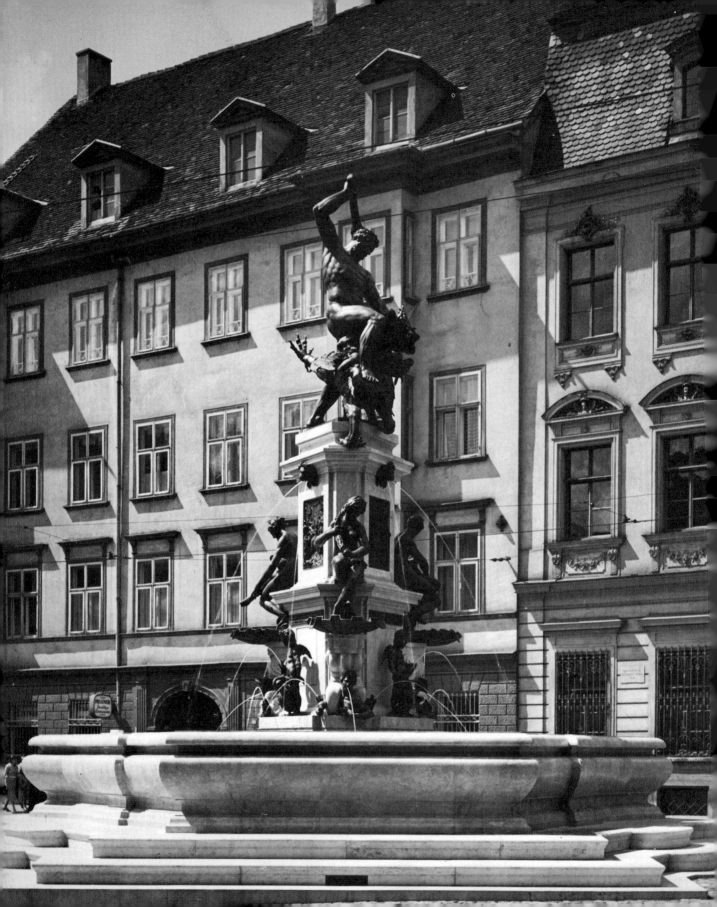

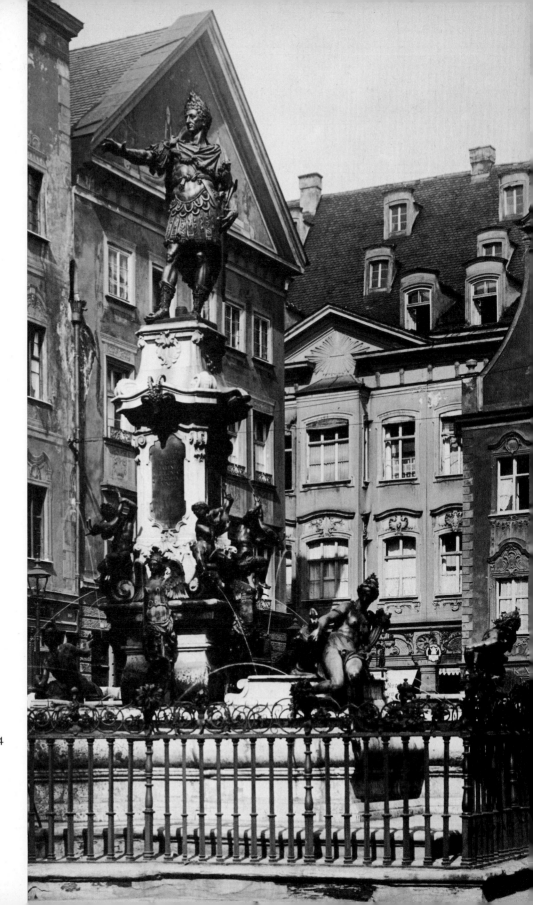

125 Adrian de Vries
The Hercules Fountain 1602
Augsburg, Maximiliansstrasse

126 Hubert Gerhard
The Augustus Fountain 1587–94
Augsburg, Ludwigsplatz

127 Hubert Gerhard
Bavaria
between 1590 and 1595
Munich, Residenzmuseum

128 Hans Krumper
Spring c. 1610–11
Munich, Bayerisches
Nationalmuseum

129 Adrian de Vries
Samson and the Philistine 1
Edinburgh, National Gall
of Scotland

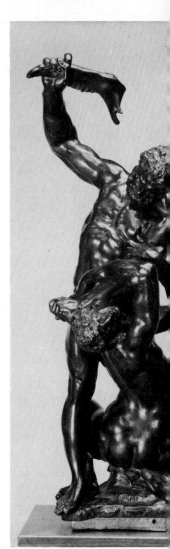

131 Jean Mone
 *Emperor Charles V and Isabella
 of Portugal* 1526
 Gaesbeek near Brussels,
 Palace

132 Guyot de Beaugrant
 *The young Daniel rescuing
 Susanna* (detail of 133) 1530–1
 Bruges, Law Courts, Het Vrije

PROVERBIORV̄ ·XXI
IVDICABIT DN̄S·CAVSAN
EIVS ET CONFINGET EOS
QVI·CONFIXERVNT·
AN̄A EIVS.

33 Lancelot Blondel
Fireplace 1528–33
Bruges, Law Courts, Het Vrije

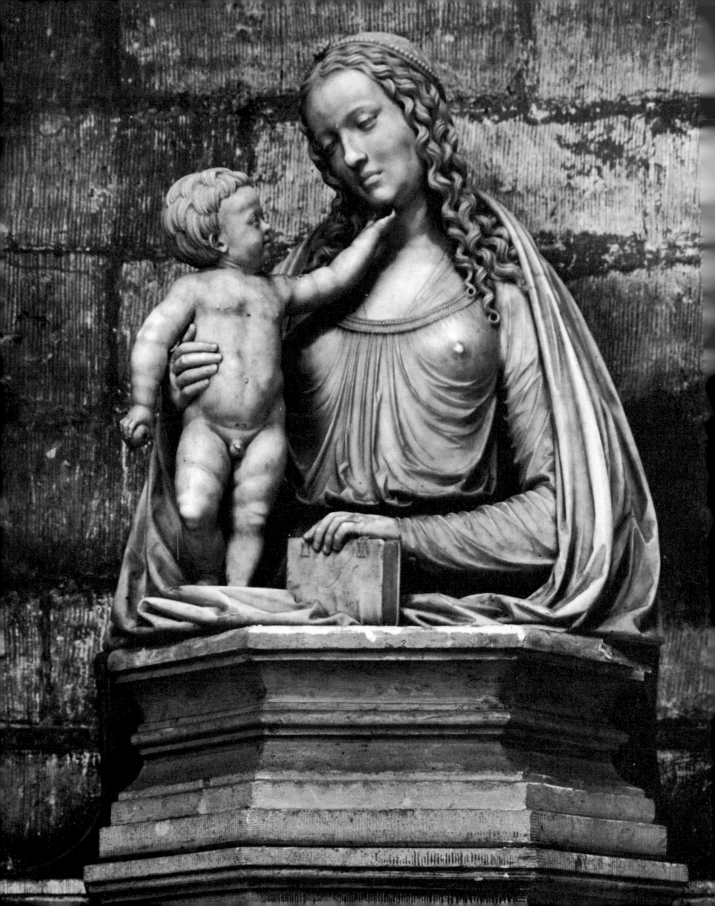

Conrad Meit
Virgin and Child
between 1525 and 1530
Brussels, Sts Michel et Gudule

135 Colyn de Nole
Fides (detail from the
fireplace decoration) 1543–5
Kampen, Town Hall

136 Jacques du Broeucq
Charity c. 1542–4
Mons, Collégiale de
Ste Waudru

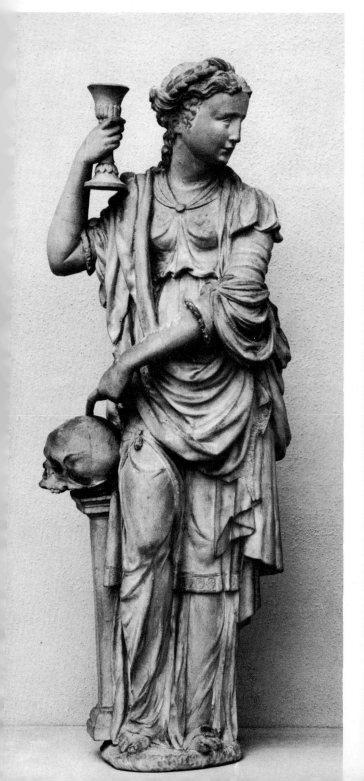

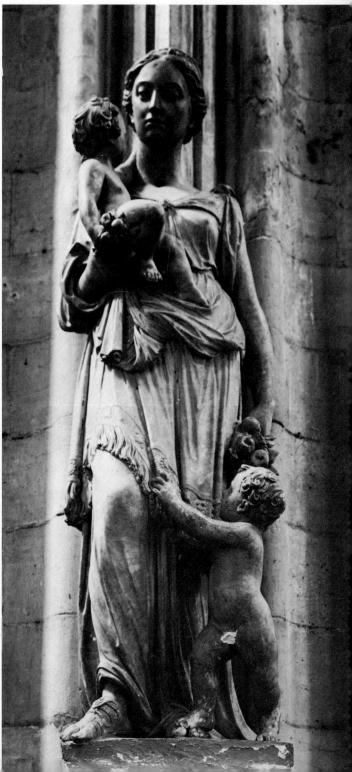

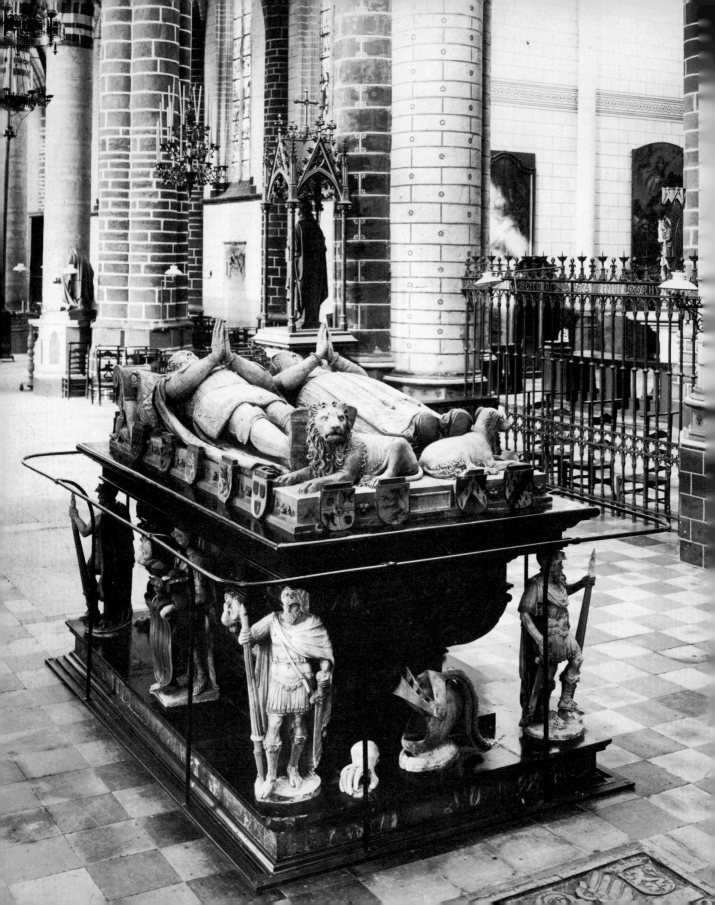

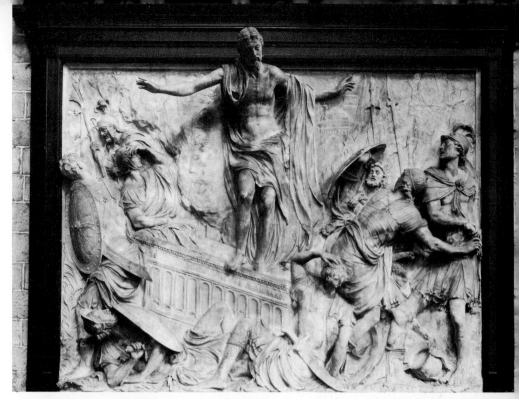

37 Cornelis Floris
Tomb of Jan van Merode 1554
Geel, Ste Dymphna

38 Jacques du Broeucq
The Resurrection c. 1546–7
Mons, Collégiale de
Ste Waudru

39 Cornelis Floris
*God showing Adam and Eve
the Tree of Knowledge*
(detail of the tabernacle)
1550–2
Zoutleeuw, St Leonard

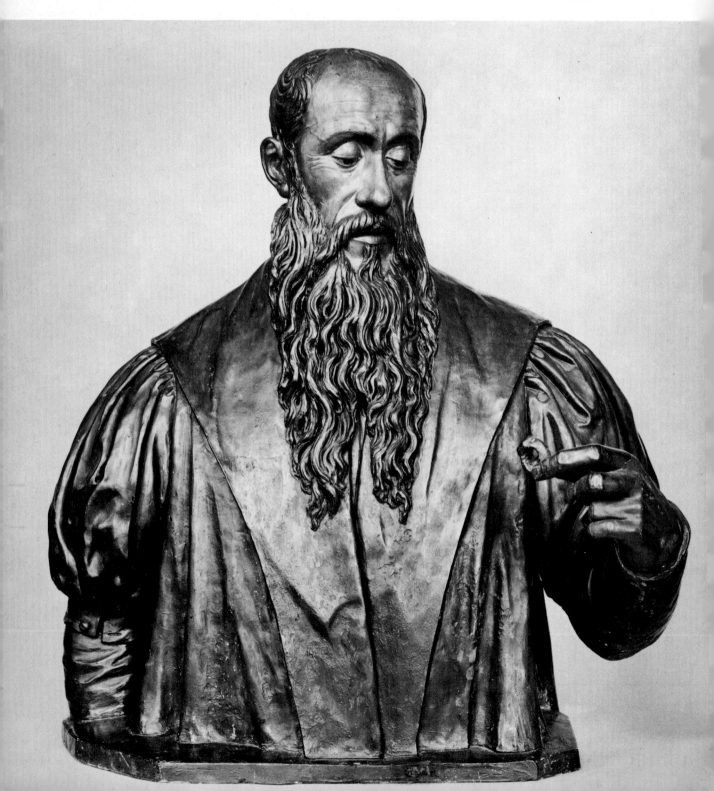

Willem van den Broecke
called Paludanus
Albrecht Dürer c. 1563
Antwerp, Vleeschhuis
Museum

142 Willem van den Broecke
called Paludanus
Jan van Eyck c. 1563
Antwerp, Vleeschhuis
Museum

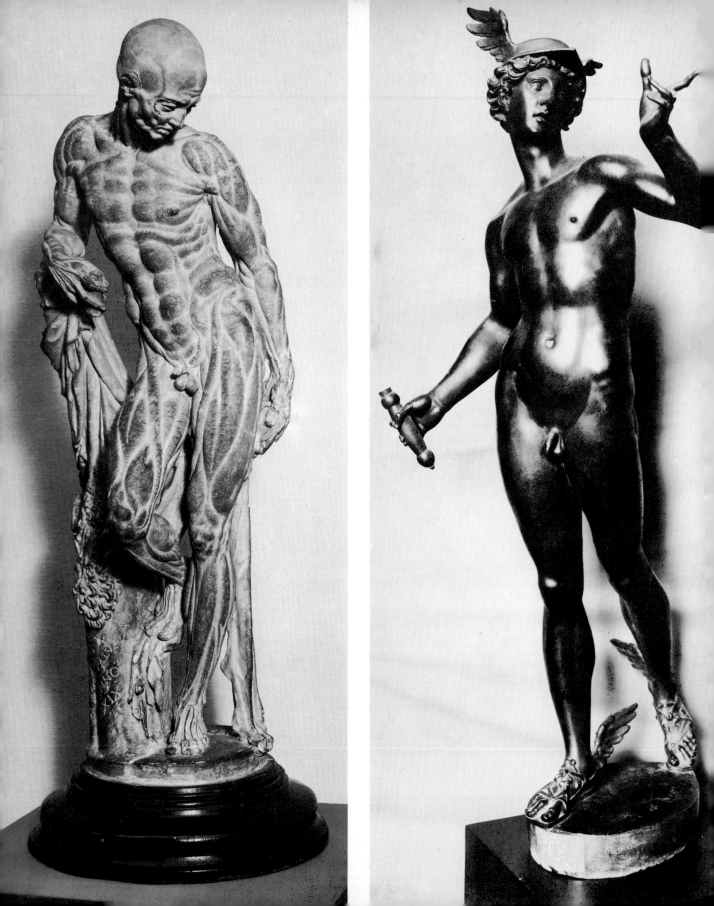

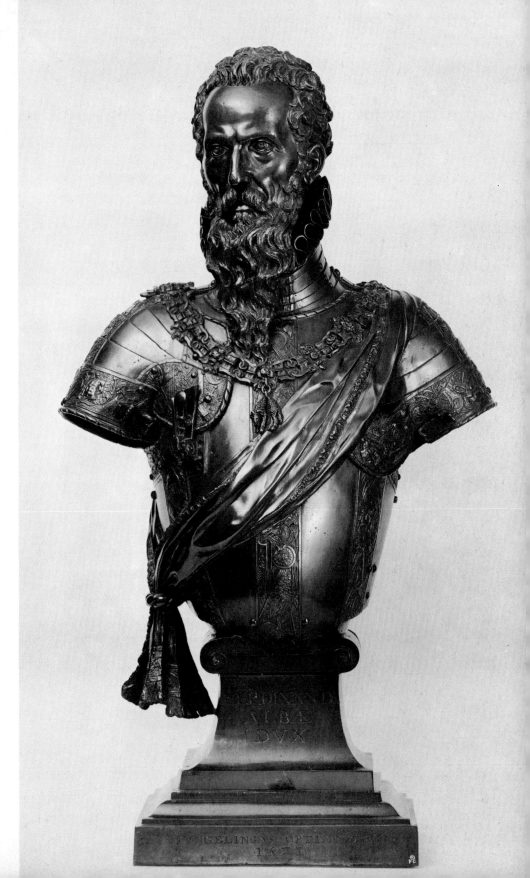

146 Hendrick de Keyser
 *Tomb of Prince William of
 Orange* 1614–22
 Delft, Nieuwe Kerk

147 Nicholas Stone
 St Paul 1610–13
 London, Victoria and Albert
 Museum

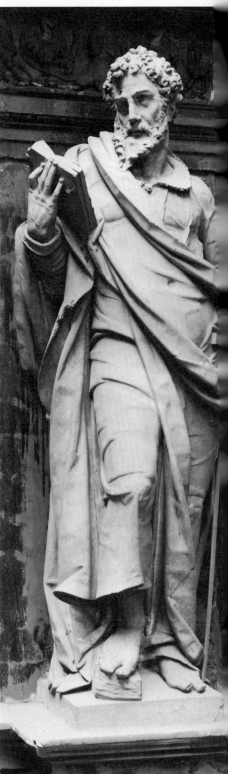

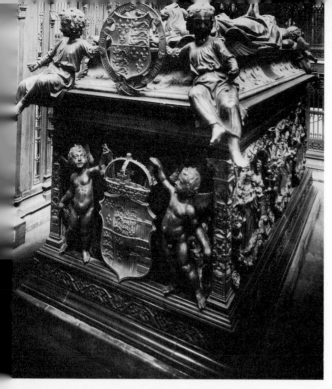

148 Pietro Torrigiano
*Tomb of Henry VII and
Elizabeth of York* 1512–18
London, Westminster Abbey

149 Maximilian Colt
*Tomb of the first Earl of
Salisbury* 1609–after 1614
Hatfield (Hertfordshire),
St Etheldreda

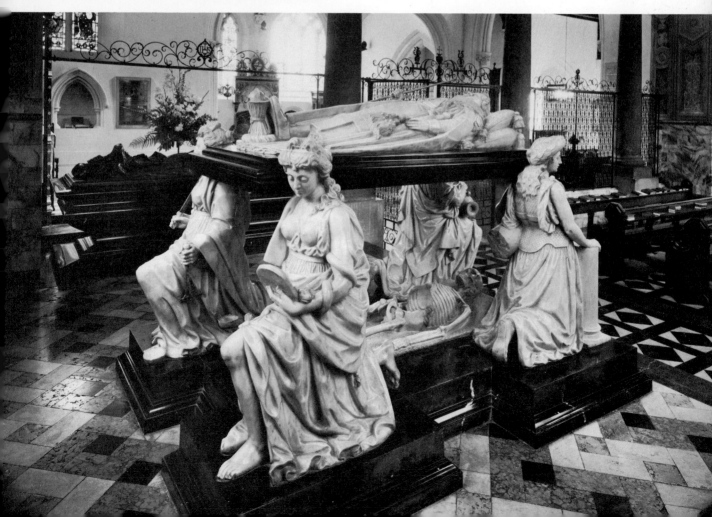

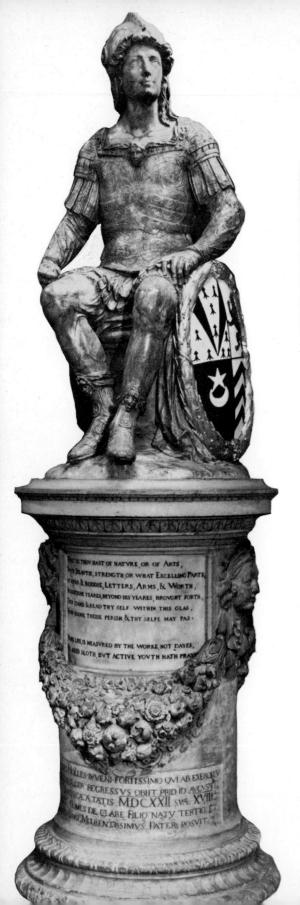

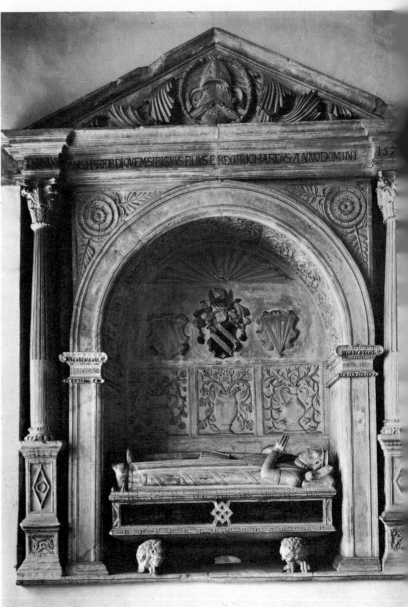

150 Nicholas Stone
The Francis Holles monument
after 1622
London, Westminster Abbey

151 John Guldon
Tomb of John Harford 1573
Bosbury, Holy Trinity

Nicholas Stone
The north gate of the Botanical Gardens 1632
Oxford, High Street

Maximilian Colt
Fireplace with statue of James I 1609
Hatfield House (Hertfordshire)

154 François Perrier
The Niobe Group in the Medic[i]
Gardens in Rome
Engraving 1638

155 Giovanni Bandini
Pietà 1585–6
Urbino, Oratorio del Duom[o]

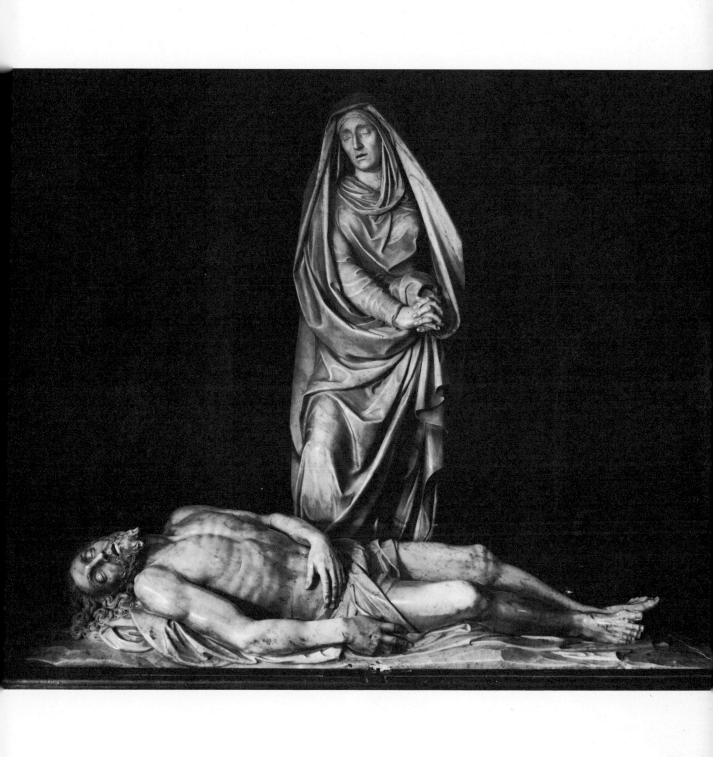

156 Francesco Mochi
Virgin Annunciate 1605–8
Orvieto, Museo dell'Opera
del Duomo

157 Francesco Mochi
Angel of the Annunciation 160
Orvieto, Museo dell'Opera
del Duomo

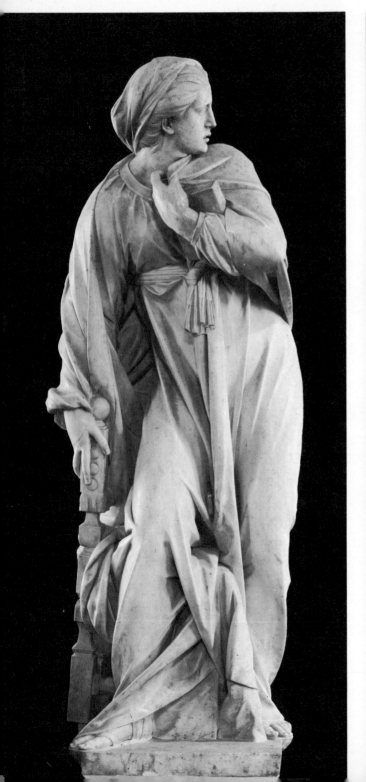

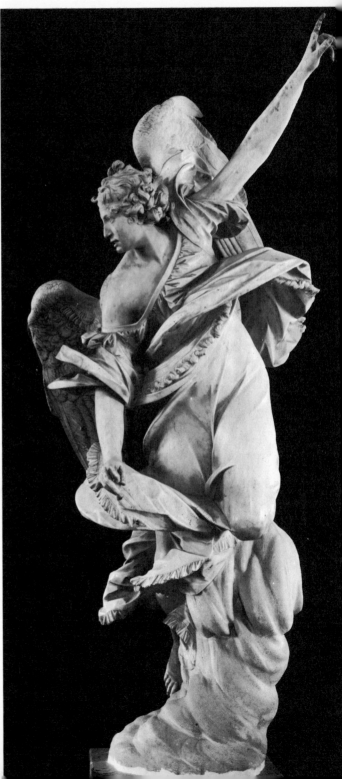

Giovanni Bologna
Rape of a Sabine 1579
Naples, Museo Nazionale
di Capodimonte

159 Gian Lorenzo Bernini
The rape of Proserpina 1621–2
Rome, Galleria Borghese

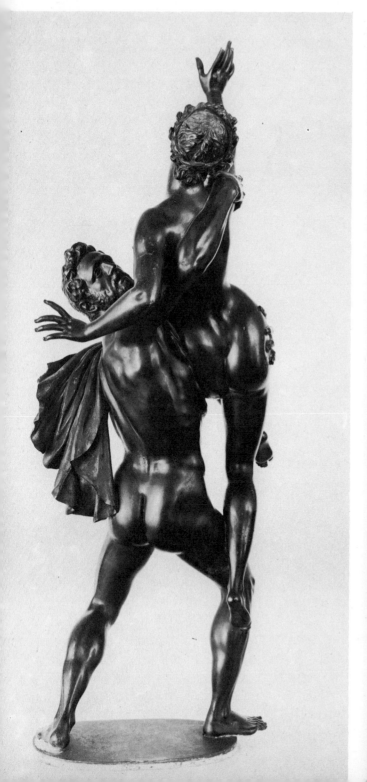

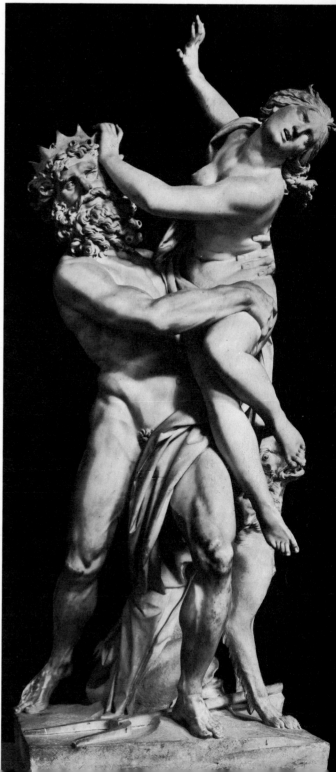

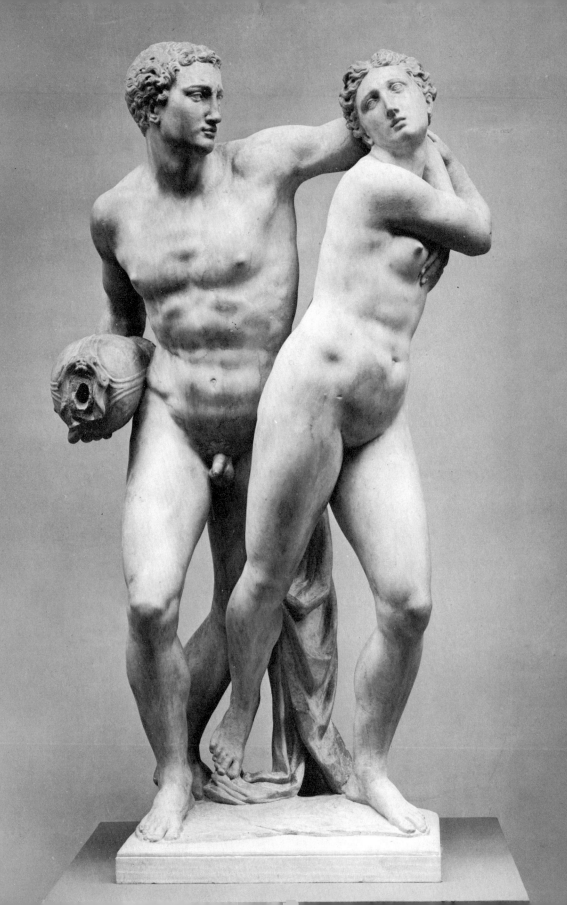

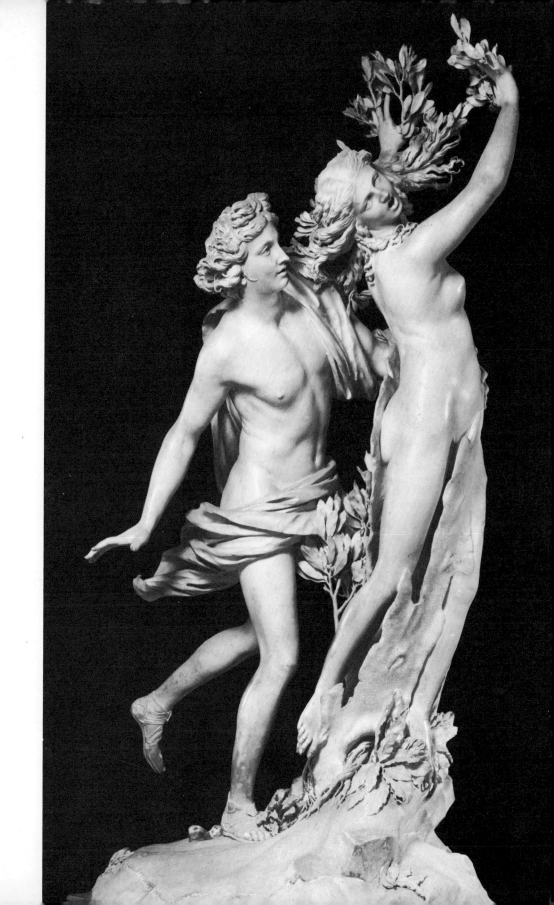

60 Battista Lorenzi
Alpheus and Arethusa
between 1570 and 1580
New York, Metropolitan
Museum

61 Gian Lorenzo Bernini
Apollo and Daphne 1622–4
Rome, Galleria Borghese

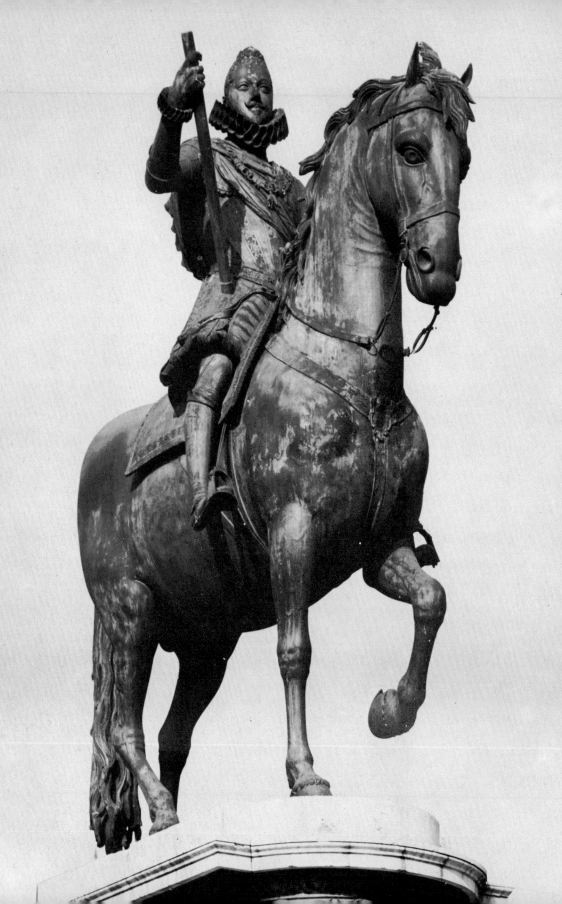

2 Pietro Tacca
*The Philip III equestrian
monument* 1609–14
Madrid, Plaza Mayor

3 Francesco Mochi
*The Alessandro Farnese
equestrian monument* 1620–9
Piacenza, Piazza dei Cavalli

164 Gian Lorenzo Bernini
St Longinus 1628–38
Rome, St Peter's

165 François du Quesnoy
St Andrew 1627–40
Rome, St Peter's

166 Gian Lorenzo Bernini
The ecstasy of St Teresa 1645
Rome, Sta Maria della Vitto

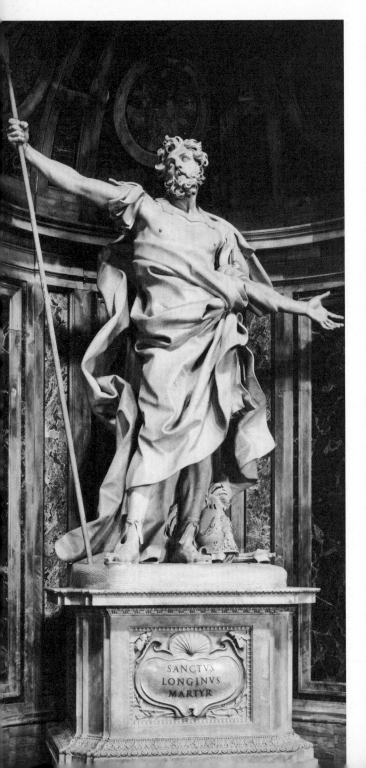

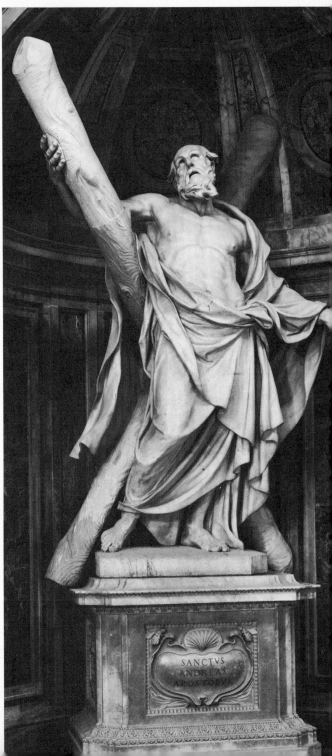

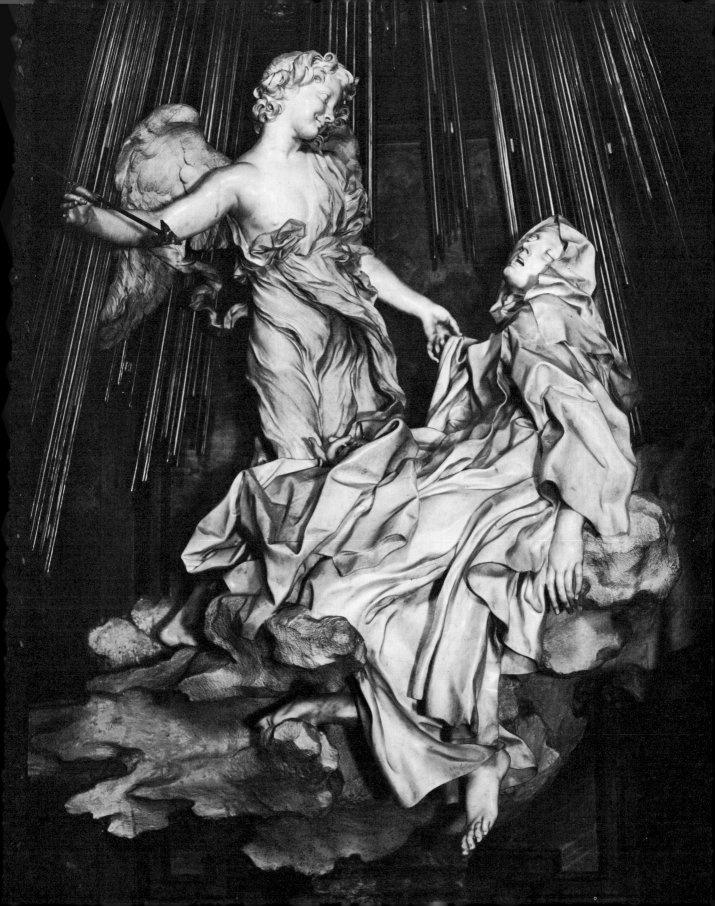

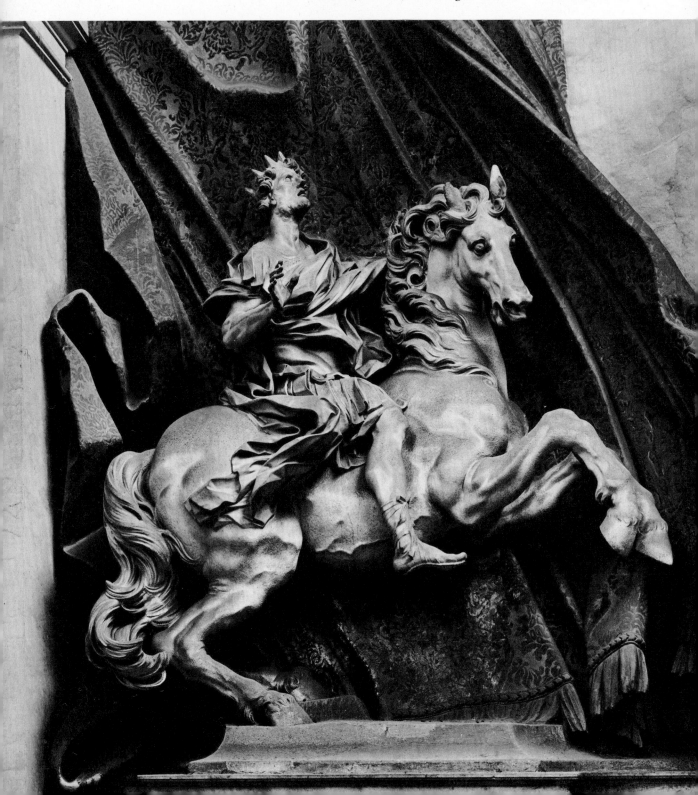

167 Gian Lorenzo Bernini
The vision of Constantine 1654–70
Rome, Vatican, Scala Regia

168 Gian Lorenzo Bernini
Tomb of Pope Urban VIII
1628–47
Rome, St Peter's

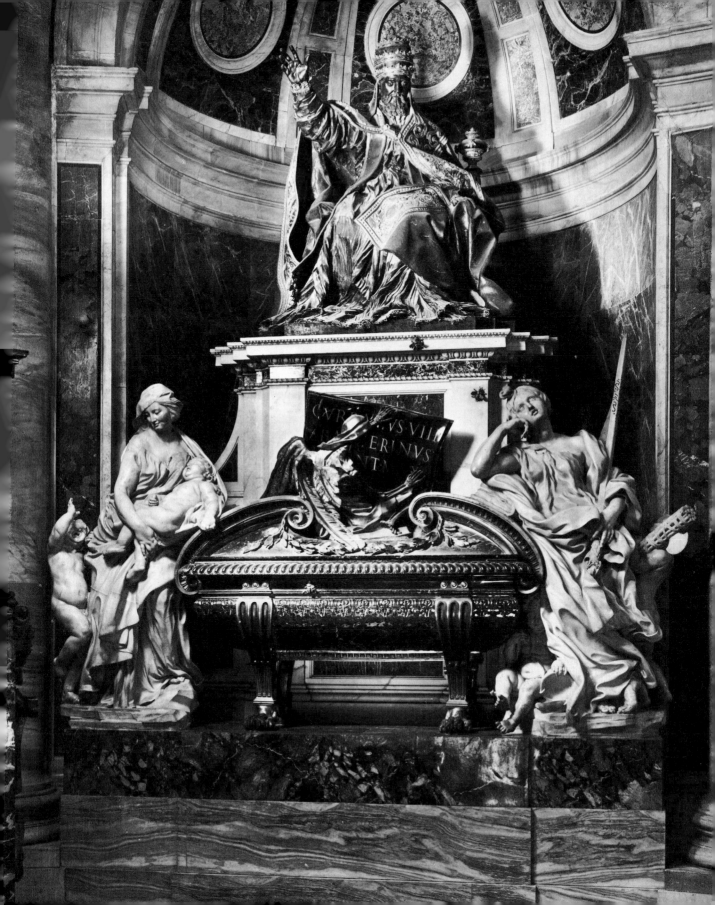

169 Gian Lorenzo Bernini
The Triton Fountain before
1633–7
Rome, Piazza Barberini

170 Gian Lorenzo Bernini
Bust of Louis XIV 1665
Versailles, Palace

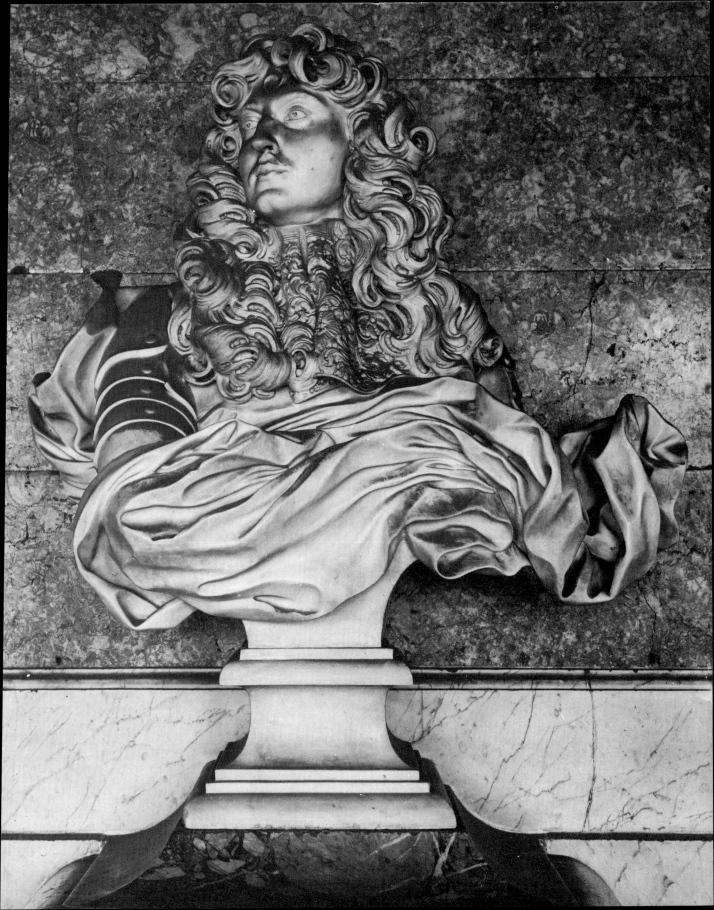

171 François du Quesnoy
 St Susanna 1626 ?–33
 Rome, Sta Maria di Loreto

172 Alessandro Algardi
 St Philip Neri 1640
 Rome, Sta Maria in Vallicella

173 Ercole Ferrata
 St Agnes 1660
 Rome, S. Agnese in Agone

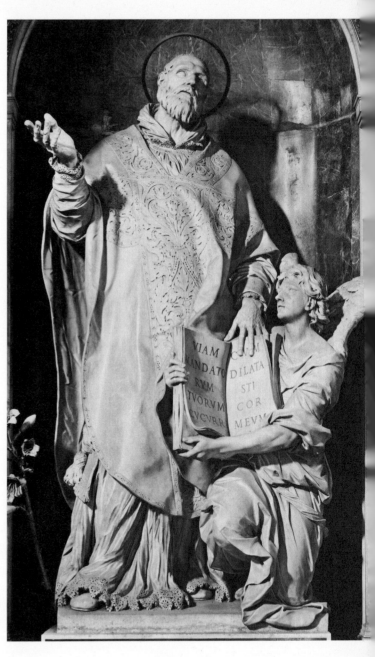

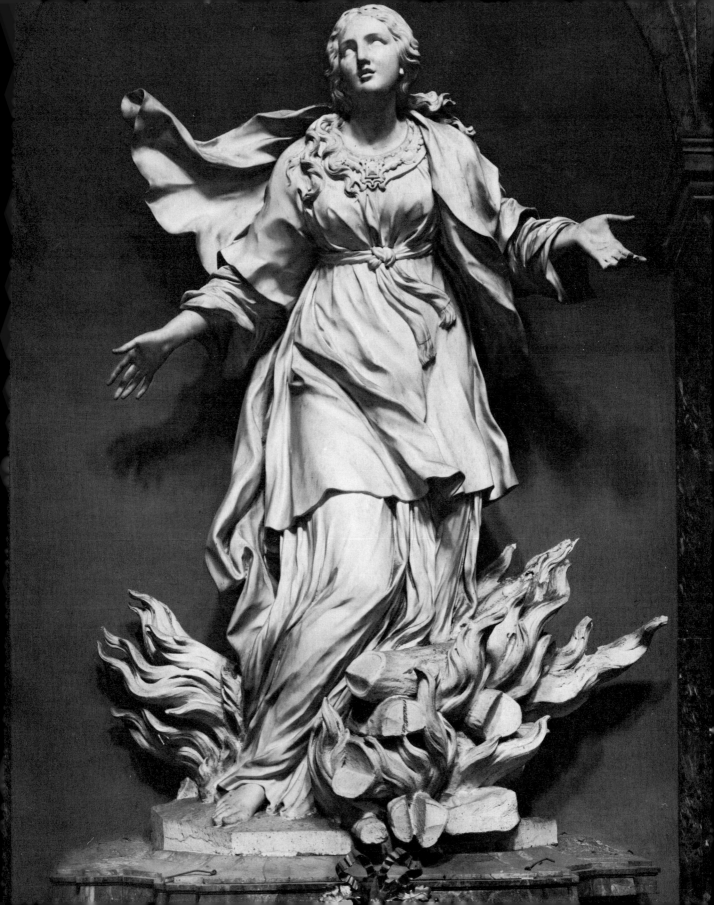

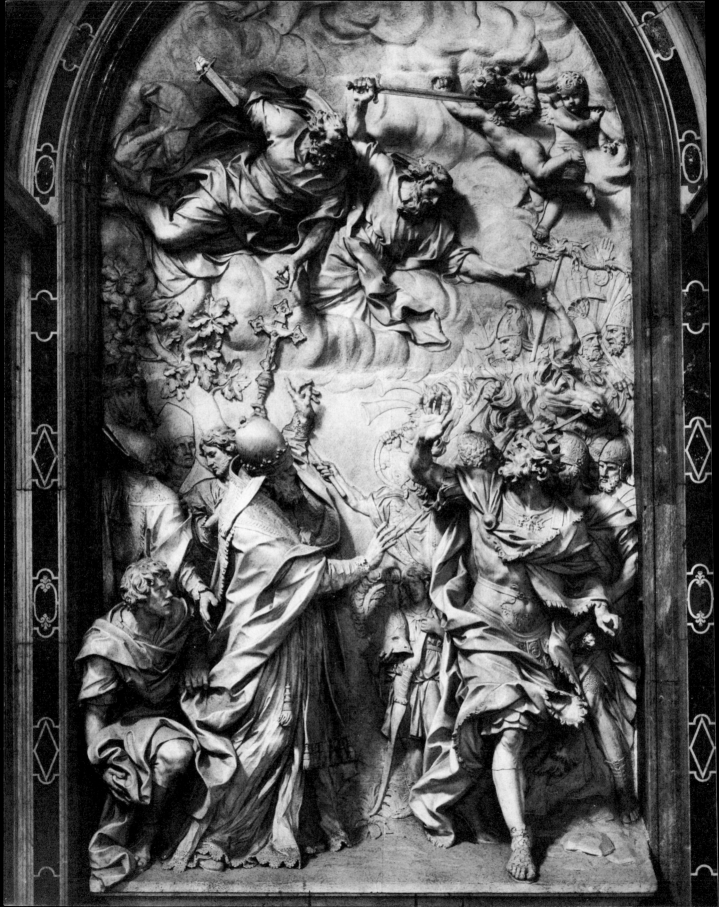

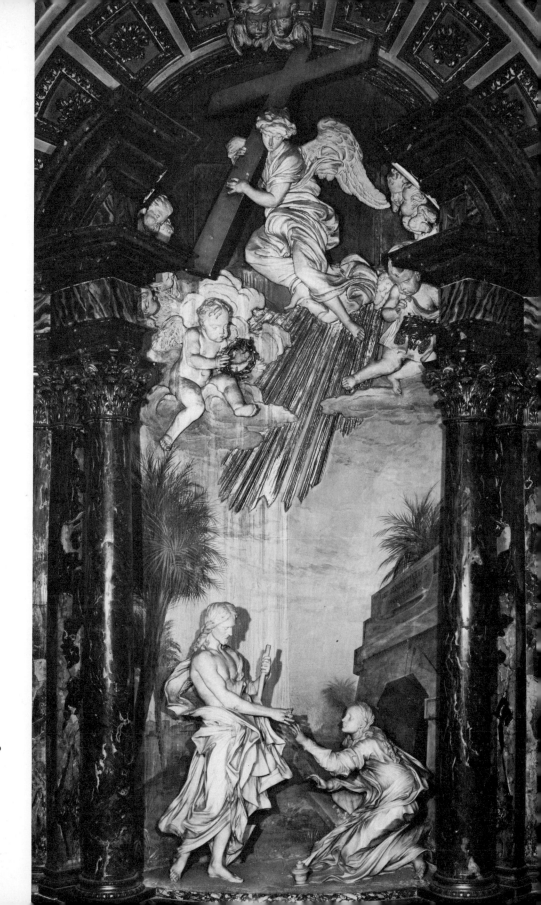

74 Alessandro Algardi
*The meeting of Pope Leo I and
Attila* 1646–53
Rome, St Peter's

75 Antonio Raggi
Noli me tangere 1649–50
Rome, SS. Domenico e Sisto

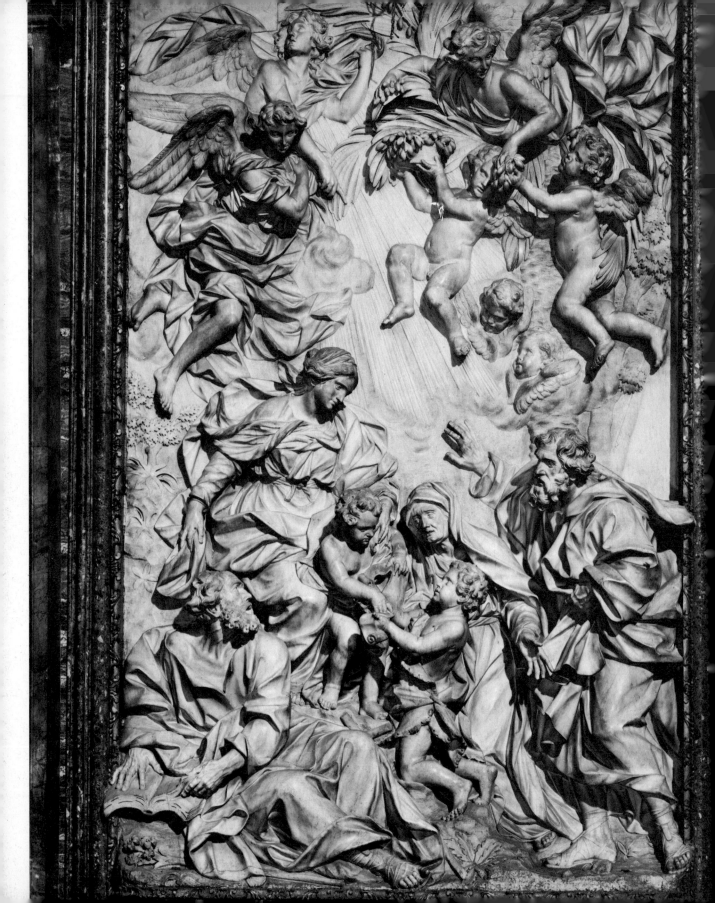

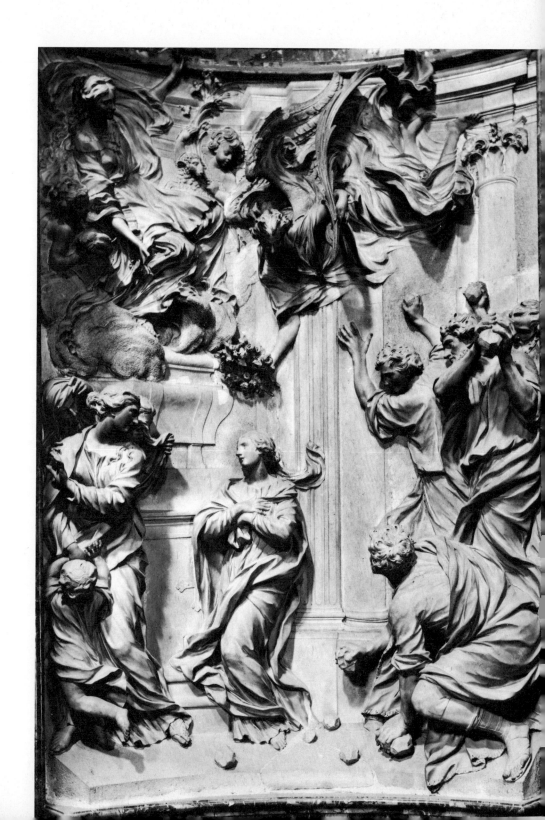

6 Domenico Guidi
The Holy Family after 1672
Rome, S. Agnese in Agone

7 Ercole Ferrata and
Leonardo Retti
*The martyrdom of
St Emerentiana* 1660–1709
Rome, S. Agnese in Agone

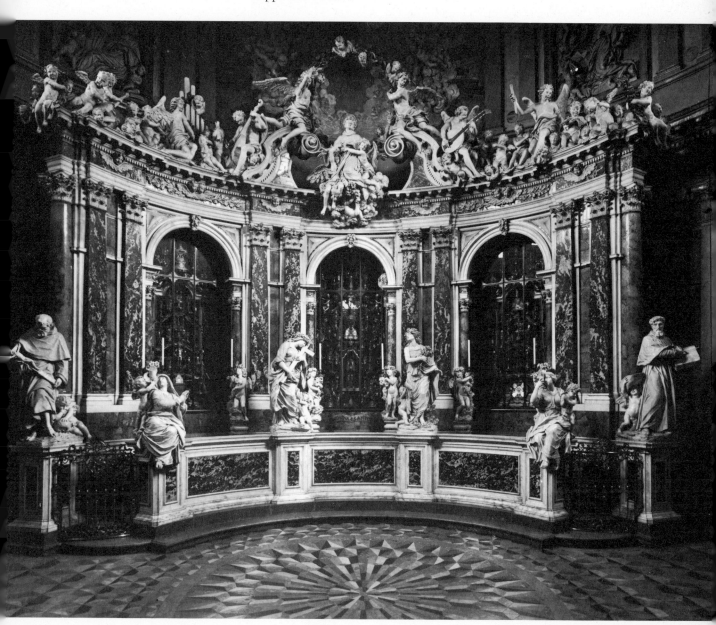

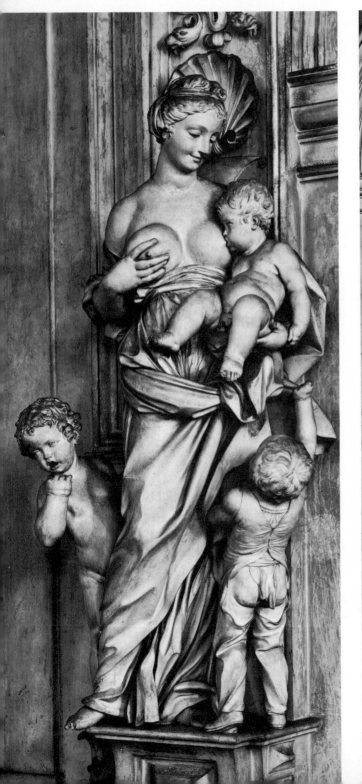

180 Giacomo Serpotta
Charity
between 1690 and 1696
Palermo, Oratorio di
S. Lorenzo

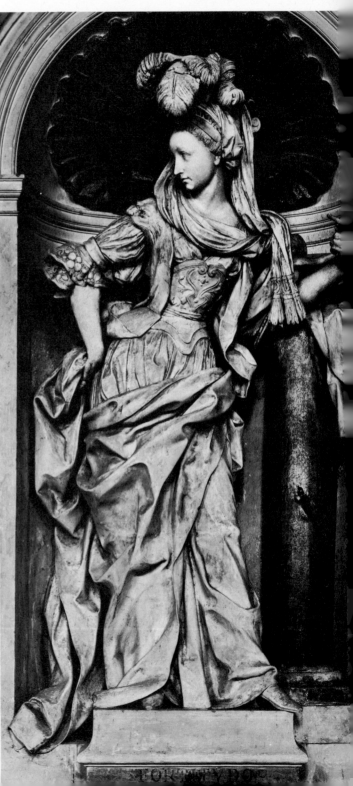

181 Giacomo Serpotta
Fortitude 1714–17
Palermo, Oratorio del Ros
di S. Domenico

Camillo Rusconi
St John the Evangelist 1708–13
Rome, S. Giovanni in
Laterano

183 Pierre Le Gros
St Thomas 1705–11
Rome, S. Giovanni in
Laterano

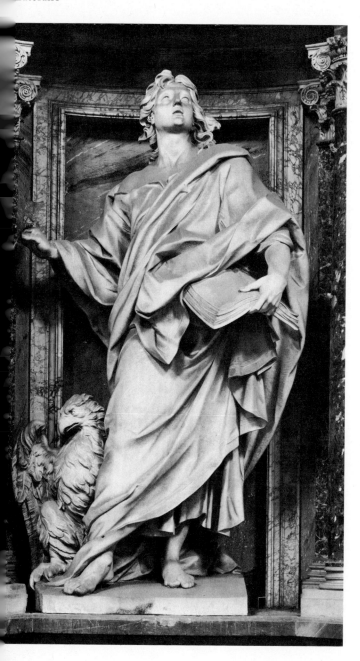

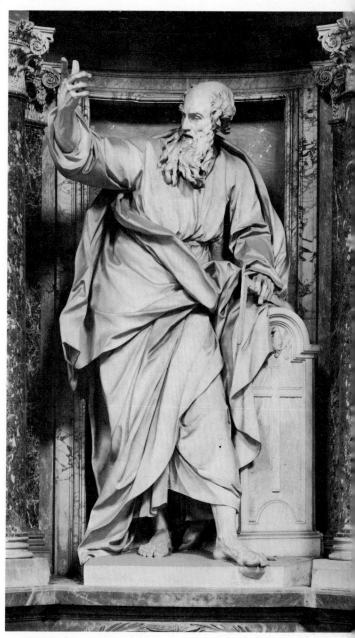

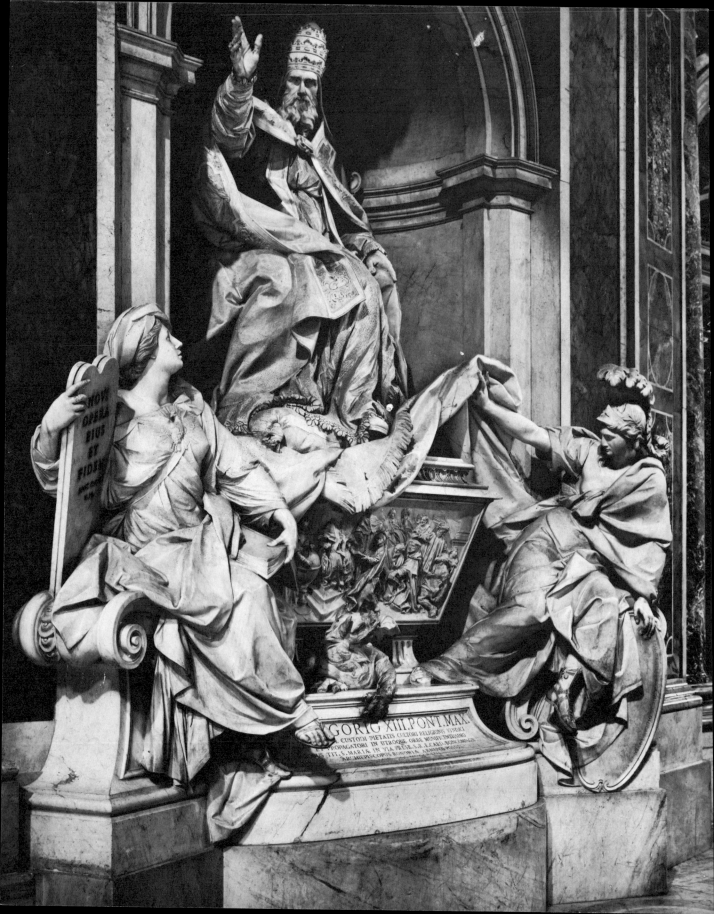

Camillo Rusconi
Tomb of Pope Gregory XIII
1715–23
Rome, St Peter's

185 Giuseppe Mazzuoli
Tomb of Stefano and Lazzaro
Pallavicini 1714
Rome, S. Francesco a Ripa

16 Giuseppe Lironi
*Tomb of Cardinal Neri Maria
Corsini c.* 1733–5
Rome, S. Giovanni in Laterano

17 Filippo della Valle
*Tomb of Cardinal Andrea
Corsini* 1732–5
Rome, S. Giovanni in Laterano

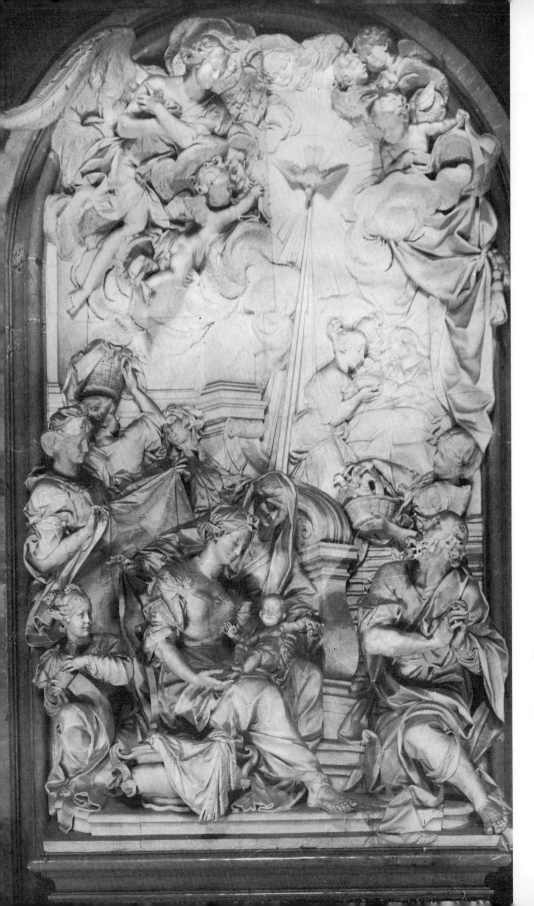

188 Agostino Cornacchini
The birth of the Virgin 1728–3
Turin, Basilica di Superga

189 Bernardino Cametti
The Annunciation 1729
Turin, Basilica di Superga

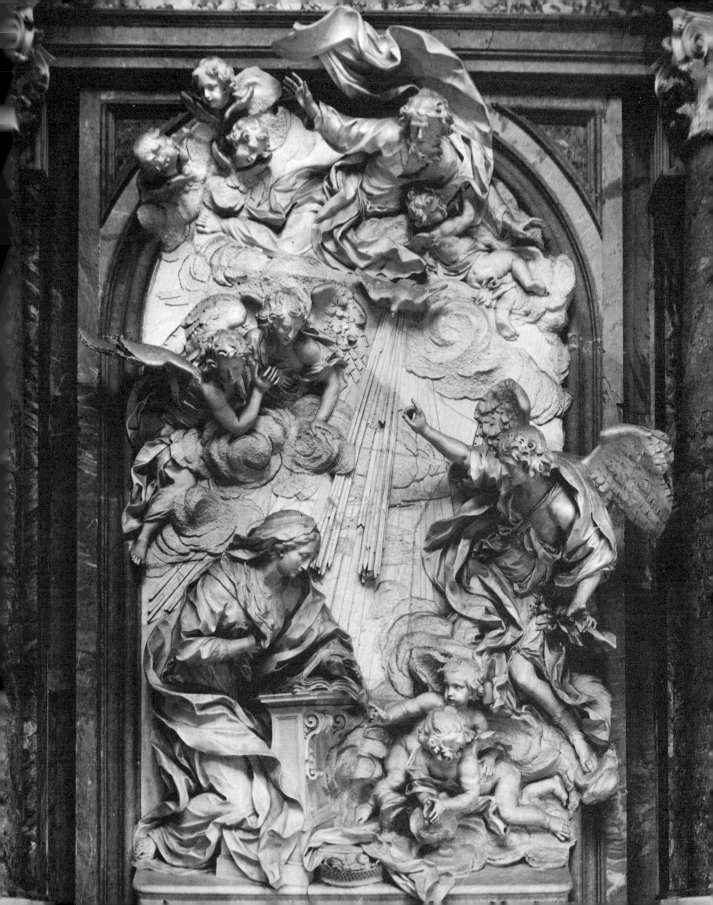

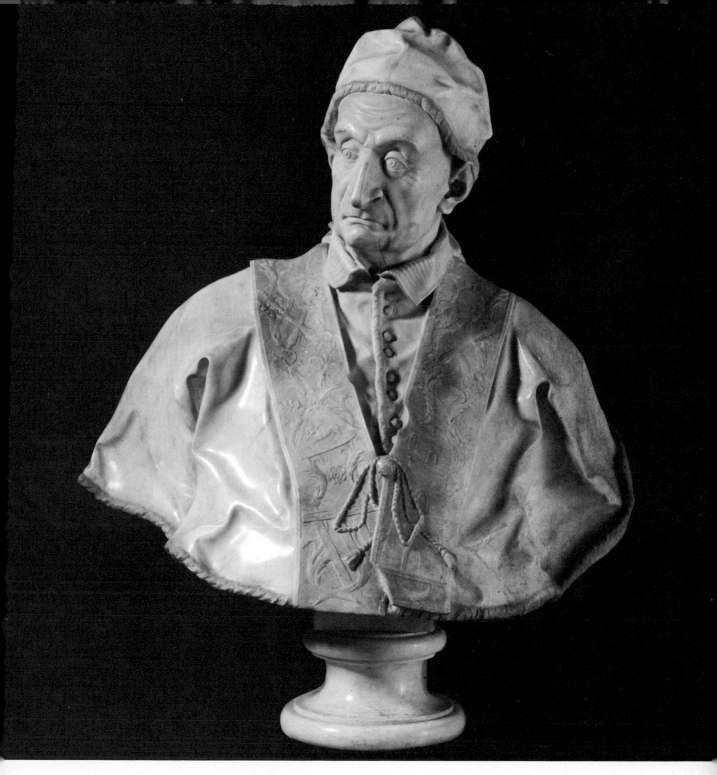

190 Pietro Bracci
Tomb of Queen Maria
Clementina Sobieski 1739–42
Rome, St Peter's

191 Pietro Bracci
Bust of Pope Benedict XIII
between 1740 and 1750
Lugano, Thyssen-Bornemisza
Collection

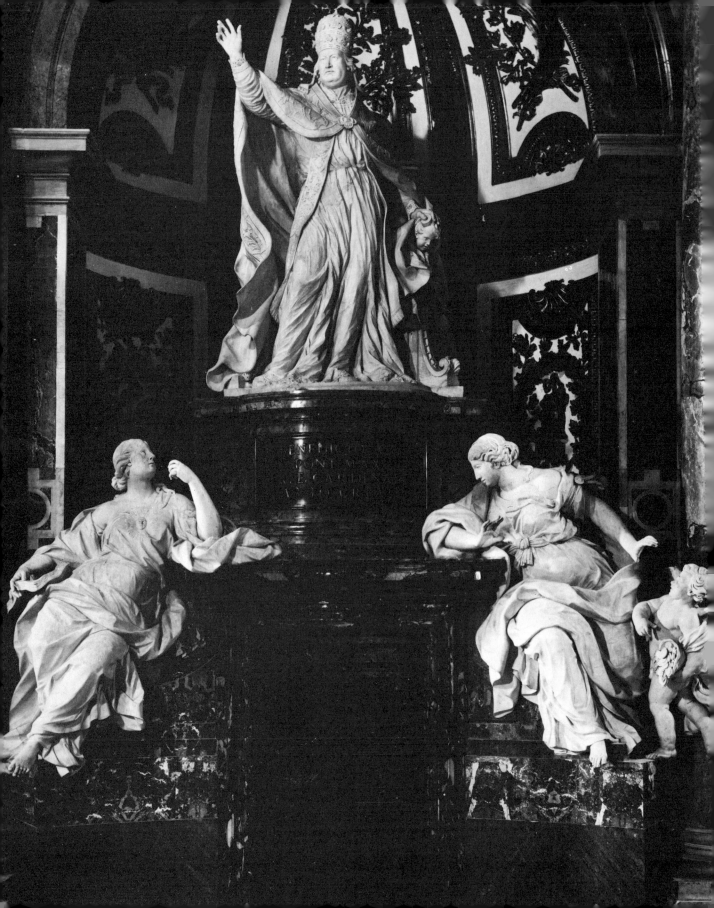

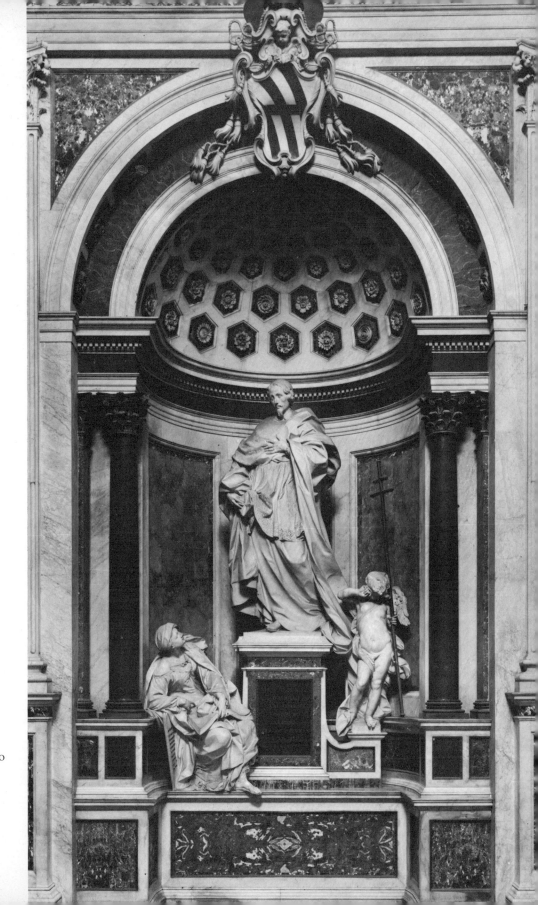

92 Pietro Bracci
 Tomb of Pope Benedict XIV
 1759–69
 Rome, St Peter's

93 Giovanni Battista Maini
 Tomb of Cardinal Neri Corsini
 1732–5
 Rome, S. Giovanni in Laterano

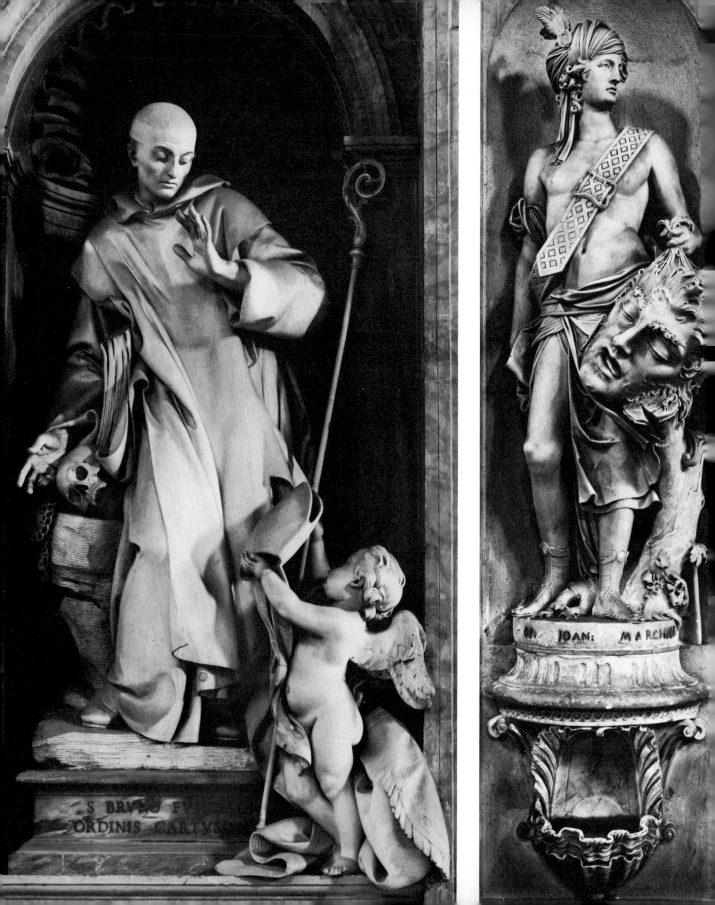

S BRVNO F...
ORDINIS CARTVS...

OP: IOAN: MARCHIO...

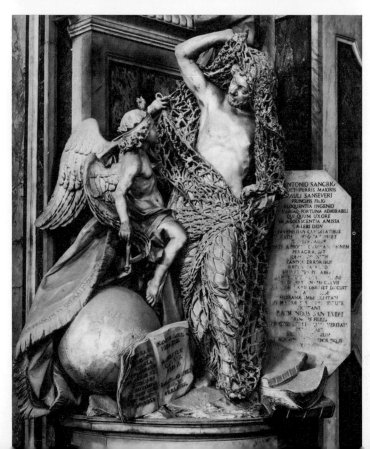

4 Michelangelo Slodtz
St Bruno 1744
Rome, St Peter's

5 Giovanni Marchiori
David 1743
Venice, S. Rocco

6 Antonio Corradini
Chastity after 1745–52
Naples, Sta Maria della Pietà
dei Sangro

7 Francesco Queirolo
Disenchantment after 1752
Naples, Sta Maria della Pietà
dei Sangro

198 Nicola Salvi and Pietro Brac
The Trevi Fountain 1731–62
Rome, Piazza di Trevi

99 Luigi Vanvitelli, Angiolo
Brunelli and others
Diana and the nymphs 1770–80
Caserta, Palace Gardens

Hendrick de Keyser
Bust of Vincent Jacobsz. Coster
1608
Amsterdam, Rijksmuseum

201 Adrian de Vries
Laocoön and his sons 1623
Drottningholm, Palace
Gardens

202 Hendrick de Keyser ?
The mad woman c. 1620
Amsterdam, Rijksmuseum

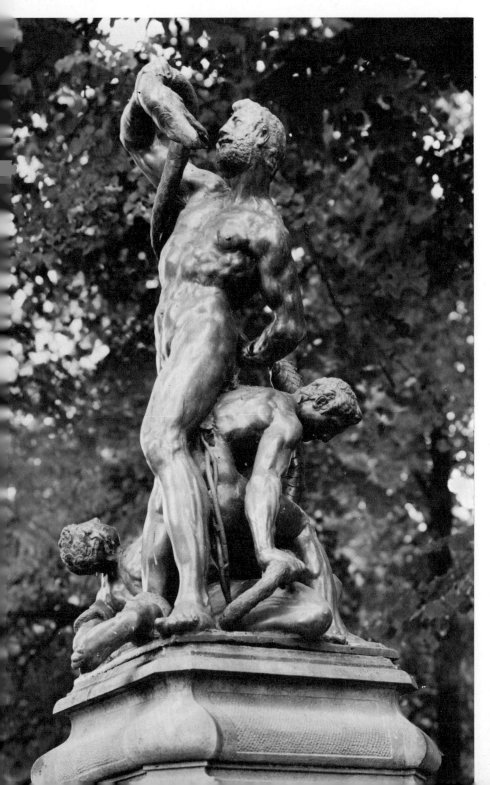

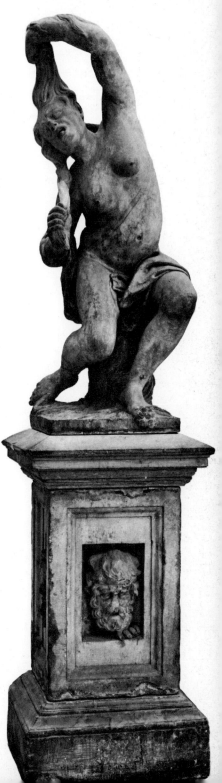

203 Robert de Nole
St Amand 1620–4
Lier near Ghent,
St Gummarus

204 Jérôme II du Quesnoy
St Thomas c. 1644–6
Brussels, Sts Michel et Gudule

205 Jérôme II du Quesnoy
The Tomb of Bishop Antoni
Triest 1651–4
Ghent, St Bavo

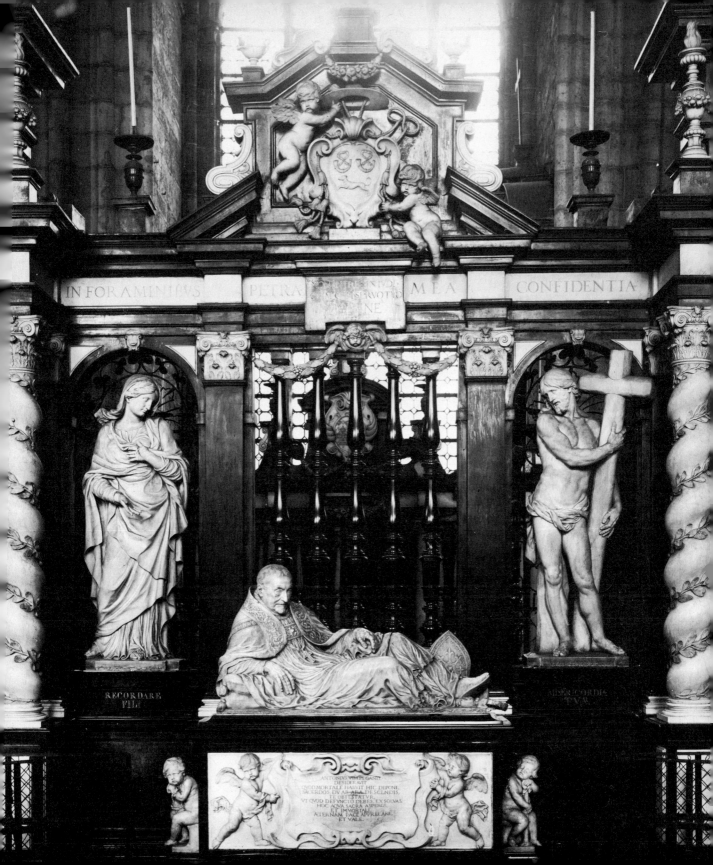

IN FORAMINIBVS PETRA ... MEA CONFIDENTIA

RECORDARE
FILI

MISERICORDIA
TVA

ANTONIVS VIVS GAND
DESIDERAVIT
QVOD MORTALE HABVIT HIC DEPONE
SACERDOS DV ARAM DESCENDIS
TE OBTESTATVS
VT QVOD DEFVNCTO DEBES EXSOLVAS
HOC AQVA SACRA ASPERGE
ILI IMMORTALI
AETERNAM PACE APPRECARE
ET VALE

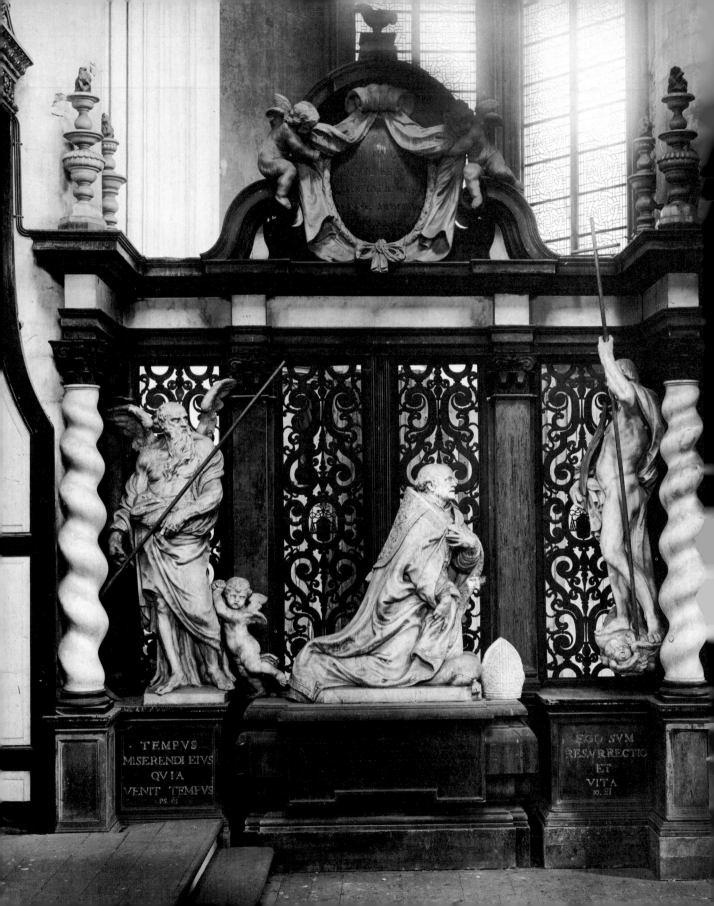

Lucas Faydherbe
Tomb of Bishop Andreas Cruesen
1660
Malines, St Rombout

Artus Quellinus the elder
*Virgin with the young Christ,
Joseph and Anne* (detail) 1644
Antwerp, St Paul

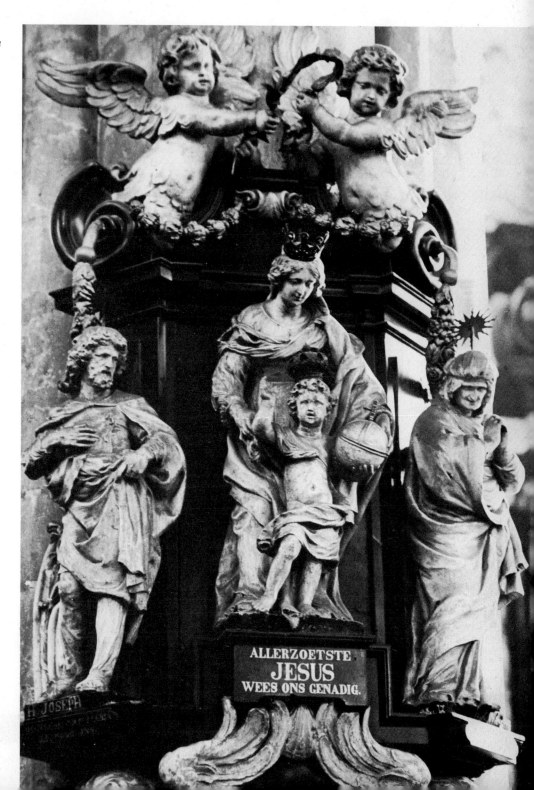

ALLERZOETSTE
JESUS
WEES ONS GENADIG.

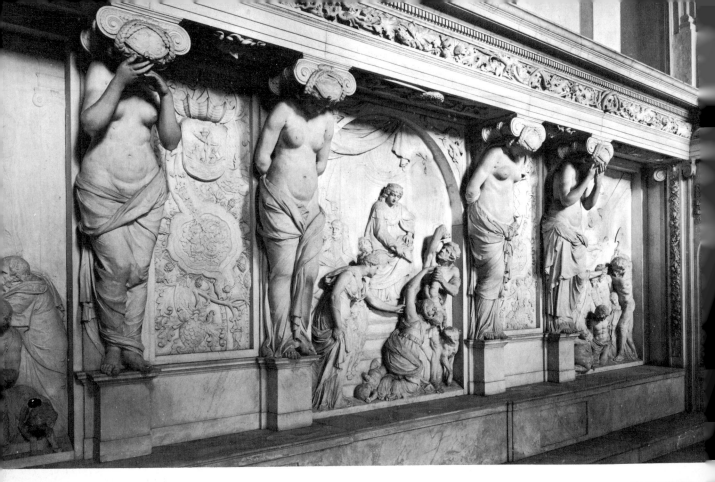

211 Pieter Rijcx
Tomb of Admiral Witte
Cornelisz. de With 1669
Rotterdam, Groote Kerk

212 Rombout Verhulst
Tomb of Admiral Michiel
Adriaensz. de Ruyter
(detail) 1677–81
Amsterdam, Nieuwe Kerk

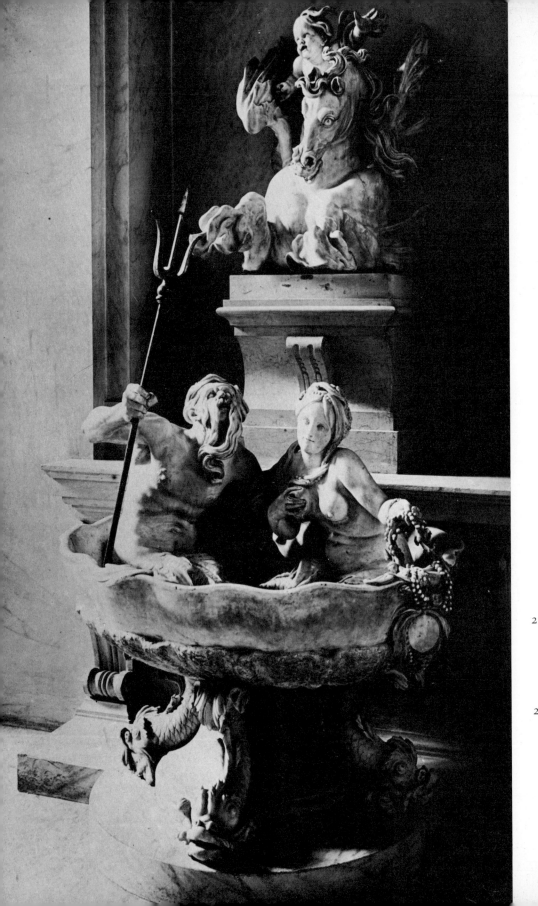

213 Gabriel de Grupello
*Fountain of the Fishmongers'
House c.* 1675
Brussels, Musée Royal des
Beaux-Arts

214 Jean Delcour
*Tomb of Bishop Eugène-Albert
d'Allamont* 1667–70
Ghent, St Bavo

15 Willem Kerricx, Willem
 Ignatius Kerricx and others
 Mount Calvary
 after 1697–after 1740
 Antwerp, St Paul

16 Michiel van der Voort
 Tomb of Ludovicus le Candèle
 c. 1730
 Antwerp, St Jacob

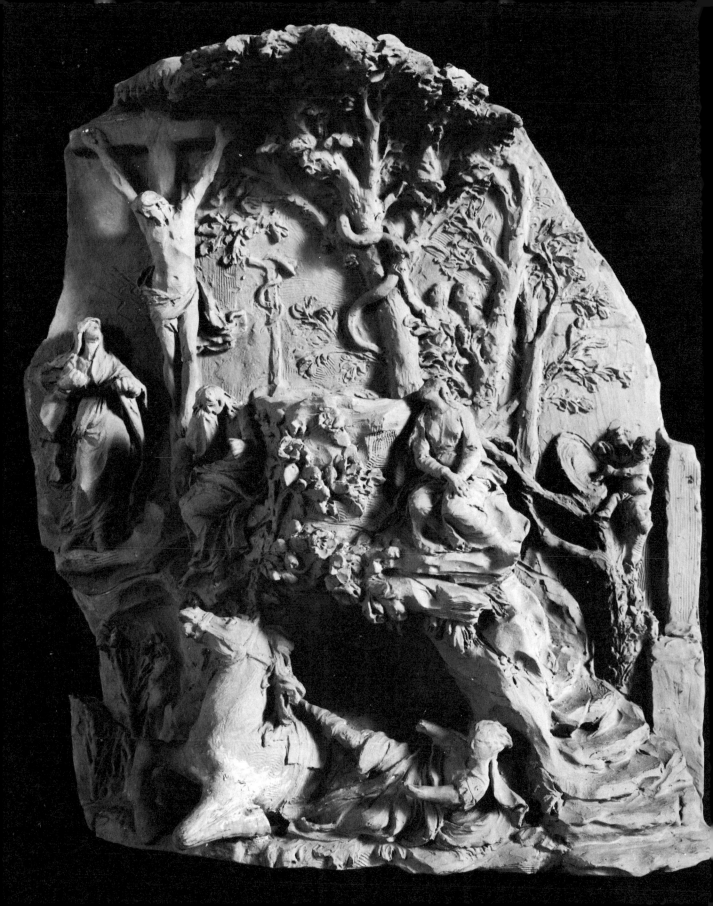

17 Michiel van der Voort
Model of a pulpit 1721
Malines, Stadsmuseum

18 Theodoor Verhaeghen
Pulpit 1743–6
Malines, Onze Lieve Vrouwe
van Hanswijk

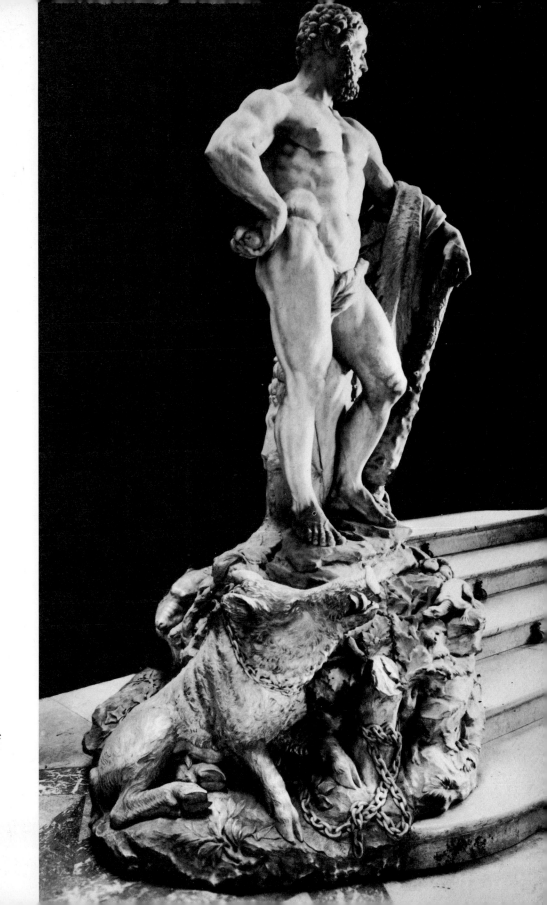

19 Laurent Delvaux
 Pulpit 1772
 Nivelles, Collégiale de
 Ste Gertrude

20 Laurent Delvaux
 Hercules 1770
 Brussels, Musée de Peinture
 Moderne

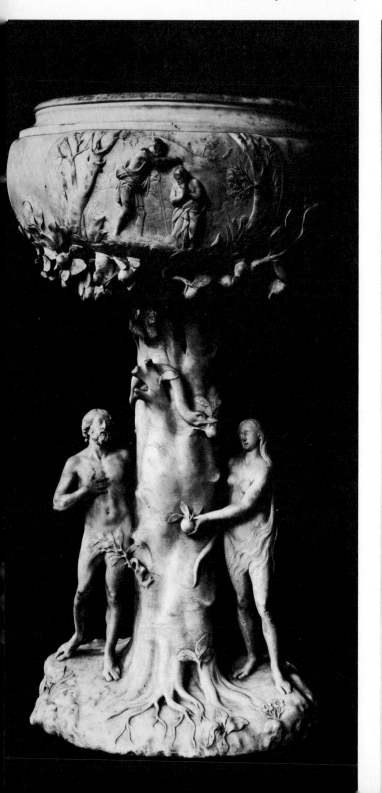

221 Grinling Gibbons
Baptismal font 1684–5
London, St James Piccadilly

222 Grinling Gibbons
The Tobias Rustat monumen
c. 1693–4
Cambridge, Jesus College

Edward Pierce
Bust of Sir Christopher Wren
1673
Oxford, Ashmolean Museum

4 Michael Rysbrack
Bust of Inigo Jones c. 1725–30
Chatsworth House
(Derbyshire)

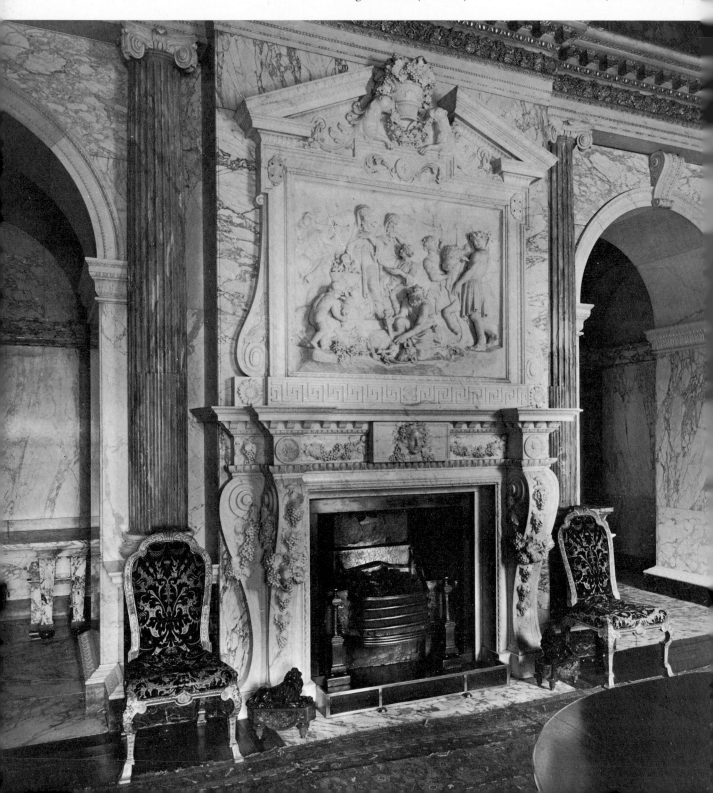

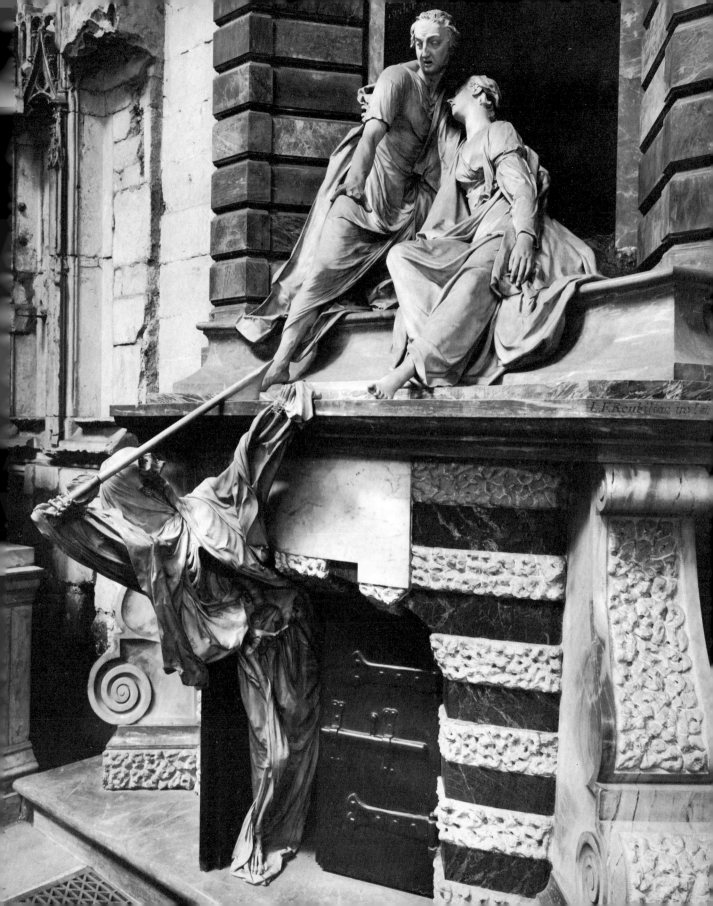

227 Louis François Roubiliac
Bust of Jonathan Swift
before 1749
Dublin, Trinity College

228 Peter Scheemakers
*The William III equestrian
monument* 1732–4
Hull, Market Place

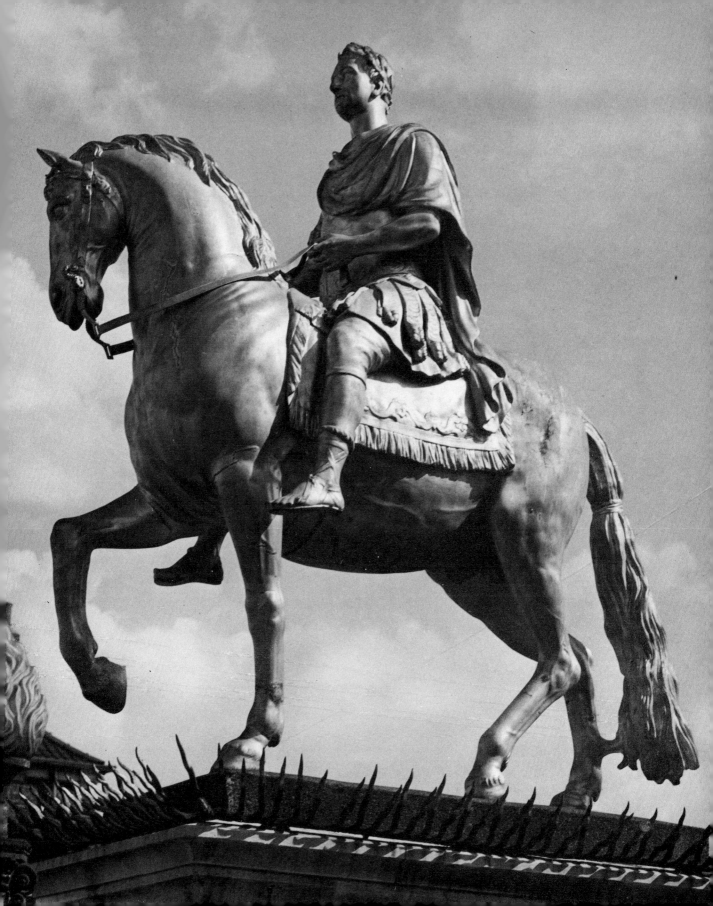

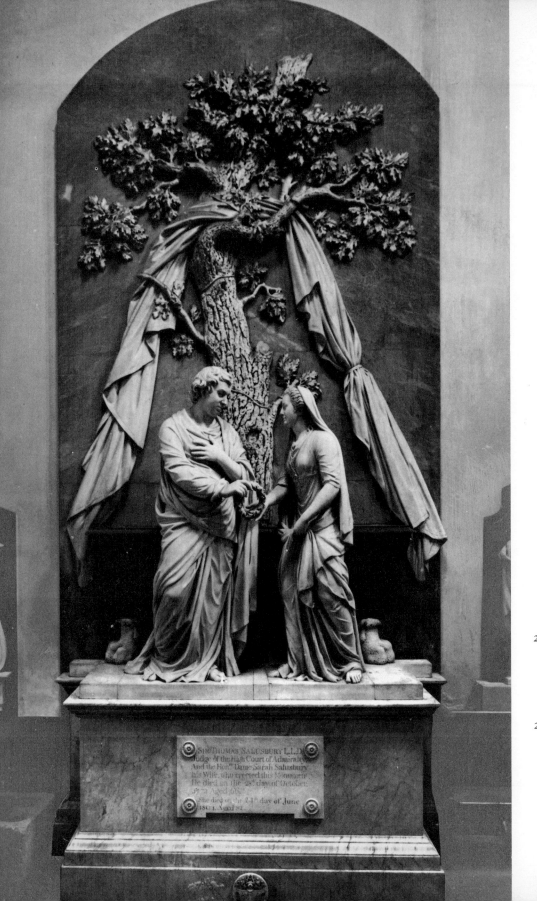

229 Joseph Nollekens
*Tomb of Sir Thomas and
Lady Salusbury* 1777
Offley (Hertfordshire),
St Mary Magdalen

230 John Bacon
Tomb of Thomas Guy 1779
London, Guy's Hospital

DARE ACCIPERE
QUAM

Underneath are deposited the Remains of
THOMAS GUY.
Citizen of London, Member of Parliament,
and the sole Founder of this Hospital
in his Life-time

It is peculiar to this beneficent Man to have persevered during a long course
of prosperous industry in pouring forth to the wants of Others, all that He had
earned by Labour, or withheld from self-indulgence. Warm with Philanthropy,
and exalted by Charity his Mind expanded to those noble affections which grow
but too rarely from the most elevated pursuits. After administring with extensive
Bounty to the claims of Consanguinity. He established this Asylum for that stage
of Languor and Disease to which the Charities of Others had not reached, He
provided a Retreat for hopeless Insanity, and rivalled the endowments of Kings.
He died the 27th of December. 1724 . in the 80th Year of his Age.

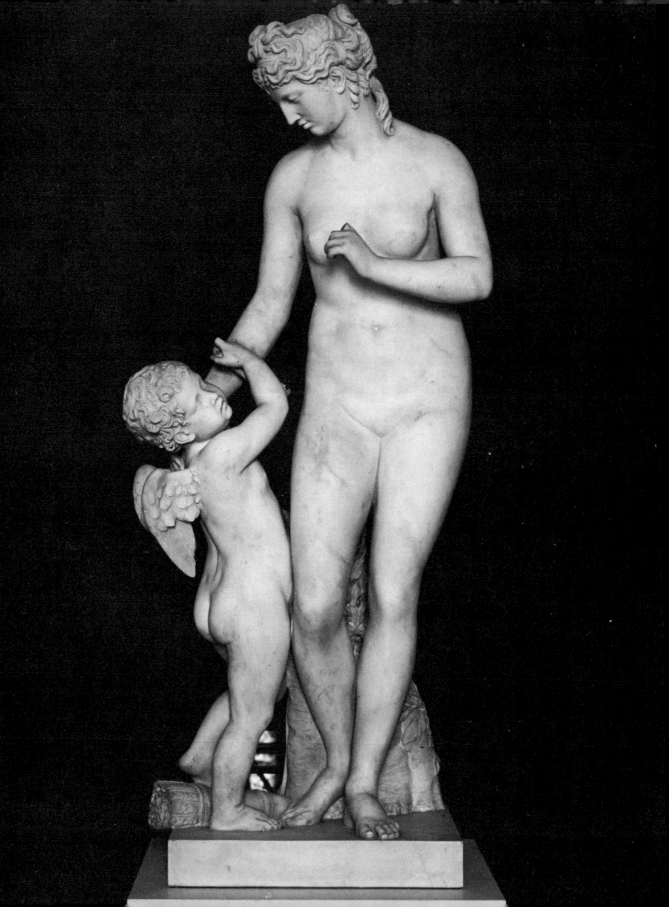

1 Joseph Nollekens
Venus and Cupid 1775–8
Lincoln, Usher Art Gallery

232 Thomas Banks
Thetis and Achilles 1778–9
London, Victoria and Albert
Museum

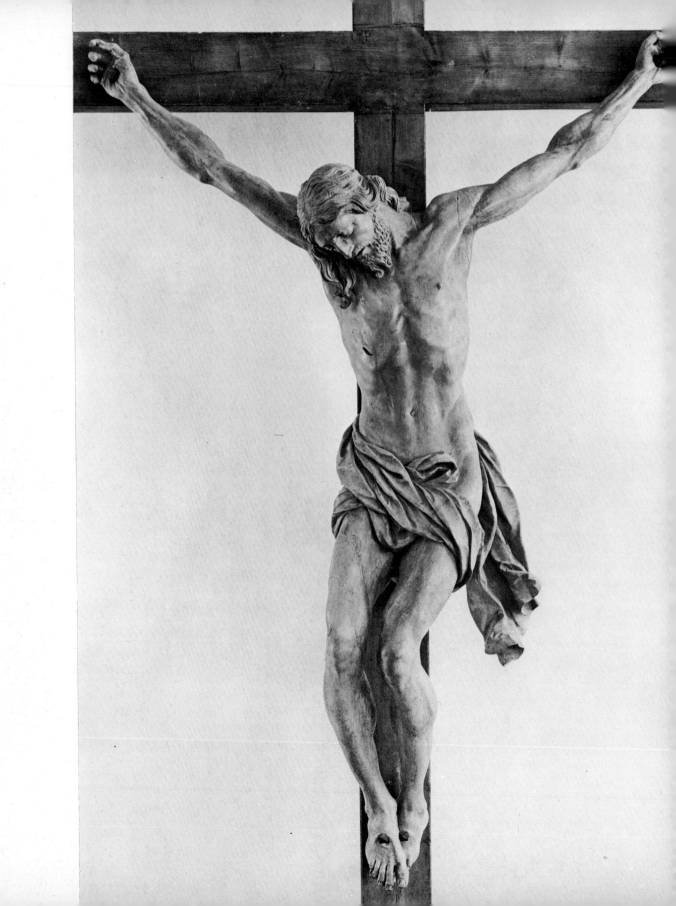

3 Georg Petel
Crucifix c. 1631–2
Marchegg (Lower Austria),
Bahnhofskirche

4 Jörg Zürn
*Shepherds with dog from the
High Altar* 1613–16
Überlingen, Münster

235 Martin Zürn
Virgin and Child 1636–8
Wasserburg am Inn, St Jakob

236 Christoph Daniel Schenck
 Pietà 1684
 Konstanz, Kloster Zoffingen

237 Justus Glesker
 Virgin of the Crucifixion group
 1648–9
 Bamberg, Cathedral

238 Johann Meinrad
 Guggenbichler
 St Leonard Altar 1715–
 Irrsdorf, Pilgrim Chur

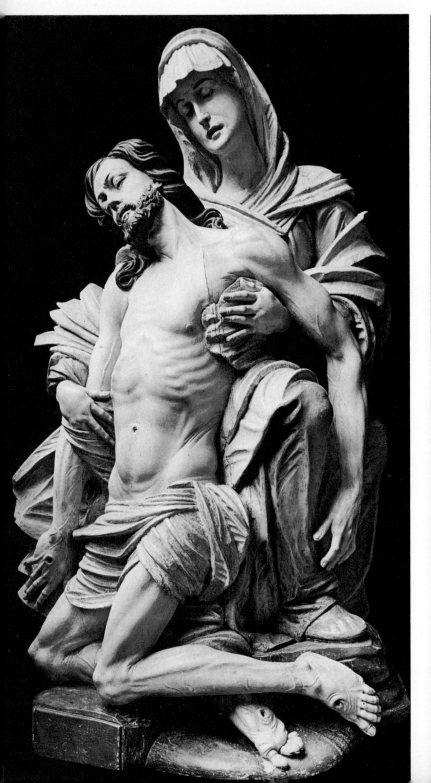

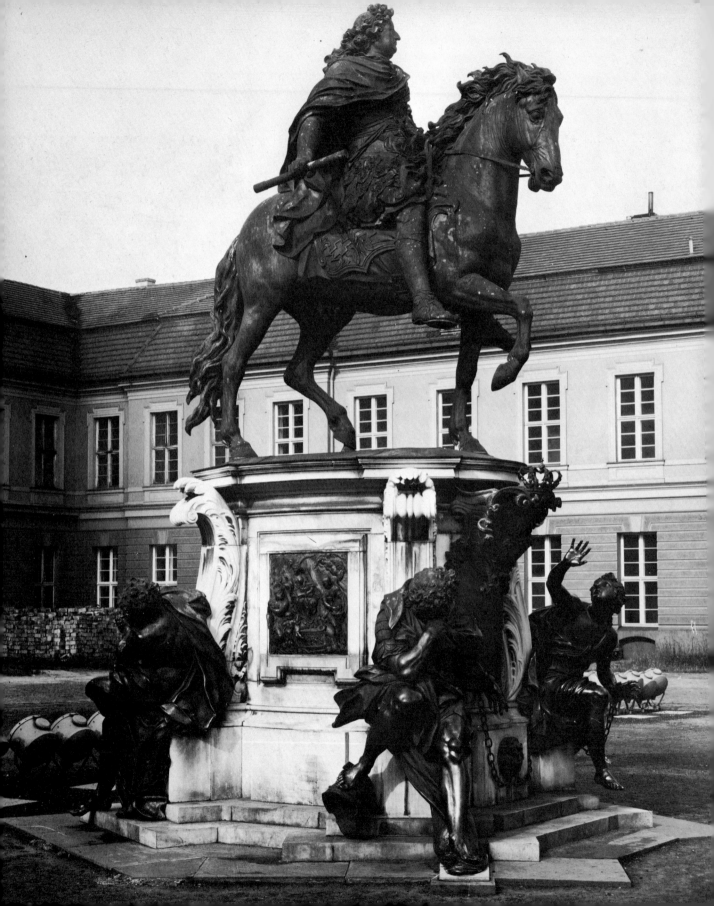

Andreas Schlüter
The Elector Friedrich Wilhelm,
equestrian monument 1696–1710
Berlin, Charlottenburg
Palace

240 Paul Strudel
Statue of the Duke of Alba
between 1696 and 1708
Vienna, Nationalbibliothek

241 Balthasar Permoser
Apotheosis of Prince Eugen
1718–21
Vienna, Österreichisches
Barockmuseum

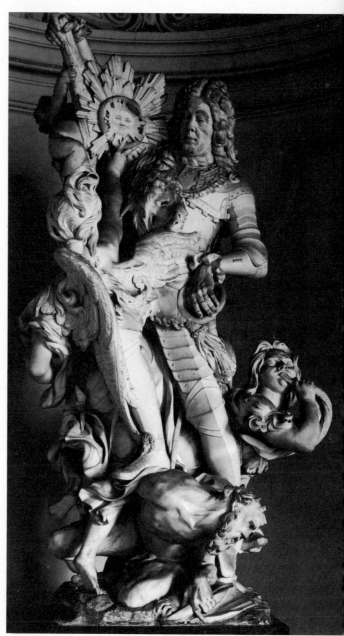

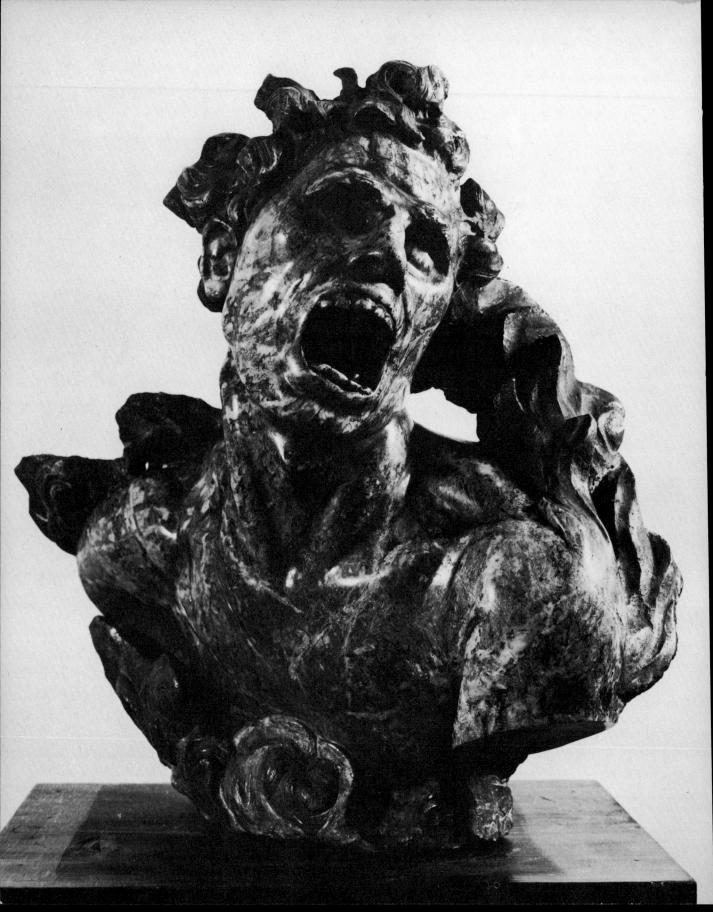

Balthasar Permoser
The damned soul c. 1715
Leipzig, Museum der
Bildenden Künste

243 Andreas Schlüter
Two heads of dying warriors
1696–1700
Berlin, Hof des Zeughauses

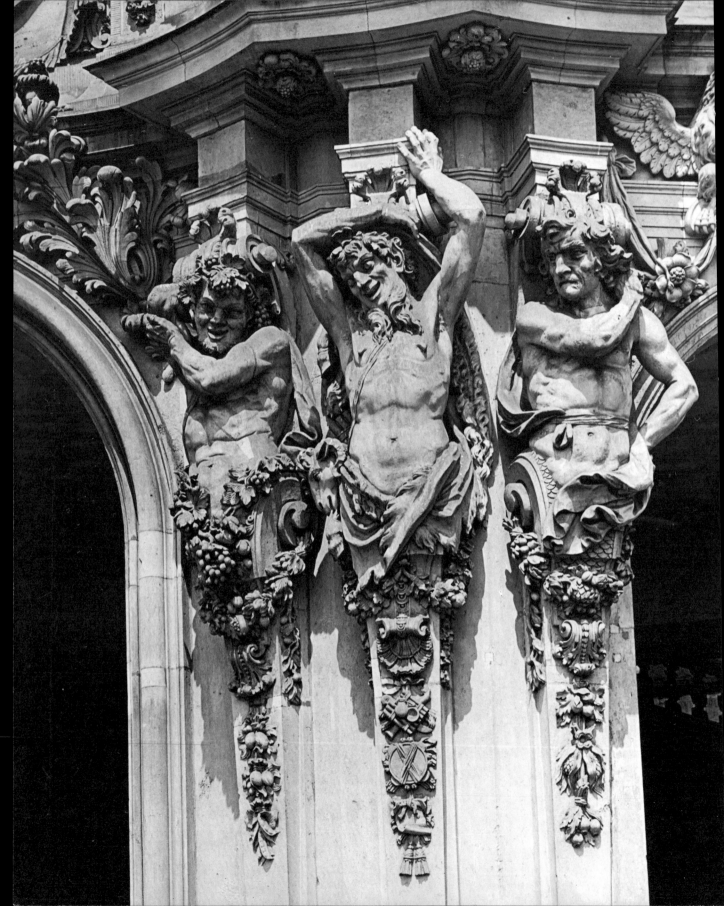

Balthasar Permoser
Three satyrs c. 1717–18
Dresden, Zwinger

245 Matthias Bernhard Braun
St Garinus 1726
Kukus, Bethlehem Garden

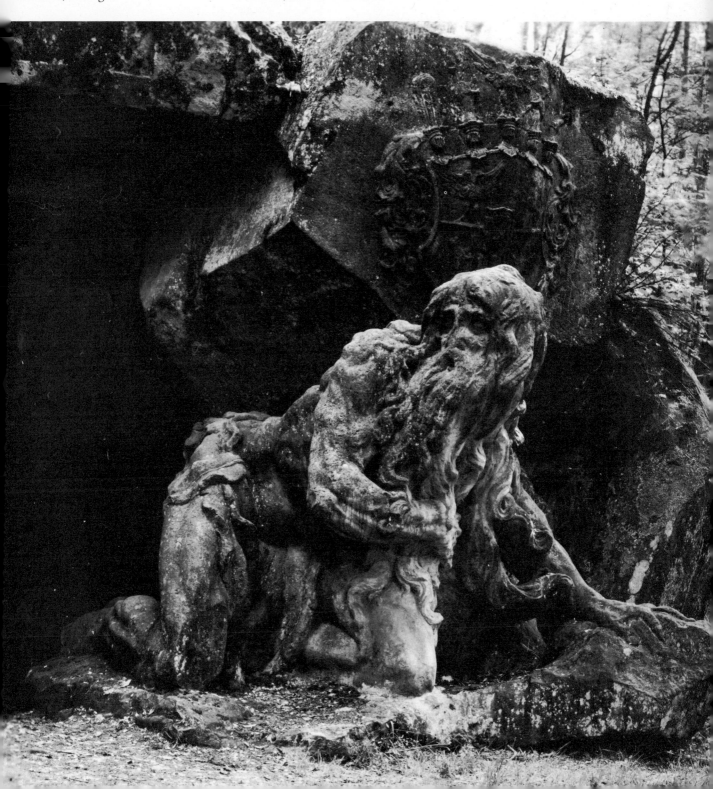

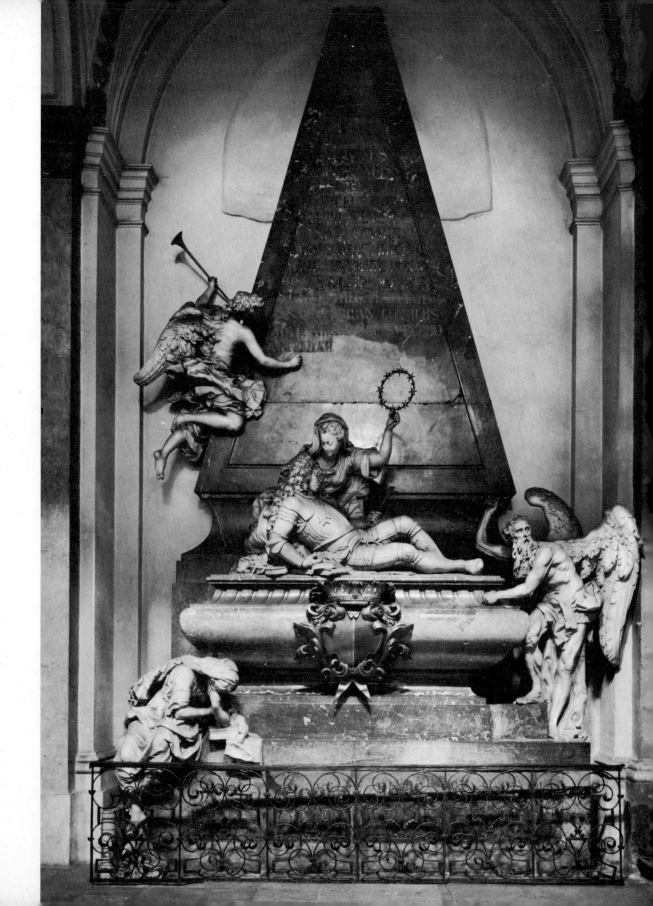

46 Johann B. Fischer von Erlach
and Ferdinand M. Brokoff
Tomb of Count Mitrowitz 1716
Prague, St Jacob

47 Ferdinand Maximilian Brokoff
Sts Vincent Ferrer and Procopius
1712
Prague, Karlsbrücke

248 Lorenzo Matielli
Apollo and Daphne 1731
Eckartsau (Lower Austria),
Jagdschloss

249 Georg Raphael Donner
Apotheosis of Emperor Charles VI
1734
Vienna, Österreichisches
Barockmuseum

250 Georg Raphael Don
*The Perseus–Androme
Fountain* 1740–1
Vienna, Hof des Alt
Rathauses

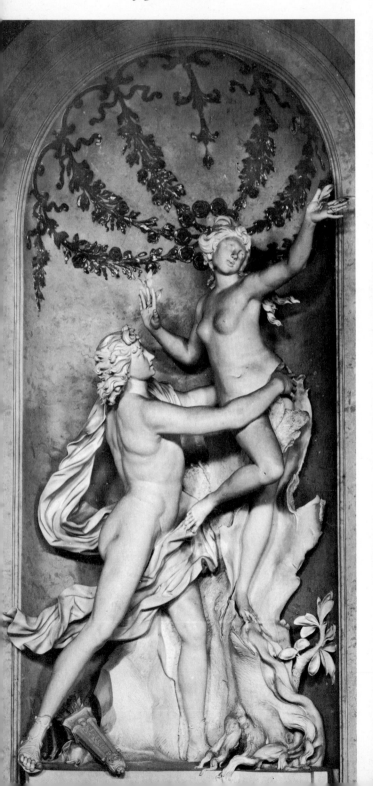

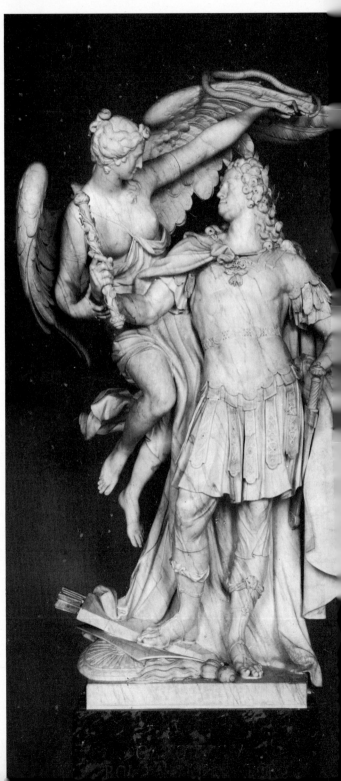

Georg Raphael Donner
Christ and the Woman of
Samaria 1739
Vienna, Österreichisches
Barockmuseum

Georg Raphael Donner
Hagar in the desert 1738–9
Vienna, Österreichisches
Barockmuseum

253 Paul Egell
St Charles Borromeo c. 1740
Berlin (East), Staatliche
Museen

254 Paul Egell
The Miracle of Pentecost 1747–8
Heidelberg, Heilig-Geist-
Kirche

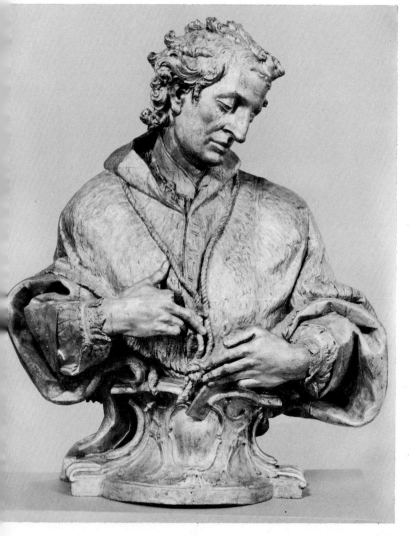

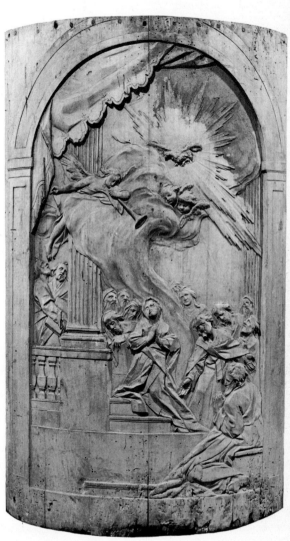

5 Johann Joachim Kändler
Harlequin and Columbine
c. 1745
Amsterdam, Rijksmuseum

6 Matthias Gottlieb Heymüller
Chinese gentlemen at tea c. 1755
Potsdam, Sanssouci Gardens

7 Friedrich Christian Glume
Caryatids 1745–7
Potsdam, Sanssouci Palace

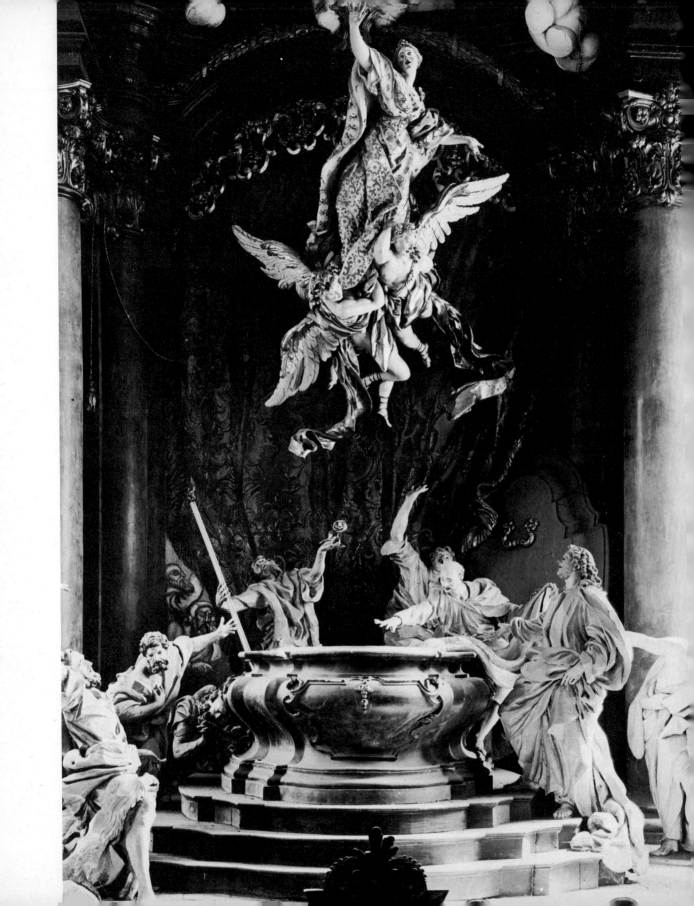

Egid Quirin Asam
The Assumption 1722–3
Rohr (Lower Bavaria),
Augustiner-Klosterkirche

259 Josef Thaddäus Stammel
Martin's Altar 1738–40
St Martin near Graz

260 Josef Matthias Goetz
 The triumph of Faith 1723–4
 Chapel of the Holy Trinity,
 Paura near Lambach
 (Upper Austria)

261 Johann Joseph Christian
 The Prophet Ezekiel 1752–6
 Zwiefalten, Benediktiner-
 Klosterkirche

262 Johann Joseph Christian
 Jacob's dream 1760–4
 Ottobeuren, Benediktiner
 Klosterkirche

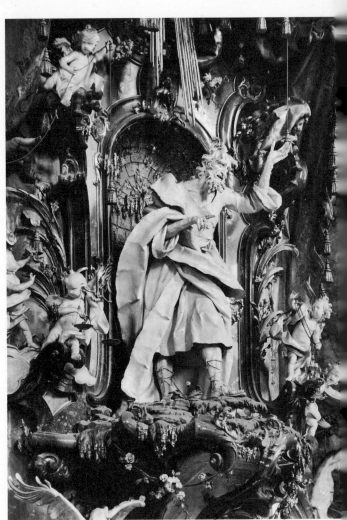

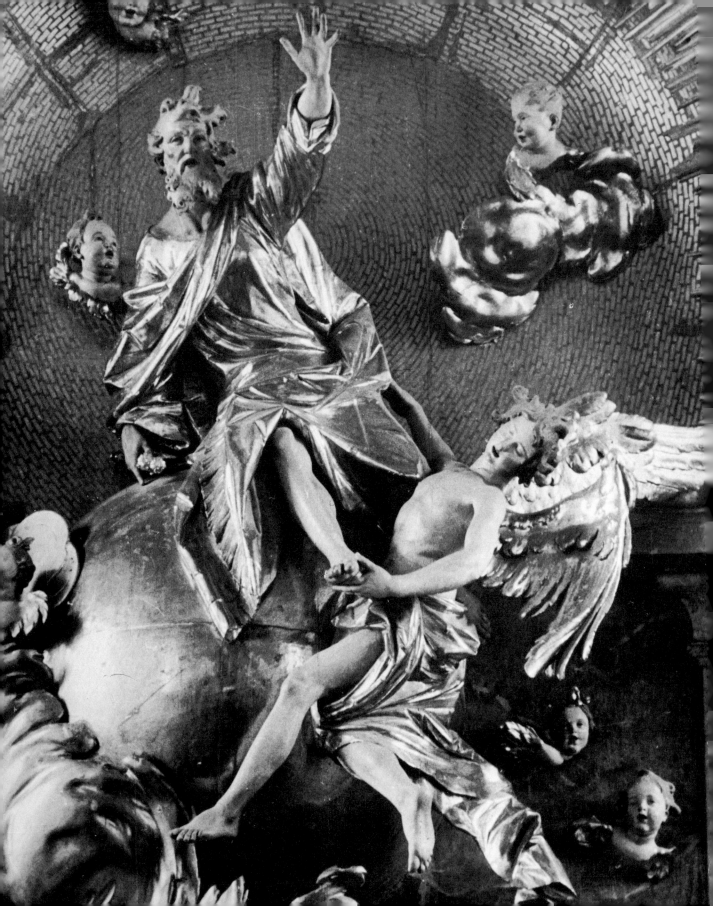

Johann Baptist Straub
*God the Father on the Celestial
Globe* 1766–7
Munich, Berg am Laim,
St Michael

264 Joseph Anton Feuchtmayer
St Elizabeth 1748–50
Birnau near Lake of Constance,
Pilgrim Church

265 Ignaz Günther
St Peter Damian 1762
Rott am Inn, formerly
Benediktiner-Klosterkirche

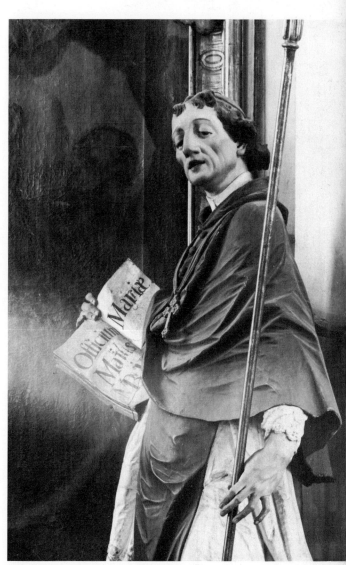

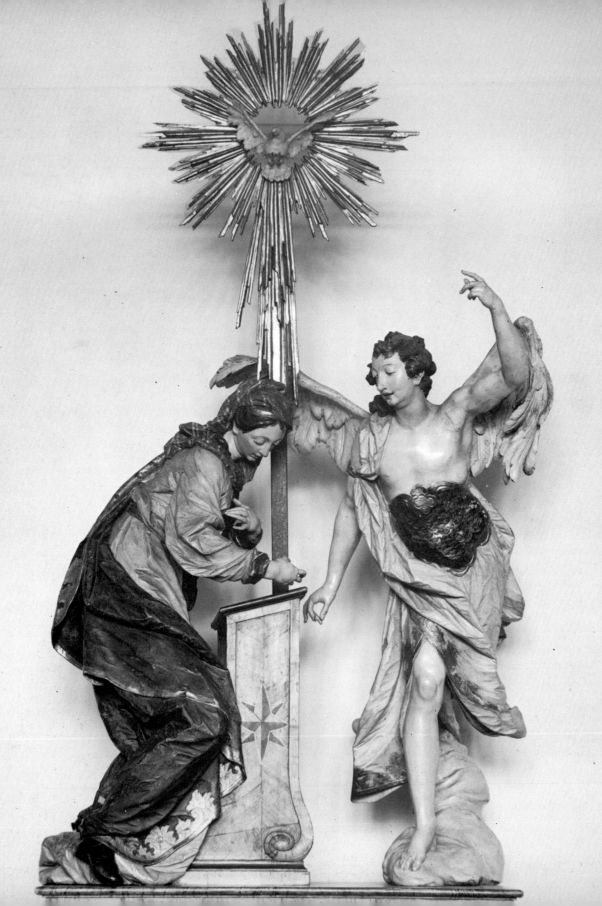

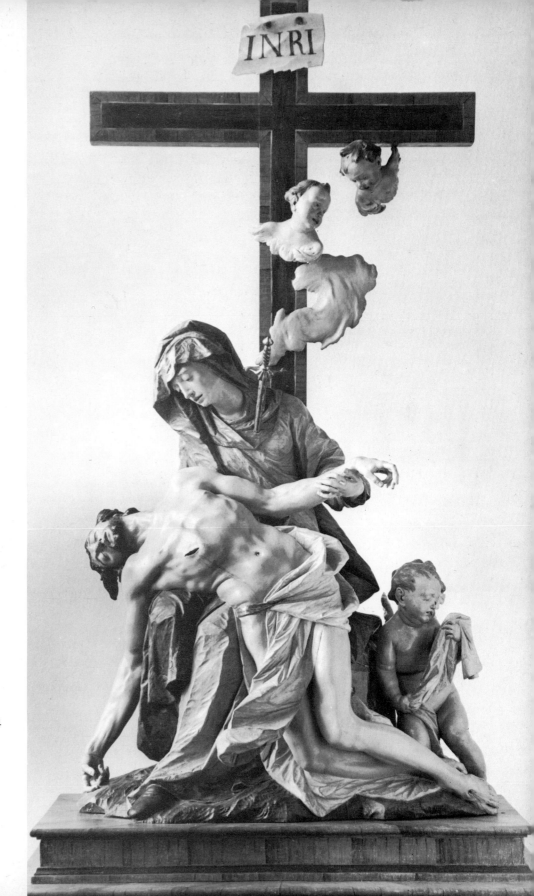

66 Ignaz Günther
The Annunciation 1764
Weyarn (Upper Bavaria),
Collegiate Church

67 Ignaz Günther
The Lamentation of Christ 1764
Weyarn (Upper Bavaria),
Collegiate Church

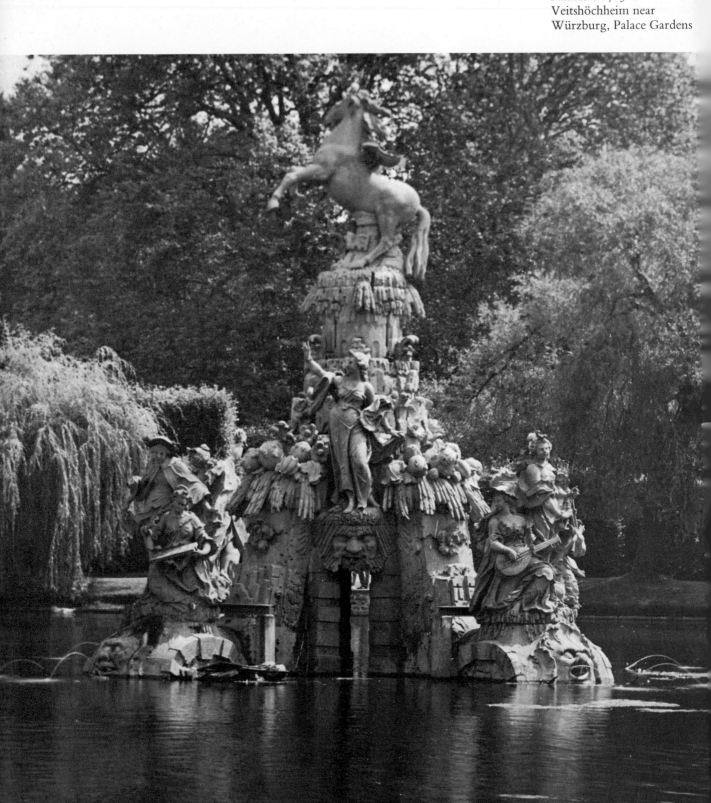

268 Ferdinand Tietz
Parnassus 1765–6
Veitshöchheim near
Würzburg, Palace Gardens

Ferdinand Tietz
A nobleman dancing 1767–8
Veitshöchheim near
Würzburg, Palace Gardens

270 Ferdinand Tietz
A lady dancing 1767–8
Veitshöchheim near
Würzburg, Palace Gardens

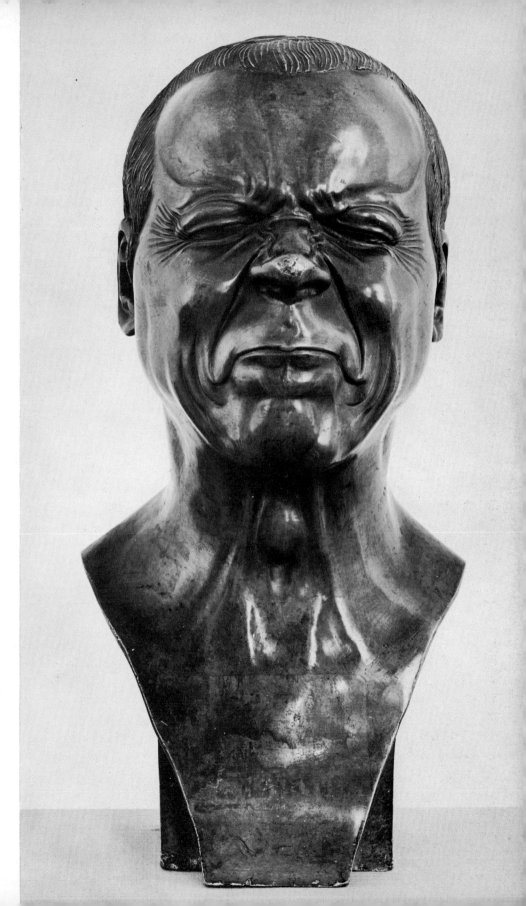

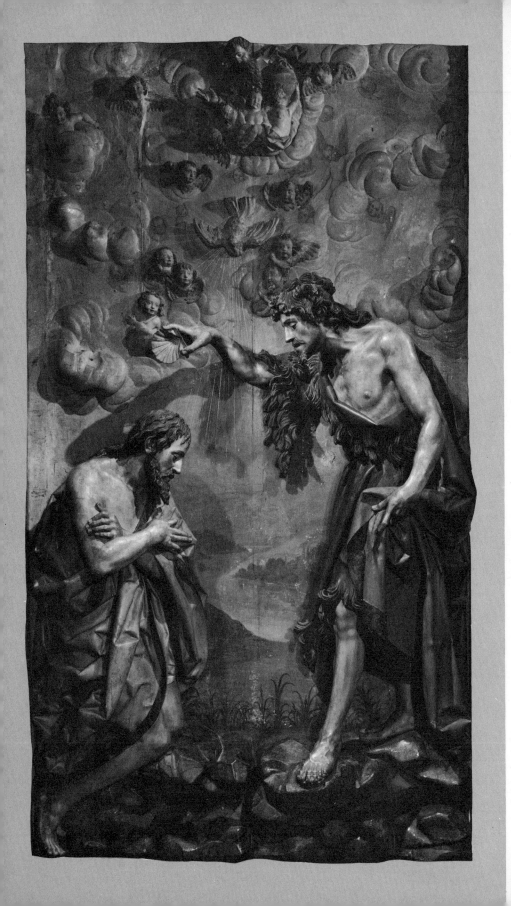

274 Gregorio Fernández
The Baptism of Christ 1624–3
Valladolid, Museo Nacional
de Escultura

275 Antonio de Paz
High Altar 1644–60
Salamanca, Convento de
Sancti-Spíritus

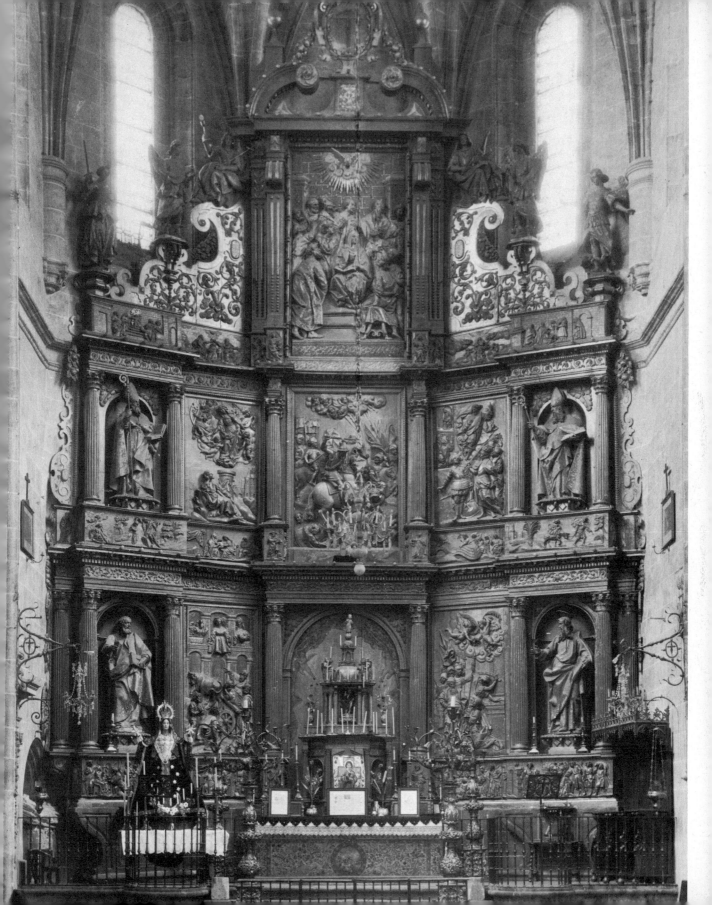

276 Juan Martínez Montañés
*The earthly and the divine
Trinity*, after 1609
Seville, S. Ildefonso

277 Juan Martínez Montañés
St Ignatius 1610
Seville, Capilla de la
Universidad

278 Gregorio Fernández
St Mary Magdalen befor
Madrid, Convento de la
Descalzas Reales

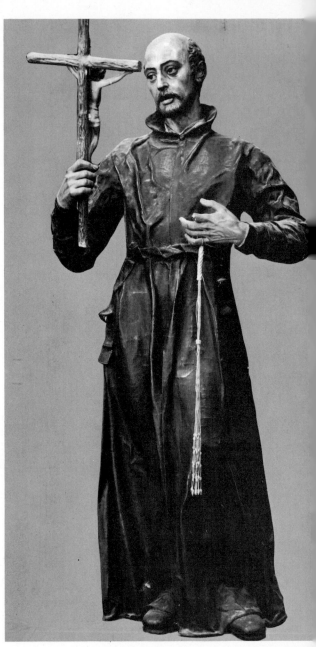

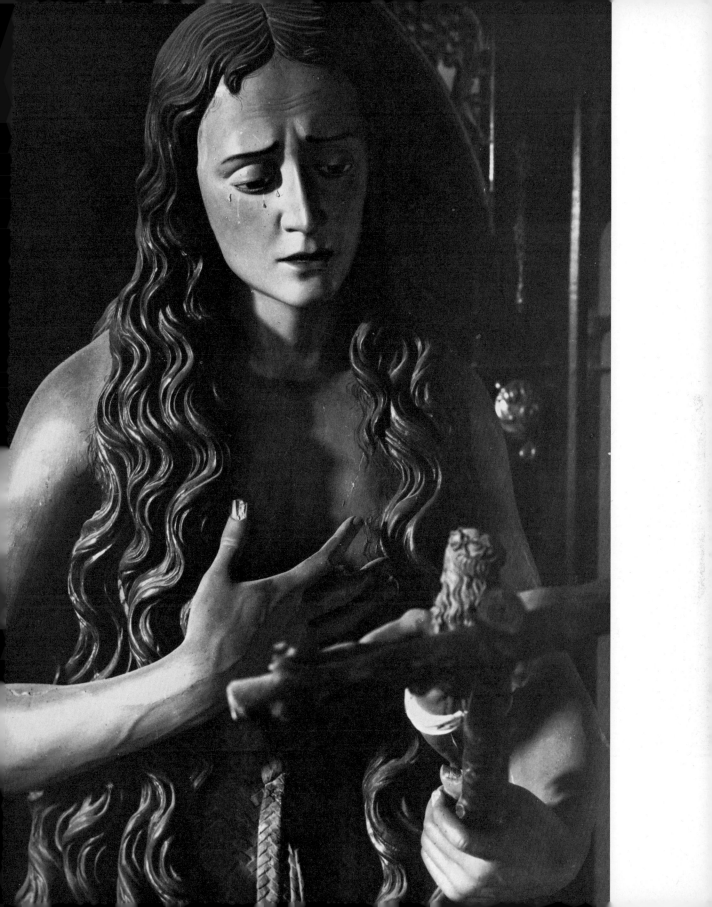

279 Pedro de Mena
St Joseph and the young Jesus
between 1658 and 1662
Malaga, Cathedral

280 Juan Martinez Montañés
St Anne and the young Virgin
1632–3
Seville, Iglesia del Buen Suceso

281 Alonso Cano
St John the Baptist 16
Barcelona, Collectio
de Güell

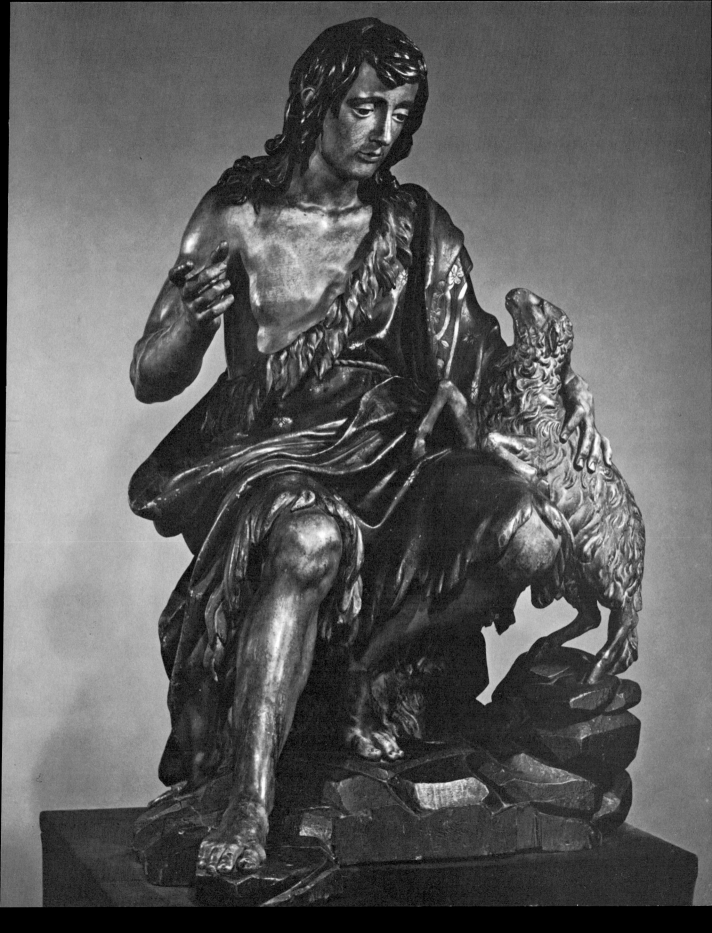

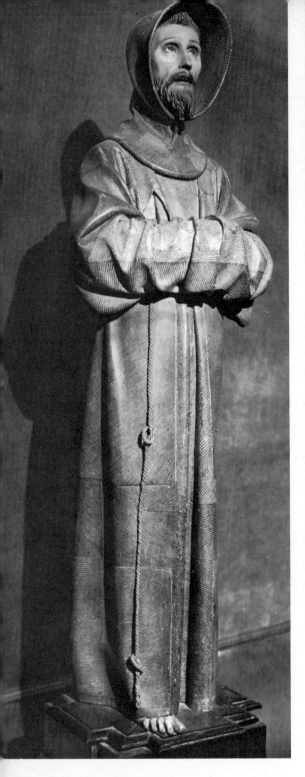

282 Pedro de Mena
St Francis c. 1663
Toledo, Cathedral

283 José de Mora
St Pantaleon
between 1705 and 1712
Granada, S. Ana

284 José de Mora
St Teresa
between 1700 and 17
Córdoba, Cathedral

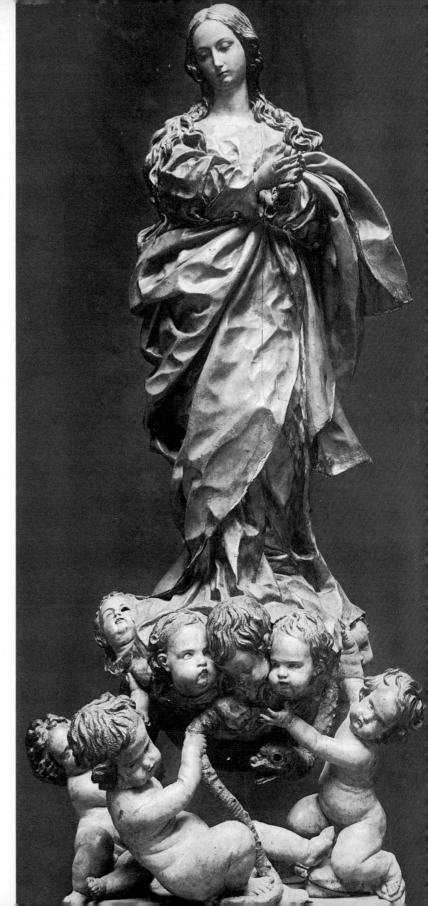

285 José de Mora
The Immaculate Conception
c. 1665
Granada, SS. Justo y Pástor

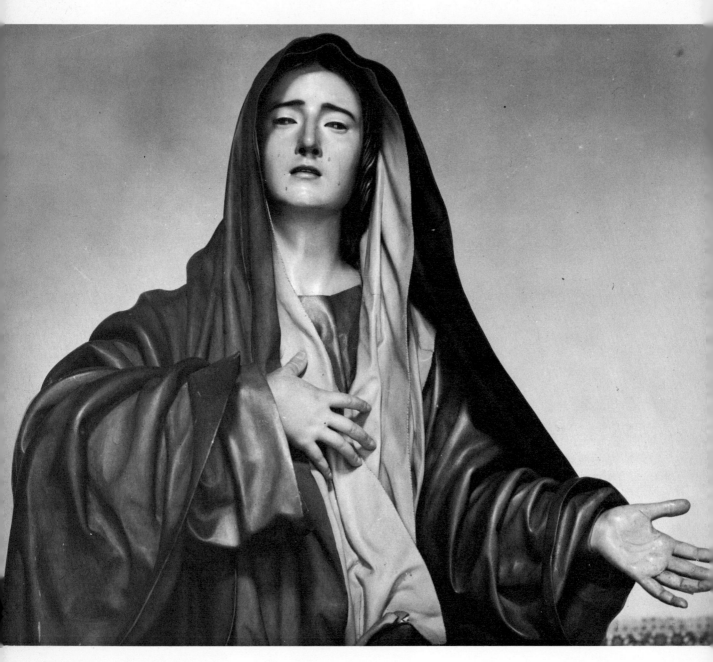

286 Pedro de Mena
Mater Dolorosa (detail) 1673
Madrid, Convento de las
Descalzas Reales

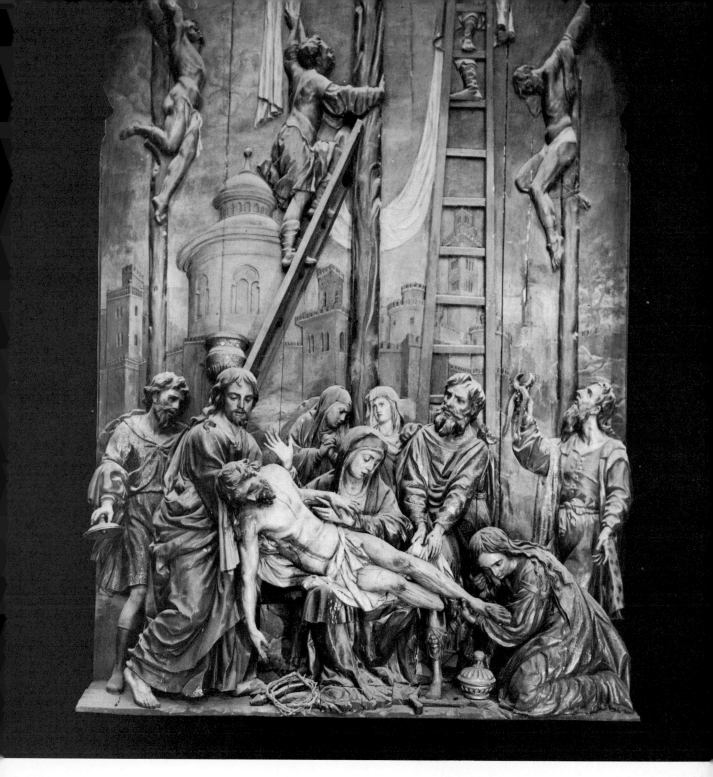

87 Pedro Roldan
The Lamentation (detail)
1664–9
Seville, Parroquia del
Sagrario

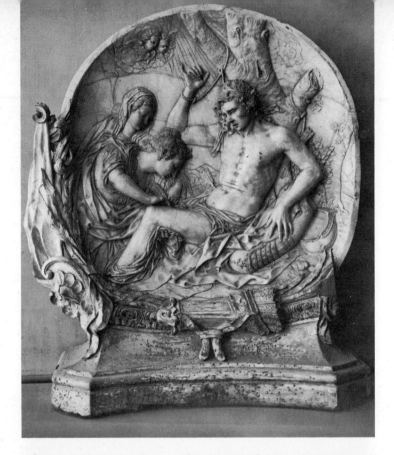

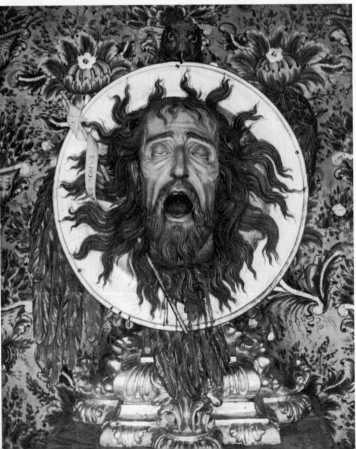

288 Luis Bonifás
 St Sebastian c. 1763
 Madrid, Academia de
 San Fernando

289 Juan Alonso Villabrille ?
 Head of St John the Baptist
 between 1700 and 1720
 Granada, S. Juan de Dios

290 Francisco Salzillo
 The Agony in the Garden
 (detail) 1754
 Murcia, Museo Salzillo

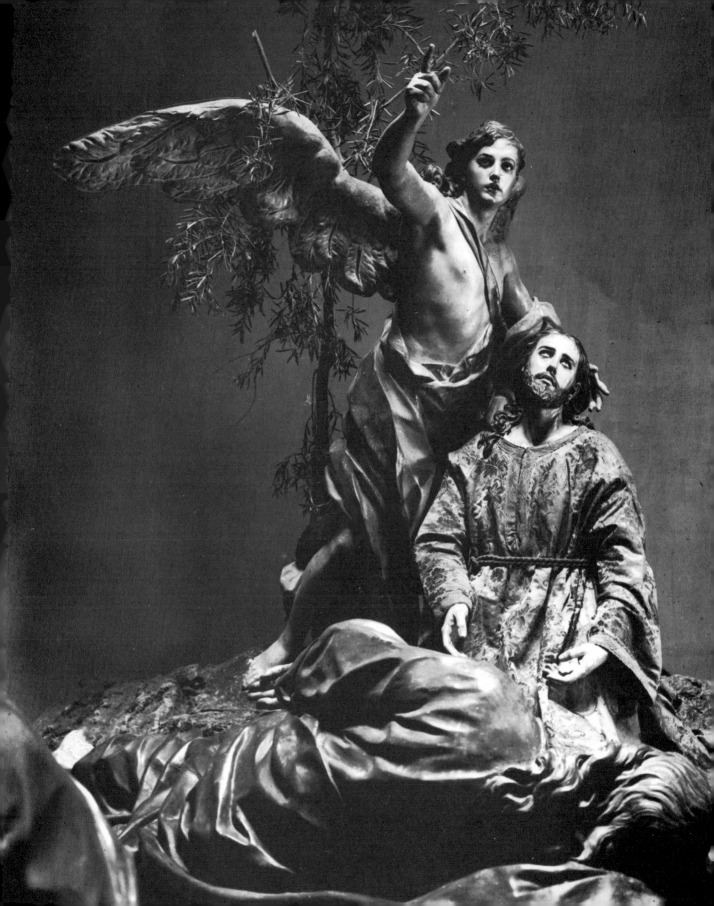

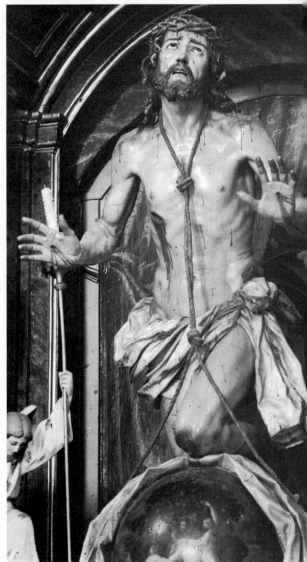

291 Francisco Salzillo
*Virgin and Child with the
little St John c.* 1745
Murcia, Museo de la Catedral

292 Luis Salvador Carmona
Ecce Homo c. 1754
Atienza, Iglesia de la Trinidad

293 Luis Salvador Carmona
The Assumption of the Virgi
1749
Serradilla (Cáceres), Parish
Church

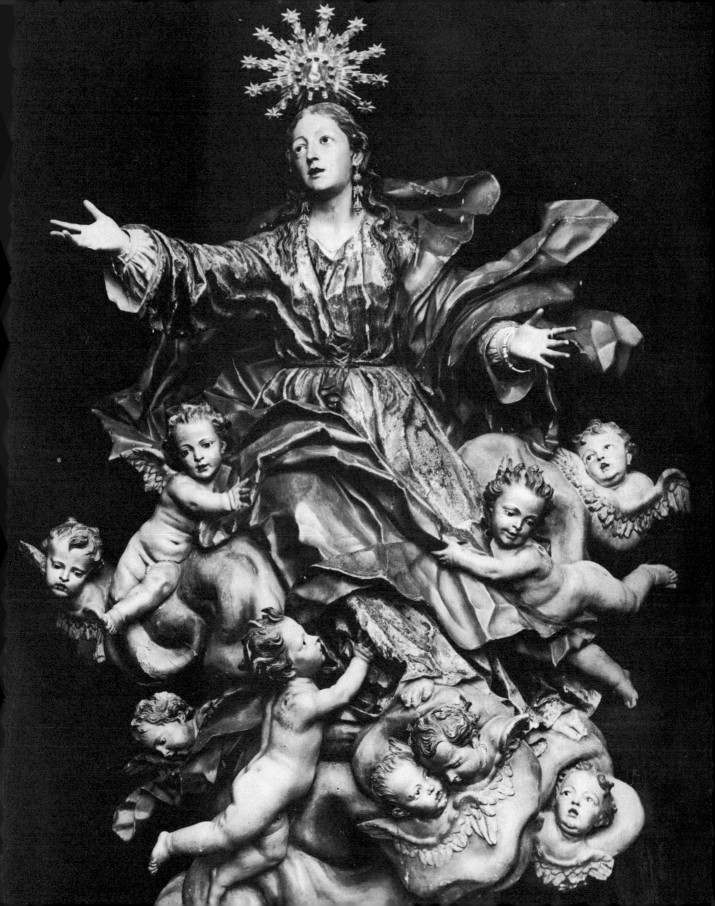

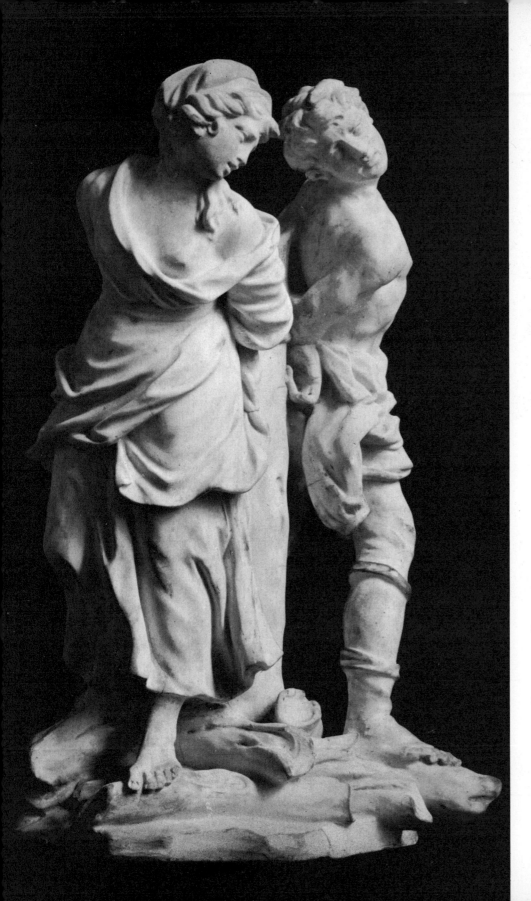

294 Carlos Gricci
The unhappy union c. 1785–90
Madrid, Museo Arqueológico
Nacional

295 Francisco Sabatini and
Francisco Gutiérrez
Tomb of Fernando VI
after 1761
Madrid, Sta Barbara

HIC IACET HVIVS COENOBII CONDITOR
FERDINANDVS VI. HISPANIARVM REX
OPTIMVS PRINCEPS, QVI SINE LIBERIS,
AT NVMEROSA VIRTVTVM SOBOLE PATER
PATRIAE, OBIIT IV. ID. AVG. AN. MDCCLIX.
CAROLVS III. FRATRI DILECTISSIMO,
CVIVS VITAM REGNO PRAEOPTASSET,
HOC MOERORIS & PIETATIS MONVMENTVM.

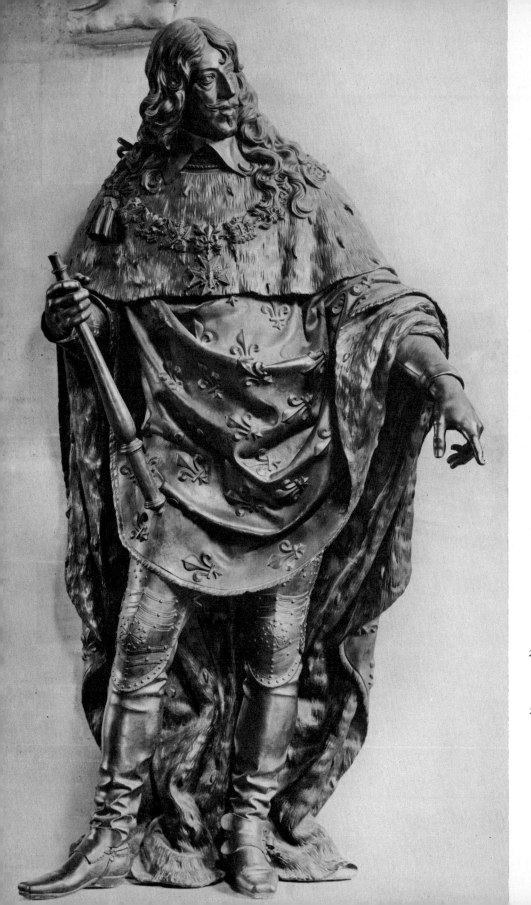

296 Simon Guillain
Statue of Louis XIII 1647
Paris, Louvre

297 Jean Warin
Bust of Cardinal Richelieu
after 1640
Paris, Bibliothèque Marazine

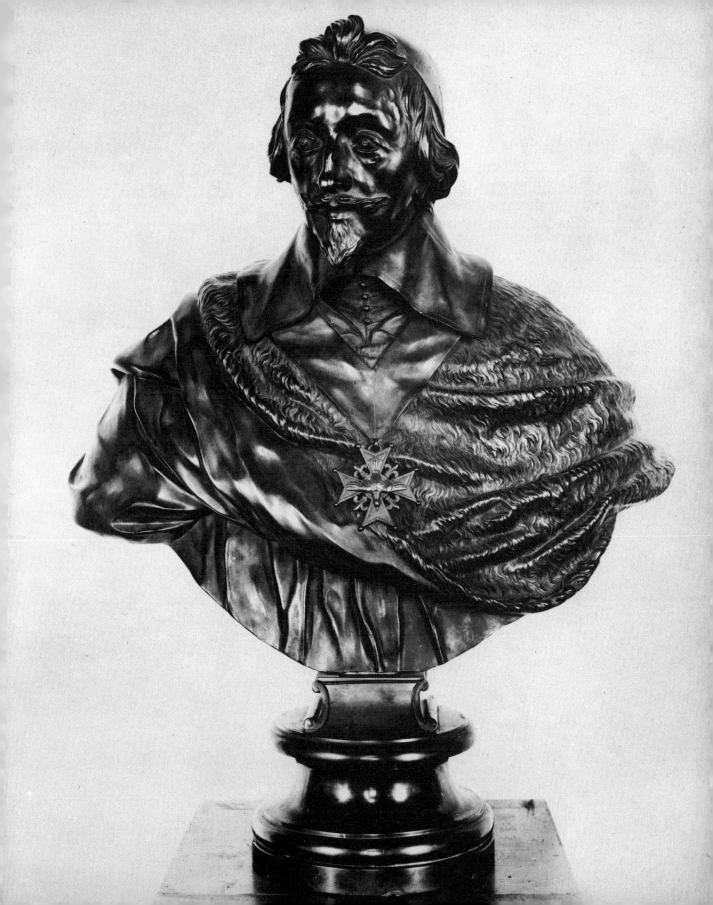

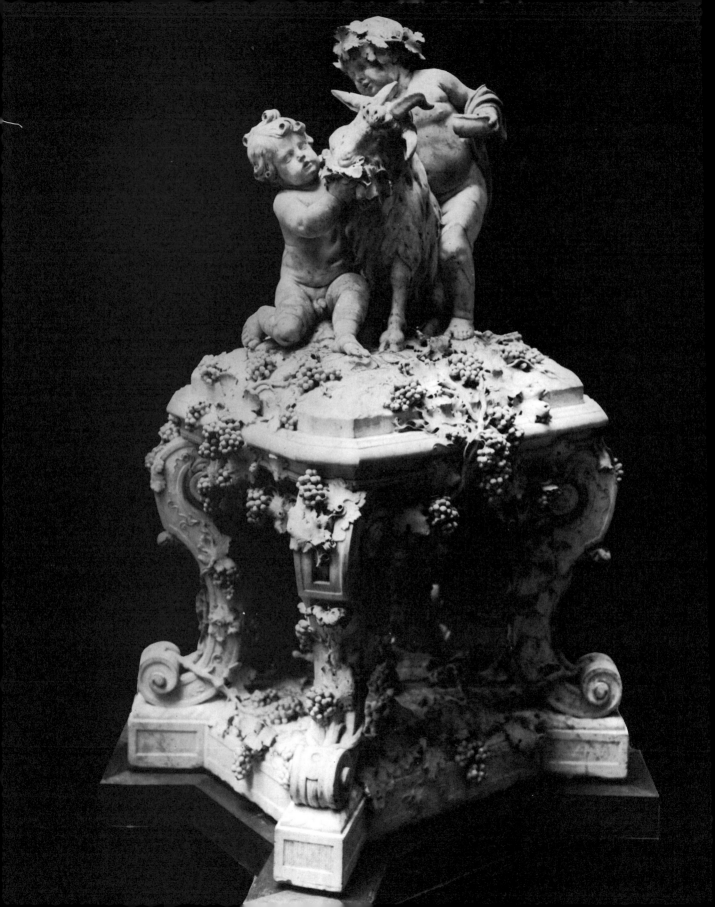

Jacques Sarrazin
Two children with a goat 1640
Paris, Louvre

299 Jacques Sarrazin
Religion before 1648–63
Chantilly, Palace Chapel

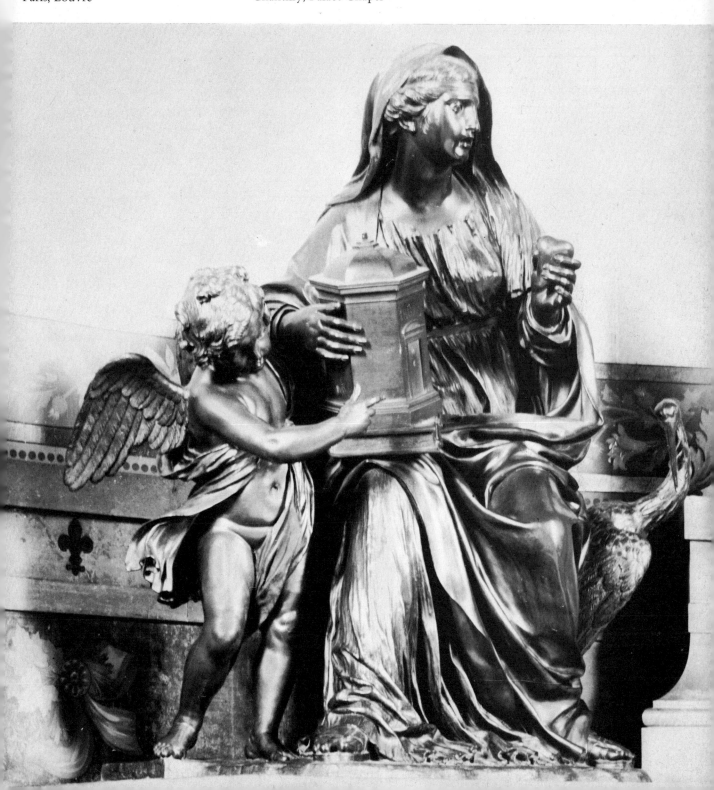

Michel Anguier
Hercules c. 1652–4
Valenciennes, Musée des
Beaux-Arts

Michel Anguier
Mars c. 1652–4
Valenciennes, Musée des
Beaux-Arts

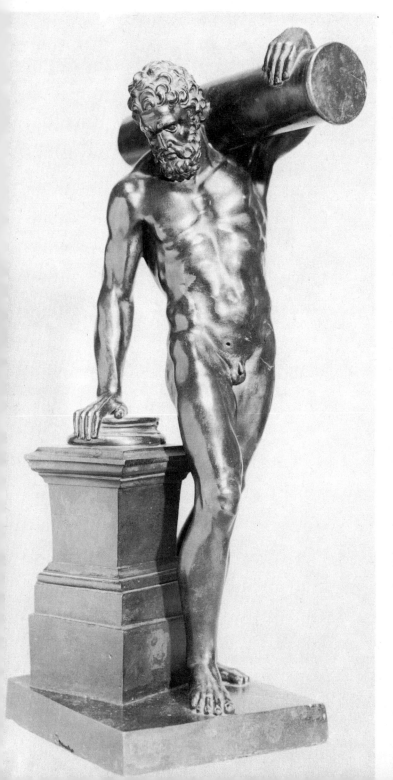

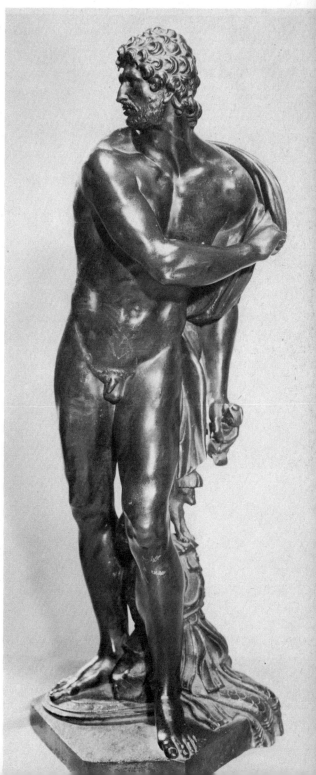

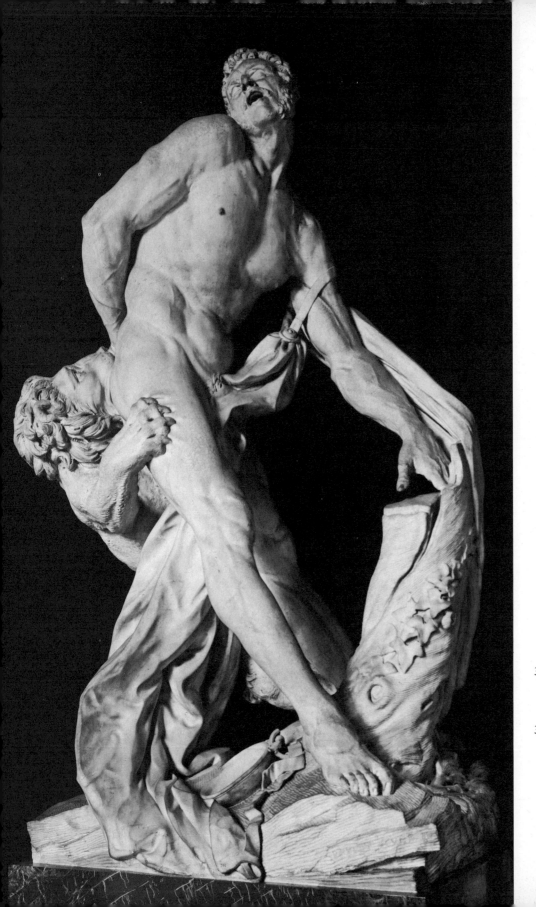

303 Pierre Puget
Milo of Crotone 1672–82
Paris, Louvre

304 Pierre Puget
Perseus and Andromeda 1678–8
Paris, Louvre

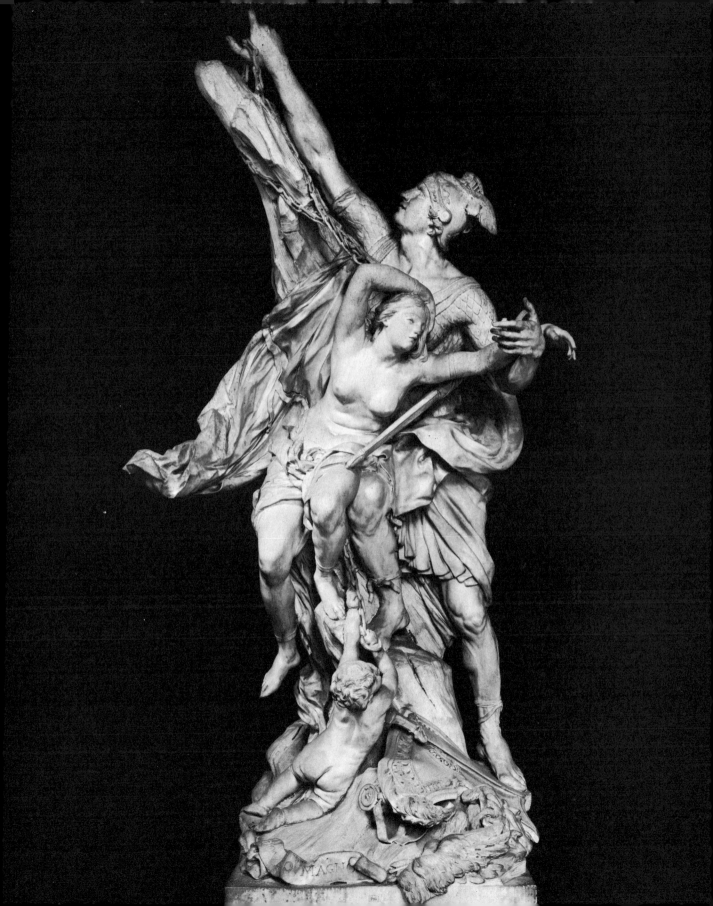

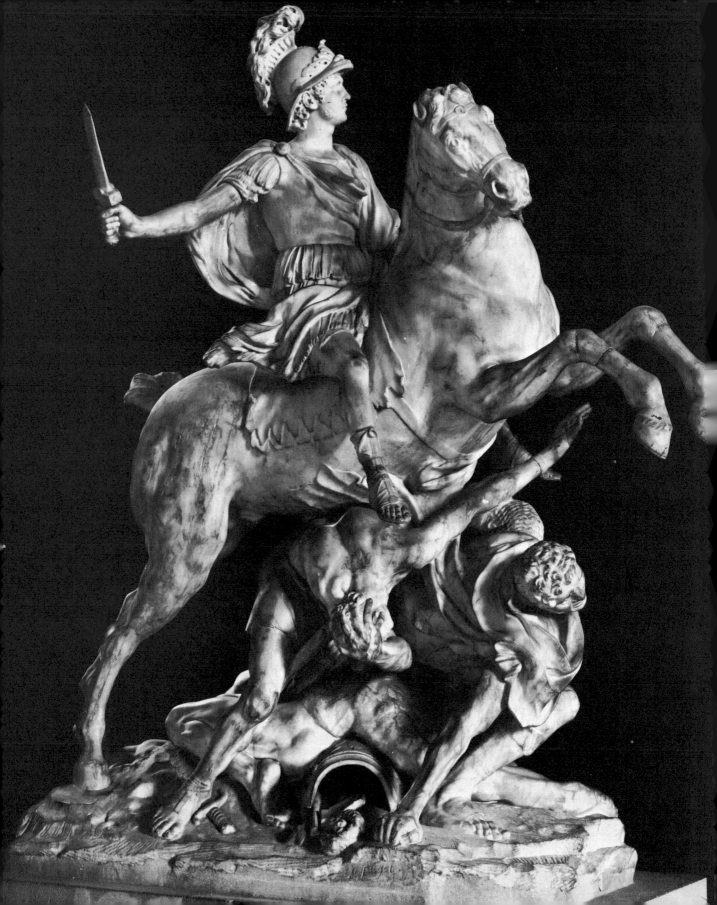

5 Pierre Puget
Louis XIV as Alexander
between 1685 and 1688
Paris, Louvre

306 Pierre Puget
Alexander and Diogenes
1671–93
Paris, Louvre

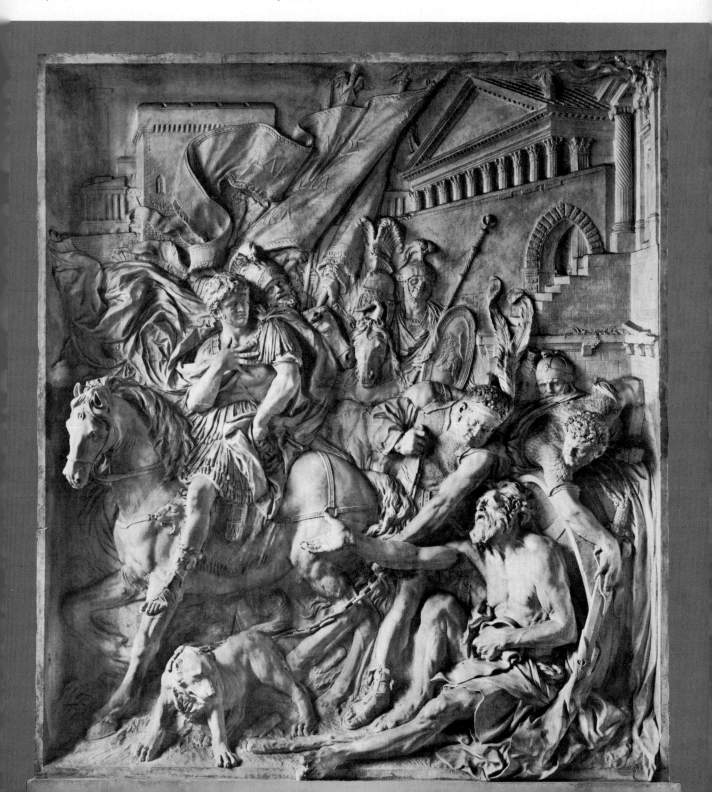

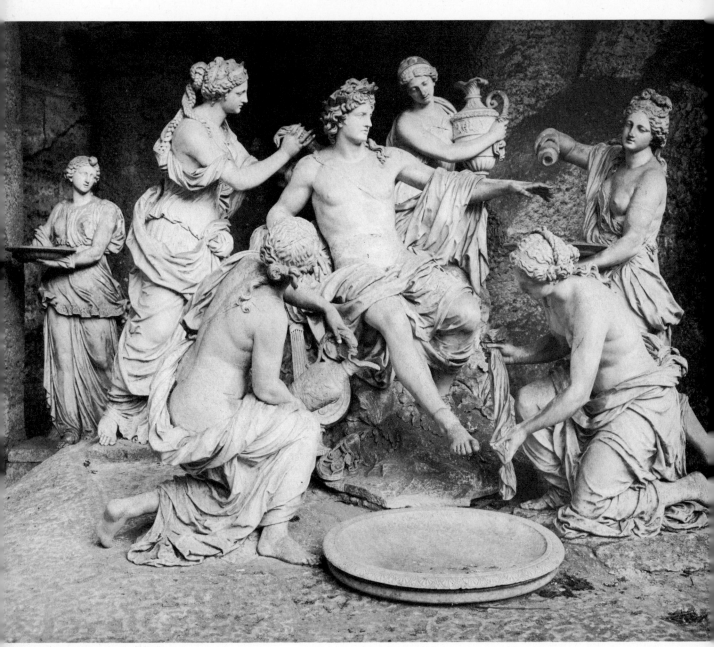

307 François Girardon and
Thomas Regnaudin
Apollo and the nymphs 1666–73
Versailles, Palace Gardens

308 François Girardon
The rape of Proserpina 1677–9
Versailles, Palace Gardens

309 François Girardon
Sapience 1693–4
Tonnerre (Yonne), Hospital

310 Martin Desjardins
Vigilance 1693–4
Tonnerre (Yonne), Hospital

311 Martin Desjardins
Louis XIV on horseback
between 1686 and 1688
London, Wallace Collection

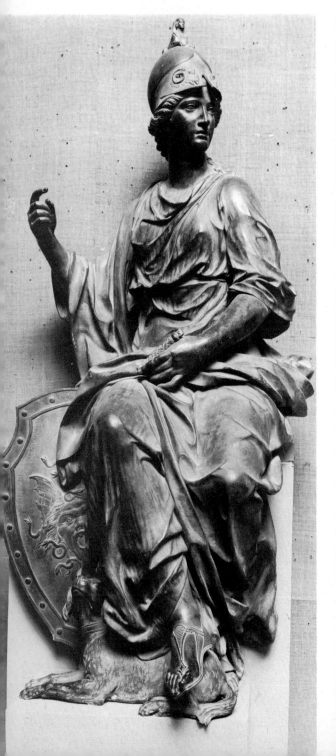

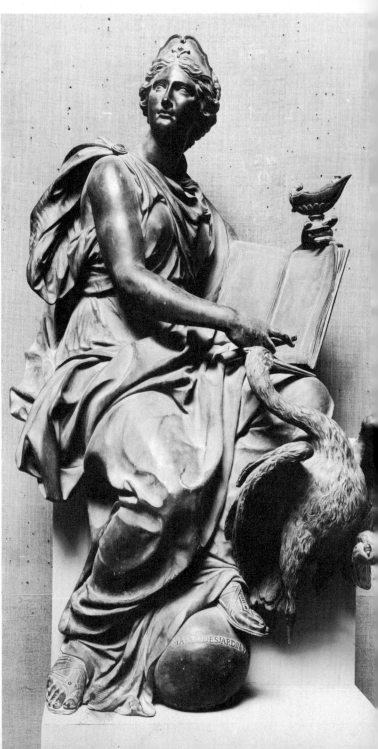

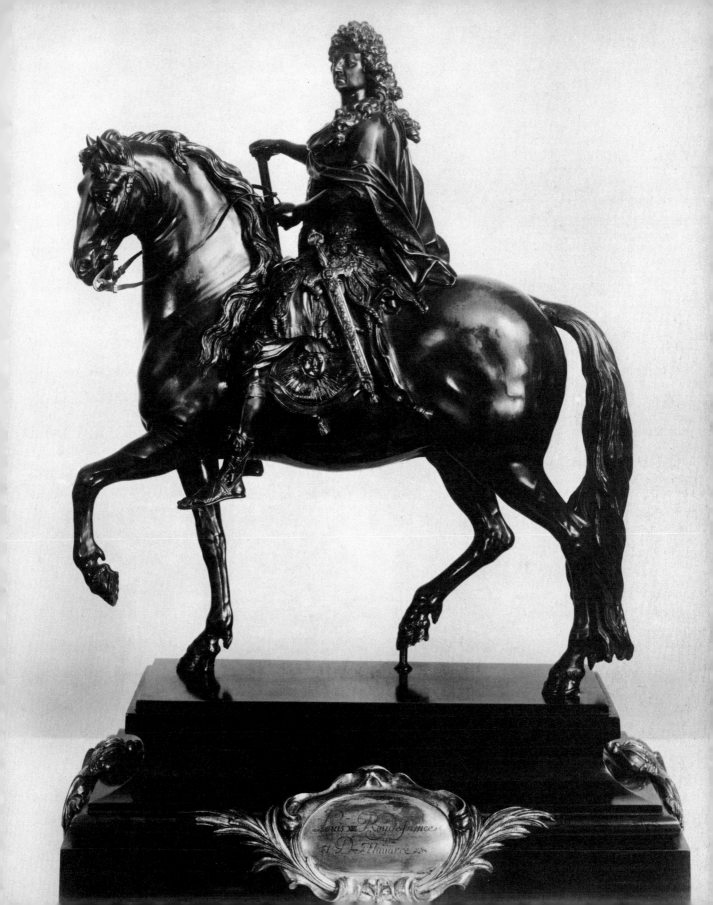

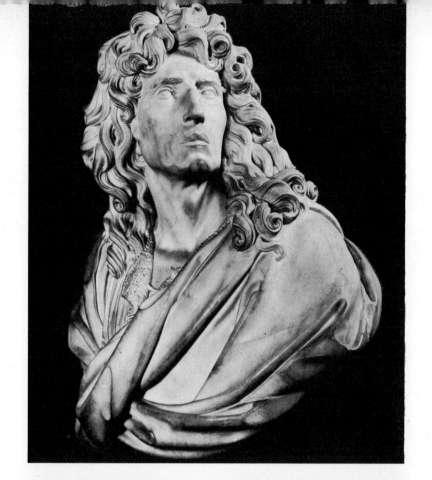

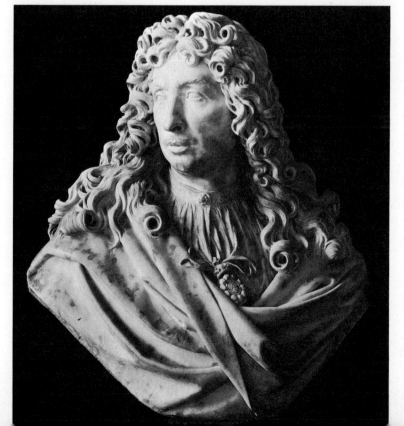

12 Antoine Coysevox
 Tomb of Marquis de Vauban
 1680–1
 Serrant (Maine-et-Loire)
 Palace Chapel

13 Martin Desjardins
 Bust of Pierre Mignard,
 before 1689
 Paris, Louvre

14 Antoine Coysevox
 Bust of Charles Le Brun 1679
 Paris, Louvre

5 Antoine Coysevox
La Renommée 1700–2
Paris, Jardin des Tuileries

316 Guillaume Coustou
A horse-tamer from Marly
1740–5
Paris, Champs-Élysées

8 Nicolas Coustou
Louis XV as Jupiter 1726–33
Paris, Louvre

319 Guillaume Coustou
Marie Leczinska as Juno 1731
Paris, Louvre

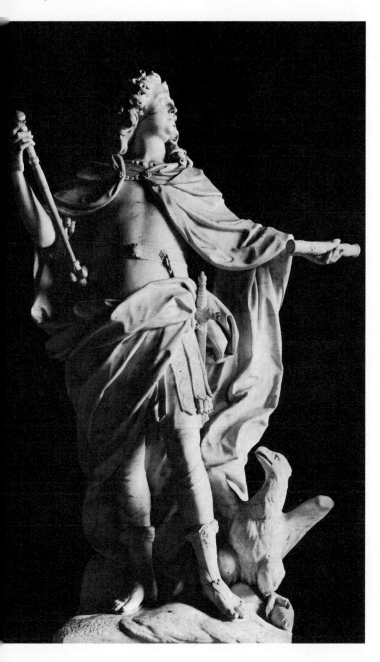

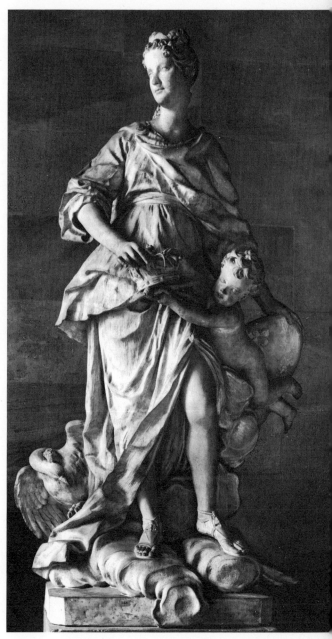

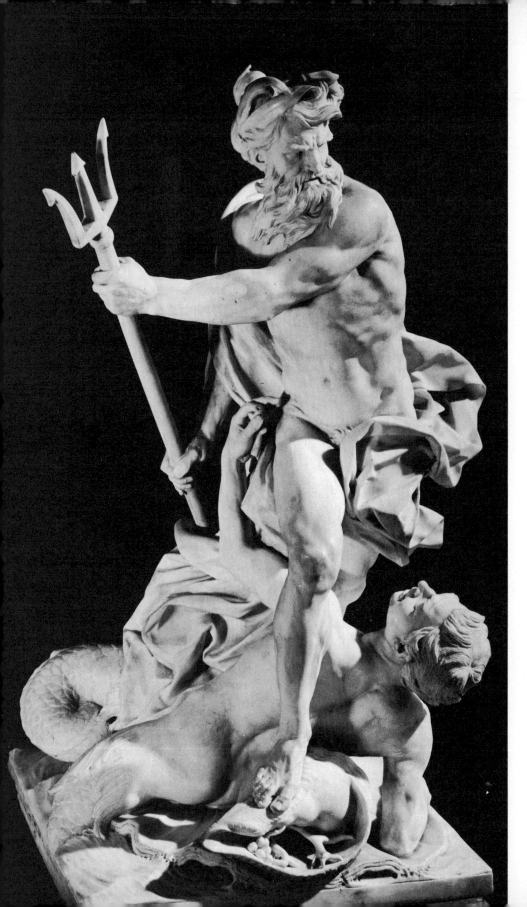

320 Lambert-Sigisbert Adam
Neptune calming the storm
1733–7
Paris, Louvre

321 Barthélemy Guibal
The Neptune Fountain 1750
Nancy, Place Stanislas

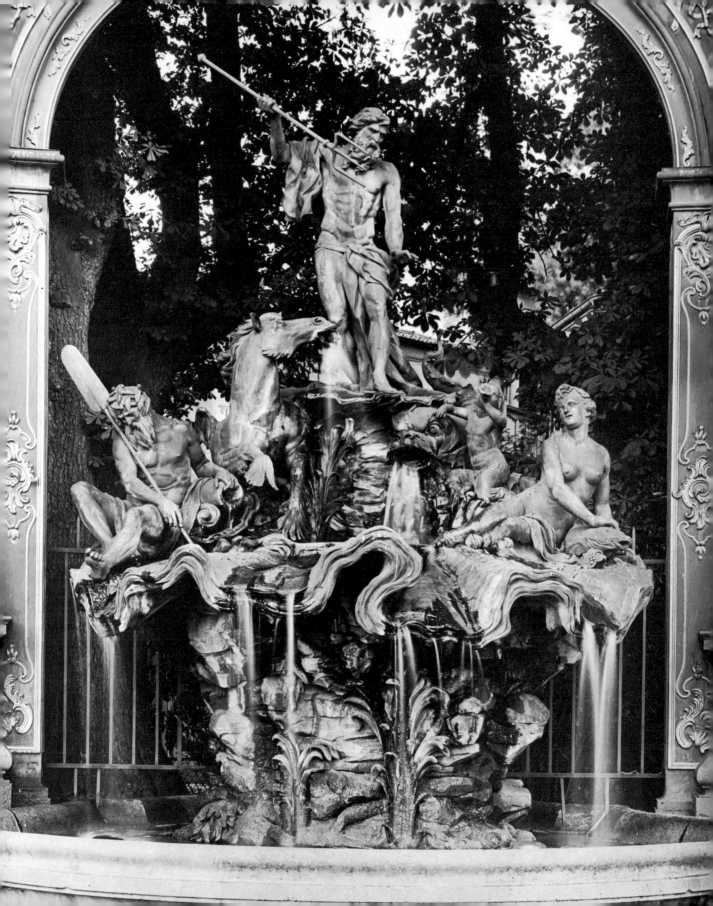

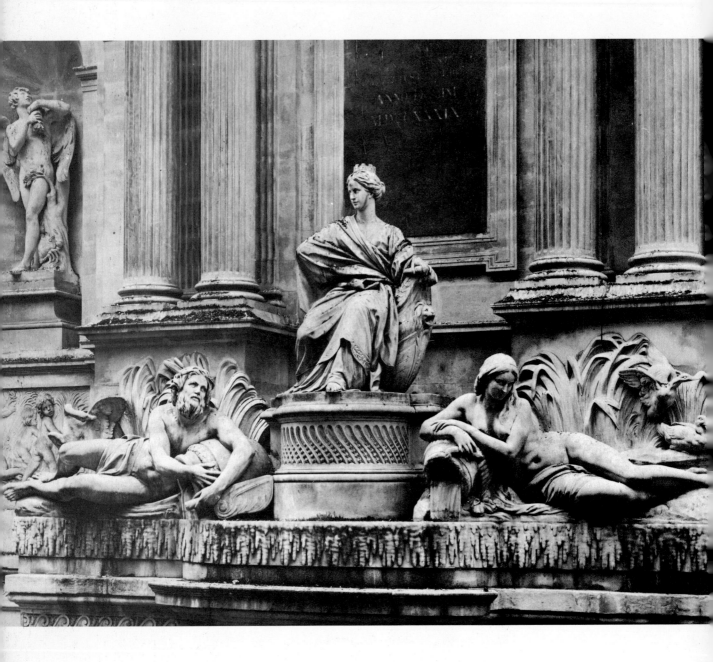

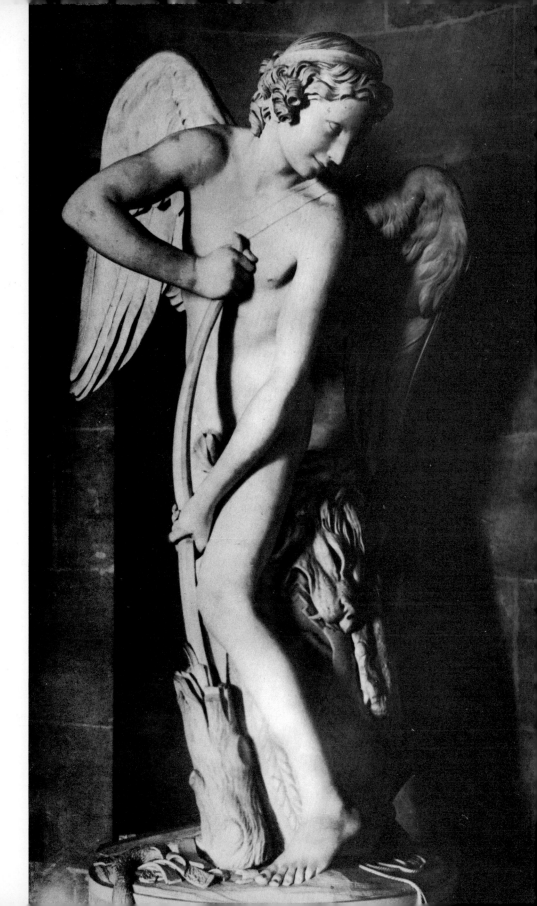

2 Edme Bouchardon
Fontaine de Grenelle 1739–45
Paris, Rue de Grenelle

3 Edme Bouchardon
Cupid with his bow 1739–50
Paris, Louvre

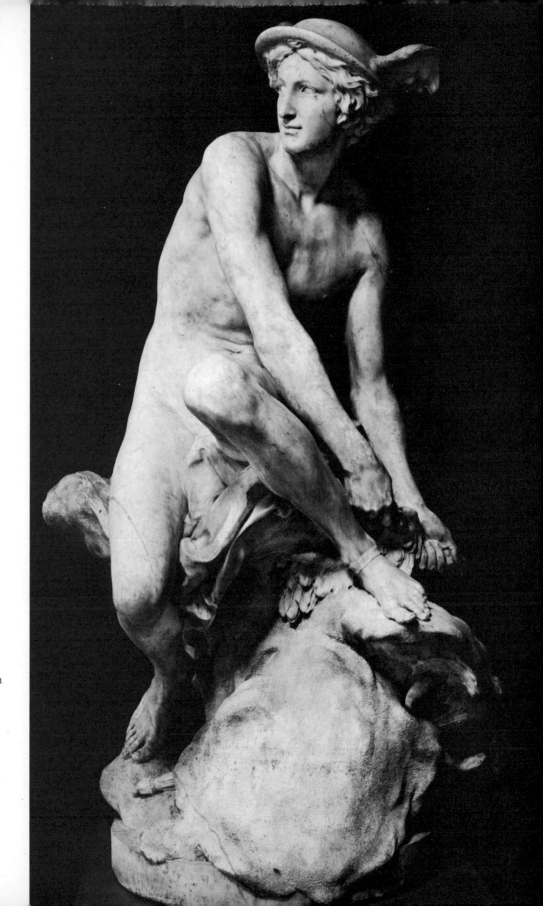

4 Jean-Baptiste Lemoyne
Bust of Countess de Brionne
1763–5
Stockholm, Nationalmuseum

5 Jean-Baptiste Pigalle
Mercury 1746–8
Berlin (East), Staatliche
Museen .

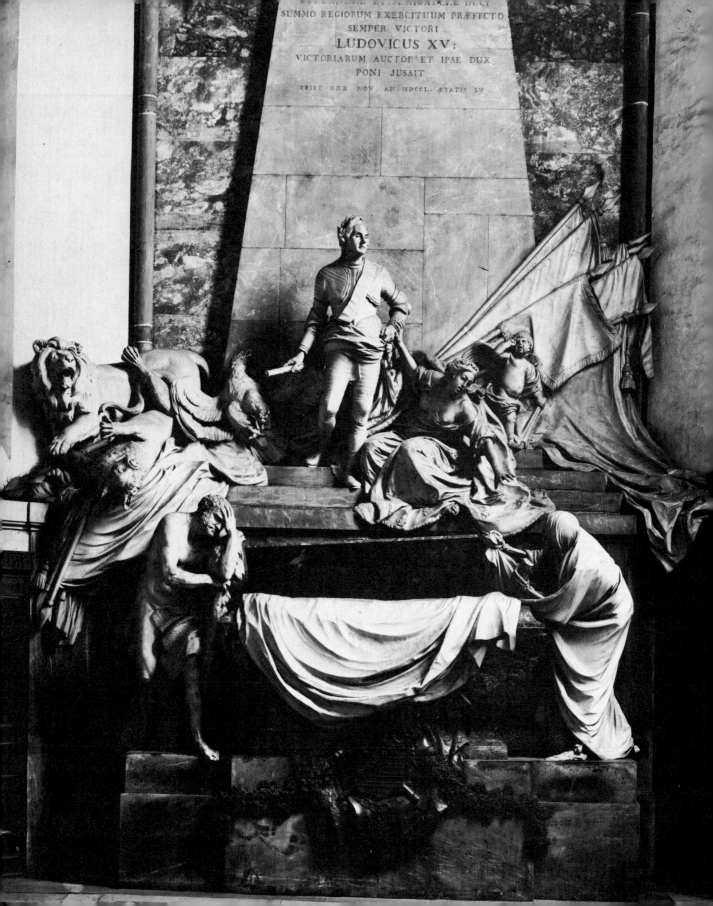

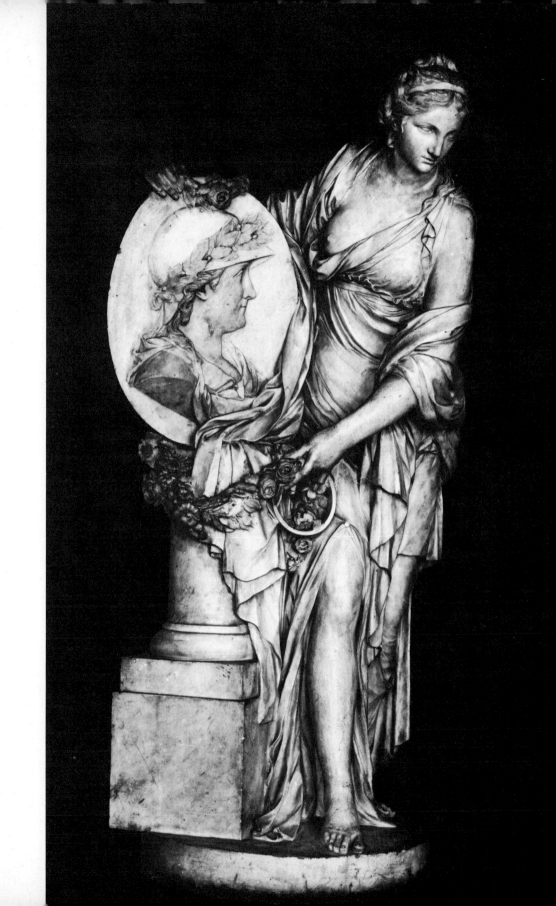

26 Jean-Baptiste Pigalle
Tomb of Maurice of Saxony
1753–76
Strasbourg, St-Thomas

27 Étienne-Maurice Falconet
The Glory of Catherine II
between 1762 and 1766
Paris, Musée Jacquemart-
André

328 Etienne-Maurice Falconet
 Bathing nymph 1757
 Paris, Louvre

329 Christophe-Gabriel Allegrain
 Venus at her bath 1755–67
 Paris, Louvre

330 Pierre Julien
 The nymph Amalthea 178(
 Paris, Louvre

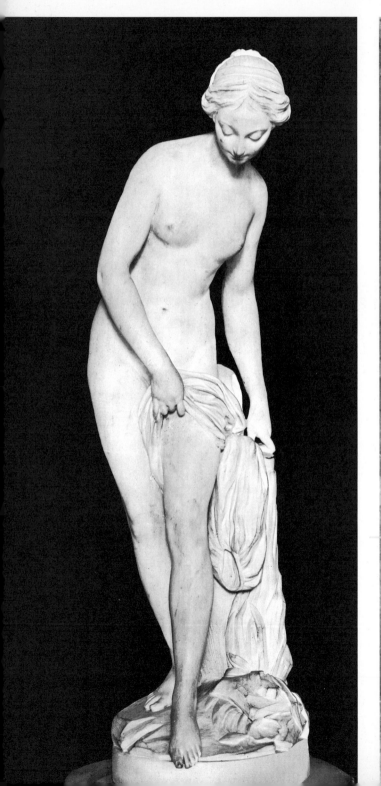

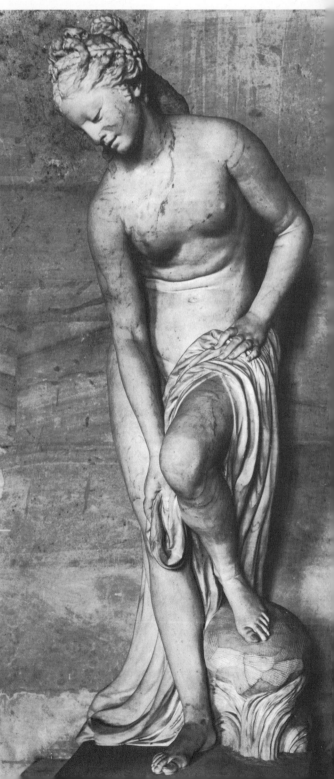

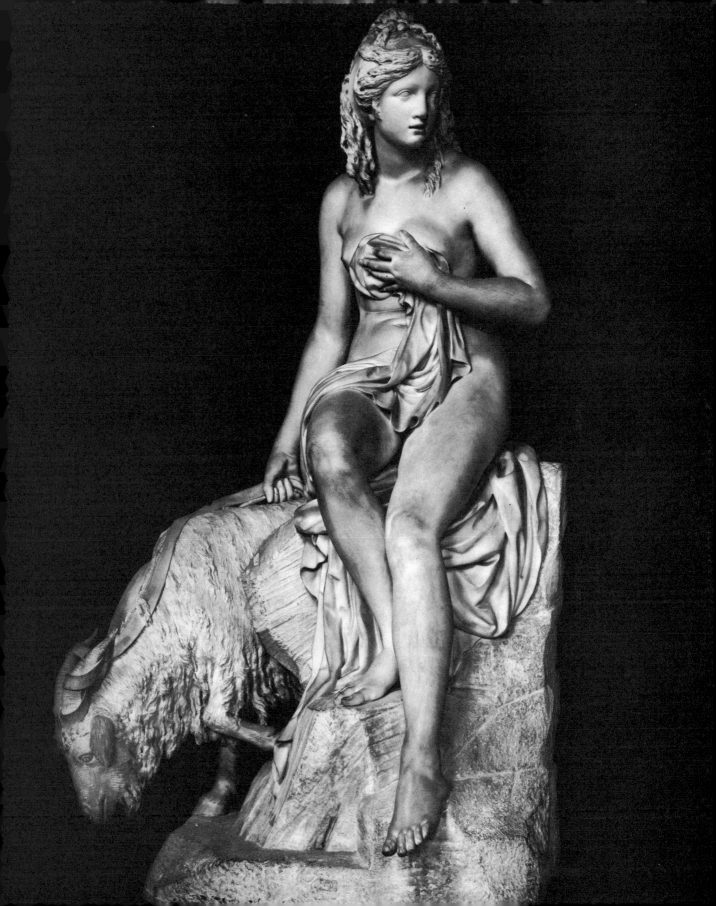

331 Jean-Jacques Caffieri
Bust of Madame du Barry
before 1779
Leningrad, Hermitage

332 Jean-Antoine Houdon
Bust of La Rive 1783–5
Paris, Comédie Française

PSYCHE PERDIT L'AMOUR

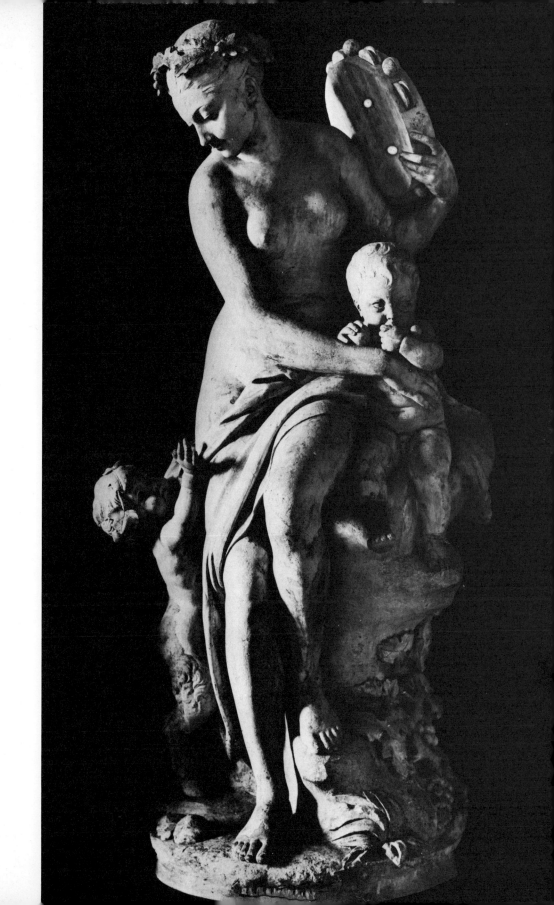

33 Augustin Pajou
Psyche abandoned 1782–90
Paris, Louvre

34 Augustin Pajou
Bacchante 1774
Paris, Louvre

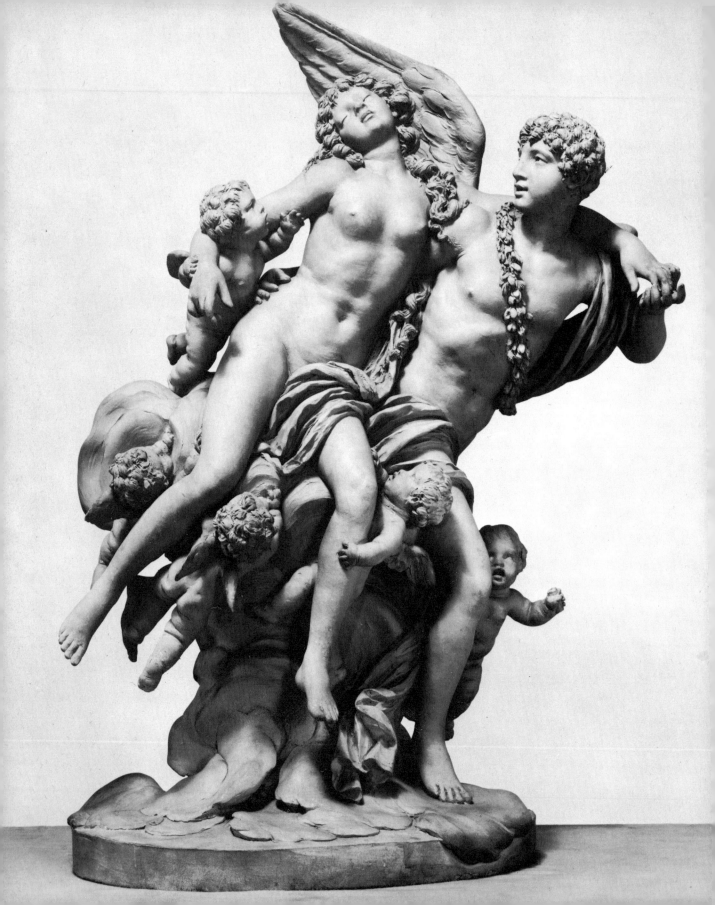

Claude Michel called Clodion
Cupid and Psyche
between 1780 and 1790
London, Victoria and Albert
Museum

336 Claude Michel called
Clodion
A maiden with fruit basket
c. 1780
Leningrad, Hermitage

337 Jean-Antoine Houdon
Summer 1785
Montpellier, Musée Fabre

338 Jean-Antoine Houdon
Seated statue of Voltaire
1778–81
Paris, Comédie Française
(*overleaf*)

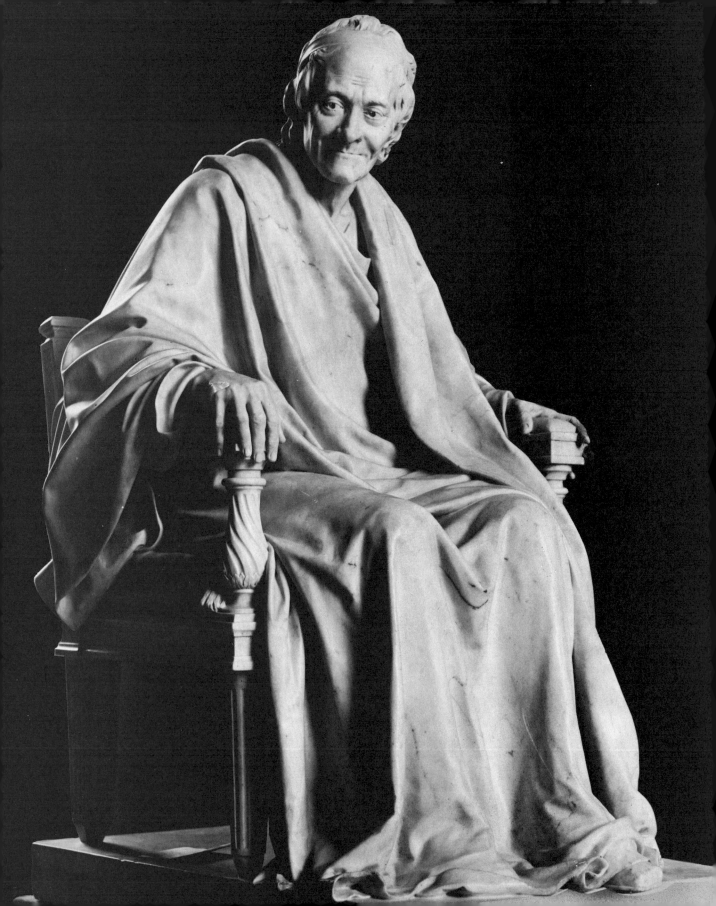

NOTES ON THE COLOUR PLATES

The measurement given is the height.

 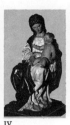 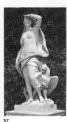 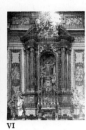 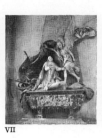 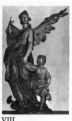

I II III IV V VI VII VIII

LUCA DELLA ROBBIA (*see* 12)

I *Tabernacle* 1441–3 marble, glazed terracotta and bronze 2·60 m.
Peretola near Florence, Sta Maria
Luca's early Florentine tabernacle with its beautiful shrinelike architecture and wealth of figure sculpture became an inspiration to later artists. Christ's dead body in the lunette, pointing to the Sacrament, and the portrayal of the Saviour giving his blood on the *sportello* form the centre of his composition. The former belongs both to the *Pietà* group and to the *Trinity*; the latter is accompanied by large angels, like antique genii.

MICHELANGELO BUONARROTI (*see* 36)

II *Crucifix* 1494 painted poplarwood 1·35 m.
Florence, Casa Buonarroti
Since the rediscovery of this crucifix in 1963 we know for certain that Michelangelo's wide range of thought and feeling, present throughout his *œuvre*, was already fully developed at an early age. Just as the melancholy mood of the Medici Madonna is already present in the *Madonna of the Steps* and the heroism of the *Victory* is foreshadowed in the *Centaur*, so the transcendental quality of the Rondanini *Pietà* is already present in this portrayal of the weightless and still body of the crucified Saviour.

GIOVANNI BANDINI (*see* 62)

III *Meleager* 1583 gilt bronze 0·50–0·60 m.
Madrid, Prado
'At present Giovanni is preparing to cast a figure, about to kill a boar from his prancing horse . . . a work which promises to be very beautiful' (R. Borghini 1584). The completed group, the design of which is reminiscent both of Leonardo and of antique Meleager reliefs, so delighted Francesco Maria I d'Urbino who had commissioned it, that he had it gilded and regarded it as a prize piece in his collection.

ALONSO CANO (*see* 281)

IV *The Virgen de Belén* 1664 painted cedarwood 0·46 m.
Granada, Museo de la Catedral
Cano carved the so-called Madonna of Bethlehem as the crowning piece of a lectern (more than 4·50 m. high) which he had made for the cathedral eight years earlier. From her original position she looked down, attentively listening, upon the priest reading the gospel. In his day, Cano was unsurpassed in his craftsmanship and beautiful use of colour – here a copper red headscarf, white tunic and blue mantle.

ÉTIENNE LE HONGRE

Paris 1628–90

V *The Element of Air* 1683–4 marble, over lifesize
Versailles, Palace Gardens
According to Le Brun's plan '*l'union ou l'enchaînement de l'Univers*' was to be represented by twenty-four statues of the four elements, continents, seasons, times of day, temperaments and styles of poetry. Le Hongre's personification of 'Air' as one of the elements was much admired. He depicted her as a gracefully moving woman, her body hardly concealed by the fluttering draperies. An eagle is at her feet and she holds a chameleon – which according to Pliny lives only on air – under her right arm.

(ANDREA POZZO)

b. Trient 1642 – d. Vienna 1709

VI *St Ignatius Altar* 1695–9 stucco and a variety of stones and metals
Rome, Il Gesù
Designed by Pozzo and executed under his general direction this altar became a uniquely resplendent structure. Numerous artists and craftsmen worked on it, among them P. Le Gros, J. B. Théodon, P. E. Monnot, A. de Rossi and L. Retti; they used white, red, green and yellow marble, stucco and gilt bronze, gold and silver, alabaster and lapis lazuli.

MICHELANGELO SLODTZ (*see* 194)

VII *Tomb of Jean-Baptiste Languet de Gergy* 1753–7 white and coloured marble and bronze, Paris, St-Sulpice
After twenty years in Rome, Slodtz found little acclaim among the artists and critics of Paris for his most important monument in his native country. It is in the Italian late Baroque style – a colourful ensemble of architecture and sculpture. The gay colouring as well as the lively and dramatic movement of the figures above the sarcophagus seemed inappropriate to the friends of Bouchardon and Pigalle.

IGNAZ GÜNTHER (*see* 265)

VIII *The Guardian Angel with Tobias* [d.] 1763 painted limewood 1·77 m.
Munich, Bürgersaalkirche
The Archangel Raphael, his draperies tucked about his waist, is leading the young Tobias by the hand as they walk along. The 'handsome youth' protects the boy under his outspread wing, wards off any danger by treading on the snake in their path, and teaches him to trust in God, by pointing with his right hand to the eye of God. This was to be seen above the group, when it stood in its original position in the Carmelite Church as a devotional effigy for the Guardian Angel Brotherhood.

NOTES ON THE MONOCHROME ILLUSTRATIONS

The measurement given is the height.

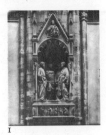 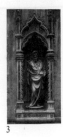 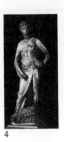 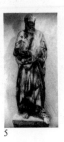 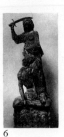 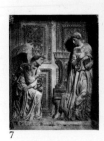

1 2 3 4 5 6 7

NANNI DI BANCO
Florence c. 1370/5–1421

1 *The four crowned saints* after 1412 marble c. 1·90 m.
Florence, Or San Michele

Standing at the threshold of the Renaissance, Nanni di Banco combined forms and ideas of Antiquity, of the Gothic, and of his own contemporary world, for the decoration of the tabernacle of the sculptors' and carpenters' guild. Christ blesses four men who are drawn together in conversation. We might have taken them for philosophers of Antiquity if we did not realize from the *predella* relief, in which we see a builder, a carpenter, a stonemason and a sculptor practising their trades, that they are the patron saints of the guild: Castorius, Claudius, Nikostratus and Sempronianus.

JACOPO DELLA QUERCIA
Siena c. 1374–1438

2 *Tomb of Ilaria del Carretto* c. 1406 marble, figure c. 1·70 m.
Lucca, Duomo

In its type, that of the sarcophagus tomb, and in the arrangement of the recumbent figure of Ilaria with the symbol of conjugal faithfulness, the dog, at her feet, Quercia closely followed the Gothic tradition, to which he adhered in all his work. Following the models of the antique sarcophagi, however, he decorated the sides of the tomb with lively *putti* in motion, carrying poppy garlands as symbols of the deceased's eternal sleep.

LORENZO GHIBERTI
Florence 1378–1455

3 *St John the Baptist* 1414 bronze 2·55 m.
s. and d. LAVRENTIVS GHIBERTIVS MCCCCXIV
Florence, Or San Michele

Ghiberti has arranged St John's robe in beautiful, broad-swinging ornamental folds, in the International Gothic style. But the realistic handling of the leg which is not carrying the weight, the balanced stance, and the modelling of the face, hands and feet, reveal the master's careful life studies in the design and execution of this work, the first large bronze since Antiquity.

DONATELLO
Florence 1386–1466

4 *David* c. 1408–9 marble 1·91 m.
Florence, Museo Nazionale

In its distribution of weight, the Gothic curve, and relief-like form,

David is designed on similar lines to Ghiberti's *St John*; Donatello, however, did not conceal David's body; instead he revealed the solidity of the articulated limbs. All the movement, which Ghiberti had imparted to the drapery to give elegance to the outward appearance, Donatello put into the tension of the body and the youthful elasticity.

5 *The bearded prophet* c. 1418–20 marble 1·93 m.
Florence, Museo dell'Opera del Duomo

The five prophets carved by Donatello for the Campanile do not appear as prophetic beings, but as earnest, hesitant, and even brooding men. More clearly than any of the others, the oldest of them, the bearded prophet, deeply withdrawn into his cloak, displays anxiety and thoughtfulness. All the folds of the drapery lead the eye constantly upwards to the pensive head resting on his hand.

6 *Judith and Holofernes* c. 1455–60 bronze parcel gilt 2·36 m.
S. OPVS DONATELLI FLO
Florence, Piazza della Signoria

The humble Judith, in her finest clothes and with all her jewels, as executrix of the divine will, draws the sword to behead the arrogant Holofernes, deprived through drunkenness of all his senses and all his strength. The whole effect of the sculpture is produced by precision of movements: the triumph of Virtue, which Donatello has here commemorated, is accomplished as if it were a natural phenomenon, quietly and inevitably.

7 *The Annunciation* between 1428 and 1435 grey sandstone (*macigno*) partly gilded and with traces of paint, figures lifesize
Florence, Sta Croce

The Annunciation is revealed by Donatello through gestures and without showing the symbols of the lily, the sceptre, the hand of God the Father, or the dove. The Angel and the Virgin withdraw from each other and yet are drawn closely together. In style, the head and drapery of Mary remind us more of classical Greek statues than any other figure of the master; yet there is no other work of his that is closer in depth of emotion to the Gothic spirit.

LORENZO GHIBERTI (*see* 3)

8 *The Door of Paradise* 1425–52 gilded bronze 4·60 m.
S. LAVRENTII CIONIS DE GHIBERTIS MIRA ARTE FABRICATVM
Florence, Baptistry

Ghiberti's second pair of bronze doors, according to Michelangelo so

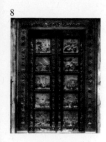

8

9

10

11

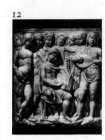

12

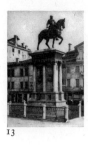

13

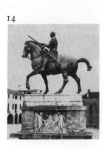

14

beautiful that they could serve as the Gateway to Paradise, were divided into ten large panels rather than into numerous small compartments, for the first time since Antiquity, and set a precedent for the future. This enabled him to design the famous, spacious reliefs, the pictorial effect of which he enhanced in execution by the addition of brilliant gilding.

ANTONIO AVERLINO called FILARETE
b. Florence *c.* 1400 – d. Milan?, after 1465
9 *Bronze doors* 1433–45 partly gilded and with enamel inlay *c.* 6·00 m.
s. and d. ANTONIVS PETRI DE FLORENTIA FECIT MCCCCXLV
Rome, St Peter's
The artistically awkward conception of the large figures, with the seated and standing motifs, and the monotony of the drapery folds are counterbalanced by Filarete with an abundance of scenes in the small reliefs. In the martyrdom of SS. Peter and Paul, as in the scenes from contemporary history, from Antiquity, and from the Christian world, he displayed his extensive, classical knowledge with more impressive clarity.

10 *The Martyrdom of St Paul* (detail of 9)
Three scenes are represented in one relief – the trial of the saint, his execution, and the handing back of the kerchief to Plautilla. All the details, the ornamentation of the *aedicula*, the features of Nero, the costumes and equipment of the Romans, as well as the great variety of trees, animals and birds, are clearly distinguishable because the forms are in shallow relief, gently rounded and evenly lit without any areas in shadow.

LORENZO GHIBERTI (*see* 3)
11 *The story of Noah* (detail of 8)
The earliest event in the story of Noah, the exit from the pyramid-shaped ark, Ghiberti assigned to the top half of the picture, in the background. The scenes of the Thank-offering and Noah's drunkenness he placed at the bottom, on the right and left of the foreground. In addition, by diminishing or enlarging the mass and volume of the figures, he intensified the illusion of distance and proximity in time and space.

LUCA DELLA ROBBIA
Florence 1400–82
12 *Children with a hand-organ and stringed instruments* (from the Cantoria)

1432–7 marble *c.* 1·05 m.
Florence, Museo dell'Opera del Duomo
In its original position in the cathedral, the group of youthful singers and musicians was directly related to the relief of the Resurrection of Christ below the singing gallery. They are not, however, angels who sing the Lord's praise but boys and girls of this world; with their taut bodies and *contrapposto* stance, these figures derive from the *putti* of Antiquity. Like Apollo's muses, these little singers and players surround the seated boy with the organ.

ANDREA DEL VERROCCHIO and ALESSANDRO LEOPARDI
b. Florence 1435 – d. Venice 1488
Venice *c.* 1460–1522/23
13 *The Bartolomeo Colleoni equestrian monument* 1479–95 bronze, formerly gilded, rider group *c.* 4·00 m.
s. ALEXANDER LEOPARDVS V. F. OPV S
Venice, Campo di SS. Giovanni e Paolo
In 1483 Felix Faber noted as something remarkable that 'the Venetians intend to honour their commander in the pagan manner with a bronze equestrian statue publicly displayed'. This monument, cast by Leopardi after a model by Verrocchio, has played an important part in the formation of our idea of the Renaissance *condottiere*. It is, in fact, the first secular equestrian statue to have been erected in modern times.

DONATELLO (*see* 4)
14 *The Gattamelata equestrian monument* (detail) before 1447–53 bronze, without pedestal *c.* 3·40 m.
s. OPVS DONATELLI FLO
Padua, Piazza del Santo
The Colleoni monument had its origins in the saints on horseback and equestrian monuments of the churches; the Gattamelata monument, which was erected as a cenotaph in the cemetery of S. Antonio, also belongs to this last category. Possibly its siting on consecrated ground led Donatello to represent the horse and rider in a manner tranquil rather than bold, and composed rather than haughty.

BERNARDO ROSSELLINO
Florence 1409–64
15 *Tomb of Leonardo Bruni* between 1444 and 1450 marble with traces of gilt and paint
Florence, Sta Croce
In the Bruni tomb monument Bernardo created a prototype of the

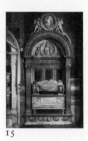

17

19

20

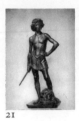

21

22

15

16

18

Renaissance tomb, the elements of which are the niche in the form of a portal or an *aedicula*, the sarcophagus with the body lying in state, and the Madonna in a circular frame in the lunette. The befitting aura of sanctity surrounding the monument derives from the perfect balance between architecture and sculpture, which make their effective contributions in equal measure.

ANTONIO ROSSELLINO
Florence 1427–c. 1479

16 *Tomb of the Cardinal of Portugal* 1461–6 white and coloured marble with traces of paint and gilt
Florence, S. Miniato al Monte
Antonio has not given the niche architecture an independent artistic function, but has treated it only as support and frame for the figure and decorative sculpture. The opened curtains reveal a scene in which the motionless body on the bier is attended by the Madonna, and by angels and *putti*, physically in diverse states of motion and spiritually encircling the tomb with varying expressions of sympathy.

FRANCESCO LAURANA
b. Zara c. 1430 – d. Avignon 1502

17 *Bust of Ippolita Maria Sforza?* (since 1945 only the head is preserved) *c.* 1473 marble, parcel gilt and paint 0·47 m.
Berlin (East), Staatliche Museen
Laurana's female busts have a classic beauty. In them, hieratic austerity is combined with deep feeling and cold aloofness with appealing tenderness. The structural symmetry is enlivened by a number of asymmetrical outlines and modelling. The somewhat harsh effect of the polished finish is softened by a rounded fullness of form. With lowered eyelids, untroubled by the world around her, the sitter listens to her inner voice.

MINO DA FIESOLE
Florence 1429–84

18 *Bust of Piero de' Medici* 1453 marble, lifesize.
S. PETRUS COS. S. AETATIS ANNO XXXVII OPUS MINI SCULPTORIS
Florence, Museo Nazionale
Mino gave this bust of Piero il Gottoso, which once stood above the door of his private chamber in the Palazzo Medici, the same expression of proud confidence and sobriety that he bestowed on all his male portraits. This he achieved through a severe frontal view, vertical structure, an abrupt turn of the head, and with sharply carved details.

DESIDERIO DA SETTIGNANO
Florence c. 1430–64

19 *Female bust c.* 1455–60 marble 0·47 m.
Florence, Museo Nazionale
Desiderio's stylized treatment of the portrait busts of his female patrons resulted in sisterly likenesses. He always stressed their nobility with an erect posture, and their charm by fashionable clothes and hair styles, A distant look gave them the appearance of maidens lost in reverie while the pointed profile with longish nose and protruding upperlip made them, at the same time, seem mentally alert and agile.

ANDREA DEL VERROCCHIO (*see* 13)

20 *Virgin and Child c.* 1475 terracotta with traces of paint 0·86 m.
Florence, Museo Nazionale
The Quattrocento, in producing the half-length Madonna figure in a wide range of variants in circular and panel form, rendered independent the very expressive detail that had been part of the full-length and enthroned Madonnas. In this work Verrocchio shows the individual as well as the type, the majesty and the intimacy of the theme, and the divine as well as the earthly beauty of Mary.

21 *David c.* 1472–5 bronze parcel gilt 1·26 m.
Florence, Museo Nazionale
Whereas Donatello's bronze *David* (*c.* 1430–2), which resembles this *David* in its *contrapposto* stance, gazes calmly ahead, and is composed and relaxed, Verrocchio's delicately articulated figure is boldly erect, and turns away with an expression that gently discourages applause. The body almost imperceptibly moves as if about to stride forward over the head of Goliath.

BENEDETTO DA MAIANO
Florence 1442–97

22 *St John the Baptist c.* 1480–1 marble *c.* 1·45 m.
Florence, Palazzo Vecchio
In executing the figure of St John, which the city of Florence had commissioned for its seat of government in homage to its patron saint, Benedetto adhered closely to Donatello's *St John* in the Casa Martelli. He did not, however, conceive John as an ascetic preacher, possessed by his mission in the desert, but rather as a youth of delicate, tender constitution with the countenance of a mild, friendly and trusting nature.

23

24

25

26

27

28

29

LORENZO DI PIETRO called IL VECCHIETTA
b. Castiglione d'Orcia *c.* 1412 – d. Siena 1480

23 *Ciborium* 1472 bronze
s. and d. OPVS LAVRENTII PETRI PICTORIS AL VECCHIETA DE SENIS MCCCCLXXII
Siena, Duomo

In the basic form of the Ciborium, which he originally cast for the Santa Maria della Scala, Vecchietta followed the tabernacle of Jacopo della Quercia in the baptismal fountain of the Baptistry. He gave the work a new character, however, by means of added plasticity. This he accomplished through the cylindrical form of the vessel, the variety of the ornamental motifs, and especially through the abundance of the figures, which lie, crouch, sit, stand and hover at every angle of the architectural structure.

ANTONIO ROSSELLINO (*see* 16)

24 *Tomb of Francesco Nori* before 1478 marble with traces of paint and gilt
Florence, Sta Croce

The peculiar position of the Nori family tomb in front of a pillar necessitated the unusual solution of its design. In front of the drapery, shaped like a canopy, and in a *mandorla* composed of cherub heads, the Virgin looks down from her throne in the clouds at the tomb slab set in the floor. On the inscribed base a bowl for holy water stands between bronze candlesticks.

BENEDETTO DA MAIANO (*see* 22)

25 *Pulpit* between 1472 and 1475 marble parcel gilt
Florence, Sta Croce

Above a niche the pulpit rises out of a circular console into a pentahedral superstructure. The admiration which has always been lavished upon this work is given in equal measure to the plant-like and geometric decoration, and to the generously designed statuettes of Virtues in the niches. Above all, however, it applies to the reliefs on the balustrade, the scenes of the St Francis legend with their interesting architectural and landscape perspectives.

ANDREA BREGNO
b. Osteno near Como 1421 – d. Rome 1506

26 *Tomb of Lodovico Lebretto (Cardinal Louis d'Albret) c.* 1465 marble with traces of gilt and paint
Rome, Sta Maria in Aracoeli

Bregno, Rome's leading sculptor at the end of the Quattrocento, was

no pioneer in the history of sculpture. However, this highly accomplished Lombard enjoyed considerable esteem for the accuracy of his chisel work. His works excelled in variety of architectural and ornamental motifs and in the scale and volume of the figures. In spite of all this abundance, the separate parts were combined to form one beautiful whole.

AGOSTINO DUCCIO
b. Florence 1418 – d. Perugia 1481

27 *Façade* 1457–62 white and coloured marble with traces of paint
s. OPVS AVGVSTINI FLORENTINI LAPICIDAE
Perugia, S. Bernardino

The Oratory was erected in memory of S. Bernardino on the spot where he used to preach. The fact that this façade was entrusted to a sculptor, unusual in the Quattrocento, is understandable, because it was conceived as a commemorative façade with the character of a sepulchral monument: as in a wall-tomb, the architectural frame and sculptural scheme were here devoted to the glorification of the dead saint.

28 *Virginity* (detail of 27) *c.* 1 m.

The relief of *Virginity*, the personification of one of the six *virtù conventuali* that decorate the walls of the portal, is one of the most beautiful of Agostino's female figures. The flowing robe, rich in folds, reveals and yet hides her bodily form; it opens at her back like a sail, and swirls at her feet; she moves past us, weightless, as though borne by a gentle breeze.

PIETRO LOMBARDO
b. Carona (Lugano) *c.* 1435 – d. Venice 1515

29 *Tomb of Doge Niccolò Marcello* after 1474 marble
Venice, SS. Giovanni e Paolo

Pietro Lombardo showed himself a connoisseur in Florentine and Roman Renaissance tombs in this well-proportioned triumphal arch supported by columns, with medallions in the spandrels and with powerful overhanging cornices. Nevertheless, he subscribed to the timeless Venetian figure ideal in the sculpture, the lunette relief, and the slender figures of the Virtues in their tight robes with wrinkled folds.

ANTONIO RIZZO
b. Verona *c.* 1440 – d. Venice 1499

30 *Tomb of Doge Niccolò Tron* (detail) after 1473–*c.* 1482 marble with traces of gilt and paint
Venice, Sta Maria dei Frari

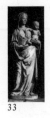
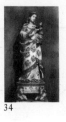

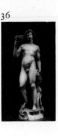

The Venetian Renaissance never completely discarded the Gothic, nor did it abandon the Byzantine tradition of its native art. Thus Rizzo, Venice's first great sculptor, closely conformed to an older type of tomb in this five-storeyed monument, a picture wall with more than twenty statues. However, he gave a new compactness to the whole structure, and a Renaissance aspect to all the decorative parts as well as to some of the moving and stationary motifs of the figures.

GUIDO MAZZONI
active from 1476 – d. Modena 1518
31 *The Lamentation of Christ* c. 1476–7 terracotta with paint
Modena, S. Giovanni della Buona Morte
We know Mazzoni was held in high esteem as director of theatrical performances and maker of masks at the courts of Modena and Naples, so it is not surprising to find that in his role of sculptor, he has arranged for the figures of the Lamentation group with their expressive and dramatic gestures to be shown on an open stage. Through works like this, he earned a reputation as the greatest realist among Quattrocento sculptors.

GIOVANNI ANTONIO AMADEO
b. Pavia 1447 – d. Milan 1522
32 *Tomb of Medea Colleoni* between 1470 and 1476 marble
S. IOVANES ANTONIVS DE AMADEIS FECIT HOC OPVS
Bergamo, Duomo, Cappella Colleoni
Lombardy did not produce a master committed to a particular type of tomb but, none the less, many unusual forms of wall-tomb were developed there. Here, for example, within the high marble frame, in the lower zone of the sarcophagus, decorated in relief, Amadeo places the figure of the dead girl and Mary with the Child in benediction, flanked by the two Sts Catherine, at eye level for intimate, devout contemplation.

ANDREA SANSOVINO
Monte San Savino, after 1465–1529
33 *Virgin and Child* 1503–4 marble, lifesize
S. SANSOVINVS FLORENTINVS FACIEBAT
Genoa, Duomo
Andrea contributed statues of St John the Baptist and of the Virgin to the sculptural decoration of the chapel, where the artist family of the Gaggini had been at work since 1450. The Virgin, in treatment of figure and weight distribution, in features and hair style, reveals a greater understanding of Classical sculpture than any of the master's earlier works. With this work he finally broke away from the artistic conceptions current in the late Quattrocento.

DOMENICO GAGGINI (Workshop)
active from 1448 – d. Palermo 1492
34 *Virgin and Child* between 1480 and 1500 alabaster 1·08 m.
Berlin (West), Staatliche Museen
Domenico Gaggini was the originator and main representative of a specific style in Sicilian sculpture, which had its exponents right up to the seventeenth century. This work is a free interpretation of the famous Madonna di Trapani from Nino Pisano's workshop. Although it is not a typical example of Gaggini's style, the delicate porcelain-like finish and the rich gilding and decoration are characteristic of the products of his workshop.

ANDREA SANSOVINO (*see 33*)
35 *Tomb of Ascanio Sforza* 1505–9 marble
S. ANDREAS SANSOVINVS FACIEBAT
Rome, Sta Maria del Popolo
To unify and monumentalize his construction Andrea borrowed from the tradition of the Roman wall-tomb by organizing the numerous separate forms into a solid structure of verticals and horizontals. He also gave monumental power to his voluminous figures, although – with the exception of the figure of the cardinal represented sleeping – they are all in fact smaller than lifesize.

MICHELANGELO BUONARROTI
b. Caprese di Michelangelo 1475 – d. Rome 1564
36 *Bacchus* 1496–8 marble 2·03 m.
Florence, Museo Nazionale
In this marble statue the young Michelangelo demonstrated his ability to represent the naked human body in the Classical manner, as a living and unified organism. However, unlike sculptors in Antiquity, he lets the Wine God sway drunkenly, not in Classical *contrapposto* but as though about to lose his balance.

GIOVAN FRANCESCO RUSTICI
b. Florence 1474 – d. Paris 1554
37 *Mercury* c. 1515 bronze, once gilded 0·46 m.
London, private collection
We know from Vasari that this youth, who keeps his balance with only one foot on a ball, represents Mercury, the Messenger of the Gods, *in*

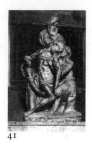

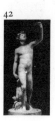

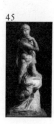

38

39

40

41

42 43 44 45

atto di volare. Nevertheless, looking at him we get little impression of flight; we are reminded rather of the figures in anatomical studies, because Rustici modelled all the limbs and muscles of the figure in an exaggeratedly distinct and powerful manner.

MICHELANGELO BUONARROTI (*see* 36)

38 *Apollo* (unfinished) 1530–2 marble 1·46 m.
Florence, Museo Nazionale
Michelangelo completed neither the surface treatment nor the face and hair of this upright, relaxed Apollo. His attributes were barely roughed out. Yet we have no doubt that he meant this to be the Sun God Apollo, who places his right foot on a celestial globe and looks pensively down to earth, his left hand stretched over his right shoulder to the quiver on his back.

JACOPO SANSOVINO
b. Florence 1486 – d. Venice 1570

39 *Apollo* 1540–5 bronze *c.* 1·50 m.
S. JACOBVS SANSOVINVS FLORENTINVS F.
Venice, Loggetta
Jacopo represents this Apollo caught at a moment between a light forward movement and a tranquil pause, as if, emerging from the depth of the niche, he is struck by the sunlight, and halts unexpectedly. Beardless, quiver and arrows in the right hand and a lyre (of which only a fragment remains) in the left, he is characterized as the planetary Sun God, whom the Venetians, in honour of their radiant and well-governed city, adopted as a symbol.

MICHELANGELO BUONARROTI (*see* 36)

40 *Tomb of Lorenzo de' Medici* 1526–31 marble, figures over lifesize
Florence, S. Lorenzo, Medici Chapel
The recumbent figures in this pyramidal group have always been more widely admired and copied than the seated statue (*Il Penseroso*, John Milton), because, through their dynamic appearance, they manifest themselves clearly as allegories of Night and Day: the man, with weary limbs, reflects upon the day while waiting for the night, and the woman rouses herself from her nocturnal dream to face the new day.

41 *Pietà* (unfinished) before 1550–5 marble 2·26 m.
Florence, Duomo
In the eighth decade of his life when his thoughts were constantly turning to death, Michelangelo carved this Lamentation group for his

own tomb. It shows Mary, Nicodemus, and Mary Magdalen bearing the weight of the dead Christ and supporting each other at the same time. To Nicodemus he gave his own features. Flaws in the marble compelled him to leave this work unfinished – 'whose beauty and depth of feeling are impossible to describe' (Ascanio Condivi).

JACOPO SANSOVINO (*see* 39)

42 *Bacchus* 1511–12 marble *c.* 1·45 m.
Florence, Museo Nazionale
Roaming and aimless, Bacchus advances with a rolling gait. He does not look at the path in front of him, but smiles at the uplifted bowl of wine. With his eyes so distracted from the direction of his movement he appears drunk, but not in a dull stupor like Michelangelo's Wine God. The state of Jacopo's *Bacchus* is rather one of blissful elation, in which the body can master even critical situations without effort.

VINCENZO DE' ROSSI
b. Fiesole 1525 – d. Florence 1587

43 *Bacchus* after 1565 marble 1·56 m.
Florence, Boboli Gardens
De' Rossi's Wine God has the same soft skin and supple movement as Sansovino's, but he does not sway from side to side and is decidedly more vigorous. With the two sides of his body in strong *contrapposto*, he moves towards the spectator, and with his left hand offers a grape plucked from his wreath – not symbolizing the happy effect of wine, but representing Bacchus, giver of grapes.

VINCENZO DANTI
Perugia 1530–76

44 *Honour triumphant over Falsehood c.* 1561 marble, lifesize
Florence, Museo Nazionale
The youth binds the body and limbs of the old man into a tight bundle with a strap which he winds round his own chest and waist. In this way the application of his strength is clearly shown, although in the process he ties himself to his captive. Danti derived the binding-up motif from Michelangelo's *The dying slave* and, in the structure as a whole, he comes to terms with Michelangelo's *Victory* group.

MICHELANGELO BUONARROTI (*see* 36)

45 *The Victory group* (unfinished) after 1519 marble 2·61 m.
Florence, Palazzo Vecchio
Michelangelo adheres to the ancient personification of Virtue and Vice

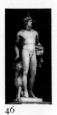
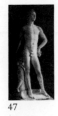
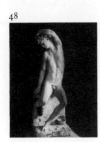
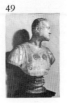
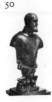
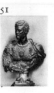
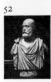

46 47 48 49 50 51 52

in which the antagonists are arranged one above the other in the attitude of victor and vanquished, and shows his victor clearly triumphant. But the extraordinarily powerful effect is produced by demonstrating the victor's feat of strength as he forces his opponent down and rises above him.

BACCIO BANDINELLI
Florence 1488–1560
46 *Orpheus c.* 1520 marble, over lifesize
S. BACCHIVS BANDINELLVS FACIEB.
Florence, Palazzo Medici
The sculptors of the sixteenth century were the first to be given the task of representing characters from Ovid's *Metamorphoses*, such as Orpheus, whose song and lyre appeased Cerberus and the Underworld. In the arrangement and surface finish of the figure (the bronze lyre has broken off) Bandinelli adhered so closely to the *Apollo Belvedere* that his contemporaries marvelled at how perfectly he had caught the *maniera* of the Classical masters.

BENVENUTO CELLINI
Florence, 1500–71
47 *Apollo and Hyacinth* 1546–after 1560 marble 1·91 m.
Florence, Museo Nazionale
In the year in which he conceived this group, Cellini enunciated his famous requirement that eight views of equal value are necessary for a complete statue. In practice, though he carved his works with equal care all round, he observed the rule of one fixed main viewpoint, as here in this unusual presentation of Apollo as the lover of Hyacinth.

48 *Narcissus* 1548–before 1565 marble 1·49 m.
Florence, Museo Nazionale
The vein of sentimentality, unusual in the middle of the sixteenth century, which is expressed in Cellini's *Narcissus*, can be understood in the light of the discovery, in those decades, of the beauty of nature and gardens, and the enthusiasm for grottoes and romantic ruins. In fact, we have in this *Narcissus* one of the beautiful early examples in a field of sculpture that was then an innovation, statuary for gardens.

BACCIO BANDINELLI (*see* 46)
49 *Bust of Cosimo I de' Medici c.* 1543–4 marble, lifesize
Florence, Museo Nazionale

With his Classicist's conception of art, which is opposed to all realism, Bandinelli translated the individualism of Cosimo's features into a general type. He raised the portrait out of its times, being the first sculptor to do so by using the form of the Roman imperial bust to portray a contemporary figure, and clothing the Medici duke in antique armour.

LEONE LEONI
b. Arezzo 1509 – d. Milan 1590
50 *Bust of Emperor Charles V* 1553–5 bronze 1·13 m.
inscription: CAROLUS
Madrid, Museo del Prado
The bust of Charles V in its stiff armour appears twice as regal in its position above the animated base: a rock, in front of which a straddling eagle, flanked by two seated figures (Mars and Minerva?), stands erect. Notwithstanding a certain amount of idealization in the modelling of the head, Leoni placed great importance on achieving a true likeness of Charles's features, just as in designing the armour he presumably copied from an original in the armoury.

BENVENUTO CELLINI (*see* 47)
51 *Bust of Cosimo I de' Medici* 1545–7 bronze, once partly gilded 1·10 m.
Florence, Museo Nazionale
Like Bandinelli, Cellini took as his starting-point the Roman Emperor bust, but has softened the firm outline by the asymmetrical draping of the cloak. The heroic traits in Cosimo's character are not neutralized by a cold idealization of his features, but are emphasized and heightened, bringing out the fearlessness and awe-inspiring quality of this imperious ruler.

ALESSANDRO VITTORIA
b. Trento 1525 – d. Venice 1608
52 *Bust of Francesco Duodo c.* 1570–80 marble 0·82 m.
S. F. ALEXANDER VICTORIA
Venice, Ca' d'Oro
The opposing tendencies in Vittoria to abstraction on the one hand and pictorial rendering of details on the other were most happily reconciled in his portraits of doges and procurators. In these tall, unostentatious busts of simple structural design, no one municipal official is more distinguished than another, but the carefully modelled heads differ from each other in their lively individuality.

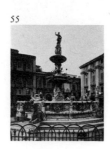
55

56

57

58

59

53

54

(GIORGIO VASARI)
b. Arezzo 1511 – d. Florence 1574

53 *Tomb of Michelangelo Buonarroti* 1564–74 marble, figures lifesize
Florence, Sta Croce
Vasari, who designed the tomb in accordance with ideas of the scholar
Vincenzo Borghini, also supervised its execution. He gave the commissions for the decorative figures representing Painting, Sculpture and
Architecture, who, seated in front of the sarcophagus, mourn the death
of their master, to the sculptors Battista Lorenzi (Painting), Valerio
Cioli (Sculpture) and Giovanni Bandini (Architecture). Lorenzi also
carved the bust of Michelangelo.

GUGLIELMO DELLA PORTA
b. Porlezza (Como) *c.* 1500? – d. Rome 1577

54 *Tomb of Pope Paul III* 1549–75 bronze and marble
S. F. GVGLIELMVS DELLA PORTA DE PORLETIA MEDIOLANENE FACIEBAT
Rome, St Peter's
While, in the planning of the tomb, Guglielmo could hardly escape
from the influence and style of Michelangelo, in the execution he
strongly emphasized his close affinity with Antiquity. The representation of Justice with the lictor's staff and Prudence with the looking-glass
he derived from antique medallions; and he showed the scholarly,
art-loving Farnese pope not as a ruler, but bare-headed and in a wide
surplice, in the style of a Greek philosopher.

GIOVAN ANGELO MONTORSOLI
Florence *c.* 1507–63

55 *The Orion Fountain* 1547–53 marble
Messina, Piazza del Duomo
The need to secure their water supply provided the citizens of Messina
with the opportunity to erect this tall fountain, consisting of three tiers
of basins – their most splendid public monument. With the recumbent
figures of the River Gods, Tiber, Nile, Ebro, and Camaro, symbols of
the imperial Mediterranean countries, Italy, North Africa, Spain, and
Sicily, they honoured their master and patron Charles V. With the
crowning figure they paid homage to the mystic founder of the city,
Orion.

NICCOLÒ TRIBOLO
Florence 1500–50

56 *River God c.* 1545 grey sandstone *c.* 1·80 m.
Castello near Florence, Villa Corsini

The soft, smooth modelling of the River God's body, the subtle pliancy
of his movements, the restless way he sits and the stretch of his right
arm over his left shoulder, might remind us of Jacopo Sansovino or
Michelangelo. The ingenious Tribolo, however, blended all the experience gathered in the workshops of his teachers into a new, individual
style, significant in the historical development of sculpture.

BARTOLOMMEO AMMANNATI
b. Settignano 1511 – d. Florence 1592

57 *A nymph of the Neptune Fountain* after 1564–75 bronze, over lifesize
Florence, Piazza della Signoria
Neptune, who stands upright in the centre of the fountain, in a chariot
drawn by sea-horses, has a retinue of four large recumbent sea goddesses
and eight satyrs along the rim of the basin. In this elegant nymph with
elongated limbs and dainty head, leaning lazily against a dolphin and
raising her shell as if it were a beautiful drinking vessel, Ammannati
shows himself to be master of the courtly style then prevailing in
Florence.

BATTISTA LORENZI
b. Settignano 1527 – d. Pisa 1594

58 *The Perseus Fountain c.* 1576 marble, over lifesize
Florence, Palazzo Nonfinito
For his monumental work, Battista chose the final scene from the story
of Andromeda's rescue by Perseus: the struggle with the sea monster.
The hero, in token of victory, places his foot on the dragon and,
in a gesture more symbolic than vigorous, wrenches open the monster's
jaw, raising his sword for the final stroke. Like Donatello in the
Judith group, Battista represents the triumph of Virtue rather than a
scene of combat.

STOLDO LORENZI
b. Settignano 1534 – d. Florence 1583

59 *Neptune c.* 1569–72 bronze, over lifesize
Florence, Boboli Gardens
The vigour and vitality with which Neptune agitates the flood with
his trident do not make sense in the figure's present location; standing
on the rocky island, where he was placed in the eighteenth century, he
appears to be thrusting into nothingness. In the original version of the
fountain he stood on a basin, supported by tritons and nereids on a base
of dolphins, just above the water level.

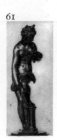
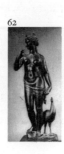
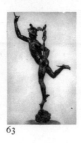
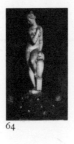

60 61 62 63 64 65 66 67

GIOVANNI BOLOGNA
b. Douai 1529 – d. Florence 1608

60 *The Apennine* 1580–2 stone, bricks and mortar *c.* 10–11 m.
Pratolino near Florence, Villa Demidoff
The thirty-foot high, slime-covered giant has, since ancient times, been taken as a symbol of the Apennine mountains, but he was erected in the luxurious gardens of Pratolino to represent the River God Nile, symbol of the wealth that comes from abundance of water. The construction of this giant, which came to be famous throughout Europe as the eighth wonder of the world, was probably inspired by accounts of similar projects in Antiquity.

61 *Venus after her bath c.* 1563–4 bronze 0·25 m.
S. IOANNES BOLOGNA BELGA
Vienna, Kunsthistorisches Museum
The so-called *Venus after her bath* is not, in fact, an image of the goddess but a *genre* representation of a maiden calmly and dreamily occupied in drying herself. When Bologna designed this figure with its lively posture and movement, he was surely conscious that the pleasure of the spectator is enhanced when he watches a beautiful creature unaware that she is being observed.

GIOVANNI BANDINI
b. Castello near Florence 1540 – d. Florence 1598

62 *Juno* 1572–3 bronze 0·95 m.
Florence, Palazzo Vecchio
Bandini shows Juno, the motherly spouse of Jupiter and strict custodian of matrimonial faithfulness, as a confident woman of powerful stature whose countenance reveals both gentleness and determination. In the decorative scheme of the Studiolo she represents the element of Air, and appears here, therefore, as ruler of the heavens, with the moon crescent in her hair and a peacock at her feet. The outspread tail of a peacock symbolized the splendour of the stars.

GIOVANNI BOLOGNA (*see* 60)

63 *The flying Mercury* 1564–5 bronze 1·80 m.
Florence, Museo Nazionale
To show Mercury convincingly in a weightless state as the God who speeds through the skies, Bologna lets the point of his foot rest on a bronze puff of air blown by a chubby Wind God. This classic solution to a difficult problem was widely copied right up to the nineteenth century.

64 *Venus of the Grotticella c.* 1575–6 marble 1·30 m.
Florence, Boboli Gardens
This most graceful marble figure by Bologna is notable for its noble proportions and unusual form. It has a delicate animation and naturalness, and yet there is shy dignity in the posture. It was only in 1590 that the figure was transferred from the apartments of the Pitti Palace to the Boboli grotto and placed in the centre of a fountain basin, supported by satyrs. It has stood there ever since, illustrating the old legend of Venus surprised by satyrs.

PIETRO FRANCAVILLA
b. Cambrai 1546/7 – d. Paris 1615

65 *Apollo* 1577 marble *c.* 1·80 m.
s. and d. PETRUS FRANCAVILIUS F. 1577
London, Kew Gardens
This Apollo is one of a series of twelve garden statues which Francavilla carved for the Florentine Canon Bracci. Having collaborated for many years with Bologna, Francavilla followed the manner of his teacher so closely in these figures that in *c.* 1660, when Mazarin and Colbert wanted to acquire them for Louis XIV, they may have been taken for Bologna's work. In the year 1768 they came into the possession of the English royal family.

ALESSANDRO VITTORIA (*see* 52)

66 *St Sebastian* 1566 bronze 0·54 m.
s. ALEXANDER VICTOR T.F.
New York, Metropolitan Museum
This statuette, made in 1566, is the only authenticated bronze by Vittoria of that year. The artist kept it in his workshop until his death. No doubt he considered this figure with its lively stance, its elongated proportions and small head, the happiest expression of his artistic ideal, as we can see from the two portraits of him that are known to us: in each case he had himself shown with the St Sebastian statuette at his side.

TADDEO LANDINI
b. Florence *c.* 1550 – d. Rome 1596

67 *The Tortoise Fountain* 1581–5 marble with bronze figures
Rome, Piazza Mattei
The *Fontana delle Tartarughe* with its much admired slender bronze youths in their lively graceful dance has its special place in the history of Italian fountains. In its structure it recalls the older type of 'candelabra'

68

69

70

72

73

74

71

or 'basin' fountain yet the basic architecture breaks away from this style, anticipating the naturalistic fountains of the Baroque.

VALERIO CIOLI
b. Settignano 1529 – d. Florence 1599
68 *The Vine-grower's Fountain* 1598–1605 marble, figure lifesize
Florence, Boboli Gardens
Valerio Cioli is one of the major early exponents of monumental *genre* sculpture for the decoration of gardens. This group of the Vine-grower spilling his grapes into a large tub while a young boy watches, is characteristic of his art: to record in marble everyday scenes of country life. As Valerio died while working on the Vine-grower's Fountain, his nephew, Simone Cioli, completed it.

ANTONIO CALCAGNI
b. Recanati 1536 – d. Loreto 1593
69 *Seated statue of Pope Sixtus V* 1585–9 bronze and marble, figure lifesize
S. ANT.US BERN.US DE CALCANEIS FACIEBAT
Loreto, Piazza della Madonna
In his pontifical robes, seated on the throne above the high base which is decorated with allegories of the Virtues, the Pope blesses *ex cathedra* in his twofold capacity: as spiritual head of Christendom and as secular ruler, who has raised Loreto to the rank of city and episcopal see. From the second half of the sixteenth century such memorials, which previously had been placed only inside churches or on church façades, were also erected in public places.

PIETRO FRANCAVILLA (*see 65*)
70 *Statue of Ferdinando I de' Medici* 1594 marble, without pedestal 2·50 m.
s. and d. MDXCIIII IOANNES BONONIA I. PETRUS FRANCAVILLA BELGIAE F.
Arezzo, Piazza del Duomo
When the people of Arezzo raised this monument to their ruler and patron, the Grand Duke Ferdinando I, they did not know, as we do today, that they had erected in their city the first public statue since Antiquity. Through innumerable similar statues erected over the last centuries, its structure and proportions have now become familiar to us to the point of satiety.

LEONE LEONI (*see 50*)
71 *Façade of Casa degli Omenoni c.* 1565–70 limestone
Milan, Via Omenoni

Because of a personal tie with Marcus Aurelius, the details of which are no longer known, Leoni erected his own residential palace as a memorial to the Roman emperor. In the inner court he placed the emperor's equestrian statue, a cast of the original. For the decoration of the façade he conceived the celebrated *Omenoni*, symbols of the Barbarian tribes subjugated during the emperor's victorious campaigns: the Svevi, Quadi, Adiabeni, Parthians, Sarmatians and Marcomanni.

GIOVANNI CACCINI
Florence 1556–1613
72 *Façade of Palazzo Altoviti c.* 1604–5 sandstone
Florence, Borgo degli Albizzi
Baccio Valori, the learned librarian of the Laurenziana and president of the Accademia del Disegno, honoured the poets and humanists of his home town by decorating the façade of his palace with their herm busts, which, at the same time, served as guardian spirits of the household '. . . after the custom of the Greeks and Romans, who honoured their great writers with their likenesses in herms'. (G. Cinelli, 1677.) Here we see Marsilio Ficino, Donato Acciaioli and Pier Vettori.

SEBASTIANO TORRIGIANI
active from 1573 – d. Rome 1596
73 *Tabernacle Altar* 1585–90 bronze, gilded
Rome, Sta Maria Maggiore
The altar, designed by the painter G. B. Ricci, stands in the Sistine Chapel above the vault which contains the relics of the holy crib. The tabernacle has the customary domed structure, and is adorned with statuettes and reliefs. But it is not used here as a receptacle for the Host: it is purely a showpiece, which Torrigiani's bronze angels raise in triumph on their shoulders, to enhance the glory of the Sacrament.

GIROLAMO CAMPAGNA
b. Verona 1549/50 – d. Venice 1627
74 *High Altar* 1591–3 bronze, figures over lifesize
S. OPVS HIERONIMI CAMPANEAE VERONENSIS
Venice, S. Giorgio Maggiore
The four Evangelists, like herculean Atlases, carry the globe, which serves as pedestal on which the *Rettore del Universo* (C. Ridolfi, 1648) stands upright in benediction. Along the vertical axis of this powerful pyramid, God the Father is united with the dove of the Holy Spirit and the crucified Christ into the Holy Trinity. The tabernacle, previously always of dominating size, is inserted unobtrusively into the *predella*. The bronze angels on the sides were cast by Pietro Boselli in 1644.

75 76 77 78 79 80

AGOSTINO SOLARIO
active in Genoa 1506–8

75 *Fountain in the courtyard of the Gaillon Palace* 1504–8 marble, destroyed in 1756, drawing by J. Androuet du Cerceau *c.* 1575
London, British Museum
The fountain, cast jointly by Antonio della Porta and Pace Gaggini in Genoa, *alta piu di xxx braza* (J. P. D'Atri, 1510), was a gift from the city of Venice to d'Amboise Cardinal Georges, the all-powerful minister of Louis XII. We presume that the crowning figure above the shaft with the naked youths, nymphs, satyrs and playful children was originally not St John the Baptist but a Hercules, like the one on a second fountain delivered at the same time to the palace gardens.

MICHEL COLOMBE
b. Bourges? *c.* 1430 – d. Tours after 1512

76 *St George and the Dragon* 1508–9 marble, relief 1·34 m.
Paris, Louvre
The setting for the knight and princess, a beautiful and spacious landscape, imparts liveliness to the St George relief on the palace fountain. In contrast, the clumsy form and the disproportionate size of the dragon appear curiously old-fashioned. Such stylistic unevenness is characteristic of several works of this period. The frame for the relief, which comes from the Gaillon upper chapel, was carved in the workshop of Jérôme Pacherot.

77 *Tomb of Francis II of Brittany and Marguerite de Foix* 1499–1507 white, green and black marble *c.* 1·60 m.
Nantes, Cathedral
The unusual impression made by this work, originally designed by Jean Perréal, is due not so much to the introduction – for the first time in a French tomb – of the row of Apostles, as to a new distribution of the masses within the traditional figure composition: the *pleurants* have been reduced from their former prominent role and removed to the base, while the allegories of the Virtues, the masterpieces of Colombe's old age, have been given the distinction of free-standing statues.

JÉRÔME DE FIESOLE and GUILLAUME REGNAULT
b. Florence 1463 – d. Tours 1543
b. Tours? *c.* 1455 – d. Tours 1532

78 *Tomb of the Children of Charles VIII* 1499–1506 white and black marble *c.* 1·35 m.
Tours, Cathedral

After he had changed his domicile to France, Jérôme de Fiesole sculpted this sarcophagus, which he decorated predominantly with antique ornamentation, and caused a stir with the small reliefs which represented scenes from the lives of Hercules and Samson, suggesting the innate virtues of the little prince and his sister. Their mother, Anne of Brittany, transferred the commission for the *gisants* to Colombe's closest associate, Guillaume Regnault.

JEAN JUSTE
b. Florence 1485 – d. Tours 1549

79 *Tomb of Louis XII and Anne of Brittany c.* 1515–31 marble
St-Denis, Abbey Church
The figures of the Apostles and the Virtues, the relief around the base, and the ornamentation, reveal the hand and spirit of the Italian *Ymagier du roy*. The tomb as a whole is in the form of an arcaded hall and appears to have been conceived under French influence (J. Perréal?). Inside, the figures of the king and queen lie *transis*, and they are seen again on the roof kneeling in prayer. The style and conception of the royal figures in both compositions also indicate a local master (G. Regnault?).

PIERRE BONTEMPS
Paris *c.* 1507–*c.* 1570

80 *Monument for the heart of Francis I* 1550–6 marble *c.* 2·50 m.
St-Denis, Abbey Church
In his main tomb in St-Denis, designed by Philibert de l'Orme, Francis I is immortalized as a ruler and a general. This monument for his heart originally stood in Notre-Dame-des-Hautes-Bruières near Rambouillet, where the king died in 1547. In the reliefs on the urn and on the base representing Architecture and Sculpture, Painting and Music, Geometry, etc., he was honoured as a patron of the arts and sciences.

LIGIER RICHIER
b. Saint-Mihiel *c.* 1500 – d. Geneva 1567

81 *Tomb of René de Châlon* after 1544 marble
Bar-le-Duc, St-Pierre
Richier did not show the young prince, who had been killed near Saint-Dizier, as a *gisant* or a *transi* on his tomb; instead he displayed him as an upright skeleton in front of a large outspread ermine cloak. The skeleton acts as though it were alive; its right arm holds an escutcheon, and it gazes pathetically at the raised left arm, offering God its own embalmed heart in a golden box. This box was replaced after 1793 by a marble one.

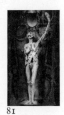

81 82 83 84 85 86 87 88

JEAN GOUJON
active from 1540 – d. Bologna between 1564 and 1569

82 *A nymph from the Fontaine des Innocents* 1547–9 stone *c.* 2·35 m.
Paris, Marché des Innocents
The reliefs of the nymphs in Goujon's large façade fountain are counted among the most brilliant works of the French Renaissance. After the Revolution the fountain was enlarged and reconstructed into a free-standing building, a kind of fountain shrine. In these subtle reliefs, representing the flow of water, Gothic and Classical characteristics have been successfully combined to reflect the spirit of the sixteenth century.

83 *Two caryatids from the Tribune des Cariatides* 1550–1 stone, over lifesize
Paris, Louvre
In Pierre Lescot's banqueting-hall *à la mode des antiques* (G. Corrozet, 1587) these caryatids supported the musicians' gallery. Their unusual form with arms cut off and drapery knotted at the hips is without precedent in Renaissance art. In their proportion and weight distribution, and even in the tranquillity of their appearance, they can only be compared with the caryatids that support the entablature of the porch of the Erechtheum – one is almost tempted to think that Goujon was acquainted with them.

FRANCESCO PRIMATICCIO
b. Bologna 1504 – d. Paris 1570

84 *Wall decoration in the former chamber of Anne d'Etampes* 1541–5 stucco
Fontainebleau, Escalier du Roi
In the monumental stucco figures, which are the main element in the decorative scheme, Primaticcio uses the human form anonymously and formally as if it were mere ornamentation. He gave the excessively slender figures an impersonal quality, without any individuality. These creatures, moving in a silent dance, are content to enliven the wall which they decorate by means of light and shade, beauty of line, and rhythmic harmony.

JEAN GOUJON (see 82)

85 *The Lamentation of Christ* 1544–5 stone 0·79 m.
Paris, Louvre
The master solved the problem involved in depicting a scene with many figures of equal size in a narrow relief panel, organizing the composition into two groups, each self-contained, but connected to the other by several formal links. In addition he grouped the figures around the recumbent Christ in a clever, academic arrangement, showing them from the front, the side, the rear, kneeling, seated and crouching.

GERMAIN PILON
Paris *c.* 1526–90

86 *The Lamentation of Christ c.* 1580–5 bronze 0·48 m.
Paris, Louvre
Pilon made his *Lamentation* group compact and forceful by arranging all the figures around the dead Christ in a semicircle which opens towards the front, and thus directly involves the spectator in the action. In the execution of the individual figures his work is less subtle than that of Goujon, because the contours and structural forms are frequently blurred, and sometimes even obscured by the voluminous, undulating draperies.

87 *The Three Graces from the monument for the heart of Henry II* 1560–3 marble, figures *c.* 1·05 m.
Paris, Louvre
One inscription on the monument, apparently drafted by Queen Catherine together with her artistic adviser Primaticcio, states that it is the privilege of the Graces to carry on their heads the heart in which they had hitherto resided. This group of beautiful serenely meditating Graces, who manifest their communion in grief by clasping each others' hands, brought Pilon more fame as an artist than all his other works.

88 *Bust of Charles IX c.* 1572–3 bronze 0·62 m.
London, Wallace Collection
Pilon characterized the king of St Bartholomew's Night as an unapproachable sovereign crowned with laurels, erect and with a stern mien, the eyes alone peering to the side. He is clad in armour and wears a coat embroidered with lilies and decorated with the order of St Michael. However, the artist succeeded in conveying the restless spirit lying beneath the stately exterior of the troubled young man, who mistrusts the whole world and is fundamentally powerless.

BARTHÉLEMY PRIEUR
active since 1570 – d. Paris 1611

89 *Bust of Christophe de Thou* 1582–5 white and coloured marble 0·70 m.
Paris, Louvre
From the monument in St-André, which was destroyed in 1793, this bust was preserved, together with two figures of recumbent athletes reminiscent of Michelangelo. They are evidence of Prieur's interest in

313

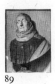

89 90 91 92 93 94 95

anatomical studies. In this bust of the first parliamentary president, Prieur showed himself to be a sensitive interpreter of physiognomy. In his treatment of the features he conveyed the wisdom and sincerity that de Thou brought to his role as mediator in the contemporaneous Huguenot struggles.

90 *The allegories of the Virtues from the monument for the heart of Anne de Montmorency* 1573–8 bronze *c.* 1·25 m.
Paris, Louvre
In accordance with Henry II's wish, the heart of his faithful field-marshal was once buried in the Celestine church next to the resting place reserved for his own heart. Following an idea of the architect Jean Bullot, Prieur cast a powerful spiral column entwined with leaf-work for the installation of the urn. In front of its base he set up the statues of *Pax*, *Abundantia* and *Justitia* as the personifications of the high aims of the *Connétable de France*.

PIERRE BIARD
Paris 1559–1609
91 *La Renommée* 1597–9 bronze 1·34 m., the original wooden wings were replaced in the nineteenth century by bronze wings.
Paris, Louvre
Biard modelled his equestrian monument in honour of Henri I de Montmorency on Giovanni Bologna's equestrian statue in Florence. Likewise he based the composition of this *Renommée*, the figure of a robust maiden, on Bologna's famous statue, the *Flying Mercury*. Until 1792 the *Renommée* stood on the tomb of Jean-Louis Nogaret and Marguerite de Foix in Saint-Blaise at Cadillac, and with her trumpet proclaimed the glory of the ducal couple.

MATTHIEU JACQUET
b. Avon near Fontainebleau *c.* 1545 – d. Paris 1611
92 *Equestrian relief of Henri IV from the 'Belle Cheminée'* 1597–1601 white marble, originally on black marble background, lifesize
Fontainebleau, Palace
Jacquet's masterpiece, the *Belle Cheminée*, has recently been restored to its old position in the palace gallery, from where it had been removed in 1725. The dimensions of the fireplace are 7 metres by 6. The centre-piece, flanked by allegories of *Pax* and *Clementia*, is an equestrian portrait of the king. By picturing the rider in flowing robes on a horse vigorously pressing forward, the master already anticipates fundamental elements of the Baroque equestrian monument.

DAMIAN FORMENT
b. Valencia 1475/80 – d. St Domingo de la Clazada 1540
93 *Self-portrait* (detail from the high altar) between 1509 and 1515 alabaster, formerly painted, lifesize
Saragossa, Nuestra Señora del Pilar
The decoration of the high altar of the Nuestra Señora del Pilar with reliefs and statues was Forment's first significant independent commission. Through pride in his work, he included in the base two medallions surrounded by garlands of ears of corn – an allusion to his own name: in one he put a self-portrait, in the other a portrait of his young wife Jerónima. This is an indication of a new approach, revealing an awareness in the artist of the importance of his own contribution to the course of history.

DOMENICO FANCELLI
b. Settignano 1469 – d. Saragossa 1519
94 *Tomb of Prince Don Juan* 1511–13 marble
Avila, Sto Tomás
For the structure of the tomb in the form of a truncated pyramid, as well as for its decoration–garlands, coats of arms and trophies, allegories of Virtues, and figures of saints – Fancelli drew on models from his Italian background, the works of J. della Quercia and, above all, those of A. del Pollaiuolo; and he introduced variations of his own. This work, sculpted in Genoa, was the first free-standing Renaissance tomb to be erected on Spanish soil.

ANDREA SANSOVINO (his influence. *See* 33)
95 *Tomb of Cardinal Pedro Gonzalez de Mendoza* after 1494–1504 marble
Toledo, Cathedral
It is assumed that Sansovino designed this tomb in 1500, the year in which he modelled a figure of St Martin in Toledo. He gave it the shape and size of a triumphal arch, in accordance with the wish of the deceased. The assumption that the design was Sansovino's does not seem unfounded if we bear in mind his Corbinelli altar in Florence (*c.* 1480) and his Sforza and Basso tombs in Rome (1505 and 1507 respectively). The entire execution, however, was the work of local sculptors.

DAMIAN FORMENT (*see* 93)
96 *High Altar* 1537–42 walnut, painted
Sto Domingo de la Clazada, Cathedral
This, the last of five multi-storeyed high altars, is rightly regarded as

314

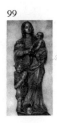

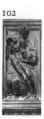

96 97 98 99 100 101 102 103

the climax of the master's artistic achievement because here, for the first time, he has related the architecture, the decoration and the figures uniformly to each other in the new manner of the Renaissance. Forment, who once referred to himself as the rival of Phidias and Praxiteles, introduced mythological scenes in the base, along with the story of the Apocalypse and themes from the New Testament.

FELIPE VIGARNY and DIEGO DE SILOE
b. Langres (France), active from 1498 – d. Toledo 1543
b. Burgos *c.* 1495 – d. Granada 1563
97 *The Presentation in the Temple* 1523–6 wood, painted, figures lifesize
Burgos, Cathedral
The altar in the chapel of Pedro Fernandez de Velasco (d. 1492) is the joint work of Vigarny, an immigrant from Burgundy, and Siloe, who was trained in Italy. In this theatrical arrangement of the Presentation group Siloe, who was concerned with the beauty and harmony of form, carved the figures of the Holy Family, and Vigarny, whose interest lay in the emphatic delineation of inner feeling, was responsible for the passionate figures of the High Priestess and the Prophetess Anna.

JUAN DE SALAS
active in Palma 1526–35
98 *Pulpit* 1526–31 stone
Palma de Mallorca, Cathedral
In this, the larger of the two polygonal pulpits erected in the cathedral, Salas displays an accurate knowledge of Italian models. This is seen in the architecture as well as in the decorative sculpture, the Virtues in the niches of the pulpit's pedestal (most of which are now lost), the scenes from the life of Mary in the reliefs on the balustrade, and the statues of the Evangelists in the *aediculae*. The Atlases have the faces of Saracens and are strongly reminiscent of ships' figureheads.

BARTOLOMÉ ORDÓÑEZ
b. Burgos *c.* 1475/80 – d. Carrara 1520
99 *Virgin and Child with St John c.* 1516–18 marble with traces of paint 1·21 m.
Zamora, Cathedral
The broad robes of heavy cloth impart a matronly calm and dignity to the slender figure of Mary. She gazes over and away from the Child, yet keeping him under her protective eyes. The intimate relationship between the two figures is revealed in the tenderness with which she carries her son, and in the way he caresses her right hand. Unconcerned

with the Virgin, the little St John, leading a young eagle, bustles towards the spectator.

DIEGO DE SILOE (*see* 97)
100 *St Sebastian c.* 1525–7 marble 0·85 m.
Barbadillo de Herreros, Parish Church
Siloe shows St Sebastian not as a martyr writhing in death throes, but as a youth in a state of agonized ecstasy. Even the arrows and scars are left out. There is hardly another work of the early Renaissance in Spain which reminds us so strongly of the Classical concept of art as this figure with its beautiful *contrapposto* structure and its restrained expression. The master had familiarized himself with this classical approach during his stay in Italy.

BARTOLOMÉ ORDÓÑEZ (*see* 99)
101 *St Eulalia before her judge* 1518 marble 1·30 m.
Barcelona, Cathedral
The constables and other onlookers stand around St Eulalia and watch her with varying degrees of interest and sympathy while she faces her judge. He stares at her spellbound and perplexed, not comprehending the candour with which she declares her faith, her right arm raised to heaven, thus invoking her own death sentence. The manner in which the relief is conceived, the types of the figures, and the style of the drapery are reminiscent of Michelangelo, of his *Virgin of the Stairs*, and the Sistine Chapel ceiling.

ALONSO BERRUGUETE
b. Paredas de Nava *c.* 1489 – d. Toledo 1561
102 *St John the Baptist* 1539–42 walnut, under lifesize
Toledo, Cathedral
Alonso Berruguete, Spain's greatest sculptor of the sixteenth century, must have been as solemn and ascetic in his life as the innumerable figures of prophets and saints that he conceived, carved and chiselled, and, like them, was obsessed by his mission. This St John the Baptist is one of thirty-six relief figures on the choir stalls. The outward restlessness of this figure and all the others, shows clearly, without a touch of pathos, their agitated inner being.

103 *The Transfiguration of Christ* 1543–8 alabaster, figures lifesize
Toledo, Cathedral
The Transfiguration of Christ, an event that prefigures the Passion, the Resurrection and the Ascension, is an ancient theme in Christian art.

315

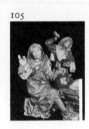

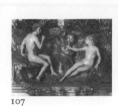
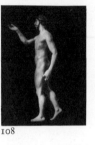

104 105 106 107 108 109

However, this was the first work, and, indeed, the only one with the exception of a single sculpture in Ubeda by a follower who came under Berruguete's influence, effectively to illustrate this mystical occurrence on Mount Tabor in lifesize, as a miracle and vision of equal wonder.

GASPAR BECERRA
b. Baeza *c.* 1520 – d. Madrid 1570

104 *Crucifix c.* 1560 wood, painted, over lifesize
Zamora, Cathedral
Becerra did not show Christ dead on the Cross. Instead he pictured him with his eyes still open, drawing his dying breath. The master, who was renowned for his anatomical knowledge, revealed appropriately but almost too distinctly the tension of the muscles, tendons and joints of Christ's body, cruelly scarred from the Flagellation and the Crucifixion.

JUAN DE JUNÍ
b. Joigny? *c.* 1507 – d. Valladolid 1577

105 *The Burial of Christ* (detail) 1540–4 wood, painted, figures lifesize
Valladolid, Museo Nacional de Escultura
After taking the Crown of Thorns, Mary Salome stands with drapery, ready to give further help in the preparations for the burial. Joseph, kneeling in his heavy-folded robe, sadly turns away from Arimathea towards the spectator, and with sorrowful mien shows the face of Christ and a long pointed thorn from the crown. It was through such figure compositions as these that Juní came to be regarded as 'the father of Spanish Baroque'.

106 *High Altar* 1550–4 walnut and oak
Burgo de Osma, Cathedral
No matter how hard Juní endeavoured to produce an impressive effect by magnifying bulk, intensifying individual passionate gestures or overcrowding particular scenes, in the last analysis he lacked a sense of true monumentality. This appears from the structure of his high altars with their confusing variation in scale and form. The reliefs on the right (the epistle) side of the altar in Burgo de Osma were executed by Juní's collaborator, Juan Picardo.

JUAN BAUTISTA VÁZQUEZ
b. Toledo, active from 1552 – d. Seville 1589

107 *The Fall of Man* 1563–4 wood, painted, figures lifesize
Seville, Cathedral

The story of the Fall, a subject that provided even the Spanish masters with an occasion to represent the nude, is told by Vázquez quite undramatically as a *genre* event. Eve, resembling a graceful antique nymph, rises from her recumbent position, and hands the apple to Adam, a slender youth with elegant limbs, who sits facing her, in the posture of the Belvedere torso.

DOMENICO THEOTOCOPULI called **EL GRECO**
b. Crete 1541 – d. Toledo 1614

108 *The Risen Christ* 1595–8 wood, painted 0·45 m.
Toledo, Hospital de S. Juan Bautista
To ensure the correct proportion, movement and lighting of the figures in his paintings, El Greco often designed them in the first place as statuettes – a practice not uncommon among painters. It can be assumed that the *Risen Christ* in Toledo with its small fine head and smooth surface, and all its joints and muscles undefined, is such a study – possibly for the *Resurrection* in the Prado (inv. 825) in Madrid.

POMPEO LEONI
b. Milan *c.* 1533 – d. Madrid 1608

109 *Philip II and his family* 1579–1600 bronze, gilded, figures over lifesize
El Escorial, S. Lorenzo
Philip II had the monastery of San Lorenzo del Escorial built in 1559 as a burial place for his father and himself. The two rulers and their families (Philip II with three of his four wives and Don Carlos on the epistle side) kneel on either side of the choir above their tombs. As lord protectors of their famous foundation, they face the high altar in perpetual prayer.

110 *Tomb of Don Fernando de Valdès* 1576–87 marble, figures lifesize
Salas, Collegiate Church
The wall-tomb erected for the grand inquisitor Valdès (d. 1568) resembles a triumphal arch, and is a severe piece of architecture without ornamentation. Flanked by the allegories of *Fides* and *Spes*, the 'persecutor of heretic seduction and defender of the Catholic doctrine' kneels in prayer in the middle niche attended by three priests. In the upper storey, a personification of Faith in triumph over Heresy, like other groups showing Virtue triumphing over Vice, symbolizes the inquisitor's earthly office.

PETER VISCHER the younger
Nuremberg 1487–1528

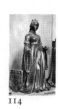
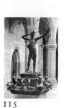

110 111 112 113 114 115 116 117

111 *Tomb of Anton Kress c.* 1513–14 bronze 1·30 m.
Nuremberg, St Lorenz
The handsome young provost kneels before the crucifix of his altar and
reads his prayers, a man inwardly composed and tranquil. We do not
know whether it was Kress himself, his family, or Peter Vischer who
designed the tomb in this form of a centrally planned, barrel-vaulted
Renaissance chapel with columns decorated with arabesques. Certainly
the manner in which the work is conceived corresponds with the
outlook and spirit of the humanistic ecclesiastics who belonged to
the circle of Dürer and Pirkheimer.

112 *Portrait of Peter Vischer the elder* between 1509 and 1519 bronze 0·35 m.
Nuremberg, St Sebald
Peter Vischer placed this lively statue of his father, wearing a leather
apron and holding the tools of a master-craftsman, in bronze, on the
eastern side of the tomb of St Sebald (1507–19). In this position of
prominence in the scheme of figurative decoration it balances the statue
of the saint on the narrow western side. He also honoured his father as
founder of the monument and head of the workshop by adding the
inscription: 'Originated by me – Peter Vischer 1508'.

HANS LEINBERGER
Landshut? *c.* 1480–*c.* 1531/5
113 *Christ at Rest c.* 1525–8 limewood 0·75 m.
Berlin (West), Staatliche Museen
Leinberger is considered to be one of the great South German sculptors
of the Late Gothic period, but not infrequently the work of this versatile
and liberal-minded man approached in style the new decorative and
figurative art which was flourishing in Italy, as can be seen in this work
and in the Moosburg Altar 1513–15. In designing the *Christ at Rest*, he
was evidently influenced by the famous torso of the resting *Belvedere
Hercules*, which must have been known to him through engravings
and copies.

GILG SESSELSCHREIBER
Southern Germany *c.* 1460/5–after 1520
114 *Elizabeth of Austria* 1516 bronze 2·12 m.
Innsbruck, Hofkirche
From 1502 onwards Maximilian I commissioned a series of twenty-
eight bronze statues of his royal ancestors so that his own prospective
burial place would serve also as a memorial for the Habsburg line.
Sesselschreiber designed and executed many figures in this series between

1509 and 1517. The statue of the wife of Albrecht I has always been
greatly admired as an especially beautiful creation, harmonious in
figure, drapery and expression.

PETER FLÖTNER
b. Thurgau (Switzerland) *c.* 1490/5 – d. Nuremberg 1546
115 *Apollo Fountain* 1532 bronze 1·00 m.
d. MCCCCCXXXII
Nuremberg, Pellerhaus
This fountain, presumably donated by the Musketeers' Guild, originally
stood in the noblemen's shooting range in the castle grounds. The
motif of Apollo shooting with a bow and arrow goes back to an
engraving of *Apollo and Daphne* by Jacopo Barbari dated 1531.
However, the proportion and distribution of weight of the figure,
which turns as it steps forward, makes us look even further back into
the past, to the *Apollo Belvedere*.

SEBASTIAN LOSCHER
Augsburg *c.* 1480/5–1548
116 *Tomb of Jacob Fugger,* between 1511 and 1518 stone 3·50 m.
Augsburg, St Anna, Fugger Chapel
This relief decorated one of the four large Fugger Chapel tombs. These
are among the earliest German Renaissance monuments, uniform in
their architecture and decorative scheme. Besides Loscher, Albrecht
Dürer, Hans Burgkmair and Hans Daucher participated in the design
and execution. Following the heroic-warrior fashion of the time, the
coat of arms, representing this banking family, is set above trophies and
captives in chains.

ALEXANDER COLIN
b. Malines *c.* 1527/9 – d. Innsbruck 1612
117 *Tomb of Emperor Ferdinand I* 1589 marble
s. and d. ALEX. COLIN 1589
Prague, St Veit's Cathedral
The tomb of Ferdinand I and Anna was commissioned by Maximilian
II and completed in the year 1573. But it was not until 1589, after
Rudolph II had had it enlarged to its present size to include his father
(d. 1576), that the tomb was placed above the mausoleum in the centre
of the cathedral. From the artistic viewpoint, the most significant figure
on the tomb is the lithe form of the Risen Christ poised triumphantly
above the skull and the serpent.

 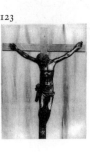

118 119 120 121 122 123 124

HANS GIENG
active from 1525 – d. Fribourg 1562/3

118 *Christ and the Woman of Samaria* 1550–1 stone with traces of paint 1·72 m.

Fribourg (Switzerland), Musée d'Art et d'Histoire

We know that the meeting of Christ and the Woman of Samaria at Jacob's Well, with its reference to the Waters of Eternal Life, has been a theme for fountains since ancient times. Gieng, one of the few notable Swiss sculptors of the sixteenth century, was, however, the first to construct it as a *genre* scene, a graceful, free-standing plastic group, which at one time crowned the column of the artesian well in the Rue de la Samaritaine. (Since 1939 it has been replaced by a copy.)

HANS RUPRECHT HOFFMANN
b. Sinzheim (?) *c.* 1545 – d. Trier 1616

119 *The Feeding of the Hungry* (detail from the pulpit) 1572 sandstone, originally painted

s. and d. HANS RUPRICH HOFMĀ BILTH. 1572

Trier, Cathedral

The allegorical statuettes representing the five senses at the foot of the cathedral's pulpit correspond – not without didactic intention – to the relief representations of the Acts of Compassion on the pulpit's balustrade. Hoffmann, who had received his artistic training in the Netherlands, in designing *The Feeding of the Hungry* and the other reliefs closely followed an engraving of the same subject after a drawing by Maerten van Heemskerck.

MICHAEL JUNCKER
active from 1588 – d. Miltenburg 1625

120 *Fireplace* 1601–2 stone *c.* 8·00 m.

Weikersheim (Württemberg), Palace

At all levels of the rich pictorial decoration of this fireplace, both in the statues and in the reliefs, there is a recurring reference to the battles against the Turks, in which many members of the family of the patron, Count Wolfgang zu Hohenlohe, had taken part. The central field of the main relief, representing the count's motto, 'Rien sans cause', had so far not been interpreted in detail. Michael's famous son, Hans, also participated in the execution of the work.

HEINRICH GRÖNINGER
Paderborn *c.* 1578–1631

121 *Tomb of Theodor von Fürstenberg* (detail) 1617/18–22 marble, slate, sandstone and alabaster, main figure lifesize

s. HAEC PATRIAE NATUS . . . ARTE MANUQUE FAECIT HENRICH GRUNIGER

Paderborn, Cathedral

The bishop-prince kneels in front of his wall-tomb, thirteen metres high and designed in five receding planes, and faces a view in relief of his palaces and the university which he founded. In the central panel there is a realistic representation of Ezekiel's vision. The prophet stands between skeletons, on which tendons, muscles and skin are renewing themselves, and corpses into which the winds are breathing fresh life. This theme – skeletons and muscled bodies – gave Gröninger an opportunity to demonstrate his anatomical knowledge.

LUDWIG MÜNSTERMANN
b. Bremen? *c.* 1560/70 – d. Oldenburg 1637/8

122 *The Last Supper* (detail) 1620 oak, painted 0·35 m.

s. and d. L M B ANNO 1620

Hohenkirchen (Oldenburg), Parish Church

Münstermann hollowed out a niche in the altar for the main scene in which Christ and the Apostles, gathered for the Last Supper, sit as on a stage. He designed the room in the form of an open hall, and covered the architectural frame with extravagant mouldings and scroll-work. The figures, with only a *bozzetto* finish, make an immediate impact through their expressive faces and vigorous gestures.

CARLO DE CESARE
active from 1560 to after 1593

123 *Crucifix* between 1590 and 1593 bronze 1·06 m.

Dresden, Staatliche Skulpturensammlung

We come across Carlo de Cesare for the first time in 1560 as Giovanni Bologna's collaborator in Florence. Authenticated works of his, however, are known to us only from 1588, after his appointment to the court of Christian I of Saxony. In the years between 1590 and 1593 he produced many bronze statues for the Wettiner Mausoleum in Freiberg (Saxony), and it was during this period that he made this crucifix. In its execution, Cesare closely followed the Bologna type of crucifix.

ADRIAN DE VRIES
b. The Hague *c.* 1545/6 – d. Prague 1626

124 *Tomb of Duke Ernst von Schaumburg-Lippe* 1618–20 white and black marble, bronze, main figures lifesize

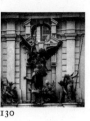

125 126 127 128 129 130 131

s. and d. ADRIANVS FRIES HAGIENSIS BATAVVS FECIT A 1618 and
ADRIANVS FRIES F 1620
Stadthagen, St Martin
To avoid 'the flaw in the Medici Chapel in Florence, the empty space
in the middle . . .', the architect, G. M. Nosseni, designed the mauso-
leum (begun 1608) so that from the start provision was made for the
tomb to stand in the centre. It is a scene of the Resurrection: surrounding
the count's sarcophagus, the back of which is adorned with a relief of
Saturn with an hour-glass and scythe, are four watchmen; Christ stands
above holding the Easter banner, with *putti* at his feet.

125 *The Hercules Fountain* 1602 marble and bronze, Hercules group
c. 3·00 m.
s. and d. ADRIANVS FRIES HAGENSIS SCULPTOR ET
ARCHITECTVS F.A.N. POST CHR.MDCII
Augsburg, Maximiliansstrasse
The group depicting Hercules fighting the Hydra – the contaminator
of water – was placed on a high three-sided pedestal with reliefs
depicting the town's early history, as a symbol of resistance in the face
of disaster, and the preservation of a flourishing civilization. The remain-
ing figures on the base, naiads, tritons, and little Cupids with their
swans, refer to the fresh element, the water in the polygonal basin.

HUBERT GERHARD
b. Amsterdam? *c.* 1550 – d. Munich 1622/3
126 *The Augustus Fountain* 1587–94 marble and bronze, figures over lifesize
Augsburg, Ludwigsplatz
Augustus, the Roman founder of the city, stands on the pedestal as if
addressing the citizens. It was renovated in the Rococo style and
raised to a greater height in 1749. The figures at his feet, sirens and
putti with dolphins, recumbent personifications of the river on the rim
of the basin, and also the setting as a whole, reveal Gerhard's exact
knowledge of Italian monumental fountains, a knowledge acquired
during his journey in the '70s.

127 *Bavaria* between 1590 and 1595 bronze 2·30 m.
Munich, Residenzmuseum
Forests are symbolized by the oak leaves on her hat; game, by the hide
of a stag with antlers and head; rich granaries, by an ear of corn (lost)
in her left hand; vine-growing and salt-trading by the wine jug and the
salt barrel at her feet – Philipp Hainhofer (1611) thus explained this
beautiful and ingeniously conceived personification of the land of

Bavaria. When he saw the statue, it was still standing in its original
position on a rocky hill in the garden of the Residenz.

HANS KRUMPER
b. Weilheim *c.* 1570 – d. Munich 1634
128 *Spring c.* 1610–11 bronze 0·80 m.
Munich, Bayerisches Nationalmuseum
Spring is personified as a maiden in flowing robes, crowned with
flowers, and playing a flute. She has also gathered flowers in the hem
of her mantle, and she moves nimbly over leaves and flowers. Unlike
his teacher Gerhard, Krumper filled his allegories with a warmth of life
and feeling. Together with the remaining three Seasons, this figure
once had its place in the grotto of the Residenz.

ADRIAN DE VRIES (*see* 124)
129 *Samson and the Philistine* 1612 bronze 0·71 m.
s. and d. ADRIANVS FRIES HAGIENSIS BATTAVVS F 1612
Edinburgh, National Gallery of Scotland
Adrian de Vries did not plan this group to be viewed from all sides;
in this period of rising Baroque, he confined himself to a single fixed
viewpoint. He shared with his younger Flemish contemporary,
Rubens, a special liking for muscular bodies, to which he gave the
appearance of powerful organisms in fluid motion. He achieved this by
merging the limbs of the two men with each other so that they become
indistinct in the brilliant play of light and shade on the body surfaces.

HANS REICHLE
b. Schongau *c.* 1565/70 – d. Brixen 1642
130 *The Archangel Michael* 1603–6 bronze, over lifesize
Augsburg, Zeughaus
An earlier plan to install the War Goddess Minerva above the portal
of the Arsenal was defeated by a more progressive proposal in favour
of the *Michael* group. With flaming sword poised for the decisive
stroke and wings outstretched, the angel keeps himself in balance; one
foot only is placed on the unstable support of the plunging Satan. It is a
powerful group full of tension, excitement and restrained beauty
– Reichle's masterpiece.

JEAN MONE
b. Metz *c.* 1490 – d. Malines 1548/9
131 *Emperor Charles V and Isabella of Portugal* [d.] 1526 alabaster 0·37 m.
Gaesbeek near Brussels, Palace

 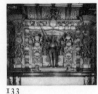

132　　　　　133　　　　　134　　　　　135　　　　　136　　　　　137　　　　　138

The tablet above the emperor and his bride in the arcade, decorated with escutcheons, tells us the year of the couple's wedding, and presumably also the date of this little nuptial portrait. It belonged to the Imperial Chamberlain Maximilian von Horn. The conception of the figures, and the treatment of the alabaster in relief, bear the impressions and reflect the experience that Mone had absorbed in the years of his collaboration with Bartolomé Ordóñez in Barcelona.

GUYOT DE BEAUGRANT
active from 1526 – d. Bilbao 1557
132 *The young Daniel rescuing Susanna* (detail of 133) 1530–1 alabaster 0·40 m.
Bruges, Law Courts, Het Vrije
As an exhortation to the judges to value truth, the story of Susanna is told in four reliefs on the frieze of the fireplace in the Lay Assessors' Hall. In this scene, Daniel convinces the two elderly judges of the falsity of the testimony against the young woman. Beaugrant's figures seem more squat than those of Mone, but they bear a close, almost sisterly resemblance to his in their movement, treatment of drapery and the characterization of their heads.

LANCELOT BLONDEL
b. Poperinghe c. 1496 – d. Bruges 1561
133 *Fireplace* 1528–33 black marble, alabaster and oak, figures *c.* 1·50 m.
Bruges, Law Courts, Het Vrije
The luxurious fireplace in the Lay Assessors' Hall, donated by the municipality in honour of Charles V, was designed by Blondel, approved by Mone, and executed by Beaugrant and Hermann Glosencamp. As chief judicial functionary in the land, the emperor appears in the central panel as count of Flanders. He is shown surrounded by numerous escutcheons, a form of composition which relates this memorial to similar heraldic monuments of the Late Middle Ages. Maximilian I liked to commemorate his reign in this way.

CONRAD MEIT
b. Worms c. 1475 – d. Antwerp 1550/1
134 *Virgin and Child* between 1525 and 1530 marble 0·62 m.
Brussels, Sts Michel et Gudule
The governor, Margaret of Austria, last representative of the Burgundian dynasty, gave her most important commissions to Conrad Meit, sculptor at the court of Malines. Although Meit's works have

the characteristics of the Renaissance, in the last analysis it is the Sluter tradition that predominates. In the Brussels *Virgin*, where the sacred and the profane are given equal emphasis, the face of Mary bears some resemblance to that of the master's noble patroness.

COLYN DE NOLE
active from 1530 – d. Utrecht c. 1558
135 *Fides* (detail from the fireplace decoration) 1543–5 sandstone, painted white 0·68 m.
Kampen, Town Hall
The master, who came from Cambrai, was the founder of a large, ramified family of sculptors. In the architectural decoration of the fireplace at the Lay Assessors' Hall, he showed that he was well acquainted with Italian decorative art. In the six statues of Virtue, he demonstrated his ability to make use of the new concepts of proportion and balance in the construction of a draped figure of pleasing appearance and animation.

JACQUES DU BROEUCQ
b. Mons or St Omer c. 1505 – d. Mons 1584
136 *Charity c.* 1542–4 alabaster 1·60 m.
Mons, Collégiale de Ste Waudru
In the year 1535, after his return from Italy, du Broeucq undertook the execution of the gallery between the nave and choir (rood-loft), destroyed in 1797, and from which this figure comes. Of the works he saw in Italy, he apparently considered those of Jacopo Sansovino the most worthy of emulation: *Charity*, with her upright posture, classical high-girdled robe, and the delicate round head, is reminiscent of Sansovino's work (*Virgin* relief in Rome, S. Marcello).

CORNELIS FLORIS
Antwerp c. 1514–75
137 *Tomb of Jan van Merode* [d.] 1554 black marble and alabaster
Geel, Ste Dymphna
By combining a table with a sarcophagus Floris developed a type of free-standing tomb, the architectural design of which is particularly suitable for the exposition of sculptural art. He made use of this for the first time in the tomb of Christian I of Denmark in Schleswig, and immediately afterwards in this monument. The double sarcophagus is hidden in the shadow behind the backs of the six armed heralds, whose heads support the wide-corbelled slab on which the bodies lie in state.

139

140

141

142

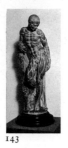
143

144

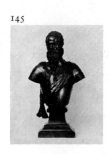
145

JACQUES DU BROEUCQ (*see* 136)

38 *The Resurrection c.* 1546–7 alabaster 1·85 m.
S. JAQVES DV BROVECQ ME SCULPTA
Mons, Collégiale de Ste Waudru
In the composition of this Resurrection scene the master adhered to
a pattern which was popular everywhere in Europe during the six-
teenth century. Christ in a flowing shroud rises from a classical
sarcophagus around which a number of watchmen start up in sudden
alarm and fumble with their weapons and shields. Our main interest in
this signed relief is, therefore, in the merits and shortcomings of the
detail, and in the master's individual style.

CORNELIS FLORIS (*see* 137)

139 *God showing Adam and Eve the Tree of Knowledge* (detail of the taber-
nacle) 1550–2 marble, figures *c.* 1·30 m.
Zoutleeuw, St Leonard
Although the tabernacle of St Leonard, a multiple-storeyed structure
with slender spires, is in the tradition of similar Late Gothic structures,
in all its detail it is a creation of the Renaissance, and one of the latest
of its kind before it finally became customary to keep the Sacrament on
the high altar. The story of the Creation is told in several relief scenes
in the lowest niches, between the prophets who are introduced as
supporting figures.

JOHAN GREGOR VAN DER SCHARDT

b. Nymwegen *c.* 1530 – d. Nuremberg (?), after 1581

140 *Bust of Willibald Imhoff the elder* 1570 terracotta with old paint 0·82 m.
Berlin (West), Staatliche Museen
The learned patrician Imhoff made it his life's work to increase the art
collection inherited from his grandfather, Pirkheimer, by adding paint-
ings, coins and jewelry. Though Van der Schardt had just returned from
Venice when he modelled this work, its only Venetian feature is the
downward extension of the bust. The representation of the collector in
the everyday action of examining a ring with care is contrary to the
Italian conception of the dignity of a portrait.

WILLEM VAN DEN BROECKE called PALUDANUS

b. Malines 1530 – d. Antwerp 1580

141 *Albrecht Dürer c.* 1563 sandstone 0·40 m.
142 *Jan van Eyck c.* 1563 sandstone 0·41 m.
Antwerp, Vleeschhuis Museum
The accomplished humanist Van den Broecke, who was active as

sculptor, architect and painter, never concealed his firm belief in the
importance of artistic genius in the life and history of human society.
When he was commissioned to decorate the façade of a house of the
Antwerp Artists' Guild, he felt called upon to demonstrate the validity
of his convictions. And so he carved for the spandrels of the portal a
Mercury and a *Minerva*, as symbols and mythical patrons of Knowledge
and Art; but in the architrave, on either side of a relief allegory of
Pictura, he placed the portraits of Jan van Eyck and Albrecht Dürer,
the artists' most illustrious predecessors in the recent past. These two
heads were the only valuable relics of the old decoration to be preserved
when the house was destroyed in 1852.

143 *St Bartholomew* ? 1569 terracotta 0·56 m.
s. and d. GULIELMO PALU(DA)NO MECHL FECIT ANNO MDLXIX
Vienna, Kunsthistorisches Museum
François Girardon owned two statuettes of the flayed apostles by
Paludanus, which, in the late seventeenth century, were associated with
a statue by the Milanese Marco d'Agrate (finished in 1562). If, indeed,
this figure is one of the terracotta statuettes, a common theme can
have been the only connection, since this sculpture, depicting the play
of muscles in a gently moving body, is incomparably superior as a
work of art.

JOHAN GREGOR VAN DER SCHARDT (*see* 140)

144 *Mercury c.* 1577–9 bronze 1·14 m.
s. I.G.V.S.F.
Stockholm, Nationalmuseum
Mercury, a slender youth in a winged hat and winged sandals, hastens
along, and in his stride turns to one side. He looks over his left shoulder,
and with pointing forefinger marks a new objective. This large statuette
once crowned the fountain in the Uranienborg Palace on the island of
Hven, a gift from Frederick II of Denmark to Tycho Brahe, who
established his first observatory there in 1576.

JACQUES JONGHELINCK

Antwerp 1530–1606

145 *Bust of the Duke of Alba* 1571 bronze 1·16 m.
s. and d. IVNGELINGUS OPTIMO DUCI 1571
New York, Metropolitan Museum
Jonghelinck's great talent, comparable to that of Leone Leoni, whose
Milanese workshop he visited in 1552, was in the field of portraiture in
all its different forms: medallions, busts, statues and tomb figures. In the

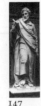

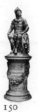

146 147 148 149 150 151 152

Alba bust we admire in equal measure the powerful modelling and characterization of the head, and the masterly ornamental chasing on the armour, the sash and the chain of the Golden Fleece.

HENDRICK DE KEYSER
b. Utrecht 1565 – d. Amsterdam 1621
146 *Tomb of Prince William of Orange* 1614–22 bronze, figures lifesize
Delft, Nieuwe Kerk
Thirty years after William's death, the Netherlands commissioned de Keyser to erect a really royal monument to the founder of their freedom. Under the arched hall, decorated with Virtues, a marble statue of the Count of Holland lies in state; at its head the count is seen again, seated and holding a baton decorated with laurels; at its feet, Fame, with a flourish, trumpets his glory to the world.

NICHOLAS STONE
b. Woodbury (Exeter) 1586 – d. London 1647
147 *St Paul* 1610–13 alabaster *c.* 1·70 m.
London, Victoria and Albert Museum
Hendrick de Keyser had the young Nicholas Stone to help him in the execution of the figures for the gallery between the nave and choir of St Jan at 's-Hertogenbosch. This *St Paul* is one of a group of figures in the gallery, authenticated as the work of Stone, which were transferred to the Victoria and Albert Museum in 1871. It seems, from the awkward chiselling of the drapery and the unsuccessful finish of the hands, that he made the full-size statue from a small scale model by de Keyser.

PIETRO TORRIGIANO
b. Florence 1472 – d. Seville 1528
148 *Tomb of Henry VII and Elizabeth of York* 1512–18 black and white marble, gilded bronze
London, Westminster Abbey
Torrigiano showed his respect for the local tradition by presenting the royal couple lying in state without insignia and in unadorned robes. However, in the execution of the tomb itself he showed himself to be a typical Italian Renaissance artist by introducing grotesquely studded corner pillars, medallions on the longer sides each with two saints absorbed in conversation, and on the narrow sides naked *putti* and draped angels holding escutcheons.

MAXIMILIAN COLT
active in England from *c.* 1595 until 1641
149 *Tomb of the first Earl of Salisbury* 1609–after 1614 black and white marble

Hatfield (Hertfordshire), St Etheldreda
The architecture of this monument, which consists only of a base and a flat bier, has its origin in earlier Dutch models. Prototypes of the iconography – allegories of Virtue in conjunction with the dead man presented both as a skeleton and in full array – are to be found in the grand French tombs. This particular arrangement by Colt, an immigrant from Arras, had no imitations of note.

NICHOLAS STONE (*see* 147)
150 *The Francis Holles monument* after 1622 alabaster and marble, figure *c.* lifesize
London, Westminster Abbey
In his conception of this work, Stone was partly influenced by Michelangelo's figure of Giuliano de' Medici. More important, however, is the way in which Stone altered the position of the legs so that the torso could be held erect and the head raised high. Thus the figure of the youthful hero could catch the light and appear transfigured. The use of a circular base is unusual in the early eighteenth century.

JOHN GULDON
active in the county of Hereford from 1573 until 1583
151 *Tomb of John Harford* 1573 red sandstone
s. and d. JOHN GULDO OF HEREFORD MADE THIS TOMBE WITH HIS OWN HANDE ANO DNI. 1573
Bosbury, Holy Trinity
The tomb of the physician Harford, an *aedicula* of well-balanced proportions, is an example of how Italian Renaissance forms spread to the provincial workshops outside the larger cultural centres. Guldon placed the sarcophagus in a round, Roman-style arch, with an ornamental inner face and framed it with Corinthian columns, entablature and gable. As decorative motif he made repeated use of acanthus leaves.

NICHOLAS STONE (*see* 147)
152 *The north gate of the Botanical Gardens* [d.] 1632 stone
Oxford, High Street
The 'Physic Garden' in Oxford was the first garden established in England for educational purposes, the study of useful and medicinal plants. Nicholas Stone gave its main entrance the form of a rustic gate in accordance with Renaissance rules for garden architecture. Of the sculptural decoration he himself carved only the bust and coat of arms of the donor, the Earl of Danby, and the coats of arms of the Stuarts, the University and St George. The statues of Charles I and Charles II in the niches at the side were added later.

153

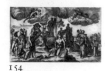

154

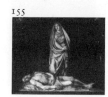

155

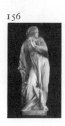

156

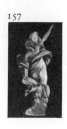

157

158

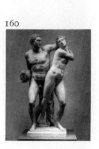

159

160

MAXIMILIAN COLT (*see* 149)

153 *Fireplace with statue of James I* 1609 black and white marble, stucco, bronze-coloured, figure lifesize
Hatfield House (Hertfordshire)
Robert Cecil, who was made Earl of Salisbury by James I in 1605, proved himself a grateful vassal in commissioning the fireplace for the drawing-room in Hatfield House. He had it designed as an architectural frame for a niche, in which Colt placed a statue of the King in full regalia. This form of homage is reminiscent of the decoration of the fireplace in honour of Charles V in Bruges (*see* 133).

(FRANÇOIS PERRIER)
b. Salins 1590 – d. Paris 1650

154 *The Niobe Group in the Medici Gardens in Rome* engraving 1638
First arrangement of the group in the garden of the Medici Villa in Rome, now in the Uffizi, Florence
The discovery of the Niobe group in 1583 encouraged sculptors, during the period of transition to the Baroque, in their efforts to broaden the scope of their work and redefine its functions. The individual figures revealed possibilities, hitherto unexplored, of representing in sculpture human beings in the grip of strong emotions and overwhelmed by fate. The stage-like arrangement of the group as a whole, unaltered until 1784, inspired new ideas for the presentation of sculpture.

GIOVANNI BANDINI (*see* 62)

155 *Pietà* 1585–6 marble, figures lifesize
Urbino, Oratorio del Duomo
Earlier monumental *Pietà* representations show the Mother of God holding her Son on her lap, or in her arms, while she mourns him; her anguish and inner sympathy are expressed in her loving demeanour as she bends closely over him. In contrast Bandini turned the intimate scene into an heroic lament. Mary rises above the dying Christ, who lies outstretched at her feet like the dying son of Niobe.

FRANCESCO MOCHI
b. Montevarchi 1580 – d. Rome 1654

156 *Virgin Annunciate* 1605–8 marble, over lifesize

157 *Angel of the Annunciation* 1605 marble, lifesize
s. and d. OPUS FRANC.CI. MOCI DE MONTEVARCO 1605
Orvieto, Museo dell'Opera del Duomo
From the middle of the sixteenth century the nave and transept of the cathedral were furnished with many new statues, sculpture groups and altar reliefs. At the turn of the century it was suggested that the choir should also be decorated by erecting an Annunciation group, with the Virgin and the Archangel Gabriel on pedestals on either side of the altar. The imaginative Mochi mastered the difficult task, and succeeded in showing communication between the two figures diagonally across the choir. The angel descends on a cloud, his draperies swirling from the violence of the flight, and, with his left arm pointing to heaven, he proclaims his mission. Mary's attitude as she encounters the tempestuous arrival of the angel is a mixture of withdrawal and attentiveness. She has the look and demeanour of a prophetess, who peers into the future and sees the end of what is now beginning.

GIOVANNI BOLOGNA (*see* 60)

158 *Rape of a Sabine* 1579 bronze 0·98 m.
Naples, Museo Nazionale di Capodimonte
The Roman clasps the Sabine woman so firmly that her only way of escape is an illusory one, upwards, in the direction of her free hand towards which she struggles. Her abductor, however, is able to thwart her efforts by a counter-twist of his body. The momentum and elegance of this powerful movement make the group appear more like a pair of dancers than a rape scene.

GIAN LORENZO BERNINI
b. Naples 1598 – d. Rome 1680

159 *The rape of Proserpina* 1621–2 marble 2·55 m.
Rome, Galleria Borghese
Pluto, a herculean figure with a monstrous head, is crowned as king of the Underworld. Accompanied by Cerberus, he carries away his beautiful prize, using his superior strength with careful deliberation. Proserpina resists her ruthless lover with desperate struggling gestures, but her piteous expression reveals that she has resigned herself to an inevitable fate.

BATTISTA LORENZI (*see* 58)

160 *Alpheus and Arethusa* between 1570 and 1580 marble 1·49 m.
New York, Metropolitan Museum
Lorenzi presented the climax of the story from Ovid: the nymph, just before her transformation into a fountain, is overtaken by Alpheus after an exhausting pursuit, and cries out, 'Help me, O Diana, he is seizing me.' To concentrate the spectator's attention on the beautiful bodies and their harmonious movement, Lorenzi, a pupil of Bandinelli,

323

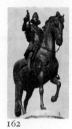

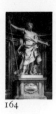
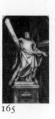

161 162 163 164 165 166 167

suppressed all expression of passion and emotion appropriate to the portrayal of such a scene.

GIAN LORENZO BERNINI (*see* 159)

161 *Apollo and Daphne* 1622–4 marble 2·43 m.

Rome, Galleria Borghese

In depicting the most dramatic phase of Daphne's flight, the moment of her transformation, Bernini made full use of the elements in the narrative. In a final attempt to escape Apollo's grasp, she turns in her flight, and at this moment begins to change into a laurel. The god does not yet realize that his quarry, whom he thought he had captured, has eluded him; only his face reflects the first signs of bewilderment and uncertainty.

PIETRO TACCA

b. Carrara 1577 – d. Florence 1640

162 *The Philip III equestrian monument* 1609–14 bronze *c.* 4·50 m.

S. PETRUS TACA FECIT FLORENTIA

Madrid, Plaza Mayor

When Tacca took over after Giovanni Bologna's death in 1608, one of the commissions in the workshop was Philip III's equestrian monument. Tacca derived the horse's gait and the rider's seat from the type conceived by the master for the statues of Cosimo I and Ferdinando I. He altered the general effect, though, by increasing the volume of the horse which created a new relationship between the two figures.

FRANCESCO MOCHI (*see* 156)

163 *The Alessandro Farnese equestrian monument* 1620–9 bronze, over lifesize

S. OPUS FRANCISCI MOCHI DE MONTIS VARCHII

Piacenza, Piazza dei Cavalli

In his conception of the Farnese equestrian monument, Mochi introduced a new element, the Baroque. Alessandro, as befits his status, sits high on his horse, not however as a royal personage, but as a dashing leader, urging on his equally fiery mount. Thus the authority that the group expresses is not a matter of rank, but of the vigour of the individual figures.

GIAN LORENZO BERNINI (*see* 159)

164 *St Longinus* 1628–38 marble *c.* 4·40 m.

Rome, St Peter's

Longinus lays down his sword and helmet and seizes the sacred lance, the visible sign of his inner enlightenment and the recovery of his sight.

He raises his face to the Cross in thankful adoration, and spreads his arms in boundless devotion. Free and redeemed, he stands relaxed in the niche, filling it with his wide gesture, unencumbered by his heavy cloak, which finds its own support in the innumerable folds.

FRANÇOIS DU QUESNOY

b. Brussels 1597 – d. Leghorn 1643

165 *St Andrew* 1627–40 marble 4·57 m.

S. FRAN. DU QUESNOY BRUSELL. FAC.

Rome, St Peter's

Du Quesnoy carved this statue of St Andrew, with its muscular torso reminiscent of Laocoön's, in the classical manner – an upright figure, relaxed and yet animated. The fall of the drapery corresponds to his posture, but the diagonal run of the folds alludes to the shape of the huge cross. The relaxation of the body is in harmony with the facial expression, resigned and ready for sacrifice.

GIAN LORENZO BERNINI (*see* 159)

166 *The ecstasy of St Teresa* 1645–52 marble, lifesize

Rome, Sta Maria della Vittoria

The ecstasy of Teresa of Avila, canonized in 1622, is depicted in sculpture by Bernini as she herself visualized it and described it in the *Obras*. Resting on a bank of clouds, Teresa, in sacrifice to God, offers her heart to the golden arrow of Divine Love with which the beautiful angel inflicts on her a pain so fierce and yet so sweet that she longs for it to last for ever.

167 *The vision of Constantine* 1654–70 marble, over lifesize

Rome, Vatican, Scala Regia

Bernini conceived the conversion of Constantine so that every part of the scene is touched by direct light from the Cross in the sky. The heavy damask curtain billows with the impact of the apparition, the horse rears and averts his head to avoid the bright rays. But the emperor, sitting erect, gazes upwards spellbound, encountering the divine sign with understanding.

168 *Tomb of Pope Urban VIII* 1628–47 black and white marble, bronze and gilded bronze, figures over lifesize

Rome, St Peter's

From the high pedestal, the pope, whose garments fall in rippling folds, raises his hand, palm outward, to give the benediction. In the lower zone of the sarcophagus a calm, more everyday atmosphere prevails:

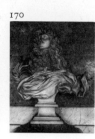
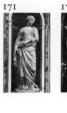
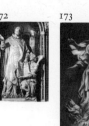

168 169 170 171 172 173 174 175

the motherly Charity tends her children, Justice, deep in thought, relinquishes her attributes to the *putti*, and Death, crouching on the coffin, composes the inscription. In giving all the figures such vitality, Bernini surpassed Guglielmo della Porta, and finally broke away from the Michelangelo type of Medici tomb.

169 *The Triton Fountain* before 1633–7 marble, figures over lifesize
Rome, Piazza Barberini
Fountains for the glorification of escutcheons and emblems of rulers, like these Barberini emblems of Pope Urban VIII, and the idea of using a triton supported on a base of dolphins' tails, were already well known in the sixteenth century. As a novelty, Bernini built his monumental fountain out of natural lifelike shapes, creating the sort of display one might see in nature itself: the triton emerges from an open shell which is lifted above the surface of the water by dolphins.

170 *Bust of Louis XIV* 1665 marble 0·80 m.
Versailles, Palace
Bernini's plan to place the bust of Louis XIV between allegorical trophies, and above a gilded and enamelled bronze globe was possibly inspired by the reverse of a 1661 medal that showed the king as the Sun God Apollo seated on a globe. This arrangement, which unfortunately was not carried out, must be borne in mind when one looks at the swirling drapery that projects excessively at the bottom of the bust.

FRANÇOIS DU QUESNOY (*see* 165)
171 *St Susanna* 1626?–1633 marble, over lifesize
Rome, Sta Maria di Loreto
This statue of the martyr, her palm branch missing, attracted the appreciation of emulating artists, the eulogy of critics and even the approval of Bernini's admirers, for instance Pope Urban VIII. Their great admiration was due to the conviction that in grace of movement, mildness of expression, and excellence in treatment of the marble, it contained all that is best in Greek and Roman sculpture.

ALESSANDRO ALGARDI
b. Bologna 1598 – d. Rome 1654
172 *St Philip Neri* 1640 marble, over lifesize
Rome, Sta Maria in Vallicella
This group is an example of Algardi in a restrained rather than a daring vein. But it exhibits as usual the extreme refinement of his art in the material, fabric, plumage, skin and hair – and in the faces, the expres-

sions of the youthful angel and the aged Philip Neri. Algardi, however, a portrait sculptor and restorer of antiques, much concerned with truth and accuracy, did not hesitate to make a close study of Neri's death mask in order to reproduce his countenance faithfully.

ERCOLE FERRATA
b. Pelsotto (Como) 1610 – d. Rome 1686
173 *St Agnes* 1660 marble, over lifesize
Rome, S. Agnese in Agone
In the statue of St Agnes, Ferrata successfully fused stylistic elements of his brilliant predecessors and teachers, Bernini, Algardi and du Quesnoy, into a beautiful and original creation of his own. The reeling posture of the tall figure could mean that she is sinking into the faggots. But as we see the leaping flames turn aside under her outstretched hands, we know that her prayer is answered, and that she is rising from the fire.

ALESSANDRO ALGARDI (*see* 172)
174 *The meeting of Pope Leo I and Attila* 1646–53 marble *c.* 7·15 m.
Rome, St Peter's
The composition of the famous deliverance of Rome from the 'scourge of God', through Leo I's eloquence and the intervention of the Apostles, is elaborately executed in relief. It is disturbing to the spectator because his attention, drawn to the crucifix, the focus of the scene, by the looks and gestures of the three main figures, is distracted by their urgent movements in other directions.

ANTONIO RAGGI
b. Vico Morcote (Como) 1624 – d. Rome 1686
175 *Noli me tangere* 1649–50 marble and stucco
Rome, SS. Domenico e Sisto
The stucco angels, in the upper part of the altar wall, with their symbols of the Passion, are modelled with liveliness, their proportions and movements successfully related to each other. The group of the Risen Christ and the Magdalen, though impressive as a vivid silhouette, is inconsistent in its detail: the delicate figures groping towards each other are clad in extremely heavy draperies, falling in arbitrary and unrelated folds.

DOMENICO GUIDI
b. Torano (Carrara) 1625 – d. Rome 1701
176 *The Holy Family* after 1672 marble
Rome, S. Agnese in Agone

325

176

177

178

179

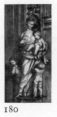

180

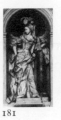

181

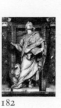

182

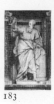

183

The restlessness in this presentation of the Holy Family with the young John and his parents, Elizabeth and Zacharias, is due only to the draperies, which fall in countless sharp and broken folds. This creates a deceptive agitation in which the figures, suited to the tranquil scene, do not share. The dichotomy between form and content in Guidi's work is one of the marks of the declining Roman Baroque.

ERCOLE FERRATA (*see* 173) and LEONARDO RETTI
active in Rome 1670–1709
177 *The martyrdom of St Emerentiana* 1660–1709 marble
Rome, S. Agnese in Agone
Ferrata, before he died, managed to finish only the dramatic scene of the stoning of St Emerentiana, based on the theme of Christ's Flagellation. Retti, who completed the upper part of the relief, made some minor alterations to the master's work, in the figures of St Agnes with the lamb and the angel with the palm and crown of roses. Nevertheless, with his 'correction' Retti impaired the earlier subtle relationship between the two zones.

GIOVAN BATTISTA FOGGINI
Florence 1652–1725
178 *The ascension and vision of St Andrew Corsini* 1676–91 marble
Florence, Sta Maria del Carmine
After his return from Ercole Ferrata's workshop in Rome, in 1676, Foggini was able to give a full account of the new, uniform decoration of S. Agnese with large altar reliefs. It was probably he who suggested decorating the walls above the three tombs, in the severe Florentine Baroque chapel, with reliefs and not paintings as had originally been planned. For the execution he is said to have enlisted the help of Balthasar Permoser and other collaborators.

FILIPPO PARODI
Genoa 1630–1702
179 *Reliquary* 1689–94 marble and stucco
Padua, S. Antonio, Cappella del Tesoro
The patrons who commissioned the new marble shrine for the worship of St Antony's relics approved Parodi's composition. The ascetic saint in the architrave appears in the midst of a lively dancing group of angels, singing and playing musical instruments. The allegories and saints on the lower balustrade are accompanied by cherubs, who mock their devout attitudes by imitation and exaggeration.

GIACOMO SERPOTTA
Palermo 1656–1732
180 *Charity* between 1690 and 1696 stucco, lifesize
Palermo, Oratorio di S. Lorenzo
Looking at the countless stucco figures and reliefs in the oratories at Palermo, one is filled with admiration for Serpotta's accurate and effortless modelling and his inexhaustible inventiveness. The courtly elegance and noble character of some of his figures impressed the ordinary citizen, and the realism and popular quality of others delighted the learned patrician. In an amiable way, Serpotta exhorted everyone to follow the path of virtue.

181 *Fortitude* 1714–17 stucco, lifesize
Palermo, Oratorio del Rosario di S. Domenico
In Serpotta's version *Fortitude*, hitherto represented as a serious robust woman, is a young coquette. She wears a fashionable bodice and a crest of ostrich-feathers instead of the customary armour and helmet. A jacket made of lion's hide is the only vestige of Fortitude's traditional companion, the lion. Her old attribute, the column, is used as a support for her elegant pose. This figure plays the part of Fortitude, but is no longer a credible personification.

CAMILLO RUSCONI
b. Milan 1658 – d. Rome 1728
182 *St John the Evangelist* 1708–13 marble *c.* 4·25 m.
Rome, S. Giovanni in Laterano
The diagonal flow of the folds and the extension of the cloak behind the left side of the body creates outwardly a predominantly asymmetrical effect. But the real significance of the Evangelist lies in the implicit triangle, formed by the quill pen in his right hand, the book in his left and the head raised to heaven for inspiration.

PIERRE LE GROS
b. Paris 1666 – d. Rome 1719
183 *St Thomas* 1705–11 marble *c.* 4·25 m.
Rome, S. Giovanni in Laterano
The preacher's cross and the dove of the Holy Ghost set in an architectural frame, and the carpenter's square, bring to mind the tradition according to which the Apostle was summoned to India as a builder. There he erected not an earthly but a heavenly palace with eloquence and missionary fervour. Le Gros therefore showed St Thomas as the inspired bearer of Christ's Word.

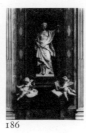

184

185

186

187

188

189

190

CAMILLO RUSCONI (see 182)

184 *Tomb of Pope Gregory XIII* 1715–23 marble, figures over lifesize

s. EQV. CAMILL. RUSCONI MEDIOLAN.INVEN. ET SCULP.

Rome, St Peter's

This marble tomb by Rusconi replaced an earlier stucco monument to Gregory XIII (1571–85) by Prospero Antichi. It was commissioned by Jacopo Buoncampagni, a remote descendant of the pope. The figure on the left is Religion, holding a tablet acclaiming the propagation of the Faith. On the other side, Wisdom unveils a sarcophagus relief by Cametti and Melloni in remembrance of Pope Gregory's reform of the calendar in 1582.

GIUSEPPE MAZZUOLI

b. Siena 1644 – d. Rome 1725

185 *Tomb of Stefano and Lazzaro Pallavicini* 1714 white and coloured marble

Rome, S. Francesco a Ripa

The tomb is constructed from different types of coloured marble carved in rich volutes. Figures of the Virtues stand motionless within the structure: Fortitude, her lion having withdrawn underneath the sarcophagus, is grief-stricken, and Justice is meditating sadly. Only the figure of Death with outstretched wings shows signs of animation and activity as he carries off the medallion portraits of the dead brothers.

GIUSEPPE LIRONI

Rome 1679–1749

186 *Tomb of Cardinal Neri Maria Corsini* c. 1733–5 marble c. 2·20 m.

Rome, S. Giovanni in Laterano

Following the example of his teacher Rusconi, Lironi gave some of his figures weight and importance by the sumptuous arrangement of their robes. He used this technique for the folds of Justice's draperies, but the volume of the material is so severely reduced that the cloak loses its value and becomes merely a pleasing piece of ornamentation for the slender contemplating figure of the maiden.

FILIPPO DELLA VALLE

b. Florence 1698 – d. Rome 1768

187 *Tomb of Cardinal Andrea Corsini* 1732–5 marble c. 2·20 m.

Rome, S. Giovanni in Laterano

The figure of Temperance reveals the master's origin in the workshop of his uncle, Foggini. Her noble pallid countenance, graceful movement, nonchalant handling of the beautiful pitchers, and her natural

unobtrusive self-assurance stem from the tradition of Florentine sculptors in bronze. There is nothing in this figure of the artistic approach of his other teacher, the Roman Rusconi.

AGOSTINO CORNACCHINI

b. Pescia 1685 – d. Rome (?), after 1754

188 *The birth of the Virgin* 1728–30 marble c. 5·00 m.

Turin, Basilica di Superga

Cornacchini's contemporaries admired this relief for the same reasons that now lead us to disapprove of it. Unconcerned, the sculptor showed on one panel, next to each other and overlapping, two events which occurred in different places and at different times. On a diagonal leading down to the right, he placed the scene of Joachim's Annunciation. The other diagonal is formed by St Anne's confinement and the group of women attending the infant Mary.

BERNARDINO CAMETTI

b. Gattinara (Prov. Vercelli) 1669 – d. Rome 1736

189 *The Annunciation* 1729 marble c. 5·00 m.

s. and d. EQUES BERNARDINUS CAMETTUS ROMANUS ORIUNDUS A GATTINARA INVEN.ET SCULP. A.D. MDCCXXIX

Turin, Basilica di Superga

One would have to go back to Andrea della Robbia or Andrea Sansovino for an Annunciation scene as elaborate as this. It includes the dove of the Holy Ghost, angels, *putti* and cherubs, and also God the Father. However, disregarding earlier compositions, Cametti gathered all the figures, both human and divine, on a common stage to participate in the central event.

PIETRO BRACCI

Rome 1700–73

190 *Tomb of Queen Maria Clementina Sobieski* 1739–42 black and white marble, porphyry and alabaster, figure c. 3 m.

Rome, St Peter's

The figure representing the allegory of *Carità verso Iddio* is placed in front of a pyramid, which was used in eighteenth-century tomb-sculpture as a symbol both of eternity and unblemished virtue. She sits on a yellow alabaster cloth, modelled in heavy folds and spread over the sarcophagus. In her left hand she raises the heart of the young wife of James III, which glows with religious zeal, and with her right arm she encircles a mosaic portrait of the queen.

191

192

193

194

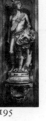
195

196

197

191 *Bust of Pope Benedict XIII* between 1740 and 1750 marble 0·90 m.
Lugano, Thyssen-Bornemisza Collection
In the busts of Benedict XIII that Bracci made between 1724 and 1730, during the former's lifetime, he always showed the elderly pope wrapt in thought and with the drawn features of an ascetic. In this posthumous bust, the stole of which he decorated with the Orsini emblems and the papal coat of arms, Bracci gave the gaunt head a more youthful, alert expression.

192 *Tomb of Pope Benedict XIV* 1759–69 marble, figures over lifesize
S. PETR. BRACCI OPERIS HOC INV.ET SCUL.
Rome, St Peter's
Bracci seems to have taken the idea for the design of this tomb from secular monuments. He showed the pope standing upright on a pedestal like a monarch. The simplicity of Benedict's demeanour and gestures give the statue its majestic appearance. The voluminous figures of *Religio* and *Disprezzo dell'Interesse* also appear more tranquil and dispassionate than in earlier representations.

GIOVANNI BATTISTA MAINI
b. Cassano Magnago (Lombardy) 1690 – d. Rome 1752
193 *Tomb of Cardinal Neri Corsini* 1732–5 marble, main figure *c.* 2·65 m.
Rome, S. Giovanni in Laterano
With a sure instinct for correct proportion, Maini arranged the figures in an asymmetrical pyramid. The architecture and sculpture are in harmony with each other, but at the same time their individual values remain unimpaired. The cardinal turns reverently towards the altar of his saintly ancestor, Andrea Corsini. In his flowing robes, Neri is the embodiment of the elegant intellectual diplomat.

MICHELANGELO SLODTZ
Paris 1705–64
194 *St Bruno* 1744 marble *c.* 3·50 m.
s. and d. MIC. ANG. SLODTZ PARISINUS F. 1744
Rome, St Peter's
This figure is artistically the most significant in a series in St Peter's, depicting the founders of religious orders. Slodtz showed the founder of the Carthusian order in an act of humility, renouncing the office of bishop. The well-articulated figure with the head of an intelligent seminarist, refusing the mitre and crosier, inclines back against the rocky bank, the skull and the Holy Scriptures, in a beautiful *rocaille* movement.

GIOVANNI MARCHIORI
b. Caviola d'Agordo (Belluno) 1696 – d. Treviso 1778
195 *David* 1743 marble
S. OP. IOAN.MARCHIORI
Venice, S. Rocco
As patrons of church music and sacred song, this David, and a St Cecilia, were carved by Marchiori to be placed beneath the organ. However, he did not characterize David as a singer of psalms but depicted him in the traditional way as the slayer of Goliath, displaying the head of the giant in his left hand. But it is hard to conceive that this unathletic youth, with feathered turban and broad sash, would have been capable of the heroic deed of which he is so proud.

ANTONIO CORRADINI
b. Este 1668 – d. Naples 1752
196 *Chastity* after 1745–52 marble *c.* 1·75 m.
Naples, Sta Maria della Pietà dei Sangro
Raimondo di Sangro had the figure of *Chastity* erected on the tomb of his mother, Cecilia Caetani, to commemorate her most precious virtue. The veil, Chastity's traditional attribute, is carved with such skill that, although it covers her beautiful body, all the forms are visible through its transparency. The theme of Chastity is repeated on the base in the biblical relief composition, *Noli me tangere.*

FRANCESCO QUEIROLO
b. Genoa 1704 – d. Naples 1762
197 *Disenchantment* after 1752 marble *c.* 1·75 m.
S. EQUES FRANCISCUS QUEIROLI IANVENSIS
Naples, Sta Maria della Pietà dei Sangro
Raimondo commissioned the allegory of *Disenchantment* for Antonio di Sangro's tomb in memory of his father's spiritual transformation, when he became a priest after the premature death of his wife Cecilia. In this composition the spirit of wisdom, hovering over the globe, helps misguided man to free himself from the meshes of his delusion in this world, just as in the scene on the base Christ opens the eyes of the blind.

NICOLA SALVI and PIETRO BRACCI (*see* 190)
Rome 1697–1751
198 *The Trevi Fountain* 1731–62 marble, main figure 5·80 m.
Rome, Piazza di Trevi
After a competition with seven other artists, Salvi, an architect trained in all the arts, was awarded the commission for the new *Fontana di Trevi.*

198

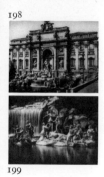

199

200

201

202

203

204

205

From 1732 onwards his design was carried out without any substantial alteration. The central group was carved by Bracci later, between 1759 and 1762. It depicts the wild but majestic Neptune and the sea-horses restrained by tritons, the *cavallo sfrenato* and the *cavallo placido*, symbols of water in its two different aspects, turbulent and destructive, and peaceful and beneficial.

LUIGI VANVITELLI, ANGIOLO BRUNELLI and others
b. Naples 1700 – d. Caserta 1773
b. Florence 1740 – d. Naples 1806
99 *Diana and the nymphs* 1770–80 marble, figures over lifesize
Caserta, Palace Gardens
Diana and her startled nymphs at the foot of the great cascade form only one part of at least nineteen sculptural groups in the Caserta Palace gardens. The themes are derived from Ovid and Pausanias, and all are connected with water. The Diana group has its counterpart on the opposite side of the cascade: Actaeon, transformed into a stag, is threatened by his own pack of hounds. The two groups together make up a single composition.

HENDRICK DE KEYSER (*see* 146)
200 *Bust of Vincent Jacobsz. Coster* 1608 marble
s. and d. H D K.F. A.O 1608, 0·75 m.
Amsterdam, Rijksmuseum
In this portrait of Vincent Coster, de Keyser departed from the Roman emperor type of bust by reducing the size of the base and making it less imposing. The features of the wine merchant, who was also an official in the Office of Weights and Measures, are neither heroic nor common-place. With his well-groomed beard and hair and piercing eyes, portraying an incorruptible character, he is shown as an upright custodian of commercial morality.

ADRIAN DE VRIES (*see* 124)
201 *Laocoön and his sons* 1623 bronze 1·72 m.
s. and d. ADRIANVS FRIES HAGIENSIS BATTAVVS FE 1623
Drottningholm, Palace Gardens
The universal admiration for the classical Laocoön group, discovered in 1506, had discouraged sculptors of the sixteenth century from attempt-ing to represent the death struggle of Ápollo's priest in different and original ways. De Vries was the first to attempt a new solution: instead of showing the father and his sons side by side and in the last throes of their struggle against fate, he constructed a pyramidal group of muscular entwined figures resisting the monsters with all their might.

HENDRICK DE KEYSER (*see* 146)
202 *The mad woman c.* 1620 sandstone with base 2·95 m.
Amsterdam, Rijksmuseum
This figure of a mad woman, which once stood in the inner court of Amsterdam's lunatic asylum, must be regarded as a realistic and moving representation of an anonymous inmate, and not as an allegory of 'Madness'. She has torn off her dress, and screams wildly as she pulls her own hair. The classical Laocoön may have provided the idea for a figure expressing unbearable pain, considered to be one of the four main causes of lunacy.

ROBERT DE NOLE
b. Utrecht *c.* 1565/70 – d. Antwerp 1636
203 *St Amand* 1620–4 alabaster, *c.* lifesize
Lier near Ghent, St Gummarus
Originally this St Amand stood together with a figure of his convert, St Bavo, in the architectural frame of the high altar of Ghent Cathedral. The altar, destroyed in 1710, also had a large painting by P.P. Rubens (1623–4) of the Conversion of St Bavo. The influence of Rubens is particularly noticeable in the folds of the wide cope, which gives size and volume to the lean old missionary bishop.

JÉRÔME II DU QUESNOY
b. Brussels 1602 – d. Ghent 1654
204 *St Thomas c.* 1644–6, stone, over lifesize
Brussels, Sts Michel et Gudule
During their collaboration in Rome, Jérôme, the double of his famous elder brother François, adopted as his own the latter's style and manner. Later, he settled in their common Flemish homeland. The *St Thomas* is a replica of Francois' *St Andrew* in St Peter's. The drapery is less voluminous, but the posture of the body and the shape and expression of the head closely follow the model.

205 *Tomb of Bishop Antonius Triest* 1651–4 black and white marble
Ghent, St Bavo
The admiration of Jérôme's contemporaries for the *grande manière*, in which this tomb is carved, was based on an awareness of its funda-mental affinity with Italian art. Indeed, the figures of the bishop, the Virgin, and Christ are free adaptations of models of Francesco da San-gallo, Michelangelo and Jérôme's italianized brother François. The two genii opposite the narrow sides of the sarcophagus are reproduc-tions in marble of figures from the latter two masters.

208

206 207 210 211 212

209

LUCAS FAYDHERBE
Malines 1617–97
206 *Tomb of Bishop Andreas Cruesen* 1660 black and white marble, figures
1·40 and 1·60 m.
Malines, St-Rombout
In the general layout of the tomb Faydherbe followed the model of the
Triest monument. But the powerful and vehement figures of this pupil
of Rubens are much superior to Jérôme du Quesnoy's symmetrical
rigid images. The winged Chronos, as master of all temporal being,
looks with anger and bitterness towards the Risen Christ, promise of
eternal life, in front of whom the bishop kneels, humble and suppliant.

ARTUS QUELLINUS the elder
Antwerp 1609–68
207 *Virgin with the young Christ, Joseph and Anne* (detail) 1644 marble and
slate, figures *c.* 0·95 m.
Antwerp, St Paul
The focus of this monument, donated by the Brotherhood of the Holy
Name Jesus, is the Christ-child in benediction, and holding a globe, as
redeemer of the universe. Mary bends over him and supports him
tenderly, Joseph and Anne turn towards him in adoration. Quellinus
always sculpted the features of his figures without flattery. The drapery
is sometimes full-blown, sometimes gathered.

208 *The caryatids' wall of the Tribunal* 1650–2 marble, relief *c.* 2·60 m.
Amsterdam, Royal Palace
Quellinus carved three exemplary scenes from classical and biblical
stories of justice for the rear wall of the stone Lay Assessors' bench in
the town hall: the magnanimity of Seleucus, the wisdom of Solomon
and the justice of Brutus. In front of the relief scenes there are four
much admired caryatids, half-naked female figures with rounded forms
and broad hips. The two inside figures have always been regarded as
symbols of penitence and the two on the outside as symbols of
remorse.

ROMBOUT VERHULST
b. Malines 1624 – d. The Hague 1698
209 *The butter-buyer* [d.] 1662 sandstone
Leiden, The Butter-hall of the Nieuwe Waag
Dutch sculptors of the seventeenth century produced *genre* sculpture
mainly in narrative reliefs to decorate and characterize public buildings.

Verhulst's butter-buyer above the entrance of the Butter-hall is a
beautiful example of this type of work: an elegant young woman takes
a sample of butter in the presence of her maid and the merchant.

BARTHOLOMEUS EGGERS
Amsterdam *c.* 1630–92
210 *Tomb of Admiral Jacob van Wassenaar-Obdam* 1665–7 black and white
marble, main figure lifesize
S. B. EGGERS FEC.
The Hague, Groote Kerk
This elaborate free-standing tomb, originally designed by the painter
Cornelis Monincx, was erected in honour of the admiral. It incor-
porates a mass of historical, heraldic and allegorical sculpture: personi-
fications of the Virtues, and emblems and reliefs of naval battles decorate
the base; beneath the baldachin, Fame, soaring above the globe on
eagle's wings, summons the hero to join the immortals.

PIETER RIJCKX
b. Bruges 1630 – d. Rotterdam 1674
211 *Tomb of Admiral Witte Cornelisz. de With* 1669 black and white marble
S. RIJCX FE.
Rotterdam, Groote Kerk
Rijckx, a capable sculptor in his field, created in this, his masterpiece, a
beautiful and instructive example of the typically Dutch type of
admiral's tomb, with its numerous allusions to the marine world and
life at sea. Mars appears here beside Neptune with his trident, and above
the cornice the personification of Seafaring, wearing a crown of ships'
keels, is placed beside Fame.

ROMBOUT VERHULST (*see* 209)
212 *Tomb of Admiral Michiel Adriaensz. de Ruyter* (detail) 1677–81 white,
red and black marble
Amsterdam, Nieuwe Kerk
Every part of the central field of this large, triptychlike tomb is
busy with sculpture. In front the *Immensi Tremor Oceani* reclines on
cannon barrels; two Tritons, covered in shells and corals, blow their
horns for his last sea battle, depicted on the relief; genii encircling Fame
with their fanfares of heavenly and earthly glory, carry the coat of
arms and emblems of this national hero.

GABRIEL DE GRUPELLO
b. Grammont (East Flanders) 1644
d. Kerkrade (Limbourg) 1730

213

214 215 216 217 218 219

213 *Fountain of the Fishmongers' House* c. 1675 marble 2·05 m.
Brussels, Musée Royal des Beaux-Arts
Dolphins carry the shell-shaped bowl of this wall-fountain, from the former great hall of the Fishmongers' Guild. Nereus and Thetis – the old man of the sea and his favourite pearl-bedecked daughter – have emerged from it and above their heads a spirited Triton child sports itself on a hippocamp. By means of this idyllic scene – with its powerfully muscular and voluptuous figures – Grupello makes antique mythology come alive for his Flemish countrymen.

JEAN DELCOUR
b. Hamoir 1631 – d. Liège 1707
214 *Tomb of Bishop Eugène-Albert d'Allamont* 1667–70 white and black marble, gilt bronze, Virgin c. 1·80 m.
S. OPUS IO(ANN)IS DEL COUR
Ghent, St Bavo
With a flaming sword in his right hand, a wingless angel protects the bishop. An inscription on the tomb tells us that in his lifetime he was always aware of Death and here he is shown conversing with him, as with an old friend, and at the same time commending himself to the Virgin. This important marble monument by Delcour shows clearly, in the treatment of the figures and draperies, that during his years of study in Rome he developed a personal style based on Algardi and Ferrata.

WILLEM KERRICX, WILLEM IGNATIUS KERRICX and others
b. Dendermonde 1652 – d. Antwerp 1719
Antwerp 1682–1745
215 *Mount Calvary* after 1697–after 1740 figures in sandstone, lifesize
Antwerp, St Paul
The Calvary was donated by two Jerusalem pilgrims, Dominicus and Jan Baptist van Ketwigh. It is an ingeniously arranged natural stage on which sixty-three figures illustrate the Christian story of Salvation. Between a garden for prophets and a garden for evangelists, a path, lined with angels of the Passion, leads to the cave of the Holy Sepulchre. Above it, arranged in three tiers, are placed the figures of the penitent Magdalen, the *Pietà* and the Crucifixion group.

MICHIEL VAN DER VOORT
Antwerp 1667–1737
216 *Tomb of Ludovicus le Candèle* c. 1730 white and red marble 2·10 m.
Antwerp, St Jacob

'Death and Resurrection', the traditional themes of sepulchral art, are here given a new interpretation. Van der Voort shows a skull with bat's wings – an allusion to human frailty and blindness – and the raising of Lazarus, in the relief – a symbol of the Resurrection on the Day of Judgment. Christ receives Lazarus, rising from his rocky grave, with open arms, while Mary Magdalen and a disciple free him from his shroud.

217 *Model of a pulpit* 1721 terracotta 0·60 m.
Malines, Stadsmuseum
This model of the first purely naturalistic pulpit illustrates for us the form in which the work – a huge wall relief – once graced the Convent Church of the Norbertines. The executed work was altered at St Rombout after 1809. Placed between the scenes of the Fall and the Salvation, St Mary Magdalen, personifying mankind in despair, glances across to the brazen serpent. The conversion of St Norbert is illustrated in the lowest tier.

THEODOOR VERHAEGHEN
Malines 1701–59
218 *Pulpit* 1743–6 oak
Malines, Onze Lieve Vrouwe van Hanswijk
The idea of letting the pulpit introduce an element of nature into the Church was taken up repeatedly in the eighteenth century. The main part of the pulpit was fashioned as a rough-hewn garden seat, attached to the trunk of a branching tree, the sounding board is like the crown of the tree in full leaf with clouds drifting through it. This glimpse of nature formed the setting for powerful and instructive illustrations of the stories of Salvation.

LAURENT DELVAUX
b. Ghent 1696 – d. Nivelles 1778
219 *Pulpit* [d.] 1772 oak and marble
Nivelles, Collégiale de Ste Gertrude
Delvaux reinstated the pulpit once more as a piece of church furniture. Here Christ and the Woman of Samaria do not meet in a landscape setting; placed on a separate base, they form an independent group, framed by the architecture of the pulpit and the curved flight of steps. The main part of the pulpit has a wavy outline and is decorated with reliefs of the Parable of the Sower, the Prodigal Son and the Wise Householder.

220 221 222 223 224 225 226 227

220 *Hercules* 1770 marble 2·88 m.
s. and d. LAU. DELVAUX INVENIT ET SCULPSIT. ANNO 1770
Brussels, Musée de Peinture Moderne
With the apples of the Hesperides in his right hand and the Calydonian boar at his feet, this Hercules still stands on the original site, the staircase of the former palace of the Stadtholders, a museum since 1877. The handle of his club is decorated with the cross of Lorraine and other orders which distinguished Prince Charles of Lorraine, Delvaux's aristocratic patron. Hercules, therefore, is here probably a personification of the virtues of this man who had done so much for his country.

GRINLING GIBBONS
b. Rotterdam 1648 – d. London 1721
221 *Baptismal font* 1684–5 marble 1·21 m.
London, St James Piccadilly
His superb woodcarvings make Gibbons the outstanding representative of English decorative style in the late Stuart period. Of his works in marble, those on a small scale, such as this font, are the most attractive. He carved the foot as the Tree of Knowledge, with the scene of the Fall, and he encircled its bowl with three reliefs illustrating man's redemption from original sin.

222 *The Tobias Rustat monument* c. 1693–4 marble c. 4·25 m.
Cambridge, Jesus College
To the usual components of a funeral monument, i.e. the tablet with the epitaph and the portrait and arms of the deceased, Gibbons has added *putti*, as was commonly done in the Baroque period. They pull aside and support the heavily draped curtain, revealing the portrait of the dead man. The lush dense garland of fruit and flowers is so characteristic of Gibbons that we can – as with a signature – regard it as proof of authenticity.

EDWARD PIERCE
London c. 1635–1695
223 *Bust of Sir Christopher Wren* 1673 marble 0·66 m.
Oxford, Ashmolean Museum
No work has kept the name of Edward Pierce more alive for posterity than his bust of the forty-year-old Christopher Wren. His rendering of the familiar features shows the architect to have been a man of independent thought, balanced judgment and decisive action. It is all the more impressive that this was achieved without the conventional Baroque trappings; Wren appears here simply in ordinary dress. In this concep-

tion of the portrait bust Pierce anticipates much of the future development of this *genre*.

MICHAEL RYSBRACK
b. Antwerp 1694 – d. London 1770
224 *Bust of Inigo Jones* 1725–30 marble 0·47 m.
Chatsworth House (Derbyshire)
For the third Earl of Burlington, Rysbrack carved busts of Palladio and Jones, the two architects who so deeply influenced the new developments in English architecture. For other patrons, he carved the portraits of the great innovators in sculpture, Nicholas Stone and du Quesnoy, and the painters Rubens and Van Dyck. Unlike the print (after a portrait drawing by Van Dyck) on which this bust is based, Rysbrack stressed the architect's genius in his expression.

225 *Fireplace* c. 1732 marble
Houghton Hall (Norfolk)
Together with other works for Sir Robert Walpole, Rysbrack made two fireplaces for Houghton Hall, both with scenes of sacrifice, taken from antiquity, and both closely modelled on Roman reliefs. The decoration of the mantelpiece in the Marble Parlour surely indicates that this was once a banqueting and dining-room, for in the pediment panthers are shown eating grapes; on the lower cornice is a head of Bacchus and the sides are decorated with bunches of grapes.

LOUIS FRANÇOIS ROUBILIAC
b. Lyon 1702 ? – d. London 1762
226 *The Nightingale monument* 1761 white and black marble
S. L.F. ROUBILIAC INV.T ET SC.T
London, Westminster Abbey
Washington G. Nightingale commissioned Roubiliac to design a monument to his parents which would illustrate the unforgettably horrific and poignant event in the life of the family, the death of the young mother. Roubiliac conceived the scene most realistically, yet removed it from life and translated it into allegory by showing it as the desperate attempt by the husband to shield his much loved wife from the thrusting lance of the skeleton.

227 *Bust of Jonathan Swift* before 1749 marble 0·84 m.
Dublin, Trinity College
The marble bust of this proud, misanthropic satirist, Jonathan Swift, in his own college, Trinity, is one of the numerous busts which gave

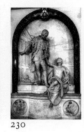
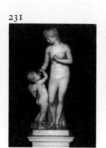

231

232

233

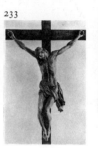

234

228 229 230

Roubiliac the reputation of the greatest portrait sculptor in 'the century of physiognomy'. Although such works offer little scope to the creative imagination, Roubiliac still managed to convey in each bust the particular character, personality and mood of the sitter.

PETER SCHEEMAKERS
Antwerp 1691–1781
228 *The William III equestrian monument* 1732–4 gilt lead and tin
Hull, Market Place
Competing for the commission for an equestrian monument to William III for Bristol in 1732, Scheemakers lost to the more imaginative Rysbrack. He was able, however, to execute his model, on a monumental scale, for Hull. As an artist, thoroughly versed in the antique and inspired by classicist-academic ideals (which made him the most successful teacher of the younger generation), he based his own work closely on the equestrian statue of Marcus Aurelius, but gave his group greater vertical emphasis.

JOSEPH NOLLEKENS
London 1737–1823
229 *Tomb of Sir Thomas and Lady Salusbury* 1777 white and black marble, figures over lifesize
Offley (Hertfordshire), St Mary Magdalen
From the branches of an oak tree, the symbol of steadfastness and loyalty, a sail hangs down, trailing over the narrow sides of the sarcophagus. In front of this backdrop husband and wife meet, calm and dignified, as if to renew their original troth. In this monument to the Judge of the Admiralty, the elegiac mood of the scene is reminiscent of an antique funeral stele. The arrangement of the figures recalls the famous Roman wedding relief from the Palazzo Sacchetti.

JOHN BACON
London 1740–99
230 *Tomb of Thomas Guy* [d.] 1779 marble, figures lifesize
London, Guy's Hospital
The fashionable dress of the wealthy founder of Guy's Hospital is most carefully worked, as is the wasted body of the sick man. The precise drawing of the background architecture and subtle carving of the allegories of Philanthropy and Charity on the medallions of the base show that Bacon's talent and temperament were more inclined towards a lively narrative naturalism than impersonal idealization.

JOSEPH NOLLEKENS (*see* 229)
231 *Venus and Cupid* 1775–8 marble 1·57 m.
Lincoln, Usher Art Gallery
Nollekens took no part in the revival of art that took place in his lifetime. He worked in a conventional style based on a knowledge of the antique and the art of older native masters. His works of the '70s won general approval, particularly when he chose a somewhat sentimental subject such as this group with Venus, here gentle and motherly, chiding the unruly Cupid in mock-seriousness.

THOMAS BANKS
London 1735–1805
232 *Thetis and Achilles* 1778–9 marble 0·91 m.
London, Victoria and Albert Museum
Isolated on the right is the main group of Thetis and her son Achilles, stretched out and moaning with grief for the death of Patroclus. On the other side the nymphs, smooth of body and intertwined to create a beautiful linear rhythm, follow Thetis's lead; then, taken aback, they halt and shyly bend back to reverse their movement, thus forming an inner frame. This composition strongly recalls Banks's friendship with Fuseli.

GEORG PETEL
b. Weilheim (Upper Bavaria) 1601 – d. Augsburg 1634
233 *Crucifix c.* 1631–2 limewood 1·70 m.
Marchegg (Lower Austria), Bahnhofskirche
In his small ivory crucifixes Petel tried to emulate the great painters Rubens and Van Dyck and to win their approval. His three monumental representations of Christ on the Cross, in Augsburg, Regensburg and Marchegg (formerly Vienna, Augustinerkirche), are based on the crucifix type created by Giovanni Bologna which the seventeenth century took as its canon.

JÖRG ZÜRN
b. Waldsee (Upper Swabia) c. 1583/5 – d. Überlingen c. 1635/8
234 *Shepherd with dog, from the High Altar* 1613–16 limewood 1·68 m.
s. (on altar) G. Z.
Überlingen, Münster
In this carved altar, still arranged in the Renaissance manner in three tiers, the shepherd with his dog is placed on the right side of the main scene of the Adoration of the Shepherds. His picturesque costume, the consummate elegance with which he turns his head while striding

235 236 237 238 239 240 241

forward, the way in which he raises his hat and greets the Child, half in reverence, half in wonder, make him seem like an ancestor of eighteenth-century shepherd figures.

MARTIN ZÜRN
b. Waldsee (Upper Swabia) *c.* 1590/5 – d. Braunau am Inn (Upper Austria) after 1665

235 *Virgin and Child* 1636–8 wood 1·33 m.
s. (on the pulpit): MARTHIN UND MICHAEL ZIRNEN GEBRIEDER VON WALDSE
Wasserburg am Inn, St Jakob
From the top of the sounding board of the pulpit, the Virgin of the Crescent, 'exalted above all things temporal', looks down upon the on-looker in gracious pose, and with a kindly expression. The taut, smoothly polished roundness of the heads, the stiff, carefully turned strands of curly hair, the sharp edges and broken folds of the draperies are vivid reminders that woodcarving has its origins in the craft of the carpenter and turner.

CHRISTOPH DANIEL SCHENCK
Konstanz 1633–91

236 *Pietà* 1684 painted limewood 1·03 m.
s. and d. C.D. SCHENCK INV. ET SCUL.1684
Konstanz, Kloster Zoffingen
This, the latest of the three groups of the *Pietà* by Schenck, shows the least external movement yet the most deeply felt inner emotion. The Virgin holds up the body of her Son with tenderest care. The slack skin shows up most realistically stigmata, wrinkles and veins. The deep undercutting in the drapery folds, making them appear like rotating discs, is a characteristic of all Schenck's work.

JUSTUS GLESKER
b. Hameln *c.* 1610/20 – d. Frankfurt 1678

237 *Virgin of the Crucifixion group* 1648–9 gilt limewood 2·00 m.
Bamberg, Cathedral
As sculptor in charge of the Baroque decoration of Bamberg Cathedral after the Thirty Years War, Glesker carved five altars, rich in figure sculpture. These were dismantled again in the nineteenth century. The group of the Crucifixion is the only one to survive from the Heinrich-Altar, in which the mourning Virgin is the most moving figure. Her eyes closed, bent and swaying as if near to fainting, yet she holds herself upright.

JOHANN MEINRAD GUGGENBICHLER
b. Maria Einsiedeln 1649 – d. Mondsee 1723

238 *St Leonard Altar* 1715–16 painted wood, figures lifesize
Irrsdorf, Pilgrim Church
In this late work Guggenbichler gives pride of place to the figures, and pays little attention to the architecture of the altar which seems an arbitrary assembly of pieces of movable scenery. In the figures he gives final proof of the wide range of his artistic talent: St Sebastian nude, with arrows piercing his body, and St Pantaleon, clothed with hands nailed to his head, express sentimentality and pathos in their Baroque poses, whereas the pious and learned St Leonard appears natural and untheatrical.

ANDREAS SCHLÜTER
b. Danzig *c.* 1660 – d. St Petersburg 1714

239 *The Elector Friedrich Wilhelm equestrian monument* 1696–1710 bronze, main figure 3·90 m.
Berlin, Charlottenburg Palace
Schlüter is here clearly influenced by the Henry IV equestrian monument by Giovanni Bologna on the Pont-Neuf in Paris (unveiled in 1614; destroyed in 1792). This shows itself not only in the placing of the equestrian statue on a tall base, with inscribed tablets, reliefs and figures of slaves glorifying the ruler's deeds in war and peace, but also in the original siting of this monument on the Lange Brücke, completed in 1695. Schlüter, however, changed the character of his prototype and translated it into Baroque terms by giving greater liveliness to his figures.

PAUL STRUDEL
b. Cles (Trentino) 1648 – d. Vienna 1708

240 *Statue of the Duke of Alba* between 1696 and 1708 marble, over lifesize
Vienna, Nationalbibliothek
In 1696 Leopold I commissioned from the sculptor a series of statues of his ancestors for the old 'Paradise Garden' of the Imperial Palace. The Duke of Alba was admitted to this company, for he had served the Habsburgs well in Spain. When the existence of this garden came to an end (1728), these lively figures, designed to be free-standing, found a home in the Laxenburg Palace and the Imperial Palace Library, which had been completed in 1735.

BALTHASAR PERMOSER
b. Kammer (Upper Bavaria) 1651 – d. Dresden 1732

241 *Apotheosis of Prince Eugen* 1718–21 marble 2·30 m.
Vienna, Österreichisches Barockmuseum

334

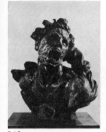
242

243

243

244

245

246

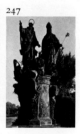
247

The degree of glorification accorded here to the 'Saviour of the West' is without parallel. Standing on the hand of Fame he follows a genie and rises over the vanquished Turk, towards the snake-encircled sun. Like Hercules in ancient times, he ascends to immortal fame and a hero's eternal life. The parallel is emphasized by the lionskin on his shoulder and the club in his right hand.

242 *The damned soul c.* 1715 grey flecked and red veined marble 0·55 m.
Leipzig, Museum der Bildenden Künste
Through his stay in Rome and his knowledge of Bernini, Permoser was familiar with the idea of personifying the *anima damnata* in the form of a male bust. He renders the existence in hell as unsupportable agony, even more dramatically than Bernini; he represents the damned soul as an emaciated face of repulsive ugliness, engulfed by flames and crying out in despair. Works like this were probably intended to be placed in a study as a *memento mori*.

ANDREAS SCHLÜTER (*see* 239)
243 *Two heads of dying warriors* 1696–1700 sandstone, over lifesize
Berlin, Hof des Zeughauses
For the outer façade Schlüter carved fifty-four richly decorated helmets, and for the façade towards the courtyard twenty-two heads of dying warriors. This must be the most concise monumental portrayal of the glories and miseries of soldiering, whose tools were housed in this arsenal. The facial expressions of the dying show most movingly the whole range of the spiritual condition of the dying, from angry revolt to peaceful resignation in death. Schlüter avoided anything gruesome, but also any expression of ecstasy.

BALTHASAR PERMOSER (*see* 241)
244 *Three satyrs c.* 1717–18 sandstone, three times lifesize
Dresden, Zwinger
Among the vast number of sculptures made for the Zwinger – that large sumptuous pleasure-palace, built for Augustus the Strong by M. D. Pöppelmann in the 'contemporary style', but based on Roman prototypes – the satyr-herms, carved entirely by Permoser himself, are the most famous. The three satyrs, which are grouped in a loosely symmetrical way are given individual existences, differing features, facial expression and bacchic attributes.

MATTHIAS BERNHARD BRAUN
b. Ötz (Tyrol) 1684 – d. Prague 1738

245 *St Garinus* 1726 sandstone, originally painted, three times lifesize
Kukus, Bethlehem Garden
The sectarian Count von Sporck added to his favourite seat at Kukus some woodland which he intended as a religious nature park with four hermitages. His only intrusion upon the unspoilt scenery was to commission from Braun figures of the holy penitents and hermits: Magdalen, Jerome, Francis, the wasting figure of the ascetic Onofrius and our Garinus in front of his cave. These were to be carved from existing scattered boulders.

JOHANN B. FISCHER VON ERLACH and FERDINAND M. BROKOFF
b. Graz 1656 – d. Vienna 1723
b. Rothenhaus (Western Bohemia) 1688 – d. Prague 1731
246 *Tomb of Count Mitrowitz* 1716 marble architecture and stucco figures
s. and d. HAE STATUAE FACTAE A BROKOFF 1716
Prague, St Jacob
The dying Imperial Court Chancellor and Grand Prior of the Order of the Johannites has sunk back on to his books. An allegorical figure of eternal divine Love carefully raises up his body. This beautiful group, reminiscent of a *Pietà*, forms the centre of the pyramidal tomb structure, designed by Fischer von Erlach. It is, at the same time, the centre of an asymmetrical triangle formed by the mourning figure of Religion, by Chronos with his hour-glass and by Fame, writing the memorial inscription.

FERDINAND MAXIMILIAN BROKOFF (*see* 246)
247 *Sts Vincent Ferrer and Procopius* 1712 sandstone, over lifesize
s. and d. (chronogram) OPUS IOAN. BROKOFF 1712
Prague, Charles Bridge
The Spanish Dominican saint and the Bohemian patron saint, bearers of the Faith to East and West, occupy the same base. This is one of twenty-eight groups and single statues which decorate the Charles Bridge and make it a unique monument in the history of bridge sculpture. The reliefs and herms of the base as well as the figures of the sick, the possessed and the devils at the feet of the saints relate to their legendary lives and acts.

LORENZO MATIELLI
b. Vicenza *c.* 1682/8 – d. Dresden 1748
248 *Apollo and Daphne* 1731 glazed stucco, lifesize
s. and d. LAURENTIUS MATIELI FE. AN. 1731

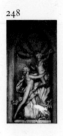
248

249

250

251

252

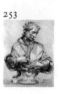
253

254

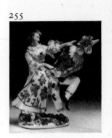
255

Eckartsau (Lower Austria), Jagdschloss

Matielli designed both this group and its counterpart – the Alpheus-Arethusa rape – like a relief. They occupy the two niches in the grand hall of the castle. The decorative beauty of the slender graceful figures, which appear to us the very essence of elegance, explains how this virtuoso artist was able, for several years, to hold his ground as the most important sculptor in Vienna, against the more serious and pretentious G. R. Donner.

GEORG RAPHAEL DONNER
b. Esslingen (Lower Austria) 1693 – d. Vienna 1741

249 *Apotheosis of Emperor Charles VI* 1734 white marble, veined with grey, 2·33 m.
s. and d. G. R. DONER AUST. F. POSONII PAN. 1734
Vienna, Österreichisches Barockmuseum

Donner represented the glorification of the emperor through the symbols of wisdom and fame, the snake forming a halo-like circle above his head. Yet he did not see the scene, with its ample, self-possessed figures, as a triumphal ecstasy, but as a solemn ceremony. This group, commissioned by the Superintendent of the Imperial Forests, G. W. von Kirchner, stood originally in the great hall of his castle at Breitenfurt.

250 *The Perseus-Andromeda Fountain* 1740–1 stone and lead 2·68 m.
Vienna, Hof des Alten Rathauses

As the *putti* groups, originating in the Donner circle, which form part of the architectural surround of the fountain, allude in their attributes to the civic virtues of wisdom and courage, so the subject of Donner's autograph relief relates to the municipal council by whom it was commissioned. The story of Perseus and Andromeda has always been understood to symbolize the protection of a town (Andromeda) from any oppression (dragon) by a wise and strong ruling body (Perseus).

251 *Christ and the Woman of Samaria* 1739 marble 1·44 m.
s. and d. G. RAPHAEL DONNER AUSTRIACUS POSONIJ 1739

252 *Hagar in the desert* 1738–9 marble 1·44 m.
Vienna, Österreichisches Barockmuseum

The reliefs of the Woman of Samaria at the well and of Hagar in the desert, accompanied by her exhausted son Ishmael – both sculpted as decoration for a wall-fountain – never reached their intended destina-tion in the sacristy of St Stephen's Cathedral. Immediately after their completion they were sumptuously framed, like precious collector's pieces, and taken to the Imperial Treasury. Donner really shone here as in no other of his works, where he had always reduced decorative accessories to a bare minimum, in order to let content and message speak all the more forcefully and directly. Here he showed himself a master in the handling of small forms, in the detailed description of *genre* and landscape, and able to express in his art delicate nuances of mood and tender sentiment.

PAUL EGELL
b. Salzburg (?) 1691 – d. Mannheim 1752

253 *St Charles Borromeo c.* 1740 gilt limewood 0·86 m.
Berlin (East), Staatliche Museen

In this bust of St Charles Borromeo (and its counterpart St Philip Neri), Egell continued the *rocaille* form of the base in the outline and move-ment of the half-length figure. He thus gave visual unity to the two disparate parts of this work. The monumentally conceived head, inclined towards the now lost crucifix, is set off to advantage by the carefully worked hands and draperies.

254 *The Miracle of Pentecost* 1747–8 limewood, formerly gilt 0·905 m.
Heidelberg, Heilig-Geist-Kirche

Unique in subject-matter, this relief, on the curved tabernacle door of the former high altar, does not show the appearance of the 'tongues of fire' but the preceding phase of the Miracle of Pentecost, when 'a rushing mighty wind filled all the house'. Thus, while the gathering of the Apostles around the Virgin seems to be an arbitrary arrangement, the grouping within the room – indicated simply by an architectural surround – reveals the hand of a skilful artist.

JOHANN JOACHIM KÄNDLER
b. Fischbach near Dresden 1706 – d. Meissen 1775

255 *Harlequin and Columbine c.* 1745 painted porcelain 0·207 m.
Amsterdam, Rijksmuseum

Kändler gained his world-wide reputation not as a carver of monu-mental stone sculpture, but as chief modeller of the Meissen porcelain factory. For this he modelled mythological and Christian themes, scenes of court life and scenes of the animal world, with an ever fertile imagination. Particularly popular, however, were his ingenious and charming groups of *genre* figures, not least the famous characters of the Commedia dell'Arte.

256 257 258 259 260 261 262

MATTHIAS GOTTLIEB HEYMÜLLER
b. Upper Austria *c.* 1710/15 – d. Potsdam 1763
256 *Chinese gentlemen at tea c.* 1755 gilt sandstone, lifesize figures
Potsdam, Sanssouci Gardens
In the secular field it was the task of the Rococo artist to create sculpture
for the decoration of buildings and gardens. Both purposes are served
by these Chinese groups, reclining at the foot of palm-like columns
which form part of the three vestibules of the teahouse at Sanssouci.
When Chinoiserie was fashionable, such ornamentation became
popular as a means of embellishing the everyday world through the
introduction of exotic elements and also as a way to evoke an ideal and
wise way of life, believed to prevail in the Far East.

FRIEDRICH CHRISTIAN GLUME
Berlin 1714–52
257 *Caryatids* 1745–7 sandstone, over lifesize
Potsdam, Sanssouci Palace
To form a boundary between architecture and nature, Frederick the
Great, as was the custom, had the garden façade of his country-seat
decorated with satyr-herms – hybrid creatures belonging to both
realms. As bearers of the entablature these powerful figures were
inextricably united with the architecture, but in their role as descendants
of Bacchus, addicted to all the pleasure of the senses, the sculptor
directed their eager glances to the vine below.

EGID QUIRIN ASAM
b. Tegernsee 1692 – d. Mannheim 1750
258 *The Assumption* 1722–3 painted stucco, figures over lifesize
Rohr (Lower Bavaria), Augustiner-Klosterkirche
From the nave one witnesses the Assumption taking place, like a
triumphal finale of a *Theatrum Sacrum*, on a raised stage in the choir
beyond the altar. Excited and moved, the Apostles, with dramatic
gestures, express their wonder at the miracle; they follow the Virgin's
ascent or reassure themselves that the miracle has really taken place by
looking into the empty sarcophagus, which had contained only the rose,
now held up by St Peter.

JOSEF THADDÄUS STAMMEL
b. Graz 1692 – d. Admont 1765
259 *Martin's Altar* 1738–40 painted and gilt wood, figures lifesize
St Martin near Graz
Through his extensive commissions for the monastery at Admont, with

which he had lifelong connections, Stammel became very experienced
in the handling of large-scale narrative sculpture. He was, therefore,
able to execute most skilfully the sophisticated programme – aimed at
creating a spectacular effect – of portraying in one altar the three saints,
Paul, Martin and Eligius, with their horses which played such a
decisive part in their lives.

JOSEF MATTHIAS GOETZ
b. Bamberg 1696 – d. Munich 1760
260 *The triumph of Faith* 1723–4 alabaster, figure of Faith 0·55 m.
Paura near Lambach (Upper Austria)
The direct source for the decoration of Paura was the altar in S. Ignazio
in Rome, designed by Andrea Pozzo (*see* VI). From the monumental
group of the same subject, carved by G. B. Theudon, Goetz took
over almost literally the figure of Faith, standing over the dragon,
and the figure of the pagan king adoring the sacrament. However, he
represented Heresy, not as an old hag but in the Northern tradition
as a bearded Protestant, falling headlong into the depths, clutching
his bust of Luther.

JOHANN JOSEPH CHRISTIAN
Riedlingen 1706–77
261 *The Prophet Ezekiel* 1752–6 glazed stucco, lifesize
Zwiefalten, Benediktiner-Klosterkirche
The mighty and expressive figure of the prophet Ezekiel, rousing and
admonishing, testifies to Christian's ability to plan and work on a
monumental scale. He is dressed in a loose mantle which flutters around
his emaciated body. His left hand points towards heaven, while the
outstretched finger of his right hand lends majestic emphasis to his
glance, directed towards the pulpit opposite, the place from which the
Gospel is proclaimed.

262 *Jacob's dream* 1760–4 relief in gilt limewood 2·14 m.
Ottobeuren, Benediktiner-Klosterkirche
As at Zwiefalten, Christian carried out the complete decoration of the
church at Ottobeuren, its stucco statues and woodcarvings. The relief
of Jacob's dream, with God's command to Israel and the heavenly
ladder with angels deftly climbing up and down, is one of the nine
biblical scenes of the East Choir stalls. It was considered to represent
a prefiguration of events in the life of St Benedict, which are depicted
on the opposite side.

337

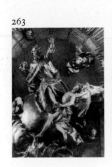

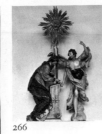
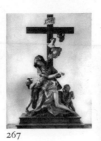

263 264 266 267 268 269 270

265

JOHANN BAPTIST STRAUB

b. Wiesensteig (Württemberg) 1704 – d. Munich 1784

263 *God the Father on the Celestial Globe* 1766–7 gilt limewood, over lifesize
Munich-Berg am Laim, St Michael

This group, which crowns the high altar of St Michael, shines into the nave, standing, as it does, against the painted background of a vault, which appears to be made of golden bricks. After experimenting with ideas he later rejected, Straub finally arranged his group in opposing diagonals, from which the arm of God the Father alone reaches up vertically in a mighty gesture of creative power.

JOSEPH ANTON FEUCHTMAYER

b. Linz (on the Danube) 1696 – d. Mimmenhausen (Lake of Constance) 1770

264 *St Elizabeth* 1748–50 stucco, lifesize
Birnau near Lake of Constance, Pilgrim Church

Feuchtmayer restricted the movement of his elongated figures by enveloping them in long narrow draperies and in this way he tied them optically to their narrow base. His figures move from the hip, thus making cloaks and draperies swirl out; their freely gesticulating arms and their powerful, sometimes mask-like faces give them vitality and expressiveness.

IGNAZ GÜNTHER

b. Altmannstein near Ingolstadt 1725 – d. Munich 1775

265 *St Peter Damian* 1762 painted limewood 1·57 m.
Rott am Inn, formerly Benediktiner-Klosterkirche

The sculptor here portrays this learned cardinal and moral zealot in the character of a man whose individual personality stood out, regardless of circumstance, instead of relating the portrait to its sacred position on the St Leonard Altar. In his pose of spiritual and moral superiority, Damian attracted the covert admiration of those around him whom, from his lofty standpoint, he criticised and despised.

266 *The Annunciation* 1764 painted and gilt limewood *c.* 2·35 m.

267 *The Lamentation of Christ* 1764 painted limewood 1·97 m.
Weyarn (Upper Bavaria), Collegiate Church

The *Annunciation* and the *Lamentation*, two of the most beautiful creations of Rococo religious sculpture, were commissioned by the Rosary Fraternity in Weyarn. They were intended for carrying

in votive processions and on pilgrimages. For this purpose Günther extended both these groups to a height unusual in earlier free-standing groups with these themes by adding appropriate emblems which could be seen from afar: for the *Annunciation* a dove in an aureole to which the angel points in exhortation, 'The Holy Ghost shall come upon thee', and for the *Lamentation* the empty cross encircled by angels' heads. In keeping with their great importance in the story of the Salvation, these events are shown as taking place with calm solemnity and restraint, without vehement exclamations of joy or sorrow. The measured movements of the figures convey their tender emotions and deep spirituality.

FERDINAND TIETZ

b. Holtschitz (Western Bohemia) 1709 – d. Memmelsdorf near Bamberg 1777

268 *Parnassus* 1765–6 sandstone, formerly painted and gilt, figures lifesize
Veitshöchheim near Würzburg, Palace Gardens

Parnassus, the mountain of the Muses, with Apollo and the nine muses placed under the winged horse Pegasus, was the first work by Tietz (or Dietz) in connection with the new programme, devised in 1763, for the embellishment of the gardens at Veitshöchheim. There, as in similar grand schemes since the sixteenth century, it formed the showpiece of the whole decoration of the park. The massive individual forms of the architectural base remind one of his first teacher, Matthias Braun, and the decoration of his bases on the Charles Bridge in Prague.

269 *A nobleman dancing* 1767–8 sandstone, formerly painted, lifesize

270 *A lady dancing* 1767–8 sandstone, formerly painted, lifesize
Veitshöchheim near Würzburg, Palace Gardens

A *rondelle* forms a second centre in this garden layout, a kind of great hall, open to the sky, lined with bench-seats, vases and figures. Its eastern approach is flanked by this courtier and lady turning in a dance. In his efforts to beguile the onlooker by a most lifelike portrayal, the sculptor has given an accurate rendering of currently fashionable garments with embroidered hems, bows, frills, patchpockets and cuffs. He distinguishes the characteristics of different materials, pulling taut or billowing out, and also achieves the exact proportion of body and limb, deftly grasping a fleeting movement. Caught in stone, it was supposed to surprise and astonish the eye. In its original lifelike colours, the illusion of living figures must have been complete.

271

272

273

274

275

276

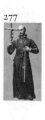
277

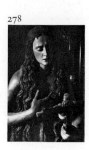
278

BALTHASAR FERDINAND MOLL
b. Innsbruck 1717 – d. Vienna 1785

271 *Statue of Emperor Francis I* between 1750 and 1760 marble 1·98 m.
Vienna, Österreichisches Barockmuseum
Moll gave Francis I (d. 1765) all the emblems of an emperor: laurel wreath and leather armour, baton, globe and rising eagle. Yet his relaxed pose and easy stance, his friendly and gentle expression make him appear sociable and kind rather than a hero; in fact he is presented as a dignified father figure, respected and beloved by both family and people.

FRANZ XAVER MESSERSCHMIDT
b. Wiesensteig (Württemberg) 1736 – d. Pressburg 1783

272 *Statue of Empress Maria Therese* 1766 lead 2·02 m.
Vienna, Österreichisches Barockmuseum
Maria Therese had herself portrayed in the Hungarian coronation robes of 1740. Messerschmidt rendered every detail accurately, whether it was the embroidered pattern of the garment or the decoration of the crown, without letting the delicate details detract from the monumentality and movement of the figure. By happily uniting external splendour with inner grandeur, he created an unforgettable representation of inborn majesty.

273 *The morose one* between 1772 and 1780 lead 0·43 m.
Vienna, Österreichisches Barockmuseum
In most of the sixty-nine expression studies by this artist, one is concerned with self-portraits. In his day, the practice in physiognomic science was to represent the various characters and temperaments by different facial types, but Messerschmidt instead attempted to convey the range of different moods and mental states with his own face in a variety of expressions.

GREGORIO FERNÁNDEZ
b. Pontevedra? 1576 – d. Valladolid 1636

274 *The Baptism of Christ* 1624–30 painted wood 3·05 m.
Valladolid, Museo Nacional de Escultura
Fernández gave the two figures external unity by enclosing them within a semicircle. He showed their inner affinity by making their bodies incline towards each other. Their serious faces show their awareness of the solemnity of the ceremony. Christ, with arms crossed and eyes lowered, kneels humbly before the gaunt St John, who,

bewildered, gazes down at him, while hesitantly and carefully administering the baptism from a respectful distance.

ANTONIO DE PAZ
active from 1628 – d. Salamanca 1658?

275 *High Altar* 1644–60 painted wood
Salamanca, Convento de Sancti-Spíritus
While artists were still basically adhering to the Renaissance type of high altar in the seventeenth century, there was a growing tendency to have fewer main scenes, and less, but larger individual panels, thus achieving greater unity. In this altar the Pentecost relief and the statues of the Apostles and Fathers of the Church deserve special attention. Their style clearly shows the artist's link with the Fernández circle.

JUAN MARTÍNEZ MONTAÑÉS
b. Alcala la Real 1568 – d. Sevilla 1649

276 *The earthly and the divine Trinity* after 1609 painted wood, figures lifesize
Seville, S. Ildefonso
Jesus, shown here as a ten-year-old boy, with soft colouring and almost feminine appearance, is part of both Trinities and forms the centre of the composition. Nevertheless, the subject-matter and pictorial arrangement were chosen to give added importance to St Joseph. After the appearance of St Teresa of Avila, his special cult spread from Spain over the whole of Europe.

277 *St Ignatius* 1610 painted wood and cartapesta, lifesize
Seville, Capilla de la Universidad
Simple composition, natural drapery folds and restrained gestures give this figure of St Ignatius (carved to celebrate his beatification in 1609) a simple dignity, common to all Montañés's figures. Yet, with considerable insight, he shows them to be human beings of great inner strength, well in control of their feelings and their passions.

GREGORIO FERNÁNDEZ (*see* 274)

278 *St Mary Magdalen* before 1615 painted wood, lifesize
Madrid, Convento de las Descalzas Reales
Fernández shows us a haggard, penitent figure in a garment of plaited straw, her hair falling loosely over her shoulder. Deeply moved, her beautiful face, with its regular strong features, is turned towards the crucifix in her left hand while her right is caught in a gesture of submission.

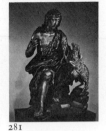
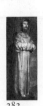
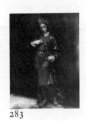
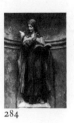
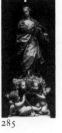

279 280 281 282 283 284 285 286

PEDRO DE MENA
b. Granada 1628 – d. Malaga 1688

279 *St Joseph and the young Jesus* between 1658 and 1662 cedarwood 0·87 m.
Malaga, Cathedral
For a long time the figure of St Joseph was thought not to be one of the
forty reliefs with which de Mena completed the decoration of the
famous choir stalls, begun in 1633 by Louis Ortiz. Yet this beautiful
calm group, which depicts Joseph showing paternal concern for the
lively boy, proves the authentic authorship of de Mena by its *contrapposto*
movement, the form of the heads and the treatment of hands
and hair.

JUAN MARTINEZ MONTAÑÉS (*see* 276)

280 *St Anne and the young Virgin* 1632–3 painted wood, lifesize
Seville, Iglesia del Buen Suceso
Traditionally St Anne has the young Virgin as her attribute, shown
either in her arms or seated on her lap. In seventeenth-century Spain,
the Virgin becomes an independent figure and her mother's com-
panion, corresponding to the group of St Joseph and Jesus. As in many
other works, voluminous draperies give added weight to Montañés's
slender yet firm female forms, thus adding dignity to majesty and
grace.

ALONSO CANO
Granada 1601–67

281 *St John the Baptist* 1634 painted wood 1·55 m.
Barcelona, Collection de Grüell
This statue originally occupied the central niche of the high altar of
San Juan de la Palma at Seville. It shows St John in belted camel-hide
and wide cloak, seated motionless on a rock; his left hand rests on the
lamb's back, his right hand probably once held his cross-shaped staff.
Lost in serious thought, he does not respond to the affectionate and
comforting behaviour of the lamb.

PEDRO DE MENA (*see* 279)

282 *St Francis c.* 1663 painted wood, under lifesize
Toledo, Cathedral
In this famous statue de Mena represents St Francis, not in the usual way
with stigmata, crucifix and book, but as Pope Nicholas V (1447–55) is
reputed to have found him on opening his tomb: upright, without any
signs of bodily decay, his hands obscured by his sleeves and his open eyes
directed towards heaven: rigid in death, yet as if alive.

JOSÉ DE MORA
b. Baza 1642 – d. Granada 1724

283 *St Pantaleon* between 1705 and 1712 painted wood, under lifesize
Granada, S. Ana
De Mora created this statue of their patron saint for the Physicians and
Surgeons Guild of the town, conceiving it in a rather unusual and
personal way. He shows him, not as physician to the Roman Emperor
Maximian, nor as the beheaded Christian martyr, but as a beautiful,
sensitive youth with delicate hands and an abundance of curly hair.
As he moves forward gracefully, he contemplates the crucifix with
tear-stained eyes.

284 *St Teresa* between 1700 and 1705 painted wood, lifesize
Córdoba, Cathedral
Outside Spain St Teresa is usually represented as a mystic haunted by
visions and fainting in rapturous ecstasy. In Spanish art she lives on as
the beautiful, highly cultured reformer and author of celebrated
religious poetry inspired by the Holy Ghost. De Mora, however, gave
us this charming portrayal of the earnest nun, here almost flirting with
the dove of the Holy Ghost whilst engaged in her writing.

285 *The Immaculate Conception c.* 1665 painted wood, under lifesize
Granada, SS. Justo y Pástor
In the general composition, and the pose and movement of the figures,
the young de Mora models himself most closely on the work his
teacher Cano created ten years earlier for Granada Cathedral, but gives
his Virgin an open outline, more flowing draperies and a friendlier
expression. Instead of his master's virginally delicate and unapproach-
ably shy, sublime figure, he has created a more worldly and womanly
Virgin.

PEDRO DE MENA (*see* 279)

286 *Mater Dolorosa* (detail) 1673 painted wood, lifesize
s. and d. PS. DE MENA Y MEDRANO FT. MAL . . . E A.NO 1673
Madrid, Convento de las Descalzas Reales
Seen as a devotional picture, this half-length figure of the *Mater
Dolorosa*, the lonely mourning Virgin, is deeply moving. Seen as
sculpture, it is distinguished by a powerful plasticity and extremely
sensitive modelling. Together with his contemporary *Ecce Homo*, de
Mena has taken up a traditional theme of Spanish and Flemish painting:
the image of the Virgin pointing to the Passion of Her Son.

287 288 289 290 291 292 293 294

PEDRO ROLDÁN
Seville 1624–99
287 *The Lamentation* (detail) 1664–9 painted wood, figures over lifesize
Seville, Parroquia del Sagrario
In this early Spanish example of a monumental altar relief, Roldan created for himself an opportunity for detailed narrative sculpture by directing the thoughts of the onlooker from the mourning over the body of Christ back to the deposition and forward to the entombment. Joseph of Arimathea still looks up to the men on the ladders, while St John, Mary Magdalen and her helpers are already busy anointing the body and wrapping it in winding sheets.

LUIS BONIFÁS
Valls (Catalonia) 1730–86
288 *St Sebastian c.* 1763 alabaster, figures under lifesize
Madrid, Academia de San Fernando
Bonifás carved this relief in support of his application for admission to the Academy of Art, founded by Ferdinand VI in 1752. It shows the rarely represented scene of the widow of Catulus saving St Sebastian's life after his first martyrdom. With great skill he fitted the main group – consisting of the wounded saint leaning against a tree and his armour and the two women gently busy about him – into the circular form of the alabaster panel.

JUAN ALFONSO VILLABRILLE?
active in the first quarter of the eighteenth century
289 *Head of St John the Baptist* between 1700 and 1720 painted wood
Granada, San Juan de Dios
There is some doubt now about the traditional attribution of this head to Villabrille. The dying look, the gaping mouth, the hair encircling the head like flames, the beard overlapping the edge of the dish, terrify in their realism. This dish is supported by an eagle, the symbol of St John the Evangelist. As the old emblem of the Misericordia Brotherhood it is much venerated in this church, dedicated to the founder of the order of the Monk Hospitallers.

FRANCISCO SALZILLO
Murcia 1707–83
290 *The Agony in the Garden* (detail) 1754 painted wood and velvet, figures lifesize
Murcia, Museo Salzillo
Between 1752 and 1778 Salzillo created eight, still extant, groups and figures of the Passion to be carried in Holy Week processions. In all these works he aroused the devotion and emotion of his fellow-citizens by the contrast of the sad events and their portrayal through figures of heavenly beauty with a wealth of naturalistic detail, which the Rococo period had made available to him.

291 *Virgin and Child with the little St John c.* 1745 painted wood 0·70 m.
Murcia, Museo de la Catedral
In 1730, Salzillo had to abandon the project of a study trip to Italy for family reasons. This oval relief, carried out for a private patron, proves, however, that Italian art was not unknown to him. For the composition he is clearly indebted to a Correggio painting of the same subject, now in Budapest. It is brilliantly carved and delicately coloured.

LUIS SALVADOR CARMONA
b. Nava del Rey 1709 – d. Madrid 1767
292 *Ecce Homo c.* 1754 painted wood, lifesize
Atienza, Iglesia de la Trinidad
Carmona himself tells us that the subject and style of this Man of Sorrows derive from a now lost work by Manuel Pereira. He shows him kneeling on the globe, which bears a portrayal of the Fall – the most concise representation of the Salvation. The carefully modelled and well-proportioned body shows tendencies which foreshadow Carmona's later change to classicism under the influence of A. R. Mengs.

293 *The Assumption of the Virgin* 1749 painted wood 1·79 m.
s. and d. LUIS SALVADOR CARMONA 1749
Serradilla (Cáceres), Parish Church
The Virgin, seated on a cloud, surrounded by angels and cherubs, is shown here floating up to heaven; her mantle is windswept and her arms outstretched as she glances upward expectantly. The dramatic movement and swelling forms of this late Baroque work are not combined with an appropriately solemn air of renunciation. Instead, reminiscent of a Niobe group, there is an expressive attitude of resignation and surrender.

CARLOS GRICCI
active from 1759 – d. Madrid 1795
294 *The unhappy union c.* 1785–90 biscuit 0·34 m.
Madrid, Museo Arqueológico Nacional
This charming group tells in Rococo version the old story of the ever separated lovers. The unhappy pair is shown tied back to back against

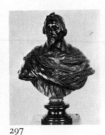

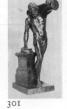

295 296 297 298 299 300 301

a tree-trunk. Carlos Gricci was in charge of the Buen Retiro factory (1784–95) which produced *biscuit* sculptures of pastoral and mythological subjects. We cannot be sure, however, that he himself was responsible for the modelling of this and other stylistically related groups.

FRANCISCO SABATINI and FRANCISCO GUTIÉRREZ
b. Palencia 1722 – d. Madrid 1797
b. San Vicente de Arévalo 1727 – d. Madrid 1782
295 *Tomb of Fernando VI* after 1761 white and coloured marble
Madrid, Sta Barbara
The tomb was designed by Sabatini, who for many years had worked in Caserta with Luigi Vanvitelli. For the glorification of the deceased he has displayed the whole repertory of Roman Baroque symbolism and allegory. Gutiérrez was responsible for the execution of the figures, Abundance and Justice, the sarcophagus and its relief decoration, the *putti* with the insignia, Fame bearing arms and finally the chained figure of Chronos carrying a medallion portrait of the king.

SIMON GUILLAIN
Paris 1581–1658
296 *Statue of Louis XIII* 1647 bronze 2·00 m.
Paris, Louvre
This statue comes from a monument, erected in 1647, opposite the northern bridgehead of the Pont-au-Change on the occasion of its restoration. The figures were arranged as follows: the ten-year-old Louis XIV, surrounded by arms and trophies, stood, slightly raised, between his mother, Anne, Regent of Austria, and his father, who looked up at him and at the same time pointed to the renovated bridge at their feet.

JEAN WARIN
b. Sedan 1596 – d. Paris 1672
297 *Bust of Cardinal Richelieu* after 1640 bronze 0·70 m.
Paris, Bibliothèque Mazarine
Warin, Richelieu's special protégé, modelled this bust in the latter's lifetime (d. 1642), but it was not until after the cardinal's death that a few bronze casts were made. The lean intelligent head emerges like a dart from the many layers of his ecclesiastical robes. This man, who paved the way for absolutism, is here depicted with keen observant eyes and tufts of hair which rise like flames above his forehead.

JACQUES SARRAZIN
b. Noyon 1588 – d. Paris 1660
298 *Two children with a goat* 1640 marble 2·10 m. (with base)
s. and d. JACOBUS SARRAZIN FACIEBAT 1640
Paris, Louvre
Sarrazin's sculpture seems like a counterpart to the early Bernini *Amalthea with the young Zeus*, a work he must have known from his stay in Rome (1610–28). Bacchus, shown as a child, with vine-leaf wreath and wine goblet, sits astride the goat which his playmate is feeding with vine-leaves. The central part of a child bacchanal, a favourite subject in the sixteenth and seventeenth centuries, has here become an independent group. The pedestal was added in 1710.

299 *Religion* before 1648–63 bronze, lifesize
Chantilly, Palace Chapel
Of the four Virtues from the mausoleum of Henry II of Bourbon (formerly in the Jesuit church, since 1883 in Chantilly), Religion is the most impressive. She appears like a sibyl, enveloped in soft classical draperies. As well as her rightful attributes of book, church and heart she is here accompanied by an angel and a stork, the symbols of religion under royal protection.

MICHEL ANGUIER
b. Eu (Normandy) 1613 – d. Paris 1686
300 *The Nativity* 1665–7 marble
Paris, St-Roch
Till 1796 this free-standing group – much copied as the classic solution of the subject – was on the high altar of the Val-de-Grâce, the church built by Anne of Austria as a thanksgiving for the birth of Louis XIV. The reason for the foundation must also be the explanation for the unusual choice of the Nativity as the subject to be portrayed on a high altar, and for its being placed under a huge triumphal baldachin.

301 *Hercules c.* 1652–4 bronze 0·53 m.

302 *Mars c.* 1652–4 bronze 0·54 m.
Valenciennes, Musée des Beaux-Arts
Both statuettes, which for a long time were thought to be variants by an unknown Florentine master of antique prototypes, are in fact variants by Anguier of works by Florentine masters who modelled themselves on the antique. Hercules is based on Giovanni Bologna's *Hercules with a boar* and Mars is designed as a mirror image of Michel-

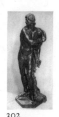
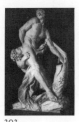

302 303 304 305 306 307 308

angelo's *Christ* in Sta Maria sopra Minerva. Both figures differ from their prototype, however, and resemble each other in their emphasis on a beautiful outline and in their surface modelling, where muscles and joints are allowed to flow softly into each other. These traits secure these works for Anguier on stylistic grounds. François du Quesnoy and Alessandro Algardi could have taught him in Rome (1641–51) how to depict calm, relaxed, male figures and he seems to have made their style his own.

PIERRE PUGET
Marseilles 1620–94
303 *Milo of Crotone* 1672–82 marble 2·70 m.
 s. and d. P. PVGET SCVLPT MASSILIENSIS FA ANNO 1682
 Paris, Louvre
Puget's first monumental work for the court of Louis XIV was this portrayal of the shameful death of the presumptuous Milo: with his hands trapped, he stood defenceless before the attack of wild animals. Although intended as a free-standing group for the gardens at Versailles, Puget designed it to be seen from one viewpoint – like Italian Baroque sculpture – so that the onlooker can take in the scene at one glance.

304 *Perseus and Andromeda* 1678–84 marble 3·20 m.
 s. and d. P. PVGET MASSIL. SCVLP.ARCH.ET PIC. SCVLPEBAT ET DICABAT
 EX A.A. DOM. MDCLXXXIV
 Paris, Louvre
The range and, at the same time, the duality in Puget's art are illustrated in this group. The artist gives Perseus a dramatically broken outline by depicting him in an open pose with limbs stretched to their limit, which makes him appear twice as tall. From a distance one is led to expect a highly dramatic action, yet, seen close to, it turns out to represent the quiet sequel to Andromeda's liberation: the gentle freeing of the exhausted body from its fetters.

305 *Louis XIV as Alexander* between 1685 and 1688 marble 1·10 m.
 Paris, Louvre
Louis XIV let himself be identified not only with the Sun God Apollo and with Hercules, but also with some of the most illustrious heroes of Antiquity. This group of the so-called *Alexandre Vainqueur* is probably a marble model by Puget for a projected equestrian monument in Marseilles. Here – possibly in competition with Bernini's portrayal of the king as Hercules – he planned to represent Louis XIV as Alexander the Great.

306 *Alexander and Diogenes* 1671–93 marble 3·20 m.
 Paris, Louvre
The shape and theatrical composition of this scene – the meeting between the youthful conqueror and aged philosopher – are reminiscent of the large Roman altar-reliefs by Algardi, Guidi or Raggi. In this secular scene, however, Puget clearly defines the space of the stage, so that it can be taken in at a glance, but spoils the clarity of the narrative by adding many subsidiary figures and accessories, so often characteristic of his work.

FRANÇOIS GIRARDON and THOMAS REGNAUDIN
 b. Troyes 1628 – d. Paris 1715
 b. Moulins 1622 – d. Paris 1706
307 *Apollo and the nymphs* 1666–73 marble, figures lifesize
 Versailles, Palace Gardens
Thetis's nymphs minister to Apollo, weary from his hot day's journey, and prepare him for his rest. Originally the group did not give the same impression of a *tableau vivant* as it does today; the figures – the three nymphs in the background are the work of Regnaudin – were differently placed, closer together, on a shallower stage and they filled the central niche of a grotto-room, while the niches at the side were occupied by Tritons caring for Apollo's sun-steeds.

FRANÇOIS GIRARDON (*see* 307)
308 *The rape of Proserpina* 1677–99 marble 2·70 m. (without pedestal)
 s. and d. PAR.F.GIRARDON TROIEN 1699
 Versailles, Palace Gardens
Le Brun's share in the design of this group, originally intended to stand in the garden *parterre*, cannot go beyond the choice of subject, for the composition betrays an intimate knowledge of earlier and similar scenes of rape by Bologna, Bernini and Susini, which only Girardon possessed. He completed the main group between 1677 and 1687, but did not carve the reliefs on the base till 1696–9 when the group was erected in the *Rondelle*.

309 *Sapience* 1693–4 bronze 2·00 m.
 S. GIRARDON IN.ET F.

MARTIN DESJARDINS
 b. Breda 1640 – d. Paris 1694
310 *Vigilance* 1693–4 bronze 1·80 m.
 S. MART.S DESJARDINS FECIT

309 310 311 312 313 314 315 316

Tonnerre (Yonne), Hospital

These two over-lifesize statues belonged to the Church of the Capuchins on the Place Vendôme, where they were part of the decoration of the funeral chapel of François Louvois, for many years war minister and political adviser to Louis XIV. When the chapel was destroyed in the French Revolution, the descendants of Louvois had the tomb with its surviving figures erected again at Tonnerre. The attributes and characterization of both Girardon's *Sapience* and Desjardins' *Vigilance* derive from the description of these allegories in Cesare Ripa's *Iconologia*. *Sapience* is shown with a sphinx-crested helmet – a symbol of her keen intelligence – a lance (now lost) and the shield of Medusa, to keep enemies at bay. *Vigilance* is accompanied by a crane with a stone in its claw as the symbol of her watchfulness, while book and oil-lamp protect her from unwelcome whims of fate.

311 *Louis XIV on horseback* between 1686 and 1688 bronze 0·44 m.
London, Wallace Collection

After the repeal of the Edict of Nantes in 1685, Lyon among other towns showed its loyalty and gratitude to the king, the 'protector of the true religion', by commissioning an equestrian statue. This monumental work, completed by Desjardins in 1691, and erected as late as 1713, was destroyed in 1792. Our statuette, one of several surviving bronze models, is distinguished by particularly delicate chasing.

ANTOINE COYSEVOX
b. Lyon 1640 – d. Paris 1720

312 *Tomb of Marquis de Vauban* 1680–1 white and black marble
Serrant (Maine-et-Loire), Palace Chapel

Lost in his own thoughts the marquis reclines on his sarcophagus, oblivious of the sorrowing wife at his feet. The guardian angel too – with the trophies of victory in his left hand and a laurel wreath in his outstretched right hand – floats upward without any real relation to the figures far below him. As in other words, Coysevox forces the onlooker to establish for himself a connection between the isolated and only loosely related figures.

MARTIN DESJARDINS (*see* 310)

313 *Bust of Pierre Mignard* before 1689 marble 0·63 m.
Paris, Louvre

Desjardins gives us a very forthright portrayal of Mignard's character. The abrupt turn of this intelligent, powerfully masculine head shows the pride and self-willed nature of this man who scorned a seat in the Academy while his rival Le Brun was still alive. This bust, probably carved between 1675 and 1680, and mentioned in Mignard's will (1689) as a present from Desjardins, was left to the Academy by his daughter Catherine in 1726.

ANTOINE COYSEVOX (*see* 312)

314 *Bust of Charles Le Brun* 1679 marble 0·65 m.
s. and d. C.LE BRUN PREMIER PEINTRE DU ROI ET CHANCELIER DE L'ACADEMIE. A. COYSEVOX FECIT 1679. PAR ORDRE DE L'ACADEMIE
Paris, Louvre

Having exhibited a clay bust of Le Brun (now in the Wallace Collection in London) in the Salon of 1676, Coysevox carried it out in marble as his *morceau de réception* for the Academy in 1679. The precise rhomboid outline, the carefully arranged loose drapery folds, the very exact, but rather empty rendering of the features make it a strictly academic piece.

315 *La Renommée* 1700–2 marble, over lifesize
s. and d. ANTOINE COYSEVOX LUGD. SCUL. REG. FECIT 1702
Paris, Jardin des Tuileries

As intensely as he had criticized Bernini's equestrian statue seventeen years earlier, Louis XIV now lavished praise on Coysevox's groups of *Mercury* and *La Renommée*, the latter an elegant laurel-crowned figure. He shows them galloping along, proclaiming the fame of France, their long-legged winged horses taking hills of trophies in their stride. On the occasion of their unveiling at Marly, Louis rewarded the sculptor with the highest pension ever given to an artist.

GUILLAUME COUSTOU
b. Lyon 1677 – d. Paris 1746

316 *A horse-tamer from Marly* 1740–5 marble, over lifesize
s. and d. COUSTOU FECIT 1745
Paris, Champs-Élysées

This horse, rearing in protest against his athletic tamer's efforts, once stood with its counterpart at the watering-place in the garden at Marly, where it was more appropriate than the *Mercury* and *La Renommée* groups which it replaced. The horse belongs to that long-maned fiery breed of sun-steeds, represented already eight decades earlier by the brothers Marsy, and contemporaneously by Le Lorrain on the Hôtel de Rohan.

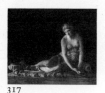

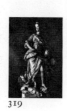
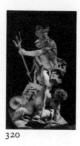

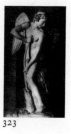

317 318 319 320 321 322 323

ANTOINE COYSEVOX (*see* 312)

317 *A nymph with a shell* 1683–5 marble 1·15 m.
Paris, Louvre
Coysevox surely derived this beautiful motif of a nymph reclining on
the shore from an antique prototype which has, however, up to now,
escaped identification. Leaning on her left arm, she draws water with
a shell held in her right hand, and watches the flow of the river beyond.
Bowl and urn frame this quiet contemplative scene, which originally
decorated the edge of the Latona Fountain at Versailles.

NICOLAS COUSTOU
b. Lyon 1658 – d. Paris 1733

318 *Louis XV as Jupiter* 1726–33 marble 2·00 m.

GUILLAUME COUSTOU (*see* 316)

319 *Maria Leczinska as Juno* [d.] 1731 marble 1·95 m.
Paris, Louvre
Rulers in previous centuries regarded their representation as gods or
heroes as the sublime form of their apotheosis. The transformation of
Louis XV and Maria Leczinska into Jupiter and Juno has become a
courtly game, for the early Rococo no longer believed that the ancient
world was worthy of imitation. Dressed in fantastic garments,
they stand like actors on a stage and are clearly identified as King and
Queen of France by their physical appearance and their attributes of
Bourbon sceptre and marshal's staff and the crown and *fleur-de-lys*
shield. The eagle and the peacock appear only as subsidiary attributes
to enable us to recognize the roles allotted to them in the world of
statues in the garden of Versailles. They are not convincing as the
two divinities, since they themselves no longer took such a charade
seriously.

LAMBERT-SIGISBERT ADAM
b. Nancy 1700 – d. Paris 1759

320 *Neptune calming the storm* 1733–7 marble 0·86 m.
Paris, Louvre
Adam ended his ten-year stay in Rome triumphantly by winning first
prize in the competition for the design of the Trevi Fountain. In 1733
the model for this group – executed in marble four years later – gained
him admission to the Paris Academy. It may be surmised that the figure
of Neptune repeats essentially the main figure of his design for the
Trevi Fountain.

BARTHÉLEMY GUIBAL
b. Nîmes 1699 – d. Lunéville 1757

321 *The Neptune Fountain* 1750 lead and stone
Nancy, Place Stanislas
Stanislas I Leczinski, the philosopher-monarch, greatly enlarged and
beautified the Place Royal, the most important project in the improve-
ment of Nancy, the seat of his Court. Its completion was celebrated
with great pomp in 1755. For the centre, Guibal, the court sculptor,
made a large statue of Louis XV (destroyed in 1792), for the two north
corners, two large fountains with Neptune and Amphitrite as their
main figures.

EDME BOUCHARDON
b. Chaumont 1698 – d. Paris 1762

322 *Fontaine de Grenelle* 1739–45 stone and marble, figures over lifesize
Paris, Rue de Grenelle
Like Goujon's *Fontaine des Innocents* of two hundred years earlier,
Bouchardon's fountain is primarily a piece of architecture. It is a two-
storeyed structure of seven bays with a bold concave sweep. Its sculp-
tural decoration – statues and reliefs of the seasons at the sides, the
personification of Paris and the rivers Seine and Marne in the centre
(illustrated here) – enlivens the severe structure in a calm and unobtru-
sive way.

323 *Cupid with his bow* 1739–50 marble 1·73 m.
Paris, Louvre
The model for this figure was exhibited in the Salon of 1739 as a work
done for Louis XV. It shows Cupid testing the bow he had fashioned
with the arms of Mars from the club of Hercules. Venus's graceful son
smiles with satisfaction at the havoc his bow and arrow are about to
cause. Bouchardon executed this figure in marble as late as 1747–50.

JEAN-BAPTISTE LEMOYNE
Paris 1704–78

324 *Bust of Countess de Brionne* 1763–5 marble 0·80 m.
Stockholm, Nationalmuseum
In this bust Lemoyne characterizes the beautiful widow as a life-loving
woman of sparkling wit. This he achieves by asymmetry and rich
contrasts: the fall of gathered draperies over her right breast – the head
turned to the left; one shoulder bare – the other draped; curls falling
forward on one side – kept back on the other. By portraying her with
chin raised, head erect, and with a penetrating expression looking out

324 325 326 327 328 329 330 331

of the frame formed by the draperies, he added spontaneity and an air of rapt attention to her expression.

JEAN-BAPTISTE PIGALLE
Paris 1714–85

325 *Mercury* 1746–8 marble 1·85 m.
s. and d. J.B. PIGALLE FECIT 1648 PARISIIS
Berlin (East), Staatliche Museen
Mercury, seated on a cloud, is tying his winged sandal to his left foot, ready to depart for a goal he has already fixed his gaze on by glancing over his right shoulder. In its *contrapposto* movement, the figure reminds one of Bernini's style; its slenderness and beautiful head recall the *Apollo Belvedere*, and yet the figure breathes above all the spirit of the carefree and elegant Rococo.

326 *Tomb of Maurice of Saxony* 1753–76, white and coloured marble, figures over lifesize.
Strasbourg, St-Thomas
In front of the pyramid of immortality, Maurice of Saxony, with marshal's baton, strides erect towards his tomb which Death has opened at his feet. While Hercules, the 'strength of France', gives himself up to his deep grief, France, in her lily-embroidered mantle, tries to keep Death from our hero. Lion, leopard, and eagle, the symbols of England, Flanders and Austria, against whom he had fought victoriously, bestir themselves on his right.

ÉTIENNE-MAURICE FALCONET
Paris 1716–91

327 *The Glory of Catherine II* between 1762 and 1766 marble 1·02 m.
Paris, Musée Jacquemart-André
The 'Glory', a tall slim figure, unmistakably a Falconet female type, has halted in her stride and from underneath her mantle has uncovered a medallion with a portrait of Catherine in a laurel-covered helmet. She is here placing it on the stump of a column and decorating it with roses. Falconet started work on this statue – a token of his personal devotion to the Czarina – in Paris, but completed it in St Petersburg.

328 *Bathing nymph* 1757 marble 0·82 m.
Paris, Louvre

Falconet created one early and one late work in the dramatic and Baroque spirit of his much revered Puget: Milo of Crotone and the equestrian figure of Peter the Great. The year 1757 – in which Madame de Pompadour appointed him head of the sculpture *atelier* at the porcelain factory of Sèvres – represents the highwater mark of his middle period, when he created works which to all the world are the essence of French Rococo sculpture.

CHRISTOPHE-GABRIEL ALLEGRAIN
Paris 1710–95

329 *Venus at her bath* 1755–67 marble 1·75 m.
Paris, Louvre
For this figure of Venus, Cochin, the Secretary of the Academy, allocated to the sculptor a faulty block of marble, full of grey veins and other impurities, as he mistakenly doubted his ability. Diderot praised the completed work effusively and Madame du Barry, to whom the king had presented it in 1772, was so delighted with the beauty of the figure that she immediately commissioned from Allegrain a companion piece – *Diana at her bath*.

PIERRE JULIEN
b. Saint-Paulien (Haute-Loire) 1731 – d. Paris 1804

330 *The nymph Amalthea* 1786–7 marble 1·74 m.
Paris, Louvre
Only a relief over the entrance survives *in situ* of Julien's extensive decorations for the dairy in the gardens of Rambouillet, a pavilion which Louis XVI had had erected for Marie Antoinette. The figure of Amalthea, the foster-mother of the young Zeus, came from the backroom of a small temple, where it occupied the centre of the wall, fashioned to look like Ida's Grotto.

JEAN-JACQUES CAFFIERI
Paris 1725–92

331 *Bust of Madame du Barry* before 1779 marble 0·56 m.
Leningrad, Hermitage
In this very late Rococo bust all the elements that make up the period of Louis XV are combined once more. There is the sitter, this woman who knew how to use her beauty for diplomatic gain; then Caffieri's masterly carving, which, with great imagination, used coiffure, rose

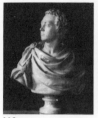
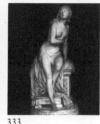

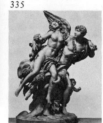

332 333 334 335 336 337 338

garland and lace to enhance the charm of his model and make her appear like a jewel in a precious setting.

JEAN-ANTOINE HOUDON
b. Versailles 1741 – d. Paris 1828
332 *Bust of La Rive* 1783–5 marble 0·80 m.
Paris, Comédie Française
Houdon's bust may be conceived as a counterpart to Michelangelo's Brutus, but the ideas behind the two works are totally different. Michelangelo created an idealized portrait of a fighter for freedom against tyranny; Houdon saw the stage-character of Brutus, a role in which La Rive was much celebrated at the time, and he created an individual portrait of a famous actor of the Comédie Française.

AUGUSTIN PAJOU
Paris 1730–1809
333 *Psyche abandoned* 1782–90 marble 1·80 m.
s. and d. PAJOU CITOYEN DE PARIS 1790
Paris, Louvre
Pajou here illustrated the moral of Apuleius's fable: 'Love is lost once its mystery is solved'. Dagger and oil-lamp at the feet of the beautiful but foolishly inquisitive Psyche point to earlier events which led to her present confusion and despair, with which she now sinks back on to the richly ornamented marble seat, throwing a last glance at the escaping Cupid.

334 *Bacchante* 1774 gypsum 1·82 m. s. and d. PAJOU FÉ. 1774
Paris, Louvre
Pajou made an inconographic error in this idyllic group whose model was exhibited in the Salon of 1765 as *une bacchante tenant le petit Bacchus*, for it was nymphs who brought up the infant Bacchus. Had he not given the attributes of a Bacchante to this elegant figure of a girl, he would not have come into conflict either with mythological tradition or contemporary opinion, which criticized the figure's cold sobriety.

CLAUDE MICHEL called CLODION
b. Nancy 1738 – d. Paris 1814
335 *Cupid and Psyche* between *c.* 1780 and 1790 terracotta 0·59 m.

London, Victoria and Albert Museum
Psyche was thrown into a dead faint by the poisonous fumes from the box of Proserpina, which she had opened against Venus's will. Cupid rescued her and carried her off to Olympus where they married. An *Enlèvement de Psyché* appeared in a sale catalogue of 1814 of Clodion's estate and seems to be identical with this undated group.

336 *A maiden with fruit basket* c. 1780 terracotta 0·44 m.
S. CLODION
Leningrad, Hermitage
Bronze, ivory and porcelain had replaced each other in the history of small-scale sculpture, before Clodion – in the transition period to classicism – introduced unpretentious clay as a new material. With his highly developed feeling for line and form, his statuettes, for all their finish, have the spontaneous charm of a sketch. In his graceful figures, taken from the lower hierarchy of the Olympians or from everyday middle-class life, he never oversteps the limit to become pathetic or banal.

JEAN-ANTOINE HOUDON (*see* 332)
337 *Summer* 1785 marble 1·55 m.
s. and d. HOUDON F. 1785
Montpellier, Musée Fabre
Houdon portrays *Summer* as a beautiful young girl with wheatsheaves and watering-can. She is conceived with great tenderness. In her measured walk, she turns to the right, yet her glance and attention are still riveted to the left: a girl from the country, yet with the majestic presence of a goddess. M. de Saint-Vaast did not commission the figure for his garden: he had always intended it for the decoration of his palace.

338 *Seated statue of Voltaire* 1778–81 marble 1·65 m.
Paris, Comédie Française
'Marble statue of Voltaire, seated in antique chair, in the mantle of the philosopher, his head encircled by the fillet of immortality.' Thus Houdon entered this figure in the list of his works, emphasizing the antique embellishments by which he wished to distinguish Voltaire as a man of immortal fame in the world of the intellect.

INDEX OF SCULPTORS AND WORKS ILLUSTRATED

Numbers refer to illustrations

349